FREEDOM'S DANCE

Karen Celestan *Eric Waters*

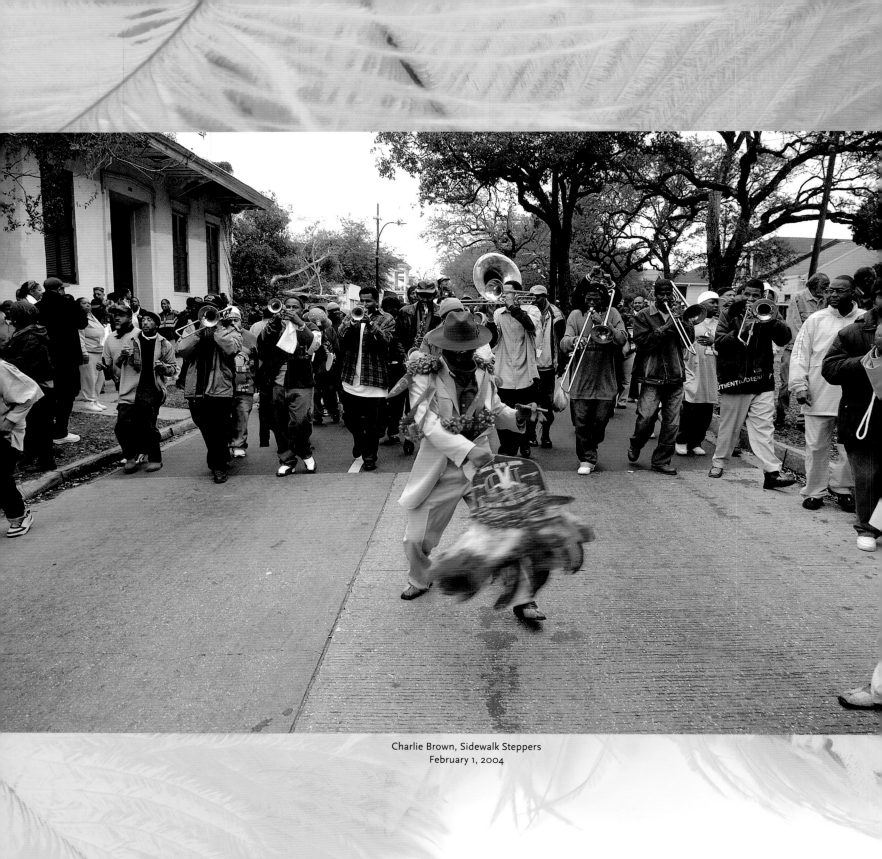

Charlie Brown, Sidewalk Steppers
February 1, 2004

FREEDOM'S DANCE

SOCIAL, AID AND PLEASURE CLUBS IN NEW ORLEANS

PHOTOGRAPHS BY **ERIC WATERS** NARRATIVE BY **KAREN CELESTAN**

FEATURED ESSAYS BY

JAMES B. BORDERS IV, RACHEL CARRICO AND ESAILAMA ARTRY-DIOUF,
FREDDI WILLIAMS EVANS AND ZADA JOHNSON, JOYCE MARIE JACKSON, KALAMU YA SALAAM,
CHARLES E. SILER, AND MICHAEL G. WHITE

SELECTED INTERVIEWS BY

VALENTINE PIERCE

LOUISIANA STATE UNIVERSITY PRESS

BATON ROUGE

Published with the assistance of the Borne Fund

Published by Louisiana State University Press
Copyright © 2018 by Louisiana State University Press
All rights reserved
Manufactured in China
First printing

DESIGNER: *Mandy McDonald Scallan*
TYPEFACE: *text: Chaparral Pro; display: Eveleth and Trend*
PRINTER AND BINDER: *Regent Publishing Services*

Library of Congress Cataloging-in-Publication Data are
available from the Library of Congress.
ISBN 978-0-8071-6883-7 (cloth: alk. paper) — ISBN 978-
0-8071-6884-4 (pdf) — ISBN 978-0-8071-6885-1 (epub)

This book is dedicated to the *parrain* of Second Line culture,

Lionel "Unca Lionel" Batiste

(February 11, 1931–July 8, 2012)

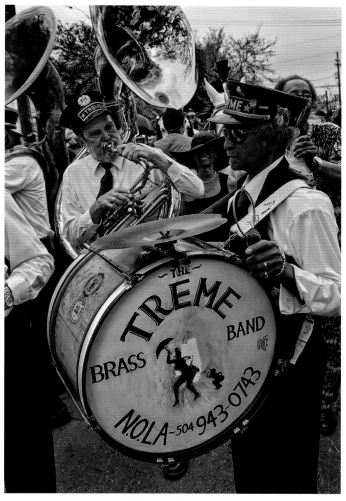

February 28, 2009

This book would not have been possible if it were not for George and Marguerite Waters, who provided me with a stable home life and a quality education; their gifts were love and support. My parents instilled in me a sense of culture, of Black culture. They surrounded me with the sounds of Jazz (big bands and vocalists) and introduced me to the Second Line, filling me with a love for the dance and its music. I am who I am because of who they were. Thanks, Mom and Dad.

—ERIC WATERS

This book is dedicated to my parents, New Orleans born and raised—who never forgot from whence they came—Amy Victor Celestan and George J. Celestan (1929–2012). To Dad, thanks for instilling a fearless love of music, dance, and culture that has enriched my life in a tremendous and defining way—from Native American pow-wows, concerts at Melody Fair just outside of Buffalo, trips to the Aquarium, my first Mardi Gras, and anyplace else our family dreamed up to visit; to my daughter, Nikki Lee; brother, Gregory Celestan; and niece, Bryce Celestan, the ever-present joy and laughter, and for the shared family experiences that make life worth living; to my ancestors, whose lives and spirits keep me aloft every day when I open my eyes; and all praises to God for every gift and blessing that allows me to be a mere vessel to tell our stories. To the music and the culture, for releasing and invigorating the core of me.

—KAREN CELESTAN

Nyame Dua—"tree of God"
Adinkra symbol of God's presence and protection

CONTENTS

ACKNOWLEDGMENTS

How do you quantify and qualify an acknowledgment? How do you express appreciation to so many who have given so much? My answer to these questions is to apologize to anyone who has been left out (totally unintentionally).

I acknowledge the assistance in achieving a dream that became a goal that has become a realization. My other acknowledgments are to all the persons whose image(s) appear on these pages and to all those who contributed their voices via interviews. All expressed their love and passion for the culture and their willingness to keep it alive and thriving by passing it on to the next generation. My undying gratitude to the writers who have enriched this endeavor beyond my wildest imagination with their insight and knowledge. Thanks to all who have made this book possible.

Special thanks to Erik D. Waters, Lori Waters, Charlene Braud, and my grandchildren, Eadan Rayne Waters and Schyler Morton.

And finally, to Karen Celestan who came up with idea to help me organize and review thousands of images in order to select key photos for this book. The original concept we discussed may have changed, but her singular focus has never wavered.

—E.W.

Special thanks to Lois Andrews, Norman Dixon Jr., Eric and Erica Dudley, Alvin Jackson, Wanda Rouzan, Fred Johnson, Barbara Lacen-Keller, Gregory "Blodie" Davis, Oliver "Squirk" Hunter, and Markeith Tero for the time and willingness to discuss their lives in the Second Line culture.

Supreme thanks to our talented essayists—Joyce Marie Jackson, Ph.D., Kalamu ya Salaam, James Borders, Chuck Siler, Freddi Williams Evans, Zada Johnson, Ph.D., Rachel Carrico, Ph.D., Esailama Artry-Diouf, Ph.D., and Michael White, Ph.D.— whose scholarship, patience, and devotion to this project is without peer. Thanks to Valentine Pierce for her dedication in following up with key people to be interviewed for this book and for doing the painstaking, tedious work of transcribing critical interviews—Ms. V, you're the best! Much love and gratitude to our academic advisers and supporters—Gwendolyn Midlo Hall, Ph.D. (professor emerita, Rutgers University), Rashauna Johnson, Ph.D. (associate professor of history, Dartmouth College), and Russell Rickford, Ph.D. (associate professor of history, Cornell University), and Tayari kwa Salaam, Ph.D., for her scholarly review and evaluation of the manuscript.

To my dear family and friends, for their patience and understanding as I hibernated for nearly a year to complete this project. Many thanks to my literary spirit-warriors, Dartinia Hull, Beth Uznis-Johnson, Jack King, Rita Juster, and Angele Davenport.

And to Eric Waters, a Crescent City morning star, whose ocean-deep love for this most African of African-American cultures overcame physical pain (his poor knees!), heat, torrential rain, time, and even Hurricane Katrina to create a body of work that tells the true story of this treasured tradition.

Freedom's Dance was a fifteen-year journey of many steps with a few arguments, lots of tears along the way (both Eric and I endured the loss of parents), and rejection by numerous agents and publishers. But oh, we persevered, keeping our sights set on honoring the SAPC culture and the principle of *Kujichagulia* (self-determination)—about us, by us . . . *Ashé!*

—K.C.

Special thanks to the Louisiana Endowment for the Humanities for their support of this project through their grants program.

—*Karen Celestan and Eric Waters*

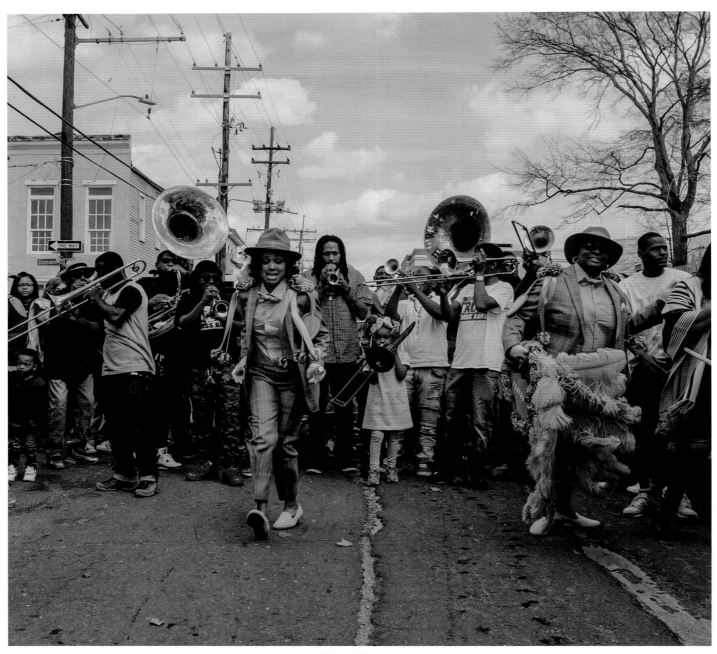

Sidewalk Steppers
February 14, 2016

INTRODUCTION

KAREN CELESTAN

DEFINING THE SECOND LINE

There are so many lies, misconceptions, biases, and plain old ignorance about the Second Line in New Orleans. The aim of *Freedom's Dance* is to serve as both a myth-slayer and militant defender of the culture. Think whatever you want, believe whatever you choose, but this book will tell our truth.

Freedom's Dance will detail Second Line customs while providing an inside look into the *who, what, when, where, how,* and *why* of the people creating and participating in this private-public ritual. It will permit people of African descent to define what we do and how we do it, without being objectified by those who study the culture for personal and professional gain. Most culture-bearers believe that many of those individuals view Second Line culture through the blurred, patronizing lens of disdain wrapped in subconscious admiration.

It is critical that this collective sets the cultural standard, right down to determining style and terminology. This is simple and complex, open to argument and interpretation, but *Freedom's Dance* will cover the classification, characterization, delineation, and designation of the Second Line. Through lengthy and involved discussion, scholarly study, empirical evidence, and personal experience that comprise this volume, this African-American body defines the Second Line as presented by Social, Aid and Pleasure Clubs in New Orleans.

1. The organization that initiates and participates in annual public parades is a Social, Aid and Pleasure Club and is also referred to by the acronym SAPC (plural: SAPCs). There is a dedicated parade season for SAPCs that runs in a cycle from August to June.

2. The public parade organized by a SAPC is a Second Line. It is an individual, scheduled event that is held annually. It is a proper noun to be capitalized. (*Example:* Valley of the Silent Men SAPC opens the Second Line parade season every year.)

3. The Second Line is a partner noun that refers to the people who are not SAPC members but surround and participate in music and dance rituals that are creative and fluid, yet often are specific to the parade event and part of town in which the parade occurs. It is not to be used interchangeably with the term referring to the public parade organized by a SAPC. Individuals who comprise the Second Line are part of a body and are referred to as second-liners. This is a hyphenated noun, but not a proper noun. SAPC members and brass band musicians make up the *first line,* but that is a formal, more academic term that is rarely used within the community. (*Example 1:* Jerome and his cousins were determined to be the most on-point Second Line at the Sudan parade. *Example 2:* Shantell is a true second-liner, going to most of the Second Lines during the season.)

4. When SAPC members and their followers are engaged in a Second Line, it is a dedicated and specific action referring to dance and movement, so to second-line or to engage in second-lining is a verb and to be written in lowercase. (*Example 1:* If you go to the Original Ladies Second Line, be prepared to second-line your ass off. *Example 2:* Baby, I was second-lining so hard for the whole route, I pulled a muscle.)

The Social, Aid and Pleasure Club culture is comprised of organizations that may be one or more of those aspects in their mission. Some clubs may be only social in nature, and some might be a combination of two or all three to serve multiple purposes. Each club defines itself at its inception, but that distinction is fluid and may change over time as the membership changes or new officers are installed. SAPCs evolve with societal shifts, including community demographics, interaction with law enforcement and local government, or the simple need to change the club's designated parade route.

A number of clubs are chartered with the city and state as SAPCs but may drop the acronym as a matter of expediency—to shorten a lengthy club name or just as a point of familiarity over time. For example, the Black Men of Labor *is* a Social, Aid and Pleasure Club but forgo using the SAPC designation other than in formal situations such as completing forms for permits or on their website. Many are not concerned about strict definitions but are focused on maintaining the structure and order of the tradition. SAPC culture-bearers know who they are, and most understand their place in the continuum.

CODE NOIR, JIM CROW, AND WHY WE MUST DANCE . . .

New Orleans is a mélange of cultures—among them African, French, Native American, and Spanish. Due to the city's location, its status as a major U.S. port and former enslavement portal, and its proximity to the Caribbean, customs and rituals introduced by ruling classes, slaves, and native people found a home and took up permanent residence. As the nation grew, New Orleans did not evolve in the same fashion. The city absorbed different ethnic cultures, yet each group maintained a strong sense of tradition and self, becoming an identifiable, separate part of the whole.

African people living in New Orleans found a way—despite enslavement, Code Noir, Jim Crow, and all attempts to control and dehumanize them—to maintain some semblance of home memory. The SAPC tradition, in the simplest of terms, evolved from that memory and is one of the most direct cultural links to Africa and the Caribbean that exists in the United States. Social, Aid and Pleasure Clubs are separate from the **Mardi Gras Indian*** culture—each having distinctive customs and approaches to their pa-

rade milieu—but New Orleans is the only place in America where these two specific, organized, public African-based rituals occur.

SAPC members are dedicated to maintaining this custom "come hell or high water," which, in terms of New Orleans weather patterns with its scorching heat, hair-scraggling humidity, and drenching rain, is a real possibility. Each club's parade takes up to a year to plan and develop, and every detail is attended to with loving care and dedication.

Freedom's Dance captures every aspect of the Second Line, from SAPC members' rollicking introductions at a neighborhood lounge to a funeral procession's last steps toward the cemetery or mausoleum. *Freedom's Dance* shows the SAPC's approach to the parade, the musicians' critical contribution, as well as the various characters who religiously follow the route to make up the Second Line. Practices are uncovered, from the selection of suits to the elaborately decorated baskets, fans, and sashes displayed by SAPC members. Yet, this overview respects the privacy of individual clubs and their members. The devotion of SAPCs to tradition positions a Second Line in New Orleans as one of the purest rites carried down through centuries of African-American life in America.

Freedom's Dance will explore the historic applications of several humanities disciplines (performing and visual arts, history, religion, and philosophy) and use critical analysis to show a direct line from Africa and the Caribbean to the streets of New Orleans (with several neighborhoods holding the distinction of being the oldest African-American enclaves in the United States). African Americans in New Orleans live and display the most African-retentive rituals in the United States and understand the connection with their ancestors. From the enslaved using the *djembe* and their feet to strike the earth in tribal dances at Congo Square in the 1800s to a SAPC strutting down Governor Nicholls Street in Tremé in 2018, the Second Line has maintained the architecture and spirit of a people and their culture.

Eric Waters has been photographing Second Lines since 1970. He was the principal photographer for years for a number of SAPCs, primarily Black Men of Labor and Sudan, and has semi-retired since 2014. He has shot more than 128,000 images of SAPCs—following some groups from their inception to the

*Terms that appear in **boldface** on first use in the text are defined in the glossary.

present. (A large number of photos were lost when his home was swamped by the London Avenue levee breach in the aftermath of Hurricane Katrina. Some images were salvaged from negatives housed at an alternate location, and some were saved from his computer's hard drive.) This book will be filled with Waters' photos to support a narrative that will provide history, scope, and perspective—the true, full story. This is a complete look at the famed Second Line in New Orleans, focusing on the SAPC tradition, which has both a historic and an anthropological perspective. It is a special tribute to the working- and middle-class people who have continued this custom.

REASON AND PURPOSE

Some believe that being part of Second Line culture is a situation where you can "pay your dues" and get credentials to prance in the street in a brightly colored suit and shoes. Oh, but no, my dear! To second-line is to demonstrate the lifeblood that courses through your veins—it is generational; it is a feeling. You get it from being close to the culture: wrapped up, jammed up, and jelly-tight.

Generations of life under the crush of vicious and unnecessary restrictions created a need for a specious "freedom," the only control afforded African descendants—the ability to feel the sound and vibrations of the drum and dance. It is the wine that evolved from human grapes being smashed into society and the plantations and fields throughout Louisiana. The result of that unrelenting pressure was an intoxicating nectar that moved limbs in liquid muscle memory. People of other races can mimic certain movements, but what is missing is the essential oil of Mother/Father Africa.

Eric's photographs display love in every shot. He took the time to get to know people as individuals, endearing himself by doing basic things for them: taking family portraits, shooting their weddings or other life events. But Eric is not an exploiter—he respects and loves each organization and its people, and in turn, the culture and its people respect and love him back. His relationship to Second Lines was key to having critical discussions with elusive and private culture-bearers, such as Lois Andrews, Oliver "Squirk" Hunter, and Markeith Tero.

When you view the photographs throughout *Freedom's Dance,* that is love—the beauty gained over forty-plus years

of dealing with people one-on-one—caring for them without judgment and not just trying to snap a picture to make money. It was always about capturing SAPCers at their best. For example, most of society would write off Squirk as just another (*insert your own denigrating term here*), yet Eric always recognized the élan, beauty, and talent buried deep within Hunter's heart. All of those incalculable traits are captured in Eric's iconic photographs of Squirk in midleap—not once, but twice—in two different decades. Eric will play it off, "Oh, I just happened to raise my camera at that moment," but what many have come to recognize in his capture of the instant of those jumps is a meeting of spirits, a meeting of hearts, a meeting of artistic and spiritual zeniths that will be forever entwined—milliseconds of time that have been documented forever.

And that is the Second Line. It is spontaneous, it is beauteous wonderment, it is joyfulness—all the things people want and need it to be at that moment. It is the controlled chaos that is purely African, the tributary flowing from God. African-American culture in New Orleans is majestic and pays homage to the spirit world (ancestors). It shrouds itself in secrecy for protection yet is open enough to deliver itself for public spectacle. Second Line culture is performance art that is emotional, intuitive, precise, and labor-intensive.

The descendants of slaves and free people of color in New Orleans have managed to keep that piece of self, hold onto it, and revere it. Others try to infiltrate the culture, to get in the middle of it, bouncing around all herky-jerky and hurdy-gurdy, not feeling the feeling. When you see people in SAPCs dipping and bobbing and weaving, dancing and carrying on, that is a heart-release that can't be explained or taught through step-by-the-numbers classes. Sure, you can put on the suit and have the color, but an innate swag is missing. Observers know when it's real because they feel it, too. And just because you feel something doesn't mean that you should be a part of it or insert yourself into what you're witnessing.

It is imperative for people to respect the culture and know that you can appreciate, applaud, praise, study, and even criticize it without attempting to co-opt it—acting as cultural, fiscal, and academic vampires. The feeling is deeper than a vibe, it's more than just being on the scene and trying to be cool—it goes all the way back into the ancestry and flows through SAPCers and throngs of second-liners.

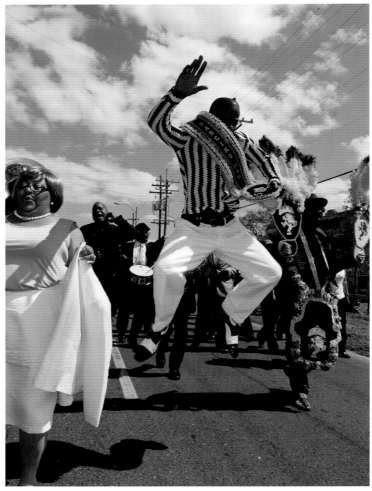

Darryl "504 Dancing Man" Young
March 12, 2011

The Second Line is an outward sign that the creativity and sacrifice of the elders will never be forgotten. It is a public display of the sweat, blood, and tears of a people stolen from their native land. It is the life-fluid of the **African Diaspora**.

This is the world of the Social, Aid and Pleasure Clubs in New Orleans. It doesn't take place anywhere else in the United States. It is a culture unlike any other. It is art, it is spirit, it is ritual, it is humanness, it is pure.

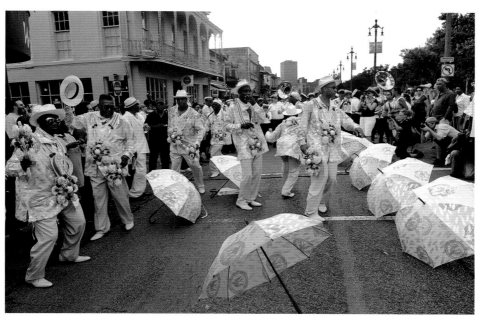

Black Men of Labor
September 12, 2009

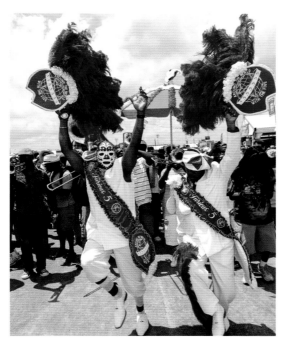

Furious Five
April 29, 2012

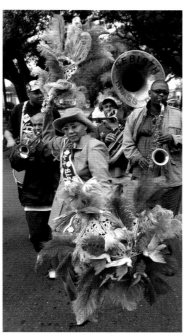

Terry Aspree, Big Nine
December 28, 2003

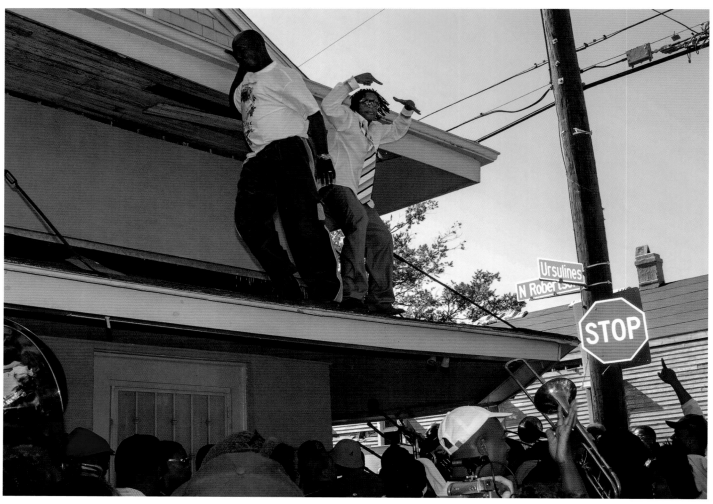

November 4, 2006

MY LIFE'S WORK

Freedom's Dance

ERIC WATERS

Freedom:

1. Not under the control or in the power of another; able to act or be done as one wishes. Self-determining, not a slave.

2. Not physically restrained, obstructed, or fixed; unimpeded.

3. The absence of necessity, coercion, or constraint in choice or action.

4. Liberation from slavery or restraint or from the power of another.

—*Merriam-Webster Collegiate Dictionary,* 10th edition

I came to experience the Second Line at an early age. As I grew older and started to attend dances and began second-lining, I felt a sense of euphoria but did not have an understanding of its cultural significance.

When I began my photographic journey, I embarked on documenting all things culturally indigenous to New Orleans. I started to understand the Second Line's connection to Africa. I began to fully appreciate the art of dance and improvised movement; the rhythms of the brass band giving additional impetus to the dancers. I saw the same sense of euphoria that I first experienced many years prior; freedom from everything but the moment, synchronized chaos, movement and music in perfect harmony.

The Second Line is a cultural expression, a rhythmic message, a spiritual continuum, incantations through movement. Ours given to us by our Ancestors. An umbilical cord from Africa, supplying sustenance for our souls. The Second Line is to be free in the moment.

Freedom's Dance is the embodiment of innate rhythm, our African Heritage.

ROOTS OF THE SECOND LINE

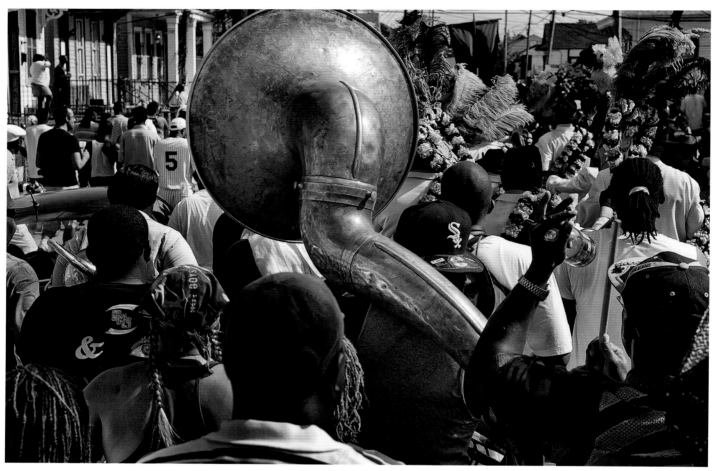

October 9, 2011

New Orleans Second Line Aesthetics and Identity

Including an Interview with Eric Waters

JOYCE MARIE JACKSON

Music here is as much a part of death as it is of life.
—SIDNEY BECHET

After two full days at an African Studies Association conference in the Hilton Riverside Hotel, listening to various sessions on Africa and its Diaspora, I thought it was time to get out and take a break. So on the third day, I decided to take one of my African colleagues out to experience the **Creole** cuisine of New Orleans.

One of my favorite restaurants was located on North Robertson Street in the downtown Tremé area—a place called Chez Helene. The premier chef, whose culinary arts were ranked among the greatest in New Orleans, was Austin Leslie. Later, the restaurant became known as Chez Louisianne, after the popular television sitcom named *Frank's Place,* which itself was based on Chef Leslie and Chez Helene.

My colleague loved the food and marveled at the delicate seasoning, spicy taste, and other similarities to his home country's cuisine. So we had a good conversation on the similarities of New Orleans and southern foodways as compared to West African foodways—names of dishes, how they are prepared, and which foods actually came from West Africa during the **Trans-Atlantic Slave Trade**. After our wonderful culinary experience and fellowship, my colleague had a chance to meet Leslie. They had a brief encounter discussing some of those culinary similarities that I am sure neither ever forgot.

Although not raised in New Orleans, I was born there and have lived there twice. I am always conducting research and enjoying cultural events in New Orleans, as well as taking time to visit relatives and friends. I enjoy giving my own insider's cultural tour to friends and associates who visit New Orleans. So as my African friend and I returned to the afternoon session of the conference, I decided to drive down Claiborne Avenue and show him more of the city's neighborhoods and one of its cemeteries. Suddenly, we heard a brass band. We looked around and then we saw it: a Second Line parade.

I began to explain what was happening, but before I could finish and find a place to park so we could join the celebration, my friend became so excited that he jumped out of the still-moving vehicle and ran toward the parade. I parked and finally caught up with my colleague, who had already become a second-liner. He said, "I feel so at home! This is just what we do!" This was a man who had been living in New York for about fifteen years, first as a student and then as a professor. Within that time, he had traveled to many cities in the United States, but he had never seen anything like the Second Line or experienced that feeling of being in his native land. He said that it was not only the height of the conference for him but the best experience of his years living in the United States. Between the

Creole cuisine and the Second Line parade, he said, he felt like he was back in Ghana. Needless to say, we never made it back to the afternoon conference sessions at the Hilton!

I have told this story to a number of people to illustrate the strong African foundation of the New Orleans Second Line tradition. Although I had read about this and had experienced processions when I traveled to Africa myself, it was invigorating to compare notes with a Ghanaian friend and colleague who had just experienced a Second Line procession in a New Orleans contextual street setting.

Those fortunate enough to have participated in these street ritual processions by way of second-lining to the accompaniment of a brass band will understand the awesome energy and spirit of this tradition. The Second Line is the product of an African aesthetic and sensibility as well as the result of Diasporic sources that emerged and helped shape New Orleans' street cultural history and other rituals. Through these rituals we can grasp the essential similarities of African and African-American culture. We can thereby appreciate the early foundation laid by Africans and people of African descent in New Orleans; the fidelity of those who followed their teachings; and the intoxicating and sublime music created during this era called Jazz.

HISTORICAL BACKGROUND

Several generations of West and Central Africans who were enslaved and forced to migrate to Louisiana were able to regroup and reestablish certain important homeland traditions and institutions in the process of their self-liberation before and after Emancipation. Although the first Africans brought to Louisiana by the French colonials (1699–1768) were from the Sénegambia region and left an indelible legacy of traditions in Louisiana, the Spanish slave trade (1769–1803) also brought in enslaved Africans from three other areas: the Bight of Benin, the Bight of Biafra, and Central Africa. There was also a resurgence of Sénegambians during the Spanish slave trade to Louisiana due to the rise of warriors captured in battle during the rise of empires such as the Kingdom of Segu (Hall 1992, 289). Gwendolyn Midlo Hall extracts the following figures from testimonies in the slave conspiracy trials, ship and plantation inventories, notarial records, and other documents: "The largest number of slaves, 28.7 percent,

came from the Bight of Benin. The Mina and the Fon maintained their numbers throughout the time period studied. The Yoruba (Nago) were present in largest numbers before 1783. . . . Significant numbers of Fon (Dahomean) and Yoruba women were clustered on the same estates" (Hall 1992, 291).

Male societies, secret societies, and cult cooperatives were a widespread phenomenon in many parts of Africa. These societies were dominant in western Sudan, from Sierra Leone to Ghana, and from Nigeria and Cameroon into the neighboring Congo region. There were both inclusive and exclusive societies. The former were generally comprised of all the initiated men of a group, whereas the latter did not admit all initiated males. Common to all members of these societies, however, was their knowledge of certain secrets, primarily those of a traditional sacred nature concerning prayers, chants, rituals, remedies for certain illnesses, the art of carving, and playing certain ceremonial instruments.

The Yoruba (originally a Hausa term for the Kingdom of Oya) live mostly in Nigeria, where they number about 15 million. Among the Yoruba, there have existed many societies of varying degrees of exclusivity that are the control factor in the communities, that is, their basic function is to maintain social control. These exclusive societies are primarily religious in nature. Other societies, such as the Gelede, play a more profane role, such as providing entertainment. They are also centered on their sacred orientation but are less exclusive than others.

Women's societies in Africa exist but are rarer. They are found mostly in the western Sudan, and more prominently in Sierra Leone and Liberia. Not much is known about their structure and functions since very few women researchers and no men are permitted access. Their main purpose seems to be assisting in childbirth, as well as dealing with other medical and agricultural matters and conducting their corresponding rituals. However, the Kulere were once in a position to use their solidarity as a sphere of influence and to counter men's claim to dominance with some degree of success.

Africans from these cultures re-created societies similar to those in their homeland as a form of social security and to instill their value systems in their Louisiana-born offspring. This achievement occurred not in a marginal backwater but in New Orleans, a fortified port city at the heart of France's maritime colonial empire. These African-style secret societies involved not just a few people but hundreds and, later, thousands work-

ing collectively. Indeed, they became foundational to the future of African Americans not only in New Orleans but in many southern cities, especially during Reconstruction, Jim Crow, and the post–World War I era.

Voluntary associations affirm the shared communal spirit of the people. The years following Emancipation witnessed a burst of associational activity in the South and the creation of thousands of Black organizations for the purposes of communal security. These organizations included Masonic, Eastern Star, and Odd Fellow lodges; benevolent and mutual-aid societies; militia companies; rowing clubs; religious societies; social and literary clubs; orphan-aid associations; racial improvement societies; baseball clubs; and other, church-affiliated organizations. These associations grew out of a need for Black people to care for their community, provide for their sick, properly bury their dead, and care for the families of deceased members, as well as for entertainment and social life. The society collected dues and fees in order to subsidize these activities. The funds were invested to pay sick benefits and support indigent members. Occasionally, the group also lent money to individuals and provided "strong boxes" for savings. Mutual-aid groups also partnered with Black fraternal and Masonic orders. Mutual-aid groups contained the germ of what was to become a major Black business, the insurance company.

If Black people were to prove their capability as freedmen, the Black community had to provide for those members who could not fend for themselves, given that public dependency was frowned upon and not sanctioned by the community. Mutual-aid societies were crucial to preventing public dependency, as John Blassingame explains:

> There were probably three reasons for the apparently low rate of public dependency in the Negro community. First of all, New Orleans whites were generally unwilling to support Negro paupers. Secondly, Negroes had an abhorrence of public relief. Whites had contended so vociferously and continuously that Negroes would not work, that most New Orleans Negroes shunned public relief as a matter of racial pride. Negro newspapers tried to discourage their readers from going on relief even in times of public disaster. . . . The third factor which kept people off public relief was the activities of benevolent societies and the desire of Negroes to care for their friends and relatives. (Blassingame 1973, 167)

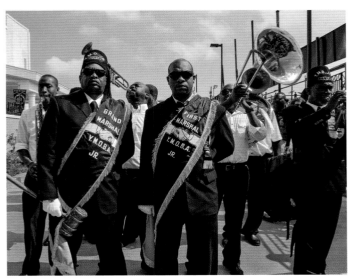

Young Men Olympian Benevolent Association
October 7, 2011

The Black societies and benevolent associations were significantly involved in orchestrated efforts to resolve community social issues. In the era before the advent of Black insurance companies, these organizations provided social security in response to poverty, health issues, and death. The societies also helped give people a sense of identity while institutionalizing the desire of Black people to take care of their own. On May 20, 1865, the *New Orleans Black Republican* summed up these sentiments: "It is indispensable that the people of color indicate ability to seize upon all the avenues that are open to any people. We must have our own intellectual activity, or collective organization in churches, asylums, or secular organizations, that make up society and reveal the capacity of government in a people."

Some 226 African-American societies were registered between 1866 and 1880 in New Orleans alone (Barlow 1989, 183). These societies were listed in either the Signature Books of the Freedman's Bank or the newspapers.[1] There is a strong probability that there were more, because only the prominent and active ones were listed in such newspapers as the *New Orleans Tribune,* the *Louisianian,* and the *New Orleans Black Republican.* These associations provided status and entertainment to members, who often staged parades in full regalia to commemorate their societies' founding anniversary dates. The societies also par-

ticipated in larger cooperative processions celebrating other events on the calendar and in the community (Blassingame 1973, 147). One of the more significant events was the death of a musician or prominent community member, which often resulted in a Jazz funeral with a brass band and Second Line. In the words of Jelly Roll Morton, a renowned child of the golden age of Jazz:

> Of course, as I told you, everybody in the city of New Orleans was always organization-minded, which I guess the world knows, and a dead man always belonged to several organizations—secret orders and so forth and so on. So when anybody died, there was always a big band turned out on the day he was supposed to be buried. . . . You could hear the band come up the street taking the gentleman for his last ride, playing different dead marches like *Flee as the Bird to the Mountain*.
>
> In New Orleans, very seldom they would bury them in the deep in the mud. They would always bury um in a vault. . . . So they would leave the graveyard . . . the band would get ready to strike up. They'd have a second line behind um, maybe a couple of blocks long. . . . Then the band would get started and you could hear the drums, rolling a deep, slow rhythm. A few bars of that and then the snare drummer would make a hot roll on his drums and the boys in the band would just tear loose, while second line swung down the street, singing . . .
>
> Didn't he ramble?
> He rambles.
> Rambled all around,
> In and out the town.
> Didn't he ramble?
> He rambled,
> He rambled till the butchers cut him down.

That would be the last of the dead man. He's gone and everybody came back home, singing. In New Orleans they believed truly to stick right close to the scripture. That means *rejoice at the death and cry at the birth*. . . . (Lomax 2001, 16–17)

This early and eloquent description of a Jazz funeral by one of its frequent participants was given to Alan Lomax in 1938. Morton was sharing one of his rare moments of ecstasy, but he was also describing a cultural transmutation, a moment when African culture became African American.

As one of the world's most influential composers of Jazz, Morton was a giant in early New Orleans who later was known throughout the world as a musical innovator. He was a pioneer of Jazz piano, and he made a vital and lasting contribution both to that music (performing, composing, directing, and recording) and to literature by way of his Library of Congress recordings and the book *Mister Jelly Roll*. Although historians often misinterpreted Morton's words so that some of his discourse may not appear as he would have wished, we are privileged to read his detailed account of the development of this new hot genre as it paralleled other significant New Orleans traditions such as the Jazz funeral and Second Line parades.

It is interesting to note that not many churches had designated cemeteries, especially in view of the fact that cemeteries were segregated in both the North and the South during this time. This situation certainly led most Black communities to establish a church cemetery and some type of burial association to guarantee a "good home-going and resting place." To be properly buried in the Black community was a final testimonial to a person's human worth, Christian decency, and the individual and community life they had lived. In the post–Civil War years, many economically disadvantaged Black people bought into burial plans, paying five to ten cents per week or fifty cents per month for insurance in order to assure themselves of a decent burial. The benevolent societies collected this money and would frequently take on the responsibilities surrounding the final passage, often having to add to the individual's collected sum. In New Orleans, some associations established cemeteries for their members, including the Good Samaritans and the Union Benevolent Association (Blassingame 1973, 168). Another example is the community of Fazendeville, right across the Orleans Parish line in Chalmette. There, the Progressive and Silver Star Benevolent Associations combined resources and established the Ellen Cemetery off Paris Road (Jackson 2003, 47).

I can vividly remember my grandparents paying their benevolent society dues—three dollars a month in the 1970s—which

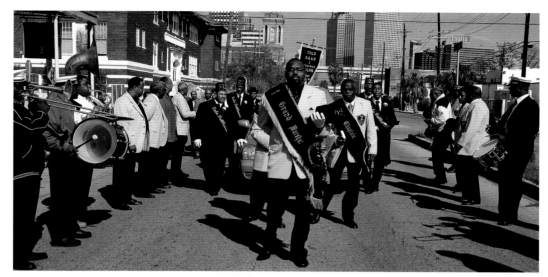

Zulu funeral procession
January 2, 2007

was their burial policy. It increased a small amount about every ten years. I thought this was insane. Did they really think they could be buried today for what that policy would yield, even after paying for years? My parents explained that it was all about the tradition and being loyal and not stopping something that you started. Indeed, my grandparents had another burial plan. But they also had to continue with the old one simply because they had put something into it every month for fifty years. They were still members of their society, after all! Even though they did not attend meetings anymore, to stop paying was like breaking a contract. They knew the society would still give their children *something* toward the expenses of their final rites, even if not much.

The traditional custom of the open funeral casket in the African-American community prompted many people to keep up their burial insurance payments in spite of the pressure of poverty. The society had to guarantee an impressive and proper burial by hiring the band, holding special rites over the body, marching in special regalia, and wearing mourning badges. This economic investment represented a lifelong goal of making a final impression that was favorable to the community. The deceased and their family wanted the dead to look their best for their final viewing and last ride.

Once again, we see a powerful cultural continuity between these rituals in Africa and the Diaspora. For example, in *The Joys of Motherhood,* Nigerian novelist Buchi Emecheta describes a funeral in her homeland:

> She let out a loud cry to tell the world that her father . . . had gone. People woke and rushed in and took up the cry. . . . Soon the whole of Ibuza and the neighboring towns as well knew that an important person had left this earth to go to his ancestors. The mourning and dancing and the wake went on for days. . . .
>
> With a great deal of dancing and festivities, Obi Nwokocha Agbadi was set up on his Obi stool and sat right there in the grave dug inside his courtyard. The coffin, a sitting coffin, was very long, for he was a tall man. He was dressed in his chief's regalia. . . . [H]e sat there as if he were about to get up and speak. (1979, 154)

Malidoma Patrice Somé, author of *Ritual: Power, Healing, and Community,* describes a similar funeral scenario:

> The dead person is seated a few yards away from the weeping crowd on a wooden stool freshly built from

a special tree. The same tree is used to build a shrine around the dead. The dead person is dressed up in full ceremonial regalia. The shrine is decorated with colorful fabrics and with the sacred objects that belonged to the person now dead. The shrine represents the place from where the dead reaches out to the great beyond. (1993, 77)

In this area of the Dagara, an ethnic group in Burkina Faso (formerly Upper Volta), West Africa, an elderly deceased person is honored by a special ritual, attired in full ceremonial regalia. It is a further honor to be buried sitting up.

A similar example in New Orleans was the wake/viewing service of "Uncle" Lionel Batiste, drummer for the Tremé Brass Band. Uncle Lionel, as he was affectionately called by those in the community, passed in 2012 and at the request of the family, his body was viewed in an unusual way. Morticians at the Charbonnet-Labat Funeral Home actually stood him up to appear as though he was greeting guests at his own wake/viewing service. He was dressed in his usual dapper attire: suit, hat, shoes, gloves, and walking cane. Of course, the next day he had an appropriate Jazz funeral with a brass band and many second-liners joining in the procession. He definitely had a traditional send-off with all the cultural elements befitting a musical icon who was well loved and respected in the community.

To consider yet another African counterpart, I traveled to Ghana in 2004 and stayed in Anloga in the Volta region. During this time, I attended two funerals in one day for the same elderly gentleman in the community of Wo. Prior to the funeral, I learned from a shaman whom I had previously interviewed that the only morgue was full and they were sending bodies to the next town until they had more vacancies.

I was very much concerned by this because I had nine students with me doing research and conducting projects. "Has there been an outbreak of a contagious disease or a civil war that I did not hear about?" I asked him. He laughed and said: "No, this happens frequently. Some bodies have been there for more than three months. It is customary that family members have a proper burial, especially for an elder of the community. This means that relatives, especially those in the immediate family, have to come home and some from as far away as the United States and other countries." He went on to explain that you have to have enough food to feed your family and a large part of the community. You also have to pay musicians, some-

times mourners and ancestral reenactors. Of course, all of this depends on your relationship with the supporting entourage of participants. In essence, the family has to either have or take time to raise all the funds to orchestrate a culturally proper funeral for an elder or well-known and respected resident of the community. This can take some time.

In viewing this funeral in Wo, I could not help but remember other parallels with funerals back home in New Orleans. The African ceremony was held outside under large trees. The procession came into the designated space in a slow and stately manner, with other elders (parade marshals) carrying the casket, family members, the master drummer with his ensemble of drummers (brass band), reenactors, and community members (second-liners). We left the main funeral after more than four hours of various speakers, drumming interludes, animal sacrifices, circular blood rituals around the casket, and performances by ancestral dancers dressed in traditional funeral attire with all faces and visible body parts covered in white powder. The deceased, however, was more than one hundred years old with two families, so each family had a separate funeral on the same day. Accordingly, we moved on to experience some of the other funeral celebration for the same person, a simultaneous event, albeit without the body and on a smaller scale in terms of speakers and sacrifices.

This custom of dual funerals is not only an African one. A celebrity or some other prominent person might well have two funerals in the United States. A case in point is Mahalia Jackson, the premier gospel performer. Full-blown funerals were held for her in Chicago, where she lived, as well as New Orleans, where she was born and raised.

Also in New Orleans, some bodies are kept for two weeks until families can raise the funds needed for a decent funeral. Although there is surely some limit on the time a morgue and/or funeral home can store a body in the refrigerated drawer, most people try to avoid a pauper's grave for their family members. The importance to families of a good and proper burial for their relative can be seen in the attention given to the graves in Holt Cemetery (a pauper's cemetery) in New Orleans. The graves there are adorned with eclectic embellishments and various types of ornaments, paraphernalia, and artifacts. This practice is meant to show observers that the person buried has not been forgotten and was/is important. The continuities between Africans and the Black people of New Orleans are striking—

with the African practices just slightly adapted to the second country's policies and cultural milieu.

Although I have not had the opportunity to witness a Haitian funeral and procession, a friend showed me a film clip of one during my 2014 field trip to Jacmel. In true New Orleans style, my friend's deceased cousin also had a band with his funeral procession. Ministers led the way, the deceased's casket was carried by pallbearers, and following were family members, a group of women singing, the brass band in uniform playing, and friends, associates, and students in uniforms. With just a few variations on the theme, this was a very similar group of people, ordered in a very similar way, to those who would make up a Jazz funeral procession in New Orleans.

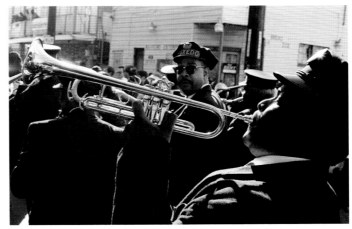

Kenneth Ferdinand *(foreground)* and Dr. Michael White at Danny Barker's funeral Second Line
1994

PERFORMING AFRICAN AND DIASPORIC CULTURAL AESTHETICS

In the Black festive style, elements of spectacle and performance are always prevalent, in both Africa and the Diaspora. And so, as we view New Orleans street rituals—Jazz funerals and Second Line parades—we are immediately reminded of West and Central African dramatic events, which always include music and dance. This African consciousness and aesthetic has had a lasting influence on New Orleans' culturally unique urban space.

Aesthetics is a culture-bound concept that implies a particular attitude, including the values held about a type of art. The way art is used or presented goes hand in hand with the culture's concept of the aesthetic. For instance, in West and Central Africa, music and dance have an inseparable relationship.

Brass Band Music and Decorum

The African expresses life in all its aspects through sound. The vitality of African music, even at a funeral, is an affirmation of life, transforming both the living and the dead into another form of existence. Above all, the music and dance of Second Line parades are group activities: the sharing of creative experiences as well as avenues for expressing common sentiments.

Funerals with musical accompaniment in other countries predated the development of Jazz in the United States. However, procedures and activities associated with Jazz bands in New Orleans that perform for funerals are in themselves a rit-

ual within a ritual, following detailed formulas and decorum. Methods of assembly, order of processional, uniformed attire, hymn selection, dirge and march tempos, and songs performed after the body is "cut loose"—when the procession is rejoined by second-liners—are all carefully planned and executed.

Rejoicing toward the end is fundamental to the Jazz funeral, but it is not impromptu or undignified rejoicing. The ritual shows that "death is swallowed up in victory." The end of life is not despair, but hope in resurrection (Schafer 1977, 67). The bands have a way of strutting, of swinging their bodies, and of turning corners in spectacular fashion as they have rehearsed prior to this important ritual for the deceased. This is extremely important for some people who cherish the traditional way of doing funerals, as illustrated by Gregg Stafford, a mentee of Danny Barker and trumpet player for the Olympia, Young Tuxedo, Onward, and Original Hurricane brass bands. Stafford said he had to promise Blue Lu Barker, Danny's widow, that his funeral procession would be executed with the traditional decorum because she was very reluctant to have one due to the carelessness she had witnessed in the handling of other musicians' funerals during that time.

Groups such as Sylvester Decker, Excelsior, Onward, Magnolias, and Allen's are fondly remembered by New Orleans old-timers. The spectacle of "full dress suits . . . with sashes . . . down to [the] knees," gold bangles, emblems, and strutting delights the imagination (Bechet 1960, 66).

High street drama prevails when these bands perform for funerals and Second Line parades (see Wanda Rouzan interview, later in this book). When more than one brass band is involved, there is often musical competition, including "bucking or cutting contests" and inspired improvisation. These contests might involve the whole band or just individual performers from each band such as the trumpet players or clarinetists. In Second Line parades without the funeral cortège, the bands are more relaxed in terms of attire and decorum.

Interrelationship of Dance and Music

The artistic medium of Second Line dancing is a response to the music that is shown outwardly in physical behavior and contributes to the social interaction, aesthetic, and expressive quality of the performance event. The dance is valued for more than the scope it provides for social interaction and release of emotion; it also serves as an artistic medium of communication through the dancers' choice of movements, postures, and facial expressions. Through the Second Line dance the individuals can demonstrate their reactions to others' friendships and offer respect to superiors or appreciation to well-wishers and benefactors. Many nonverbal expressions can be understood by their choice of appropriate dance vocabulary or symbolic gestures, which have all come from a synthesis of various ancestral memories and roots of cultures.

It was definitely the African and Diasporic ancestral performance traditions that formed the syntheses of practices and avenues of expressions embodied in the Second Line culture. These included West and Central Africa, Haiti, and the American South Black Christianity or "Black folk church." Although I will not discuss those in detail here, it is beneficial to note Joseph Roach's fragments of "memory, performance, and substitution" that govern the creation of Second Line performers; Margaret Thompson Drewal's discussion of play and improvisation and how it has transformative powers during performances of certain Yoruba rituals; and Yvonne Daniel's explanation of the spiritual powers embodied in the unified dancers of Haiti, Cuba, and Bahia (Roach 1996; Drewal 1992; Daniel 2005). Also, the Ghanian ethnomusicologist Kwabana Nketia writes:

> Because the dance is an avenue of expression, it may be closely related to the themes and purposes of social occasions. . . . Dancing at funerals, for example, does not necessarily express only sorrow or grief; it may also indicate tribute to the dead or group solidarity in the face of crisis. Among the Konkomba of Ghana, it is the duty of young men to dance at the burials of elders of their clan, or related clans, and even of contiguous districts, if they are sent by their leaders, for dancing at burials is a symbolic of clan membership as well as an expression of interclass relationship (David 1961). For similar social reasons, one will find in other societies that, in addition to what is intended specifically for the funeral, other forms of music and dance—including recreational music—may be performed as an homage to the deceased or as a means of identification with the bereaved. (1974, 208)

In all of the above instances, a body of dancers go through transformation for the benefit of many. Mahalia Jackson and Louis Armstrong also assert the spiritual aspect of the Second Line, discussing music and dance in the funeral tradition as primarily Protestant as they both were involved with Baptist and Sanctified churches.

Samuel Floyd, music historian, takes the analysis further when he writes about the Second Line and how it actually came out of sacred and circular ritual dancing, or the African "ring shout." The historian Sterling Stuckey's *Slave Culture* is a testament to how "the ring shout was the main context in which Africans recognized values common to them. . . . These values were remarkable because, while of ancient African provenance, they were fertile seed for the bloom of new forms" (Stuckey 1987, 16). Therefore, early in the development of African-American culture, the ring shout was a nucleus in the cultural convergence of African traditions with those of African-American traditions. Floyd writes:

> In New Orleans, for example, the ring became an essential part of the burial ceremonies of Afro-Americans, in which "from the start of the ceremonies in the graveyard, complementary characteristics of a religion, expressed through song, dance, and priestly communication with the ancestors, were organic to Africans in America[,] and their movement in a counterclockwise direction in ancestral ceremonies was a recognizable and vital point of cultural convergence" (Stuckey 1987,

23). What Stuckey does *not* say, but will be clear to readers familiar with black culture, is that from these burial ceremonies, the ring straightened itself to become the Second Line of Jazz funerals, in which the movements of the participants were identical to those of the participants in the ring—even to the point of *individual* counterclockwise movements by Second Line participants, where the ring was absent because of the necessity of the participants to move to a particular remote destination (the return to the town from the burial ground). And the dirge-to-jazz structure of the jazz funeral parallels the walk-to-shout structure of the ring shout, where "the slow and dignified measure of the 'walk' is followed by a double quick, tripping measure in the 'shout'" (Gordon [1979] 1981, 449). Today, the ring shout has practically disappeared from rural black culture, but remnants of it persist in black churches in solo forms of the dance. (1991, 268)

I should point out here that in northern Louisiana, there is a ring shout tradition that is still vibrant in Winnsboro in a rural plantation church referred to as the Easter Rock. It is a pre–Civil War tradition that focuses on the death and resurrection of Jesus Christ. The ritual practiced there, which is coordinated by women in a Baptist church, has all the African practices of the counterclockwise shout around a table with various symbolic items to represent biblical aspects of the last three days of Christ before he was crucified. The music during the ritual consists of spirituals and shout songs, and other aspects are also African-centered. Even today, the Easter Rock ritual has retained all the elements and expressive values that have made it central to the community (Jackson 2015).

Robert Farris Thompson, Yale professor emeritus of art and art history, cites five traits of West African music and dance in several studies: the dominance of a percussive concept of performance; multiple meter; apart playing and dancing; call-and-response; and songs and dances of derision (Thompson 1966). I will briefly look at the first four as also being characteristics of the Second Line dance and music aesthetic.

Although Thompson codifies these five traits, it was really the ethnomusicologist Alan P. Merriam who initially spoke of the first one in several of his works. The dominance of a *percussive concept of performance* is central to Second Line music

and dance. The dancers perform explosive movements to coincide with the instrumental work of the band, which provides a balance in the streets, as in African dancing. It is an amazing experience to see strength and vitality emerge in an elderly person's dance steps as the pains of arthritis are temporarily removed or forgotten as soon as the percussive mode of the band takes its stride. *Multiple meter,* or *polymetric* music, creates interdependence because it forces all participants, musicians, and dancers to be aware of one another as well as the whole as they are moving through the streets.

Apart playing and dancing, or solo playing and dancing, are also essential. As the saying has it, "Africans unite music and dance, but play apart; Europeans separate dance and music, but play together." Apart playing grants musicians space to maintain their own private meter, while apart dancing gives dancers freedom to play hand movements against the body and anywhere else in space they want to situate them, something they could not do if their hands were locked in an embrace. In a Second Line event, dancers can liberate their actions for continuous dialogue between body movement and music.

The fourth characteristic of West African music and dance is *antiphony,* or *call-and-response.* The call can be from the soloist to the group, with the group responding; from one soloist to another; or from the dancer to the musician. In terms of the collective group of the Second Line, there are many solo dancers who are free to move and be themselves without choreography.

Some Second Line performers compete individually for audience approval and develop their own style or personal antics. As the streets of New Orleans serve as performance sites and readily accessible urban spaces, so do some of the roofs of buildings. It is not unusual to see Second Line dancers taking advantage of these high points to give the audience a different theatrical perspective. Oliver Hunter, also known as "Squirk," developed a reputation for his own stylistic antics from midair splits (see page 113–15) to dancing on rooftops. He is not afraid of heights and, as a talented, well-known second-liner, took advantage of the unique vantage point so everyone could see him.

From the above example, we can see that the Second Line tradition fosters individual improvisation—but within an approving communal context and in the collective theatrical setting of the streets. In Black festive style, the principal performers interact primarily with a participatory audience, not one of spectators. When the band takes a pause and gives dancers a chance to

"strut their stuff," a principal dancer gets in the middle and other second-liners form a circle to cheer on the dancer. This is similar to traditional African dancing and what William D. Piersen refers to as the "principle of the second line" (1999, 421).

Fixy Dress

As in slavery times, the aggressive color combinations preferred by southern Blacks attracted whites' attention. African Americans, Willa Johnson averred, showed a "decided taste for vivid colors," so that, "without hesitation, green, yellow and red are clashed together," and a "wild colored sash" was often added for effect. Black women, Johnson declared, would "spend [their] last dime" for a color-crazy effect (Johnson n.d.).

Lura Beam called the "color combinations" in African-American clothing "exciting." "Negroes put red and pink and orange together before Matisse did," she observed. "Women who could wear only grey and blue in slavery came out in yellow, orange, cerise, green, scarlet, magenta, and purple. Women in their best clothes displayed an opulent color sense, topped by hats that were extravaganzas. They had a characteristic style" (Beam 1967, 39–40). But the manner in which African-American churchgoers constructed their appearance has a more general significance. By abandoning shabby work clothes or such negative signifiers as mob caps and bib-aprons for more dignified Sunday attire, Black churchgoers were repudiating white society's evaluation of the Black body as an instrument of menial labor. They were declaring, in effect, that there was more to life than work and that a sense of dignity and self-worth could survive the depredations of an avowedly racist society. Work clothes—nondescript and uniform—tended to erase the Black body; Sunday clothing enhanced and proclaimed it.

Second-liners in New Orleans have a love of display and normally dress in matching outfits for their parade attire. The entire club (male and female) dresses in the same color, style, and fabric, with matching accessories including shoes, ties, hats, handkerchiefs, and umbrellas. For variations on a theme, club members may use the same fabric and have slightly different styles in dresses for women or suits and/or vests for men. They have also utilized African-themed cloth on several occasions. The Black Men of Labor have worn Kente cloth, which is traditionally a bright combination of hand-woven cloth made in Ghana, West Africa. Since the authentic woven cloth is expen-

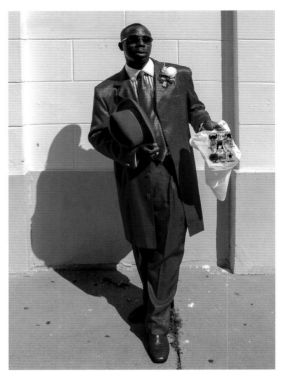

Mourner at Allison "Tootie" Montana's funeral
July 9, 2005

sive, the club opted to use a facsimile of the cloth that is also easier to work with in making parade attire for many people. For the 2015 parade, the Black Men of Labor wore bright-gold pants, shirts, and ascots with dark-brown hats and shoes with predominantly brown mud cloth vests. Mud cloth, another woven fabric, is traditionally made in Mali, West Africa, but like Kente cloth, mud cloth is found all over the continent and has become quite popular in the United States, especially among an African-conscious populace.

The visual color displayed in the cloth, whether it is an American or African motif, can be compared to color in sound. The use of color in ritual attire in West African culture in general, and New Orleans culture specifically, is a particularly good example. What is most striking is the use of multiple colors, often from complementary areas of the color wheel. As with sound, a multiplicity of color is appreciated and bold color is admired. There is also an intensity of color in the cloth for second-liners, just as we hear an intensity of sound timbre in the brass band musical sound. This pungency of color and sound

in performances is considered aesthetically pleasing to West Africans and others in the Diaspora.

This culture-affirming ritual dress is also community identity as club members, men and women, collectively express themselves in fixy dress, distinctive attire and regalia often in vivid colors and color combinations. They have framed and constructed their own reality because how they collectively choose to appear in the street parades is totally opposite to the dress of the majority society. The club members make strong visual statements about their identity and worth and display their ways of being that transcend the ordinary world for a moment and facilitate survival in their everyday lives.

IDENTITY AND AGENCY: COMMUNITAS

It is amazing how Jazz funerals and Second Line parades bring together so many friends, relatives, and strangers to express grief, honor, sorrow, joy, humor, respect, and love in their own ways. It is a moving party, fellowship, festival, and ritual of a collaboration of cultural practices strung together block by block. These are valuable traditions that celebrate the essence of life of a people and their communities. This tradition plays a role in cultural revalorization on the streets of New Orleans, where ideology and everyday practices intersect. The Social, Aid and Pleasure Clubs (SAPCs) play a vital role in New Orleans, as do voluntary associations in the rest of the Diaspora, providing a structure for community members to come together for a variety of purposes.

For many, identity is grounded in place, and the rootedness of this identity is in the specific narrative and/or visual memory landmark of a certain street or local space (for example, a park, the crossroads of two streets, a median ground, or the space in front of a specific building). Although the participants in these parades have only temporary claims of ownership when they are moving through the streets block by block, these temporary spaces offer a modicum of cultural power. Here, the spiritual, discursive, and practical worlds intersect—and the experience of *communitas* is strong.

Communitas is a term coined by Victor Turner in his studies of ritual as an expansion of concepts that Arnold van Gennep used to describe an intense, egalitarian experience of community and equality among a group of people that can occur in certain conditions. The experience of communitas transcends race, gender, class, and age, and it is a fundamental aspect of the Second Line parades in New Orleans. To the outsider, the parades are perceived as being unstructured except the fact that participants are moving on the same route to the music of a band or bands and wearing similar-colored outfits/regalia. However, having a communitas ritual experience is when the participants in the community have orchestrated sequences of structural activity such as when members perform their individual entrance dance and antistructural sequences of activity when participants perform improvisational dance at will. These activities allow them to share a common experience of interactive egalitarian roles through this annual event where performers and audiences meet on the same plane.

Second Line Preservers of Tangible Culture

Sylvester Francis started taking pictures of Mardi Gras Indians, Jazz funerals, and SAPC Second Line parades about twenty-five years ago. He became known in the community as a local cultural photographer, and over time, his arsenal of prints, film footage, suits, patches, and other Second Line regalia became a substantial collection. In 1999, he secured a former funeral home in the Tremé community and transformed it into the Backstreet Cultural Museum. Francis and the museum were recognized by the State of Louisiana for their contribution to the folklife history of the state and New Orleans.

Another place that remains significant in terms of tangible preservation of the neighborhood is the House of Dance and Feathers located in the Lower Ninth Ward. Ronald Lewis, who is also a participant in Black cultural traditions, directs the museum. He masked as a Mardi Gras Indian for a couple of years and then, in 1995, founded the Big Nine SAPC, for which he currently serves as president. Lewis saw the need to preserve tangible artifacts of the Black Indians and SAPCs, as well as archival documents including newspaper articles, magazines, and books all pertaining to the Ninth Ward, so he transformed his garage into a cultural space.

The museum was destroyed in the aftermath of Hurricane Katrina, but Lewis came back and became a powerful voice of objection to systemic oppression after the disaster. He had the foresight and ability to fight for and regain his land sooner than most who were displaced by the post-hurricane flooding. He felt that he had to come back so that others in the Lower Ninth

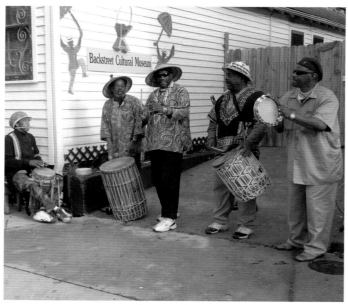

Drummers waiting for a parade at Backstreet Museum
January 6, 2007

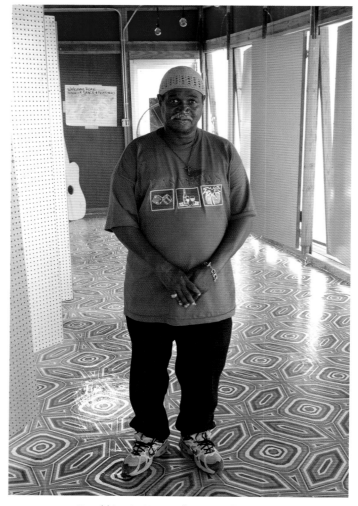

Ronald Lewis, House of Dance and Feathers
August 13, 2006

Ward could use his efforts as a model for their own return. The museum was rebuilt as a project by students from the University of Arkansas, and even before it reopened, the community and others started donating artifacts and documents.

Lewis and Francis embody the connection between place and voice. They and their museums are visited by people from around the world, but, most important, they are trusted, honored, and celebrated by their surrounding communities. This expression of connectedness between people and places creates an "environment of trust" in local communities and their traditions, which are all place-based. The communities embrace both men, women, and their sacred cultural spaces.

Eric Waters is also a preserver of tangible traditions. He has a distinctive voice and a unique set of experiences that led him into photography first as a passionate hobby and then as a profession. A culturally conscious man born and raised in New Orleans and the product of St. Augustine High School and Dillard University, Eric concerns himself with the presentation of life-affirming community celebrations. Vibrancy and pride are apparent in his photographs. By imbuing ordinary people with importance, he acknowledges his link with the community.

Although we periodically have phone conversations, and

I see him on occasion when he comes into New Orleans to shoot an event or deal with property matters, I had an opportunity to have a face-to-face, almost three-hour interview with him when I traveled to Atlanta in October 2015. We met for the interview in the newly constructed Clark Atlanta University Library, where he was to have his next exhibition. He thought that this was a good time to show me the new facility and its exquisite art collection after our interview.

I wanted to ask Eric several key questions that would give the readers and viewers of his work more insight into him—the man and the photographer. Excerpts of our interview follow.

Background, Influences, and Style

Joyce Jackson: How were you introduced to photography?

Eric Waters: By way of activism. I was introduced to activism in high school. Father McManus, who was the math teacher at St. Augustine High, took us through nonviolence training my last year of high school. We protested for voting rights and were arrested by Jim Garrison, the district attorney at the time. Albert Miller and I were seventeen, so we went to prison. The others were sixteen, so they went to the juvenile center. One image that sticks in my mind was a Black man standing under a rebel flag in the hallway of the prison and laughing at us. This was very poignant to me—a Black man thought it was funny that we were protesting for his right to vote.

Moving forward, I attended Dillard University and joined the activist group on campus, the Afro-Americans for Progress. Dave Dennis, who was in the Civil Rights Movement [and was a noted Freedom Rider], started the group. We were not welcomed by the institution. Dr. Dent, president at the time, did not like us, but they couldn't put us out. We were on the dean's list.

I worked with Jerome Smith after college with the Tambourine and Fan Club for a while. He and Rudy Lombard introduced me to Marion Porter. You know, Porter, he was a curmudgeon. He knew the man on the street, he knew the head of the mafia, the mayor, the governor. When I went to the studio, I never knew who I was going to encounter. Porter's office was in the ILA [International Longshoremen's Association] Building. Porter was the official photographer for everybody Black in New Orleans, the *Louisiana Weekly,* the *Data News Weekly,* his own monthly publication, all of the Black churches, Zulu Club, Black Labor Union. He did it all, and I was there to watch it.

I remember the first time he taught me darkroom work. He had taken a picture of a Black choir in white robes. He said, "Eric go and print this." I was eager—first time I get to print a picture. So I ran in the darkroom and spent about three or four hours in there. Came out and just as proud as I could be of that picture. Porter said, "What the f— is this?" I said, "What do you mean? I worked hard on that." Porter said, "Go back, man, go back." I stayed another three or four

hours, and it still was not right. That is when he taught me how to dodge and burn. He said, "There is no definition in these white robes, and the dark people are too dark and the light skin people are too light. Always remember, dark-skinned people don't want to be darker and light-skinned people don't want to be lighter."

JJ: After you had gotten what you thought you needed as a foundation from Porter, where did you go after that?

EW: Porter kept telling me I was not ready. I started with false confidence. I shot a wedding and did not do a good job. I did not mess it up badly. It was adequate, but not good. Porter gave me a base from which to start. So, I just started shooting and shooting. I had various jobs, but photography was not one of them. I just became addicted to it.

Then, Jerome Smith started introducing me to other people from the community like the Bucket Men (a Second Line club) and Tootie Montana, who eventually became Chief of Chiefs (Mardi Gras Indians). I have some of the only pictures of the Bucket Men. That was in 1971. They were only around a couple of years.

But between that there was Ed Brown. He is the brother of [SNCC—Student Nonviolent Coordinating Committee leader] H. Rap Brown from Baton Rouge, and John O'Neal was one of the founders (another co-founder was Dr. Doris Derby, who was also a photographer) of the Free Southern Theater, which came out of the Civil Rights Movement. John introduced me to Ed, and [he] saw some of my pictures for the first time and liked them, and we developed a lasting friendship.

Photographers have stories. I have so many stories and experiences and have been influenced by so many interesting people. I am so blessed because I have met interesting and great people such as yourself and your husband, Nash [J. Nash Porter, deceased documentary photographer, also from New Orleans], this young man who is filming for us, Richard Allen DuCree [a photographer from Atlanta], and the list goes on and on.

JJ: At this point, do you have a specific style or technique that you favor in your work?

EW: I did not think I had a style, but let me tell this story. When you were coordinating the African Heritage Stage in the Grandstand at the [New Orleans] Jazz and Heritage

Festival, you put together a panel of photographers that consisted of Girard Mouton, Herman Leonard, and myself, with Chuck Siler moderating. Chuck is a visual artist that did some shooting himself, and he asked us what our style of shooting and/or printing was. After the other two answered, I said I did not have a specific style, and Chuck said, "Yes, you do. You want everything perfectly in focus and everything tack-sharp, and you have an insider's view." Well, I have come to know a lot of people, and for whatever reason they trust me. I came by way of Tambourine and Fan, so I have access, and I was the only photographer allowed to shoot Donald Harrison Sr.'s funeral. I was one of only a few that was allowed to shoot Tootie Montana's funeral. I was one of three photographers allowed to shoot the services of Uncle Lionel [Batiste].

JJ: I know you have worked internationally, and I recall you saying that Ed Brown was responsible for you making the trip to Africa. Where did you go and what type of assignment was it?

EW: In 1978, I went with Courtland Cox, who was raised with Stokely Carmichael. Courtland was also the CEO for [Mayor] Marion Barry in D.C., and he was very worldly. I went with him to Africa to document the refugee situation, because they were at war with Rhodesia. We went to what they called the frontline states: Zambia, Botswana, Swaziland, Tanzania, and we spent one night in Joburg [Johannesburg]. It was still under apartheid.

So people were worried about me, but I wasn't worried about me because when you are there, you don't have a sense of danger like folks back home reading and listening to the news all the time. So, I asked a guy in the hotel about it, and he said they are bombing every other week. So I asked, what week is this—? [*laughter*] So it was interesting, but never did I feel like I was in danger. We met the rebels. These are the guys that took us up into the country to talk to the people to get permission to shoot or in this setting to take pictures. Don't want to use shoot.

It was this instance when I found out that m—f— is a universal word. We arrived at the refugee camp to take pictures, and this guy with an AK-47 automatic rifle said we can't take pictures. Courtland said, "Man, we came all this way to get these pictures to help the refugees to transition for food and whatever else because they were brought there

from other countries to try to help fight the Rhodesians." So, Courtland went on and on with this guy, and he still said, "No pictures." I said, "Courtland, that man got the gun—an automatic rifle." Courtland told the guy: "We gon' take these m—f—ing pictures. You go check with whoever the f— you want to, but we gon' take these f—g pictures. Do you understand what the f— I am saying?" I am about to die! Oh, Lord have mercy! The guy with the rifle left and came back and said, "You take pictures, you take pictures." That's when I found out that m—f— was universal. It had meaning in other places.

JJ: Wow, what a story, but you did get your pictures. I know you also did some shooting in Trinidad for Carnival. What was that experience like, and how was it different from New Orleans?

EW: My whole reference in terms of Carnival was New Orleans. I thought I would never see anything more beautiful than the Mardi Gras Indians until I went to Trinidad, and it was absolutely amazing! It was in 2000 or 2001, and I was shooting film at that time. This was before digital. I had about thirty-five or forty rolls of film. Every picture was technically perfect. I am not saying that they were all good, but technically the lighting, weather, and subject matter was absolutely on the money. I also learned about respect. I was trying to shoot this chief, and I think he was tantamount to Tootie Montana from New Orleans. I was trying to take his picture, and he kept on ignoring me, so I understand that he didn't want me to take his picture. So there was this guy who was not dressed, but was with the chief. So I asked him if he wanted a beer and if he thought his chief might want a beer? So they said yes, and I bought them both beers, and he started posing, and I got all the images I wanted. I just got some great, great stuff, you know.

The other story is Tootie Montana was always proud of his helmet that he connected his crown to. Other Mardi Gras Indians chiefs' crowns would move around their heads, and they always had to adjust it during the day. Tootie had a thing where he used these metal straps with foam rubber, and they were comfortable and rigid and kept his crown from moving. That was his signature, but I saw this other chief that had the exact same thing in a whole other country! It was just ironic to see that. Outside of the Indians and Sailors, they had Devils like our Skeletons and Bones, and

they had the big Buttress Woman like our Baby Dolls. I could not believe it, some of their other more elaborate costumes!

Then they had pan bands that play Jazz and classical. I am listening to about one hundred players and looking for the violins. There are no violins. The harmony was unbelievable! When you are having all of these experiences that present themselves, you do not need anybody else except maybe another photographer, and he is doing his own thing as Richard can attest to. Katrina took all of those negatives, but I do have a book with some images. It was a great, great experience, and it makes me want to see other Carnivals like in Bahia.

JJ: Speak to your passion and energy for doing what you do. What drives you to continue to do this? Why do you come back so many times every year?

EW: It is always a new photo op [opportunity]! Oh, people always talk about my photography. It is not false humbleness. Under that, I like to tell people, I shoot interesting subjects. My subjects are interesting so that makes my pictures interesting. If you shoot interesting subjects with respect, then people will like your work. You know that from the man you were married to—Nash. That is how Nash was. He was very respectful of the subjects that he photographed, and I try to be the same way. That is why I try to shoot the Mardi Gras Indians with as much sharpness and detail as I possibly can. I want people to see each individual bead that was sewn by hand.

JJ: Yes, I know and have witnessed the hard and long hours you guys spend in the darkroom. I am well aware of the painstaking moments spent to get the flesh color right, the plumes defined, and the beads sharp, and where one print might take all night to perfect. How long have you been shooting the Indians and [would you] share an unusual moment with me?

EW: One of the most poignant moments I remember is when Jerome got Tootie Montana an invitation to speak at the United Nations, and afterward they took him to D.C. to the Smithsonian African Museum. Tootie walked in, then looked at the beaded masks and robes, and said, "They doing the same thing as I do, but they did it thousands of years before I did it." It was like a revelation to him to see the continuum of the culture.

I have been shooting the Mardi Gras Indians for about thirty-five years, and I am never not impressed. It is just unbelievable. Then I found out it is from about 2,500 to 5,000 hours of work every time they make a new suit. I tried to sew a small patch for Jerome, and after pricking my thumb many times and it bleeding all over the place, I said that is all right. The other guys' fingers are calloused and hard from sewing every year. So I had a newfound respect for what they do, and I will never do it again.

JJ: How do you feel on the morning of the Black Men of Labor Parade?

EW: Anticipation and now that I have gotten older—work! They made a mistake and told me how long the route was last year—thirteen miles, and I am walking back and forth. It's anticipation because each year they are coming out with something different and I just try to portray what they are doing.

JJ: Do you get a chance to see what they are wearing beforehand?

EW: No, not really. They may tell me their colors. One year they came out in Kente cloth, and they actually gave me a coat and a vest. I was so appreciative that they gave me such gifts. They can be used for formal wear now. You never know what they are going to do. Yes, anticipation because these guys really can put on a show. They have bands, kids, and people on the side, too. You never know what is going to happen at a Second Line. There are opportunities everywhere. That's what so great about New Orleans. I like to tell people, I can take a walk in the French Quarter for an hour and take more pictures than I take in nine months in Atlanta.

Like my friend Kevin Sipp says, it is an African-retentive culture and there are only two in the contiguous United States—New Orleans and the Gullah Sea Islands. I know I don't need to tell you as a cultural researcher and an ethnomusicologist, but I did not know. I knew it was something that came from Africa but did not know it was so unique, that is, the Second Line, Mardi Gras Indians, and the cuisine of New Orleans.

JJ: You did not evacuate [during Hurricane Katrina] because you were not in the city. How did that feel having to watch from afar?

EW: Fortunately and unfortunately, I was out of town. I left town before Katrina came. She was only a tropical storm,

still in the Atlantic when I left. Nobody knew at that time she was coming into the Gulf. So, I had to watch everything unfold from the TV. I would have been one of those knuckleheads that stayed. My son evacuated my mother to Tunica [Mississippi]. So I did not evacuate, but I did wind up in Atlanta and have been here for over ten years now.

I don't think I ever processed my loss, because after I saw the devastation on TV, I kept shooting in San Francisco, in Tunica, Mississippi. I shot the Red Cross Station where Blacks and whites were receiving aid.

JJ: So, it sounds like shooting probably worked for you during this devastating period. Some people process traumatic events in their lives in different ways. I think this was your way of processing this horrific event.

EW: I guess it did give me time to process it. I just kept shooting until we had a chance to go down [to New Orleans]. Charlene [Braud, Eric's partner] walked in the house and started crying, you know, but I said it is done. We just need to clean up and see what we have left. I still had stuff that I did not lose. The biggest loss I felt was Tex Stevens' collection. I lost my work, but Tex Stevens' collection really hurt. It was unbelievable, you know. I did not even have a chance to go through all of it before it was lost. Another friend lost all he ever shot, all his cameras and his son. Don't feel sorry for me. If you measure loss, that is my measuring stick.

JJ: Yes, you can never replace a loved one, and so many people are still grieving for their family loss. Now, you have lived this two-city life for over ten years. How has that been for you?

EW: Laborious. Over 100,000 miles—so many round trips from Atlanta to New Orleans.

It is always good going back to shoot. Trying to get back to stay. I don't want to talk about Atlanta, but it is just not the place for me. Being a cultural photographer, there is just not much definable culture to shoot in Atlanta. You have to travel outside of the city. I must say though, I had a seamless transition into Atlanta. I was welcomed by the photographers and others in the arts community, so I cannot complain about that.

JJ: Since Katrina, there are so many more people paying attention to New Orleans' culture, specifically Black culture. Can you speak to being out there on the ground floor? With so

many other photographers coming in and feeling privileged when you have been out there shooting for about forty years in the community, you have a broader and more historical perspective. How has it changed? I know you can remember when it was just you and a couple more photographers out there. You are not just a photographer, you are a photographer who knows Black culture in New Orleans—an insider. What are you witnessing now? What is taking place in the streets?

EW: There was an incident and at that time I was about six two or six three taking pictures for Donald Harrison [Jr.] coming out of St. Augustine Catholic Church [on Mardi Gras morning]. Father LeDoux was blessing and throwing Holy Water on him in full suit [as a Mardi Gras Indian], and I am working hard to get that shot. This white photographer comes and stands right in front of me. I told him I would kill him on the spot if he did not get out of my way. One of the guys with Donald said, "Oh, man it does not have to be that way." I said, "I am shooting for Donald!" The guy left and did not come back. I had to be convincing because I needed that shot or I was going to lose a camera that day.

Fast-forward to another incident shooting for the Black Men of Labor parade. I have been their official photographer for the last twenty-two years. A guy photographer was shooting for *National Geographic*. He came up to me and said, "I know who you are and I know what you are doing and I appreciate what you are doing." Now I am in the chair getting ready to take the group shot before they hit the streets. He came up to me and said, "If I sit on the ground and stay out of your way, will it be okay?" I said, "Of course." Now that is respect. When you shoot for *National Geographic,* you co-sign as being a really top professional photographer—they didn't take amateurs, but he knew his place in that scene.

Now the hottest things are iPhones and iPads, and all you can see is a sea of iPhones and iPads in front of your camera. I am constantly trying to move them out the way, but you got to filter and be careful because some may be relatives, and you do not want to offend a daughter, wife, or some other relative. A fellow photographer in the streets was complaining. He was saying that everybody in the streets got cameras. They got iPhones, iPads, and everything

else. Everybody is considering themselves a photographer. I said, "Look, bruh, if you consider yourself a professional photographer, then you are supposed to do things that they can't do," although it is kind of hard with some of these phones that they have out there today.

JJ: Eric, it is always invigorating being out in the streets in a Second Line parade with you like the Black Men of Labor parade in 2015. I observed how you are respected and how you were mentoring a younger photographer, and I even benefited from some of your image set-ups and got a few more good shots. However, I want you to share with me the best advice you can give to a young budding photographer that you are mentoring.

EW: It is about composition, about seeing things, and I tell photographers that ask me to mentor them and teach them, I tell them: "I can teach you fundamentals, but I can't teach you how to see. The only way you can learn how to see, if it is in you, and if you shoot, shoot, and shoot. Did I say shoot again, didn't I? I can teach you about aperture, shutter speed, depth of field, and composition, but I can't teach you how to see. You have to achieve that on your own." Porter could see, and I think it was Ansel Adams who talked about "pre-visualization," that is, really seeing the photo before you shoot it.

JJ: I know you have a great love for music, especially Jazz, and I would like to use this as a segue into the work you did with Dr. Michael White's clarinets post-Katrina. Dr. White's precious clarinets and other vintage instruments were destroyed along with his home in the aftermath of Katrina. He saw you at the New Orleans Jazz and Heritage Festival and asked you to document the loss with photographs. You responded without hesitation; however, your artistic eye saw something else in the destruction. How did you transform these distressed instruments into beautiful works of art?

EW: Thank you. Well, at first I wanted to use the clarinets as vases for the flowers, but I thought about it and decided it was much more profound than that. Then I started seeing bodies, I started seeing death, and I thought about a metaphor: death and dying post–levee's breach, a.k.a. Katrina. I have flowers in some, so I have a funeral-type scene with some flowers dying and some vibrant. They began to die, so the decaying flowers also became emblematic of the decay-

ing clarinets. This was just serendipitous. The other thing about it was, I must have washed my hands a hundred times a day. I tried using gloves, but that did not work. The stuff was so toxic, you know, so all day long I washed. Doc saw the same things I saw, so that was my validation. The hard work paid off, and Deborah Willis wrote about it. She got it and saw some things that I didn't see.

JJ: I must admit that when you first showed me a few pictures online, I was not sure if I liked them, being from the old school and not liking too much photoshopping. The photos had to grow on me. After seeing more, though, and hearing you talk about the photographic concepts and techniques like the zone system that Ansel Adams used in his work and HDR [high dynamic range], I began to develop a taste for the new techniques you were using. I only knew about these techniques because I lived with another professional photographer for almost fifteen years, and he had worked with the zone system. Although Photoshop is not new, for you it was an exciting method to bring your photography to another level. Not only did you document those instruments—broken, rusted, and covered in muck, you transformed them into instruments of beauty that were emblematic of death and dying. Dr. White has a treasure of memories and so do the rest of us who have a copy of your limited-edition catalogue *Solemn Sounds of Silence: A Photographic Project of Reverence and Remembrance*.

EW: For Dr. White to ask me to do that was a great honor. He said that he wanted me to shoot it. That's what makes it something special. We had collaborated on a few things, but I had never done anything like that. The validation came from him. He liked it and he saw the same thing I saw with the clarinets when the (death) metaphor came to me. That's exactly what he saw in the images. That was my validation.

JJ: What is next for Eric Waters? At this point in your life, what do you need to inspire and challenge you?

EW: I would love to shoot more of the demonstrations. I have so much respect for the young people. We have gotten jaundiced about young people's involvement over the years. We have seen our young people become very lethargic, and many have assimilated into other cultures and ethnicities. I wrongly saw this lethargy especially with college kids. Then lo and behold, here comes Black Lives Matter and "I Want to

Breathe" and all the other ones. It has been profound, and he [Richard Allen DuCree] just had a major beautiful exhibit on the college civil rights workers. You asked me what would inspire me? Photographers like him, Richard Allen DuCree and Jim Alexander and other photographers in the Atlanta Photo Battle—ten images in ten minutes. The audience decides who wins.

All of Eric's dedication and stamina was needed as he embarked on his exhausting journeys back and forth between Atlanta and New Orleans in the wake of his Katrina and Rita experiences. However, that odyssey has resulted in this book, which is far more than a labor of love. Eric said: "Karen and I wanted to dance a fine line between making the book rich and readable. We want it to be respectful of the people I photographed. Also, we want academics to look at the book and want to do more research on the Second Line. I hope the people will like the pictures, but I know they will like the writing."

Eric Waters' and Karen Celestan's objective was to present a never-before-attempted comprehensive picture of the breadth and scope of the contemporary Second Line phenomenon in New Orleans. They succeeded.

Freedom's Dance represents a successful tribute to the culmination of almost forty years of chronicling the Second Line culture of New Orleans, a period that happens to coincide with Eric's photography career. This work, singularly absent of the conjecture and cant occasionally found in other works about the Second Line, invites the viewer to visit with some of today's most captivating purveyors of the Second Line tradition as well as community scholars. The stories shared are as diverse as they are sometimes provocative, other times amusing, frequently affecting, and always compelling.

This entire arsenal of artistic work shows a remarkable continuity, community, and a deep, citywide influence that overshadows the variations and gaps of time spent away from the city in a ten-year absence due to back-to-back hurricanes and the destruction and rebuilding of a powerful southern city. The images captured through the lens of a masterful photographer and spanning about forty years have an enormous documentary value.

Eric's images will continue to be his legacy and an offering to the community chronicling the time-honored phenomenon called the Second Line. Implicit in this unique array of photographs of African-American second-liners is a firm promise to readers of countless hours of illumination, inspiration, invigoration, and enlightenment. I am confident that you will share the excitement and pleasure as you travel along the cultural and spiritual continuum of *Freedom's Dance*.

Ashe, Ashe, Ashe-O

NOTES

Note: I would like to thank Richard Allen DuCree for filming my interview with Eric Waters at the Robert W. Woodruff Library, Clark Atlanta University Center on October 2, 2015. In addition, I would like to acknowledge Ms. Carolyn Hart, assistant director for planning, assessment, and communication, for providing us with a space for several hours to conduct the interview.

1. The Freedman's Savings and Trust Company (also referred to as Freedman's Bank) was created by Congress for newly emancipated slaves and African-American soldiers at the end of the Civil War. The Signature Books are the registers of depositor signatures, individuals as well as organizations. They included names, residences, and descriptions of each depositor. The bank existed from 1865 to 1874 and had twenty-nine branches.

REFERENCES

Barlow, William. 1989. *"Looking Up at Down": The Emergence of Blues Culture.* Philadelphia: Temple University Press.

Beam, Lura. 1967. *He Called Them by the Lightning: A Teacher's Odyssey in the Negro South, 1908–1919.* Indianapolis: Bobbs-Merrill.

Bechet, Sidney. (1960) 2002. *Treat It Gentle: An Autobiography.* New York: De Capo.

Blassingame, John W. 1973. *Black New Orleans, 1860–1880.* Chicago: University of Chicago Press.

Breunlin, Rachel, Ronald W. Lewis, and Helen Regis. 2009. *The House of Dance & Feathers: A Museum by Ronald W. Lewis.* New Orleans: University of New Orleans Press.

Daniel, Yvonne. 2005. *Dancing Wisdom: Embodied Knowledge in Haitian Vodou, Cuban Yoruba, and Bahian Candomblé.* Urbana: University of Illinois Press.

Drewal, Margaret Thompson. 1992. *Yoruba Ritual: Performers, Play, Agency.* Bloomington: Indiana University Press.

Emecheta, Buchi. 1979. *The Joys of Motherhood: A Novel.* New York: Braziller.

Evans, Freddi Williams. 2011. *Congo Square: African Roots in New Orleans.* Lafayette: University of Louisiana at Lafayette Press.

Floyd, Samuel A., Jr. 1991. "Ring Shout! Literary Studies, Historical Studies and Black Music Inquiry." *Black Music Research Journal* 11, no. 2 (Fall): 265–87.

———. 1995. *The Power of Black Music: Interpreting Its History from Africa to the United States.* New York: Oxford University Press.

Giddens, Anthony. 1990. *The Consequences of Modernity.* Stanford: Stanford University Press.

Gordon, Robert Winslow. 1973. "Negro 'Shouts' from Georgia." In *Mother Wit from the Laughing Barrel: Readings in the Interpretation of Afro-American Folklore,* edited by Alan Dundes, 445–51. Englewood Cliffs, NJ: Prentice-Hall. Originally published 1927.

Hall, Gwendolyn Midlo. 1992. *Africans in Colonial Louisiana: The Development of Afro-Creole Culture in the Eighteenth Century.* Baton Rouge: Louisiana State University Press.

Jackson, Joyce Marie. 2003. *Life in the Village: A Cultural Memory of the Fazendeville Community.* Washington, DC: U.S. Dept. of the Interior, National Historical Park.

———. 2015. Personal interview with Eric Waters. Atlanta, Georgia. October 2.

———. 2015. "Rockin' for a Risen Savior: Bakongo and Christian Iconicity in the Louisiana Easter Rock Ritual." In *Esotericism in African American Religious Experience,* edited by Stephen C. Finley, Margarita Simon Guillory, and Hugh R. Page Jr., 295–313. Leiden: Brill.

Johnson, Willa. n.d. "Characteristic Ways of Colored People," Record Group 60, Jackson, I, Works Progress Administration, Mississippi State Archives.

Lomax, Alan. (1950) 2001. *Mister Jelly Roll: The Fortunes of Jelly Roll Morton, New Orleans Creole and "Inventor of Jazz."* Berkeley: University of California Press.

Merriam, Alan, 1964. *The Anthropology of Music.* Evanston, IL: Northwestern University Press.

Nketia, J. H. Kwabena. 1974. *The Music of Africa.* New York: Norton.

Piersen, William D. 1999. "African American Festive Style." In *Signifyin(g), Sanctifyin' & Slam Dunking: A Reader in African American Expressive Culture,* edited by Gena Dagel Caponi, 417–33. Amherst: University of Massachusetts Press.

Regis, Helen. 2003. "Keeping Jazz Funerals Alive: Blackness and the Politics of Memory in New Orleans." In *Southern Heritage on Display: Public Ritual and Ethnic Diversity within Southern Regionalism,* edited by Celeste Ray. Tuscaloosa: University of Alabama Press.

Roach, Joseph. 1996. *Cities of the Dead: Circum-Atlantic Performance.* New York: Columbia University Press.

Sakakeeny, Matt. 2011. "New Orleans Music as a Circulatory System." *Black Music Research Journal* 31, no. 2 (Fall): 291–325.

Schafer, William J. 1977. *Brass Bands and New Orleans Jazz.* Baton Rouge: Louisiana State University Press.

Somé, Malidoma Patrice. 1993. *Ritual: Power, Healing, and Community.* New York: Penguin.

Stuckey, Sterling. 1987. *Slave Culture: Nationalist Theory and the Foundations of Black America.* New York: Oxford University Press.

Tait, David. 1961. *The Konkomba of Northern Ghana.* Edited by Jack Goody. London: Oxford University Press.

Thompson, Robert Farris. 1966. "The Aesthetics of the Cool: West African Dance." *African Forum* 2:85.

———. 1983. *Flash of the Spirit: African and Afro-American Art and Philosophy.* New York: Random House.

Thompson, Robert Farris, and Thomas Cornet. 1981. *The Four Moments of the Sun: Kongo Art in Two Worlds.* Washington: National Gallery of Art.

Turner, Victor. (1969) 1995. *The Ritual Process: Structure and Anti-Structure.* Piscataway, NJ: Transaction.

van Gennep, Arnold. 1960. *The Rites of Passage.* Translated by Monika B. Vizedom and Gabrielle L. Caffee. Chicago: University of Chicago Press.

· ·

Up from Congo Square

KAREN CELESTAN

As you read this, an exhilarating event may be taking place: men, women, and children in tailored, Crayola-colored suits, hats, and shoes are dancing and gyrating ahead of a brass band through a neighborhood. They are keeping alive an African-based tradition that dates back to the early 1900s—the Second Line in New Orleans.

The Second Line as hosted by Social, Aid and Pleasure Clubs (SAPCs) is a pulsating, vibrant event that combines the African, Caribbean, and Native American traditions of pageantry and celebration. It mixes colorfully bedecked club members and the rousing, jubilant anthems of a brass band to create a seemingly spontaneous parade that rolls through some of New Orleans' oldest neighborhoods. It is working- and middle-class people celebrating life through a dynamic display that engages even the most reserved observer.

From uptown New Orleans to the Ninth Ward to Tremé, the Second Line pulsates through the streets with a percussive, syncopated rhythm that resonates back to its participants' ancestors from Africa and the Caribbean. The Second Line is often seen as a loosely organized jam session, but it is one of the few cultural rituals that survived enslavement in Louisiana.

Africans and Afri-Caribbean people in America had to create benevolent societies as a means to bury their loved ones, pooling meager resources to offset the rigors of a society that enforced Code Noir (the Black Code), a segregation policy instituted when New Orleans was under French rule. Society members created ceremonies to honor the deceased with processions that may have included a mule-drawn pall and musical accompaniment. The term Second Line refers to the throng of people (other than family members) escorting the corpse to its final resting place. African tradition viewed death as a new beginning in the spirit world once a body has been "cut loose," or buried. This core belief resulted in a celebration of the passage into ancestorhood, allowing mourning family and friends to assuage their grief through music and dance.

The societies were precursors to modern-day Social, Aid and Pleasure clubs—organizations that have maintained this unique custom through fellowship and hosting a Second Line, an annual event that celebrates ancestry as well as the members' creativity and style. The assembly jooks and weaves through the streets, picking up onlookers or second-liners along the way. Brass bands, such as Rebirth or Hot 8 or Tremé, whose predecessors led funeral processions, now herald the distinctive New Orleans sound, driving the SAPCs through their Jazz and rhythm-and-blues paces. The result: a euphoric wave of pulsating music and humans who dance, bob, jump and shout—including the gymnastic Squirk—enveloping and inspiring every person along its route to join in the revelry.

Numerous Second Lines roll through the city at the height of the season in the fall and spring. There are more than thirty

Social Aid and Pleasure Clubs throughout New Orleans that parade each season, each with a distinctive style, mission, and history. Clubs will often take months to decide a Second Line theme and color scheme. Their appearance will often be an effort to outdo another club or just top their own show from the previous season.

Many of the rituals and traditions of New Orleans have been regarded as simple frivolity, but those who were born and raised in the Crescent City or those who have been properly schooled in the culture know that it is so much more than dancing around in colorful clothes and "actin' a fool." The Second Line is a definitive African custom, handed down through the ages from a people intent on maintaining a living representation of who they are and their ancestors' country of origin.

Many slaves and **maroons** (runaways) had managed to fashion versions of African instruments such as the flute, drums, and *shakeres* to re-create the sounds of their homeland. The Second Line's original purpose—a somber cortège for the deceased that erupts into a boisterous parade after burial—has been retained, but the SAPCs added another dimension: the procession as a cultural phenomenon.

The Second Line continues to take place in a similar form during Carnival celebrations in Haiti, Martinique, Guadeloupe, and Brazil—countries that have a strong Catholic heritage and traditions, and a definitive African influence. Dance movements and spirit world rituals that are specific to the Second Line can be traced directly back to Africa.

The Tremé area, which covers ten blocks in New Orleans just outside the world-famous French Quarter, was once considered "**back o' town**." At the entrance of Tremé is Congo Square, a park where slaves gathered as early as 1780. It is hallowed ground for those of African and African-Caribbean descent. Congo Square was a marketplace that allowed slaves from various plantations and work sites to have a "free" day on Sunday to socialize and exchange ideas, sell their own wares, dance, and play native music. This resulted in a large, self-confident slave community that thrived through the continuation of its African traditions.

According to Freddi Williams Evans in *Congo Square: African Roots in New Orleans,* the city devoted Sunday mornings to church services, but "the afternoons of the Lord's day were devoted to 'amusements, fun and frolic of every description—always with an eye to much sport for a little expense.'" This

outlook permitted "people of African descent [to hold] high carnival in Congo Square" (Evans 2011, 37).

> As stated in an 1864 *Picayune* article, "Congo Square was devoted on Sunday afternoons especially to the unrestricted pleasures of the negroes [*sic*]." . . . This buying power of the enslaved extended to the gatherings at Congo Square where the opportunity for enslaved persons to earn money during their off-time produced wages to spend with Black marketers. (Evans 2001, 36)

Other port cities in the United States that engaged in enslavement and its attendant practices (such as Charleston and Savannah) did not maintain such a community. Slaves in those areas, according to Gwendolyn Midlo Hall, in her book *Africans in Colonial Louisiana,* were often brought in from the British West Indies and were first- or second-generation Africans. After being hauled off to various plantations, slaves in those areas were unable to keep their community and rituals as was possible in New Orleans. It is the direct influence of Congo Square and the determined, cultural-minded people who were brought here directly from Africa and throughout the African Diaspora that created the Second Line tradition. Hall writes that the New Orleans region had "clearly, the most Africanized slave culture in the United States" (Hall 1992, 161).

HONORING THE ELDERS

Elders have always been treated with reverence in the African American community, a tradition in line with the *griot* tradition in ancient Africa, where the oldest members of the tribe were the history-keepers and storytellers and seen as fonts of wisdom with connectivity to the ancestors.

Elders serve as guides for new and developing Social, Aid and Pleasure Clubs, providing context and authenticity. It is the older men and women in communities who often manage the children's component of SAPCs. These respected individuals are firm and dedicated *kiongozi mzee* (Swahili for "elder leader") who assist in maintaining traditions and organizing youngsters who want to participate in Second Line parades. Also, the elders serve as an extra protective set of eyes, monitoring the behavior of SAPC children and delivering on-the-spot discipline if warranted. They are a safety net for kids, making them feel

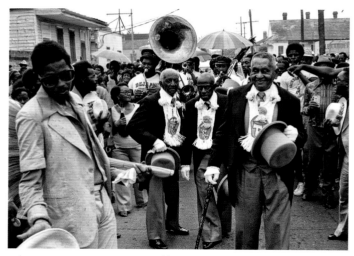

Elder Trio
"Bookey," Albert Murphy Sr., and Warren Lombard
Bucket Men SAPC
1971

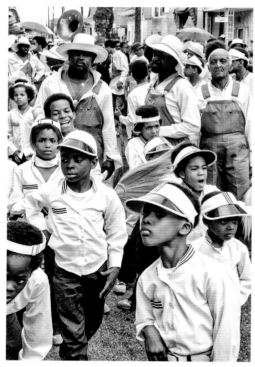

"Bookey" *(top right)*, Bucket Men parade in Tremé
circa 1971

guarded and secure. This activity serves as a cultural and neighborhood alternative to sports teams and gives kids a strong sense of belonging and pride.

Alvin Jackson, one of the founding members of the Black Men of Labor SAPC, shares one of his earliest memories of Second Lines:

"I've been involved in Social, Aid and Pleasure Clubs, indirectly, since the late 1950s. Square Deal Boys from my neighborhood, at which time, Dooky Chase Sr. was president, and my third cousin, Teddy, was the vice president. [As kids, we] would eagerly await the sound of a bass drum or the ripple of the horn coming up Orleans Avenue, a wide-open plain with date palm trees in front of Dooky Chase [restaurant]. We would wait for the parade to hit Dooky's so the band would stop, and we'd run across the street and start second-lining.

"We (also) were the ones who sit on the **banquette** and not on the street with them out of respect and in deference to them (SAPCs) being in the street."

Jackson said that his connection to the culture goes back to the late 1950s and that Second Line rituals have a strong spiritual element:

"We knew how important it was to have your mind right, free and clear on . . . Carnival morning or parade morning. And to pray to the ancestors, which we always prayed, but as youngsters, we didn't know why we prayed. As an adult, I know and understand better how praying back to the elders from the past

to protect us and have a good day. It starts off with that peace and solitude and it crescends into the euphoric feeling of 'we doing this!' We keep the divinity in the culture and because it is sacred and holy, this is how we maintain who we are, and no one can take that away from us."

SECOND LINE DANCING

Christopher Small references in his theory of *musicking* a "pluralistic inheritance that Black people carry around with them still, not as a set of beliefs but as a style of thinking, feeling, perceiving—and of playing, listening and dancing" (Small 1987, 17).

This belies the long-standing, oft-shared thought that African Americans are somehow "natural" dancers instead of the more realistic and proven view that "street" or Second Line dancing is rooted in cultural involvement and exposure from an early age. Small goes on to say that music (and therefore, dance) created by African Americans is characterized by "its openness to development, its universal accessibility and the ability of its musicians to evade capture by the 'official' values of the industrial state" or

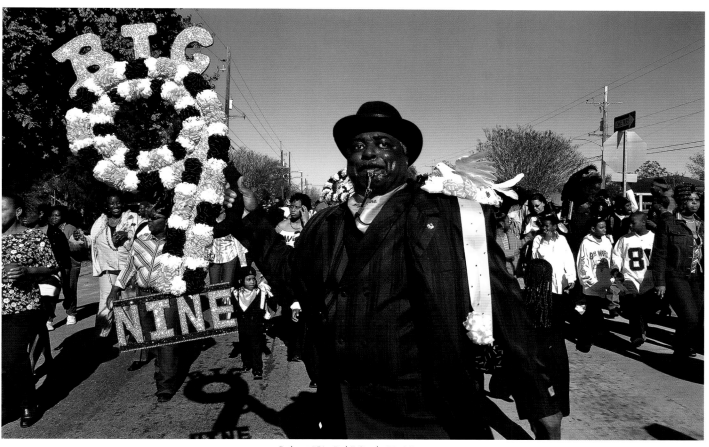

Robert "Big Rob" Stark, Big Nine
December 18, 2004

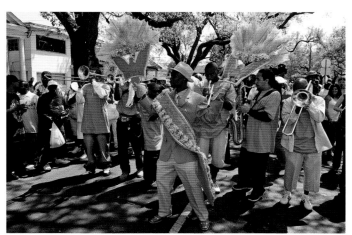

Deron "Duckey" Wilson, Pigeon Town Steppers
March 23, 2008

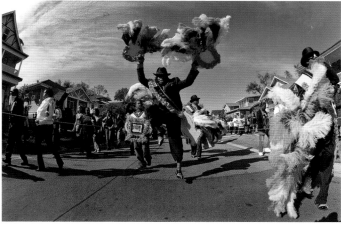

Buckjumpers
November 30, 2008

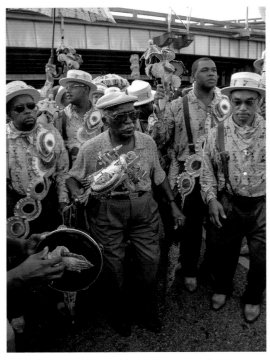

I tell ya, I hear a good second line, I'm'a dance . . .
It moves me. It touches you, man.
—Allison "Tootie" Montana
(Big Chief, Yellow Pocahontas Mardi Gras Indian tribe)

Allison "Tootie" Montana second-lining with Black Men of Labor
Left to right: Marty Blanco, Montana, Bruce "Sunpie" Barnes, Fred Johnson
September 5, 2004

the classical European tradition (18). European music and dance, Small notes, is much more structured and "gives more attention to the musical work in itself than to its social meaning" (19).

Congo Square, the gateway to Tremé, was the primary location for African slaves to gather on Sundays, a "free" day, away from the duties of their enslavement. Slaves sold wares and food they had created and engaged in tribal dances. Congo Square allowed slaves and some free people of color to maintain African rituals in music, food, and some language. A number of Second Line practices had their genesis in Congo Square. According to Evans:

The cultural practice of gatherers encircling dancers and musicians existed in many parts of West and Central Africa during sacred as well as social occasions. Those gatherers, however, did not constitute an audience of detached observers; for they joined the performers by clapping their hands, stomping their feet, patting their bodies, answering the calls of the chanters, adding improvised intonations and ululations (shrills in sometimes piercing pitches), singing songs that accompanied the dances, shaking gourd rattles, and replacing dancers who became fatigued.

. . . People of African heritage in New Orleans did not restrict this dance to Congo Square. They performed it in the streets, backyards, and dance halls. . . . [M]issionary Timothy Flint witnessed hundreds of African descendants, male and female, performing the great Congo dance during a street procession. They "have their own peculiar dress and their own contortions. They dance, and their streamers fly, and the bells that they have hung about them tinkle," he wrote. (Evans 2011, 94)

It is obvious through the long-standing connectivity and traditions that the Second Line in New Orleans as delivered by Social, Aid and Pleasure Clubs is the most African-retentive culture in the United States. The dance and music have been carried forward from the earliest days of Africans arriving in the country and informs every aspect of the SAPC/Second Line custom.

REFERENCES

Evans, Freddi Williams. 2011. *Congo Square: African Roots in New Orleans*. Lafayette: University of Louisiana at Lafayette Press.

Hall, Gwendolyn Midlo. 1992. *Africans in Colonial Louisiana: The Development of Afro-Creole Culture in the Eighteenth Century*. Baton Rouge: Louisiana State University Press.

Small, Christopher. 1987. *Music of the Common Tongue: Survival and Celebration in African American Music*. Hanover, NH: University Press of New England.

Interview with Alfred "Bucket" Carter

Longtime member, Young Men Olympian Jr. SAPC

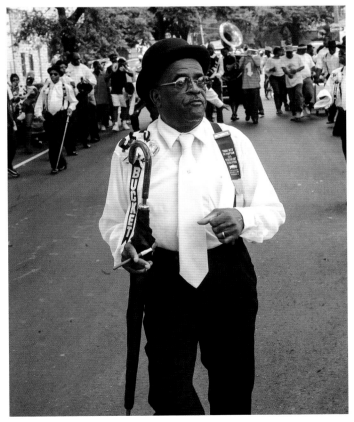

September 8, 2002

Valentine Pierce interviewed Alfred "Bucket" Carter on March 7, 2012.

Valentine Pierce: They call you Mr. Bucket. Why?

Alfred Carter: Since I was in school. From playing ball. I went to Ricard. I graduated from Ricard and I went to Booker T., and I start to playing ball, basketball. A lot of people these days don't even know my real name. Don't know my real name all these many years. "Man, I didn't know that was your real name. I grew up with you on First and LaSalle and all." I say, "Well, y'all gave it to me; I just go with it and that's it."

VP: Are you a member of a Social, Aid and Pleasure Club or a benevolent society?

AC: Benevolent society. Young Men Olympian Jr. Association.

VP: How long have you been a member?

AC: I've been a member seventy-four years.

VP: How old are you?

AC: Seventy-seven.

VP: So since you were three years old?

AC: Yeah— See all those pictures and things. All them different pictures in here. The Jazz picture over here.

VP: [*reading posters*] April 20 to May 6, 1979. The 16th annual. That's you?

AC: Yep. [*laughs*]

VP: You were a wild boy, huh?

AC: [*laughter*] Yep.

VP: So you've been a member for seventy-four years, since you were three years old. Norman Dixon was telling me a little bit of the difference between a Social, Aid and Pleasure Club and a benevolent society. You all do things in the community?

AC: Yep. Yep. We help children out. We donate money to the playgrounds. See, we've got two members all interested in kids for sports, and whenever they need something they come to us, and we try to help them. We believe in helping give away baskets, turkeys in that neighborhood. Josephine and Liberty. A lot of old people.

VP: Josephine and Liberty?

AC: Yeah. That's [the street] where our building at. So we give a lot of things. We gives a couple of bicycles and different things for Christmas.

VP: So you help children and elderly.

AC: Yeah.

VP: What is distinctive about Young Men Olympian Jr. makes them different?

AC: Like I say. It's benevolent. We bury our dead and take care of our sick. That's the difference.

VP: The colors are black and white.

AC: Uhm, hmm.

VP: Give me a little bit of the history.

AC: Well, they go 'round seeing the sick. Have you ever saw them second-line? We parade different. We go by our colors, and sometimes we have six groups in our parade. I think we got eighty-some-odd members.

VP: Eighty?

AC: Uhm, hmm. And we got a rule. You can't come in there and do anything you want. You got to give respect. To the elders and the people around. High respect. One lady in that block didn't want us to build that building there, but more of the people around there came around asking about it and said, "They don't do nothing wrong. Since they move there, the neighborhood done change. They clean-up and everything."

VP: How long has the building been there?

AC: We got that building about a year before Katrina.

VP: Are you one of the original members?

AC: Yeah.

VP: So what year did it start?

AC: Over 105 or 10 years [ago]. I might have some of that from Mr. Dixon.

VP: How did you become a member of Young Men Olympian?

AC: I came up around Greater St. Stephen.

VP: Greater St. Stephen Church?

AC: Yeah, I had a brother, and he didn't like it. We were paying forty cents a month.

VP: Forty cents a month to be a member of the benevolent society?

AC: Yeah. That's right.

VP: And your brother didn't like it.

AC: No. He got out. He told my momma he don't like that. I stuck with it. I growed up in the Olympian. Been parading so long.

VP: Do you have any particular duties?

AC: I was the chairman of finance.

VP: You were the chairman of finance.

AC: Yeah, I took a little sick. Couldn't get around like I used to, I'm over all that. Any information, you have to come to me and ask me. I give as much help as I could. I was the chairman of finance forty-some-odd years.

VP: So you held on to the purse strings.

AC: Yeah, I take care of the money and the records and everything. See that everything be right.

VP: What is the usual parade route? Do you still march?

AC: Oh yeah. This might be the first year that I don't march because I'm cripple, but I'll be riding in the— Our group have a buggy. [*shows pictures*]

VP: That's 2011?

AC: Yes.

VP: Your colors are blue and—

AC: Peach.

VP: What is the usual parade route?

AC: We make it up every year.

VP: Are there any particular items that you have to have for the parade?

AC: Oh, yeah. This always be the uniform.

VP: The black and white. The body.

AC: Yeah. The body. We have five different groups, and they have five different colors.

VP: What is this one in the peach?

AC: That's the group I'm over. The First Division. We started off last Sunday, had a parade (February 19, 2012). Have parade

all the way up to September. Shut it down around Mardi Gras and Jazz Fest. Every Sunday.

VP: Why so many parades?

AC: Different clubs. We got about forty-some-odd different clubs. Some of the clubs think it is a style show. Try to out-dress each other. Ain't used to be like that. A lot of the youngsters took over. Some of them clubs [wear] thousand-dollar-a-pair shoes.

VP: When you started what were people paying for shoes? What was it like?

AC: Aw. It was easy. You go to the tailor shop. And the band was cheaper. Now you can't get a band under three thousand dollars. Got these women parading now. Other words, it's being carried out by a new generation. Everything change. Music go up. Clothes go up. It's very expensive.

VP: How do they keep up with it?

AC: I don't know. We are debating on what we gon' wear next Sunday. See, we got six groups, and they all have different colors but the body.

VP: Each one parades on a different Sunday?

AC: We parade on the fourth Sunday in September. We have two parades. Our anniversary, we all wear black and white. Go to the church on the second Sunday. Then after church, we have a little two-hour parade. We go different places. Make it back to the building, then we have something at the building.

VP: How would you describe a Second Line or second-lining to someone who wasn't from New Orleans?

AC: Everybody be asking that. Second Line is the people who follow the parade. That's Second Line. It's not the members in the parade. They the followers.

VP: Second Line is not really a specific dance, is it?

AC: Naw, naw, naw, naw. Be out there. Do what you got to do. Enjoy yourself. You think about the money you had to put out. When I was small, my mom would say, "Boy, you ain't gon' be all tired?" I just love it. Some people were over here yesterday. "You think you gon' do it." Other say, "Yeah, he gon' do it." I was cripple, you know. Everybody on the street see me, "What you gon' do?" "I don't know." "Oh, boy it won't be the same, you not out there." I gotta take care of my health. I done paid my dues, parading all those years.

VP: You said you had a brother that was in it. Anybody else in your family?

AC: No, ahn, ahn.

VP: How do you feel when you are out there on the route?

AC: Feel joy. Feel happy. Everybody looking good. It's a wonderful feeling. Everybody having their fun. Joyful thing to be out there. People be telling me, "Boy, you gon' have a fit if you not out there." Man, get away from, don't be talking about all that. The Lord gon' take care me. I'ma be alright.

VP: Is there a particular song that makes you dance full out or [made you] go buck wild when you were younger?

AC: Oh, got so many. "Jesus on the Main Line." Oh, so many. See, another thing, band these days don't play the type of music [they did when] we was parading. They play that fast music. That's why we get a traditional brass band. New Birth. They play traditional Jazz music. All kinds. A lot of different kinds. They slow it down, slow the beat down. Them youngsters be all on the ground and everything, and they be wored out when the parade break up at five o'clock, sitting on the side of the curb. Ah huh. "Brother you ain't gon' keep up." I ain't worried about it. I been parading so long.

VP: What's your favorite moment on parade day?

AC: That morning waking up. Looking outside to see if it's raining or cloudy. Asking the good Lord to let us have a nice, peaceful day. We went to the Jazz Fest. We been going there so long. Now, I got a good li'l job. I sit in the tent and pay all the musicians.

VP: Is there a particular parade or year that stands out for you?

AC: No, I take all of 'em to heart. I ask the Lord to let us go through this street with no trouble or nothing. And to have a safe day and a dry day. No rain.

VP: Have you ever had one of those days when it was wet and nasty?

AC: Oh, yeah.

VP: What do you do?

AC: You cancel for another Sunday. Now they got so many clubs, to get it you gotta put it on a Saturday. Yeah, got too many clubs out here now.

VP: Some people outside of our culture think second-lining is a waste of time and money.

AC: I don't think so.

VP: Why do you think they think that?

AC: I really don't know. See now they be talking to other people about that. I don't even much answer 'em. They come, "Uh huh." They come a couple of weeks ago said, "I heard you ain't gon' parade. You cripple." I'm not thinking about that. I ain't got time to talk about that.

VP: What do you think is the biggest misconception about Social, Aid and Pleasure Clubs, second-lining, and benevolent societies?

AC: I don't think it's no different. I think they just feel that way. They go through the street thinking they can do anything they want. Benevolence, we go by the rules. We wear colors, too. We wear about five different colors. Each group and each of those groups gon' have black and white, regardless.

VP: Do you think that people think that second-lining is all about dancing, or do they understand the culture traditions of it?

AC: I don't think they understand it. I don't see where they get that from. One time they used to get wild out here. I thought they were gonna stop it. They start acting the fool.

VP: You thought they were going to stop second-lining?

AC: They were trying to stop it.

VP: Because of all the shootings?

AC: It don't be the clubs. It be the people following the parade, the Second Line. Year before last, we coming around Jackson Street. I'm way in the front. Two people went to running. A li'l boy got killed. Li'l baby. His family came up second-lining. When that parade got to Third and Danneel, we were still around on Second and Dryades. That's how big the parade is. A lot of police. Police on horses and everywhere. In our parade, when the title boys parade, we be watching 'em. Watch over them that they don't run out. Then their parents be out there. We protect them now. We lock them in. We lock 'em in the line. We have about two limousines to ride if they get tired. They got a horse and buggy. There about two or three of us crippled. We'll ride on the buggy, Lord say the same.

Alfred Carter passed away in New Orleans on March 9, 2015. He was a member of the Young Men Olympian Jr. Benevolent Association for more than seventy-five years. He was laid to rest after a traditional Jazz funeral and Second Line with representatives from all Social, Aid and Pleasure Clubs.

Freedom Dances across the Diaspora

The Cultural Connections of New Orleans Second Line, Cuban Conga, and Haitian Rara

FREDDI WILLIAMS EVANS AND ZADA JOHNSON

From their elaborate processional display to their rolling brass band rhythms, New Orleans Second Line parades share a rich cultural connection with street performance traditions throughout the Afro-Caribbean Diaspora. During Carnival season in Cuba, Conga processions fill the streets of Santiago in much the same way Second Line parades fill the streets of New Orleans.

Cuban Conga parades, led by bands of drummers and horn players, attract hundreds of neighborhood revelers who follow the procession into the late hours of the night. Similarly, Haitian Rara bands of dancers, drummers, and horn players parade through towns and villages during Holy Week, traveling for miles with the gathering crowds that follow them.

The link among the street-parading traditions of New Orleans, Cuba, and Haiti stems from the Trans-Atlantic Slave Trade and the millions of enslaved African peoples who were brought to the Western Hemisphere to work in the colonies of the New World. In the midst of the brutal and dehumanizing conditions of enslavement, enslaved African groups in the American South and the Caribbean were constantly finding ways to resist their exploitation and continue the cultural practices they observed in their homelands. As these street-parading traditions demonstrate, the enslaved African populations of the New World would inscribe their African cultural practices on European religious and festival tradi-tions, transforming them into the African-derived performance traditions that we recognize today.

In this essay, we examine the sociocultural links among New Orleans Second Lines, Cuban Conga processions, and Haitian Rara parades. Each of these traditions is influenced by the Carnival celebrations observed by slaveholding societies in the Caribbean and French/Spanish territories of the U.S. South. In addition to their Carnivalesque origins, the street processions of New Orleans Second Lines, Haitian Rara, and Cuban Conga processions also share origins in the mutual aid and religious societies formed by Black populations to assist with the socio-economic needs of their membership and celebrate the cultural traditions of their ancestors.

New Orleans Second Line parades originate from the racially segregated practices of New Orleans Carnival/Mardi Gras along with the street processions and benevolent societies that pro-liferated throughout the city in the late nineteenth and early twentieth centuries. Along the same lines, Cuban Conga pro-cessions arose from the *cabildos de nacion,* mutual aid societies formed by various African ethnic groups on the island as well as the winter Carnival celebration in which Afro-Cuban groups were allowed to participate at the end of the growing season. Similarly, Haitian Rara parades originate from Carnival soci-eties that formed to represent their respective regions during Carnival season through Holy Week. Second Lines, Congas, and

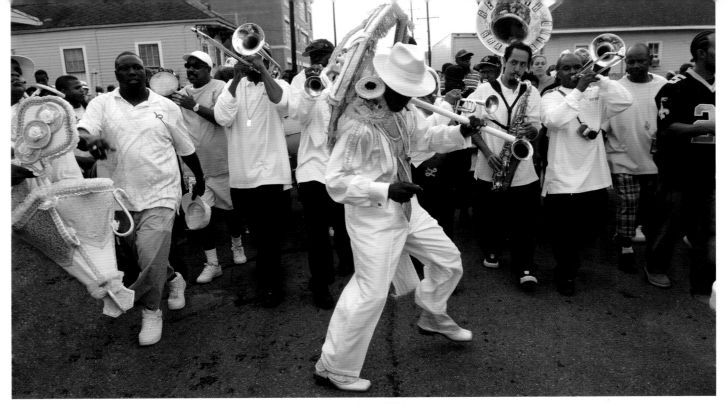

David "Lil David" Rayfield, Sudan
November 11, 2007

Rara processions share not only origins from the era of slavery but also similar African-derived rhythmic patterns and processional practices that express themes of cultural resistance and claims of equal recognition in society.

CARNIVAL AND BENEVOLENT SOCIETY INFLUENCES ON NEW ORLEANS SECOND LINE, CUBAN CONGA COMPARSA, AND HAITIAN RARA

One of the most significant holidays celebrated among the plantation societies of the Caribbean and U.S. South was Carnival, the pre-Lenten Catholic holiday season that begins in early January with Epiphany (Dia de Reyes in Cuba) and culminates with Mardi Gras. In many cases, Carnival season came at the end of the planting season and was a time that the plantation elite held lavish masquerade balls and other festive gatherings. Given the lighter winter season work schedule of the Carnival holidays, slaveholding societies would also allow their enslaved populations to gather and hold festivities of their own. This opportunity for creative expression became a prime venue for incorporating African performance styles and cultural practices

into Carnival revelry. It was also an opportunity to inscribe symbolic claims of cultural pride and recognition onto social spaces that were otherwise reserved for the white plantation elite.

Nineteenth-century travel accounts of New Orleans and the Caribbean reveal the emergence of Black Carnival activities and processions infused with African-derived performance styles. Two days before the Mardi Gras of 1819, architect Benjamin Latrobe stumbled upon a "common in the rear of the city" where he witnessed the gathering of more than five hundred Black people in what is known today as Congo Square. Latrobe's account describes large gatherings of dancers, singing in African languages, and the accompaniment of drums and other African instruments (Latrobe 1905, 179–81). After describing the various dances and instruments at the gathering, he notes that "the allowed amusements of Sunday have, it seems, perpetuated here those of Africa among its former inhabitants" (Latrobe 1980, 181). Latrobe's observations in this account reveal the presence of African performance styles and cultural practices among the Black populations of nineteenth-century New Orleans. The fact that this gathering took place at the height of Carnival season raises questions about how the dancers and drummers

of Congo Square may have further incorporated their African cultural practices into the daylong revelry of Mardi Gras.

In his 1826 travel account of New Orleans, New England minister Timothy Flint describes the Carnivalesque procession of enslaved populations that he observed during his visit:

> Every year the negroes have two or three holidays which in New Orleans and the vicinity are like the Saturnalia of the slaves in ancient Rome. The great Congo dance is performed. Some hundreds of negroes, male and female, follow the king of the wake, who is conspicuous for his youth, size, the whiteness of his eyes and the blackness of his visage. For a crown he has a series of oblong, gilt-paper boxes on his head, tapering upwards like a pyramid. From the ends of the boxes hang two huge tassels, like those on epaulets. . . . By his thousand mountebank tricks and contortion of countenance and form he produces an irresistible effect on the multitude. (Flint 1826, 140)

Flint's account goes on to describe the procession that follows the "king of the wake" as having their own "peculiar dress and contortions through the streets much to the amusement of their masters" (140). Like Latrobe, Flint witnesses African performance styles inscribed over the revelry of Carnival in the form of the "Congo dance." Flint's account also reveals a recurring trope utilized in Black Carnival traditions—the royal figure of the "king of the wake" who leads the procession through the streets of the city. Although royal figures are also a common fixture of European Carnival processions, it seems that the presence of these figures in Black Carnival processions are symbolic of claims of recognition in societies where Black populations were largely viewed as chattel.

Similar to Flint's account, the physician John George F. Wurdemann observed a procession of Black Carnival revelers in the streets of Cuba during an 1842 Epiphany/Dia de Reyes celebration that occurred at the beginning of Carnival season:

> The next day being "el dia de los Reyes" twelfth day almost unlimited liberty was given to the negroes. Each tribe, having elected its king and queen, paraded the streets with a flag having its name and the words "viva Isabella" with the arms of Spain painted on it. Their

majesties were dressed in the extreme of the fashion and were ceremoniously waited on by the ladies and gentlemen of the court, one of the ladies holding an umbrella over the head of the queen. . . . The whole gang was under the command of a negro marshal, who with a drawn sword . . . was continually on the move to preserve order in the ranks. . . . But the chief object in the group was an athletic negro, with a fantastic straw helmet an immensely thick girdle of strips of palm leaves around his waist and other uncouth articles of dress. (Wurdemann 1844, 83–84, qtd. in Bettelheim, Bridges, and Yonker 1988, 140)

Much like Flint's "king of the wake," Wurdemann's account describes the presence of Black Carnival royalty tended by a royal court and led through the streets by a military-like marshal. It is also interesting to note from this account the "viva Isabella" flag painted with the arms of Spain. In this case it seems that this Black Carnival procession may also have been using the Spanish flag to index their entitlement to the same rights and recognition as Spanish colonial subjects.

In 1845, American writer Maturin Ballou traveled to Cuba and wrote an account that included his observations of an Afro-Cuban Dia de Reyes Carnival procession in the streets of Havana:

> On January 6th, the day of Epiphany, the negroes of Havana, as well as in other cities of the island, made a grand public demonstration; indeed, the occasion may be said to be given up to them as a holiday for their race. They march about the principal streets in bands with its leader got up like a tambor major and accompanied by rude African drum notes and songs. They are dressed in the most fantastic and barbarous disguises, some wearing the cow's horns, others masks representing the heads of wild beasts and some are seen prancing on dummy horses. All wear the most gorgeous colors and go from point to point on the plazas and paseos asking for donations from everyone they meet. (Ballou 1885, 198, qtd. in Bettelheim, Bridges, and Yonker 1998, 140)

In Ballou's account, we see the prominent presence of African cultural practices incorporated into the processional order of Afro-Cuban Dia de Reyes celebrations. Ballou observes the

"African drum notes and songs" that accompany the procession. As in the previous accounts from New Orleans and Cuba, there is a processional leader, in this instance dressed in the ceremonial robes of a drum major. Ballou's account also reveals the spatial practice of Afro-Cuban processions, with participants marching through the "principal streets of the city," going from "point to point on the plazas and paseos asking for donations from everyone they meet." The movement of these processions through major thoroughfares symbolically subverts the power and authority of the slaveholding elite and highlights the recognition and entitlement of Afro-Cuban masking groups.

According to art historian Dolores Yonker, there are also colonial-era accounts of street processions in Haiti that resemble what are known as Rara processions today. Somewhat different from the Carnival-season celebrations of New Orleans and Cuba, Haitian Rara processions take place during Holy Week, the days that lead up to the Easter Holiday. However, along the same lines as New Orleans and Cuban Carnival celebrations, Haitian Rara includes processions of African-derived music and dance that traverse social spaces. In 1910, author Eugene Aubin described a Holy Week procession during his visit to the countryside of Haiti:

> A masquerading group dressed in tinseled garments moved across the countryside re-enacting the search by soldiers of Christ. Each habitation formed its group. Organization and preparations had begun on New Year's Eve. At noon on Holy Thursday, the king emerged, accompanied by his suite with flags and drums. Night and day until Easter, the processions and dances proceeded uninterrupted (Aubin, qtd. in Bettelheim, Bridges, and Yonker 1988, 39–40)

Here we see a processional order of African-derived performance styles similar to those described in the previous accounts from New Orleans and Cuba. Aubin's account also includes the presence of a royal figure accompanied by flags and drums who leads the procession through the social space of the countryside. The connection of these processions to Holy Week and Easter suggests that Haitian performers could have been utilizing the persecution and resurrection of Christ as a symbol of their own experiences of dispossession and misrecognition.

Early travel accounts of African-influenced processions in New Orleans, Cuba, and Haiti offer critical insight into not only the African performance styles that emerged from these practices but also the important symbolic work these traditions did to mark social spaces with themes of resistance and recognition. Carnival and Holy Week performances appear to be much more in these accounts than just instances of festive revelry. Instead, they seem to be acts of resistance that challenged the physical and cultural oppression of Trans-Atlantic Slavery.

The incorporation of African-derived performance styles into the colonial Carnival traditions of New Orleans, Cuba, and Haiti resisted the cultural oppression of enslaved groups who were often deprived of an opportunity to observe cultural practices in their day-to-day lives within plantation societies. The presence of royal figures and colonial flags in these processions offers insight into the way that procession participants used modes of visual display and social space to subvert and challenge the misrecognition and dispossession they experienced. The royal "king of the wake" that appears as a common trope in these processions subverts the identity of the dispossessed slave just as the presence of the colonial flag (or other flags) marks the entitlement to national identity that was often denied to enslaved populations.

In addition to early Carnival traditions, the street processions of New Orleans Second Lines, Cuban Conga, and Haitian Rara are also heavily influenced by the benevolent societies that developed in the United States and the Caribbean during the late nineteenth and early twentieth centuries. In nineteenth-century New Orleans, Black benevolent societies proliferated largely in response to the city's post–Civil War segregationist social order. According to Walker (1936), African-American benevolent societies existed during the era of slavery, providing mutual aid for fellow members including assistance with burying enslaved members and their families out of slavery. As Logsdon and Bell point out, the rise of Jim Crow legislation at the dawn of the twentieth century turned African Americans' Reconstruction-era hopes of freedom and equal citizenship into a "nightmare of peonage, segregation and disfranchisement" (Logsdon and Bell 1992, 260). In response to the city's racially segregated social order, Black residents throughout New Orleans founded mutual aid and benevolent societies that offered members financial relief as well as the only means of access to medical benefits, life insurance, and assistance with burial expenses available to Black New Orleanians at that time

(Jacobs 1988; Blassingame 1973; Walker 1936). Many mutual aid and benevolent societies also provided a "funeral with music" or Jazz funeral processions for their members as well as anniversary parades where members dressed in their Sunday finery and paraded through the city with brass band accompaniment.

During the late nineteenth and early twentieth centuries, there were more than two hundred African-American benevolent societies in New Orleans aimed at improving the quality of life for African-American residents throughout the city (Blassingame 1973). Civil rights icon Homer Plessy was a member of several benevolent societies including the Société des Jeunes Amis (Society of Young Friends), the Société des Francs-Amis (Society of French Friends), and the Cosmopolitan Mutual Aid Society (Medley 2003, 26). Over the course of the early twentieth century, the street parades of benevolent societies would gain international acclaim and would lay the foundation for the processional order and performance aesthetics of modern-day Second Line parades. In the same vein as the Carnival processions discussed earlier, benevolent society parades also utilized their visual display and spatial practice to make claims of entitlement to equal rights as citizens and challenge the marginalization of New Orleans segregationist social order.

In June 1887, the African American–owned *New Orleans Weekly Pelican* ran a full-page article on the fifteenth annual anniversary parade of the Longshoremen's Protective Union Benevolent Association. Established in 1872, the Longshoremen's Benevolent Association was founded to protect the labor rights of the growing population of African-American longshoremen in New Orleans. As the *Weekly Pelican* article suggests, their annual parades through the streets of the city were both celebrations of their organization as well as demonstrations of their entitlement to equal rights as citizens:

> Monday last had long been anticipated by the friends and members of the sterling organization, the Longshoremen's Protective Union Benevolent Association as the day upon which they would install their newly elected officers, and in a fitting manner celebrate the fifteenth anniversary of their organization. At 10' o clock the members of the association, headed by Grand Marshal Victor Snoot and Chief Aids E. A. Higgins and Edward Logan . . . started from their hall and moved over the following route: Erato to Carondelet, to Canal,

north side of Canal to Camp to Calliope to Dryades, to Philip, to St. Denis, to Washington to St. Charles, to Louisiana Avenue to Tchoupitoulas to Upperline to the Orange Grove where the installation and other exercises were held. . . . After the marshal and his aids, there came the Onward Brass Band, 13 pieces, then the order of the day . . . followed by the President, Mr. E. S. Swann and the Secretary, Mr. Jas. E Porter, also in a carriage who in turn were followed by a handsomely dressed and as well behaved body of men as ever paraded the streets of the city. (*Weekly Pelican* June 4, 1887)

The Longshoremen's elaborate processional order of a grand marshal, brass band, and horse-drawn carriages signaled that the members of the association were as dignified as any other members of New Orleans society. The parade's route through the Black neighborhoods of the city as well as the main thoroughfares of St. Charles and Canal exemplifies the way these parades inscribed claims of recognition onto both Black and white social spaces. The newspaper's description of the Longshoremen's marching unit as "a handsomely dressed and as well behaved body of men as ever paraded the streets of the city" further illustrates the importance of these parades as opportunities to be represented as respectable, well-dressed, and dignified citizens.

The *Weekly Pelican* article also reveals the military references that were often present in benevolent society parades. In addition to the marching unit of members featured in the Longshoremen's procession, the president of the Longshoremen's Protective, E. S. Swann, was a former Union soldier. In the *Pelican*'s printed keynote speech from the picnic that followed the parade, Swann's experience as a former slave and Union soldier is recounted:

> Born in the state of Virginia forty-one years ago, a slave held in chattel bondage by the historic General Pickett, [Swann] was forced into the Confederate service as a servant; but when the first opportunity presented itself, he escaped to the federal lines where, buoyed up by an undefinable hope actuated by innate courage, patriotism and heroism of a true man, he enlisted in the service of his country to do or die for his rights and his people. (*Weekly Pelican,* June 4, 1887)

Many early African-American benevolent societies were formed by newly emancipated African-American men who were also former Union soldiers. The visual display of these parades, with their pageantry and military style, challenged the subservient images of African Americans that were circulated in white society through minstrel theater and other popular media. The image of well-dressed and unified marching units of African-American benevolent society members spoke directly to the desire of African-American residents to have equal rights as citizens and equal access to city space.

The street parades of early Black benevolent societies were very much in performative dialogue with the segregated Carnival parades of the city. During the late nineteenth century, when Carnival traditions transformed into large-scale street parades, they remained a reflection of the racial hierarchy that existed in the city. In the large-scale white Mardi Gras parades of Comus, Momus, and Rex, the Black populations of the city could only participate as mule drivers for carriage floats and **flambeaux** torch carriers to illuminate night parades. This segregation of mainline Carnival participation mirrored the racial segregation of the city; white plantation elite paraded through the streets as royalty while Black populations were relegated to servile positions. Major thoroughfares including St. Charles and Canal Streets were also reserved for the parade routes of white Carnival krewes during the late nineteenth and early twentieth centuries. White Carnival celebrations of this era were an articulation of the city's racial hierarchy not only in the visual spectacle of parade procession but also in their movement through spaces generally reserved for white residents of the city.

The most well-known Black benevolent society to engage the racial dynamics of New Orleans white Carnival parades is the Zulu Social, Aid and Pleasure Club. Founded in 1909, Zulu was originally known as the Tramps, a social club of laborers and longshoremen from Uptown. After viewing a vaudeville-style skit on King Shaka Zulu of South Africa, the club changed its name to the Zulu Social, Aid and Pleasure Club and marched through the backstreet Black neighborhoods of the city on Mardi Gras 1910. The walking procession that year featured the first Zulu King, William Story, who donned a lard-can crown and banana-stalk scepter while Jubilee singers accompanied the procession (Mitchell 1995; Saxon 1987). The comical visual display of King Zulu lampooned the mock royalty of Rex, the white king of Carnival and emblem of New Orleans white Carnival traditions.

The use of blackface makeup that emerged in later Zulu parades would be a scathing comic inversion of Rex as well as an inversion of the blackface Carnival costumes white revelers frequently wore during early twentieth-century Mardi Gras. As Mitchell points out, the satire and comic inversion of Zulu contested the elitism of the city's white Carnival parades, particularly Rex:

In his way, Zulu did everything that Rex did. If Rex traveled by water, coming up the Mississippi with an escort from the U.S Navy, Zulu came down the New Basin Canal on a tugboat. If Rex had a scepter, Zulu held a hambone. If Rex had the city police marching before him, Zulu had the Zulu police—wearing police uniforms until the municipal authorities objected. All that Zulu did caricatured Rex, a Black lord of misrule upsetting the reign of the white lord, a mocker of a mocker. (Mitchell 1995, 151)

Mitchell's analysis here reveals the way early Zulu parades directly engaged the racial hierarchies that were expressed in the Rex parade. The blackface visual representation of Zulu was an act of subversion toward the supremacy of Rex as white king of Mardi Gras as well as the overall marginalization of African-American New Orleanians during Carnival festivities.

The Conga street parades of Cuba are also directly influenced by benevolent societies known as *cabildos de nacion* that were established as social organizations for the various ethnic groups of enslaved Africans who populated the island. Promoted by the Spanish colonial government to contain and separate African populations in separate ethnic groups, the *cabildos de nacion* were also religious organizations connected to the Catholic Church. In addition to their Catholic affiliations, however, the *cabildos de nacion* also became spaces where Afro-Cuban populations were able to freely practice African religious rituals such as the Yoruba-derived traditions of Lucumi and the Congo-derived practices of Palo Monte. Similar to the benevolent societies of New Orleans, the *cabildos de nacion* provided medical and burial assistance for their members. Along with these forms of mutual aid, *cabildos de nacion* also raised funds to buy members out of slavery (Bettelheim 2001). In the same vein as the annual parades of New Orleans benevolent societies, the *cabildos de nacion* also hosted a series of street parades including feast-day celebrations for Catholic saints and processions during the Carnival season.

Beginning with the Carnival season of 1823, the *cabildos de nacion* were granted permission to parade through the streets of Cuba for Epiphany/Dia de Reyes celebrations. Each *cabildo* formed its own procession through the streets that included a grand marshal, colorful regalia, flags, musicians, and an elected king and queen. Similar to the benevolent societies of nineteenth-century New Orleans, Cuban *cabildos de nacion* utilized their parading practices to challenge the oppressed racial regimes that they experienced in their day-to-day lives. In addition to the symbolic resistance of street processions, *cabildos de nacion* were also involved in several uprisings during the era of slavery in Cuba. In her discussion of *cabildos de nacion,* Judith Bettelheim points out several instances where *cabildos* served as the centers for antislavery resistance:

> There is ample documentation that in the past cabildos provided organizing centers for uprisings, such as the 1812 "Aponte Conspiracy." In Havana, another occurred in 1835 and was led by Juan Prieto, the foreman of the Cabildo Lucumi known as Ello y Oyo, referring to the ancient Yoruba kingdom of Oyo. Throughout the 1800s different cabildo groups resisted authoritarian control and persisted in rebellious behavior. The cabildos' potential for attracting free Blacks and freed slaves posed an ongoing threat to official stability. (Bettelheim 2001, 100)

Bettelheim further notes that cabildos also played a significant role in the Cuban Wars of Independence (1868–95). The Cabildo Carabali Isuama of Santiago supported Mambisa soldiers and used their drums to transport weapons and medical aid to freedom fighters during the War of 1898–1902.

Stemming from the processional practices of the *cabildos de nacion,* contemporary Conga street parades are also primary locales for challenging social marginalization and expressing Afro-Cuban cultural pride. Along the same lines of the relationship between nineteenth-century benevolent societies and modern Second Line parades, Conga street parades are critically informed by the methods of resistance linked to the *cabildos de nacion*. In their documentary *Uprising Drums: Voice of Resistance,* the Melodius Thunk film collective chronicles the links between social resistance and contemporary Conga parades in Santiago. In several interviews throughout the documentary, Conga participants share views that Conga parades represent an opportunity for symbolic free speech and resistance against contemporary forms of racial marginalization in Cuba.

Similar to the benevolent societies in New Orleans and Cuba, the Rara processions of Haiti are connected to work societies and African-derived religious societies. Haitian work societies, which include *konbit* and *eskwad* groups, are labor cooperatives who pool their resources together to work the land and buy agricultural necessities such as livestock and seeds (McAlister 2002; Vannier 2009). Rara processions are also linked to secret societies known as Bizango/Champwel, as well as Vodou religious houses (*ounfó*) that are largely influenced by West and Central African religious/ritual expression. In her discussion of Haitian Rara processions, ethnomusicologist Elizabeth McAlister points out that the leadership in these societies is in many ways connected to the organization and leadership of Rara bands:

> In 1961, Paul Moral observed that work societies sometimes turn into Rara bands or emerge in mass demonstrations to create political agitation. In 1987, Rachel Beauvoir and Didier Dominique noted a similar line of transformation: "Between January and April, many work societies transform into Rara bands; these groups dress in colored costumes and dance during the day, and punish people [with ritual retribution] during the night. The Society's money pays for the costumes, drinks and all the other necessary expenses. Thus the president of a Champwel may also be the president of a Rara band, or an ougan [Vodou priest] might be a kolonel who leads the Rara. (McAlister 2002, 139)

The Rara processions of Haiti, like those of the New Orleans benevolent societies and Cuban cabildos, are linked to the mutual-aid practices of work societies as well as Champwel and Vodou religious groups. In the same way that Second Line and Conga street parades express the socially salient interests of benevolent societies with which they are associated, Rara parades are also a collective expression of the social and religious realities of Haitian labor and religious societies.

Key examples of the way that Rara parades are critically linked to social and religious realities are the socially salient issues raised in Rara choruses as well as the Vodou ritual work that these processions do as they travel through communities.

McAlister states that during her field research on Rara parades in Haiti, the choruses of Rara bands sang about local issues as well as national and international issues, including the coup against President Jean Bertrand Aristide and the detainment of Haitian refugees at the Guantanamo naval base (McAlister 2002, 40). Rara parades are also heavily concerned with the ancestral reverence and veneration of deities within the Vodou religious traditions of Haiti (Bettelheim et al. 1988; McAlister 2002; Turner 2003). As their processions traverse communities and townships, Rara bands perform religious rituals at local *ounfó*, crossroads, cemeteries, homes, and other significant religious spaces. These processional "stops" are reminiscent of the parade stops in New Orleans Second Line parades where participants pay their respects to both the living and the dead.

Haitian Rara processions, like New Orleans Second Lines and Cuban Congas, also include references to royalty and militarism. Both McAlister and Bettelheim et al. point out that the social organization of Rara parades includes republican government offices ("president," "vice president," and "treasurer") as well as royal offices ("king" and "queen") and military offices ("general," "colonel," "captain," and "major"). According to McAlister, these offices reflect the "king" and "queen" leadership of colonial Vodou societies as well as the military ranks of peasant offices that rose against state regimes in the nineteenth century. Coupled with Vodou religious practices, the military references of Rara processions also recall the uprisings that led to the Haitian Revolution. As in Second Lines and Congas, the references in Raras to royalty and militarism index resistance against oppression and a collective desire for recognition as equal members in society.

The benevolent society links between Second Line, Conga, and Rara practices further reveal the critical role that these processional traditions played in the social activism of parade organizers and participants. Where the organization of benevolent societies provided concrete sources of mutual aid, the parades that rose from these societies advanced ideologies of resistance to marginalization and entitlement to equal rights. From the civil rights work of Homer Plessy, to the uprisings of the Cuban Wars for Independence and the Haitian Revolution, the benevolent society connections to the parading traditions of New Orleans, Cuba and Haiti demonstrate that these processions are part of a larger fabric of social struggle.

THE AFRICAN RHYTHMIC CONNECTIONS OF SECOND LINES, CONGAS, AND RARAS

In addition to Carnival and benevolent society connections within Second Lines, Congas, and Raras, there are also strong rhythmic as well as ethnic links that unite these parading traditions. When looking at the historical backgrounds of New Orleans, Haiti, and Cuba, it becomes clear that the parallel cultural practices that exist in these locations, including the performance traditions examined here, were influenced by a key event that impacted all three locations—the Haitian Revolution.

Under French rule, Louisiana shared common administrations and policies with Saint-Domingue, which was also French-ruled. This relationship often led to the receipt of enslaved Africans from the same region or countries in Africa and sometimes from the same cargo. It also led to the development of commercial exchanges and the enforcement of mutual laws. For example, the Code Noir, or Black Code, that the French used to govern enslaved Africans in Saint-Domingue was adopted for use in the Louisiana colony. When the Louisiana colony was under Spanish rule, a similar relationship existed with Cuba.

Louisiana's relationship with these locations broadened with the success of the Haitian Revolution (1791–1803), a slave revolt that ended slavery in Saint-Domingue and led to the founding of the Republic of Haiti. While some of the ruling class of Saint-Domingue fled directly to New Orleans upon the outbreak of this war in 1791, many sought asylum in Cuba because of its proximity. However, in 1809, with the outbreak of war in Europe between France and Spain, officials expelled French refugees from Cuba and other Spanish colonies who did not pledge allegiance to the Spanish crown from those locations. As a result, nearly ten thousand Haitians—enslaved, free people of color, and white—fled to Louisiana, and the majority of them remained in New Orleans. This expansion in the city's Black population increased the attendance at Sunday gatherings throughout the city and particularly at Congo Square, which became the sole official gathering place for enslaved Africans beginning in 1817. Those gatherings enabled them to reinforce and perpetuate African-based practices that already existed—including songs, dances, religious practices, foodways, and rhythmic patterns (Evans 2011).

The basic rhythmic pattern of Second Line parades, also

known as the Second Line beat, is directly connected to the music of the African Diaspora. This rhythm is a variation of an ancient African cell that arrived in Louisiana with African people, enslaved and free, who originated and resided in a variety of locations including West and Central Africa, parts of the Caribbean—particularly Haiti and Cuba—and other slaveholding states in the United States. This cell gained such prominence in Cuban music that it received a Spanish identification along with the Cuban name "habanera."

Habanera

Musicians of African heritage utilized this rhythmic cell to shape melody lines and percussive time lines for classical compositions as well as folk songs. The melodies of the most popular Creole folk songs, also called Creole slave songs and Louisiana Creole songs, followed this rhythm and its variations. People of African heritage brought some of these songs, including the favorite "Quan Patate-Latchuite" (When That Sweet Potato Will Be Cooked), to Louisiana from Saint-Domingue and other parts of the West Indies, and some of them originated in Louisiana.

"Quan Patate-Latchuite" rose to popularity among both Black and white populations in the New Orleans vicinity and accompanied the Congo dance, one of the most frequently performed dances in Congo Square during the American period. European composer Louis Gottschalk learned this song from Salley, his nurse of African descent, who fled to Louisiana with his family as a result of the Haitian Revolution. Gottschalk based his world-famous composition "La Bamboula (Danse des Nègres), Op. 2" on the melody of "Quan Patate-Latchuite." One hundred years after the Haitian Revolution and the song's debut in Louisiana, this song was more popular than ever. In 1916, Black New Orleanian Alice Nelson Dunbar wrote that every child in the city could sing its melody. This suggests that every child could also cut steps to the dance and clap the habanera rhythm.

Musicians varied this rhythm by tying the second and third notes and forming what New Orleanians now call the street beat, parade beat, *bamboula* beat, the New Orleans beat, and

the Second Line beat. This variation, which consequently has three beats, received the name "tresillo" in Cuba and became a distinctive feature of Afro-Cuban popular dance including the rumba guaguancó. In New Orleans, this rhythm became a distinctive feature of popular parade songs, early Jazz music, early rhythm and blues songs, and Mardi Gras Indian music, and songs like "Hey Pockey Way."

Tresillo

Another derivative that further connects African diasporic music is the five-beat pattern that received the Spanish name "cinquillo." The tresillo, or Second Line beat, is located within the cinquillo, and the two are often played together in musical genres specific to locations throughout the African Diaspora including New Orleans, Haiti, Cuba, Martinique, Puerto Rico, Brazil, and elsewhere.

Cinquillo

When studying how these rhythms are manifested in various locations and genres, New Orleans–based percussionist and researcher Michael Skinkus used the tresillo and cinquillo as templates to compare the New Orleans Second Line beat to the rhythms of the Haitian Petwo, Cuban rumba guaguancó, and northeastern Brazilian baião. Skinkus found that the difference in how the patterns are manifested in these various locations lies in the part of the tresillo that receives the accent (Skinkus 2008).

Previous research has also linked these rhythms to early Jazz based on the frequency of their use during the developmental stages of the musical form (Washburn 1997, 59–80). When addressing the influence of the habanera and tresillo on the development of Jazz, Jelly Roll Morton, the most noted early Jazz arranger, referred to them as the Spanish tinge and stated that if a musician could not manage to add these rhythms to a tune, he/she would never be able to get what he called the right seasoning for Jazz.

The habanera rhythm and these variations also embodied

ragtime compositions, the Bata rhythms of the Santeria religion, the ring shouts, and the Gullah, or low-country, clap in Black Protestant churches in South Carolina and the Georgia seacoast (Evans 2011).

Musicologist Samuel Floyd concluded that the cinquillo and tresillo motifs are more than basic rhythms:

> They stand as central symbols of African-diasporal musical unity transcending the boundaries of geocultural units and linking these units to each other and also to West Africa, the land from which a large part of this music derived. . . . Through it all, the rhythms of the cinquillo-tresillo complex infuse the carnival and festival bands, the second-liners, and the percussive beats and street singing of the standing and walking basers of the music. (Floyd 1999, 30)

People of African heritage who gathered in Congo Square during the antebellum period perpetuated and preserved what became known as the Second Line beat as well as other elements of the Second Line tradition including the waving of handkerchiefs. Latrobe's description of a circle of gatherers in Congo Square during the winter of 1819 included two women dancers, each holding a handkerchief by one of its corners and extending it in the air (Latrobe 1980). Robert Farris Thompson reported that such extension and waving of handkerchiefs was said to be an act of cleansing the air and removing evil spirits (Thompson 2005). The dancers moved in a slow fashion, measuring their steps to the music of drums and a stringed instrument, while those who encircled them sang an African song in a call-and-response style. This brief description contains features of the Congo dance, which originated with the Kongo/Angola nation and which was often witnessed in New Orleans during the time of Latrobe's observation. One of the drummers in that circle straddled his drum while playing with his hands, fingers, and the heel of one foot—cultural practices associated with sacred as well as secular Kongo-derived music and dance throughout the African Diaspora (Evans 2011).

Descendants from many different ethnic groups that originated in West and Central Africa participated in the Sunday gatherings, and commonalities existed among them that facilitated the exchange and intertwining of practices in Congo Square. At the same time, however, some performance practices remained distinct, identifiable, and traceable to a specific ethnic origin as was the case with some of the practices witnessed in Congo Square. The research that identifies the African ethnic groups that slave traders brought to the city at certain time periods provides significant information. Gwendolyn Midlo Hall found that by 1820, during the time of Latrobe's observation, the overwhelming majority of enslaved Africans whom traders brought to Louisiana and who remained in New Orleans were of Kongo/Angola heritage (Hall 1992).

That Sunday afternoon in 1819, in a larger circle, Latrobe witnessed a ring of a dozen women walking by way of dancing, to music made with a slit gong, a calabash drum with a round hole encircled with brass nails, and a stool-shaped drum with a leather head. Prototypes of all of those musical instruments existed in the Kongo/Angola region. Connections to Kongo origins also existed among the Conga Carnival tradition in Santiago de Cuba as well as the Rara parading tradition of Haiti. Research shows that enslaved Africans of Kongo/Angola heritage were also taken to these other two locations in very large numbers (Hall 1992).

Although the word "congo," with "conga" as the feminine version, was used generically in Cuba as well as in Louisiana to denote anything pertaining to enslaved Africans and their culture, scholars link the origin of the Conga parading practice to people of Kongo/Angola heritage. Such connections include the bokú, which is one of the instruments specific to Conga processionals and which means "drum" in the Kikongo language. Another link is an early reference to the comparsa Conga tradition relating it to "el Rey del Congo," or king of the Congo (Bettelheim 2001). The term "Conga" also identifies another Cuban dance tradition where dancers move in a processional and which originated as a street dance—the Conga line. In this case, dancers progress single file as is often true during the Second Line dance at parties and other events in New Orleans.

One of the connections of Haitian Rara bands to Kongo heritage is the significance and observance of "the crossroads." Rara band members and those who join their parades customarily stop at forks in the road, cemeteries, and religious temples to make musical tributes to the ancestors and deities (Turner 2003). In the Kongo belief system, a fork in the road or a crossroad represents a point of communication between the two worlds—the living and the dead. The crossroads is a primary concept in Kongo religious traditions, and Rara band members

honor it through their performance routines as well as song lyrics (Turner 2003, 124–50).

Another Kongo connection lies in the Kreyol term "Rara" itself, which Robert Farris Thompson argues derived from "wala," the word in KiKongo for musicians walking before others in lines and circles (Thompson 1993, 107). Rara bands, like the Second Lines in New Orleans and Congas in Santiago de Cuba, gain followers as they progress through urban centers and the open countryside.

As with the Second Line beat and dance, the traditional time signature for the Conga music and dance is 2/4, and participants in the processional advance along in small sliding steps. The rhythmic pattern of the basic Cuban Conga step, like the New Orleans Second Line beat, is a variation of the habanera beat, which is also true of the basic rhythm of the bomba music of Puerto Rico. When the basic Conga rhythm and its variations are compared to the Second Line beat, the relationships among them become apparent. They are all variations of the habanera rhythm.

The musical instruments found among the New Orleans Second Line, the Cuban Conga, and the Haitian Rara parade practices bear similarities in that they basically fall into two categories—percussion and horns. While standard instruments and organizational concepts exist within each performance tradition, frequent variations of secondary percussive instruments are found.

The primary percussion instrument in all three styles is the drum, with secondary ones often including a variety of basic handmade sound makers. For Congas, the percussion section includes the bokú, other drums called tambores, metal objects that are struck with metal beaters, and additional instruments made from found objects. Rara bands also begin with a variety of drums supported by handmade instruments. Second Line bands incorporate bass and snare drums as well as secondary percussive instruments on occasion. Horns utilized in Conga processionals are called China cornets or Chinese trumpets. Second Line bands employ brass instruments—primarily trumpets, trombones, and tubas; and Rara bands include a variety of horns including bamboo trumpets or bamboo tubes.

The shared elements found among these parading traditions—Second Lines, Congas, and Raras—shed light on New Orleans' past relationship with Haiti and Cuba and provide examples of cultural connections that exist within the African Diaspora. This study also demonstrates Congo Square's role in perpetuating African cultural practices in New Orleans and

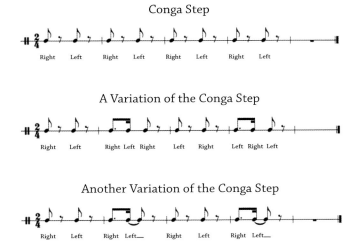

shows how those practices led to new genres that informed popular culture.

The cultural connections of New Orleans Second Line, Cuban Conga, and Haitian Rara provide fascinating insight into the shared experiences of African descendant groups in the U.S South and the Caribbean. New World Carnival traditions offered a prime opportunity for African descendant groups to incorporate their own processional forms into the festive practices of plantation societies. The Carnival holidays also presented an opportunity for African descendant groups to challenge the marginalization and oppression they experienced in their everyday lives. The benevolent society and work society origins of these traditions reveal the underlying struggles for freedom and social equality that framed these parading practices. The shared rhythms of Second Line, Conga, and Rara provided a context through which African descendant groups could continue their cultural practices in the New World. The transformation of centuries-old African rhythms into New World variations of the habanera allowed African descendant groups to celebrate their cultural heritage while creating the Diasporic musical forms that we still recognize today.

The connections of New Orleans' African-American parading traditions to the African Diaspora remain prominent, as evidenced by the twentieth-anniversary parade of the Black Men of Labor Social, Aid and Pleasure Club in 2013. Parading under the theme "From West Africa with Love," the club offered a luminous display of African visual imagery and rhythmic forms.

During his address at the awards dinner that took place before the parade, club president Fred Johnson referred to Black Men of Labor parades as a "dance across the Diaspora" connecting traditions of the past with cultural practices of the present. Precipitated by the Trans-Atlantic Slave Trade and reinforced by the Haitian Revolution, the processional traditions of New Orleans, Cuba, and Haiti have continued with common musical and performative threads that link the ancestral past with struggles for freedom and recognition in the present.

REFERENCES

Bettelheim, Judith. 2001. *Cuban Festivals: A Century of Afro-Cuban Culture.* Princeton: Markus Wiener.

Bettelheim, Judith, Barbara Bridges, and Dolores Yonker. 1988. "Festivals in Cuba, Haiti and New Orleans." In *Caribbean Festival Arts: Each and Every Bit of Difference*, edited by John W. Nunley and Judith Bettelheim. Seattle: University of Washington Press.

Blasssingame, John W. 1973. *Black New Orleans, 1860–1880.* Chicago: University of Chicago Press.

Evans, Freddi Williams. 2011. *Congo Square: African Roots in New Orleans.* Lafayette: University of Louisiana at Lafayette Press.

Flint, Timothy. 1826. *Recollections of the Last Ten Years, Passed in Occasional Residences and Journeyings in the Valley of the Mississippi. . . .* Boston: Cummings, Hilliard and Co.

Floyd, Samuel A. "Black Music in the Circum-Caribbean." *American Music* 17, no. 1 (1999): 1–38.

Hall, Gwendolyn Midlo. 1992. *Africans in Colonial Louisiana: The Development of Afro-Creole Culture in the Eighteenth Century.* Baton Rouge: Louisiana State University Press.

Jacobs, Claude. 1988. "Benevolent Societies of New Orleans Blacks during the Late Nineteenth and Early Twentieth Century." *Louisiana History* 29 (1) 21–33.

Latrobe, Benjamin H. (1905) 1980. *The Journals of Benjamin Henry Latrobe, 1799–1820: From Philadelphia to New Orleans.* Edited by Edward C. Carter II, John C. Van Horne, and Lee W. Formwalt. New Haven: Yale University Press.

Logsdon, Joseph, and Caryn Cossé Bell. 1992. "The Americanization of Black New Orleans." In *Creole New Orleans: Race and Americanization,* edited by Arnold R. Hirsch and Joseph Logsdon. Baton Rouge: Louisiana State University Press.

McAlister, Elizabeth. 2002. *Rara! Vodou, Power, and Performance in Haiti and Its Diaspora.* Berkeley: University of California Press.

Medley, Keith Weldon. (2003) 2012. *We as Freemen: Plessy v. Ferguson.* New Orleans: Pelican.

Mitchell, Reid. 1995. *All on a Mardi Gras Day: Episodes in the History of New Orleans Carnival.* Cambridge: Harvard University Press.

Saxon, Lyle, ed. (1945) 1987. *Gumbo Ya-Ya: Folk Tales of Louisiana.* Gretna: Pelican Publishing.

Skinkus, Michael. Personal interview. August 16, 2008.

Sublette, Ned. 2004. *Cuba and Its Music: From the First Drums to the Mambo.* Chicago: Chicago Review Press.

Thompson, Robert Farris. 1993. *Face of the Gods: Art and Altars of Africa and the African Americas.* New York: Museum for African Art.

———. 2005. "When the Saints Go Marching In: Kongo Louisiana, Kongo New Orleans." In *Resonance from the Past: African Sculpture from the New Orleans Museum of Art,* edited by Frank Herreman, 140. New York: Museum for African Art.

Turner, Richard Brent. 2003. "Mardi Gras Indians and Second Lines/Sequin Artists and Rara Bands: Street Festivals and Performers in New Orleans and Haiti." *Journal of Haitian Studies* 9, no. 1: 124–50.

Vannier, Christian. 2009. "Rational Cooperation: Situating Konbit Labor Practice in Context." *Journal of Haitian Studies* 15, no. 2: 332–49.

Walker, Harry J. 1939. "Negro Benevolent Societies in New Orleans." Master's thesis, Fisk University.

Washburn, Christophe. 1997. "The Clave of Jazz: A Caribbean Contribution to the Rhythmic Foundation of an African-American Music." *Black Music Research Journal* 17, no.1 (Spring): 59–80.

Interview with Lionel "Unca Lionel" Batiste

Cultural elder and bass drummer, Tremé Brass Band

Lionel Batiste sat down for a short interview with Karen Celestan and Eric Waters in Louis Armstrong Park in 2002.

Karen Celestan: Okay, you know, I have to ask, Uncle Lionel, why do you twirl your beer before you drink it?

Lionel Batiste: When I was young, I used to go get beer for the older women, ladies, they'd be sitting at night out on their steps, talking Creole and all that. All of them had their own bucket. I used to go by Chatina, which was on Liberty and Dumaine. Go by the Hollywood, which was on Dumaine and Marais, used to go by the Caledonia and get it—back then it was Regal and Dixie, that was the beer. And they used to say, "Here, take this bucket, go get me some beer. And tell 'em, don't give me all that foam." And I generally did all that for them. They used to pour the beer out to get rid of the foam, set the glass down for a minute, pick it up, and twirl it before a sip.

KC: So that's where you got that from?

LB: Eh, the ladies— It was a hell of a life.

KC: If you had to explain Second Line to somebody, especially the people from out of town, and they had never seen it before, and you had to tell it, people from overseas, what would you tell them? How would you explain that to them?

LB: I'd have to explain it to them from the roots, the way I ex-

perienced it. That's the reason for me going and traveling so many places, to show them— All right, this band from Norway, a fellow by the name of Greer, he played in the barroom, there was a band down from Norway, Joe Hayes, I don't know if you remember him [*talking to Eric*]— He's a member of the Tremé Sport. When I was coming up, there was a funeral and I had a sash on, and this man, a Norwegian, asked me to bring them to it [a Second Line], and they been coming down here ever damned since. In fact, they was down here for Jazz Fest. And Michael White, he did a show for them, so it's more than Jazz Fest. He asked about a grand marshal, and Michael White recommended me, and I've been doing it ever since.

KC: So, how do you explain it to them? How do you tell them what it is?

LB: Oh, Lord. Some places I go in, I listen to it and they playing it. It still kinda little whatcha'macallit, off.

KC: It's a little off. They don't have the feeling.

LB: I try to explain it to 'em.

Eric Waters: If somebody's never seen a Second Line before, and they ask you, "Uh, Mr. Batiste, what is this Second Line, what do people do when they in a Second Line? What is a Second Line, Mr. Batiste?"

LB: A Second Line is the ones that be on the sidewalk. They

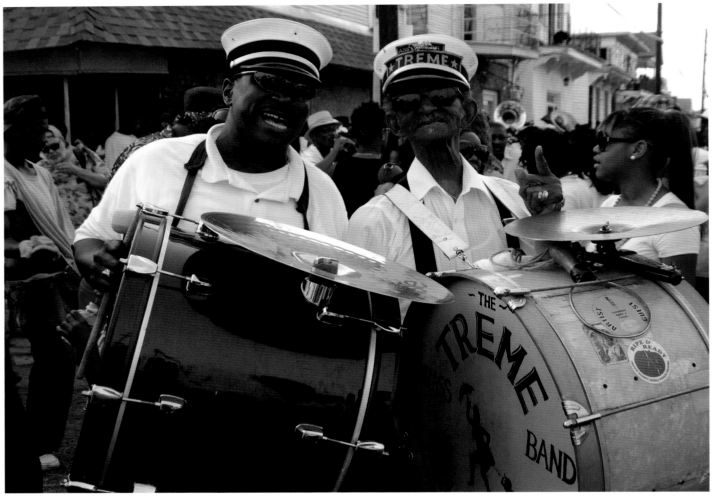

Caytano "Tanio" Hingle and Lionel Batiste
September 3, 2006

not participating with the clubs. It's like you say, "Oh, I'm going to the Second Line." You ain't going to no Second Line, you know, you're going to a parade. That's where you're going, to a parade. Carnival time, you see them folks, where you sit? Come on, mama gonna take y'all to the parades, you hold them by their hand, all them mask, all them pass. The Second Line is the ones on the sidewalk. Members parade in social clubs, they are parading, but you on the Second Line. Now, you see them every day, that's your neighbor, you see 'em every morning when you go put your trash out, you see 'em when you coming from work,

you see 'em whenever you come in from social clubs. [*takes a sip of beer*] Now, today you come out here and spend all that money [on Second Lines], ain't nothing really come about until they came out with them cameras. Television cameras. Now, they all in the front. [*mimicking prancing second-liners*] [*laughter*]

KC: Want to be seen—

LB: Watched the whole parade pass looking for one individual and when it hit the [television news] studio, they run it, take this out and hook this up with that, there's things going on out there that cannot be shown on TV—

EW: How would you explain the dancing that people do? Do you explain it as an expression of freedom? An expression of joy?

LB: Joy.

EW: An expression of release?

LB: Joy, freedom, and release. If you're not locked down, well, that's joy. You're doing what you like to do, that's your spirit. You enjoy what you're doing. You enjoy anything you undertake to do. So, fun-wise, I'm not speaking of trying to harm somebody. As for me when I'm out there, I walk the streets and sing, pluck my fingers [*snapping fingers*], sing songs that I remember, [that] my parents sang to me, that's it. I remember the words, and all this is a joy to me. And I never did like to imitate no one, put water in your mouth and sing like Louis Armstrong, choking— [*laughter from Eric and Karen*]

EW: But I've seen you have fun, Uncle Lionel. I've seen you— I've taken pictures of you when you got out in the street, and you've got a lady, and y'all doing a swing-out in the street to the beat of the Second Line.

LB: See, this place over here [*gesturing*] Vaughan's, there's history there, it just keeps me going, and I enjoy that because I like to dance. I like dancing.

EW: I saw you cut loose at the Black Men of Labor awards thing over at Storyville that time, yeah, you cut loose that night—

LB: [*laughing*] Showing all my jewelry. Whoo, I was full of it that night—

EW: Let me ask you this. That's your signature, wearing your watch on your hand like that? Where did that come from?

LB: The reason why I like it this way, all right. You pay five hundred dollars for a suit of clothes, just for the suit— [*A man across the street joyfully hollers out and whistles, "Uncle Lionel!"*] Hey! [*Lionel waves back*] Eighty dollars for the shirt, all right? Ninety dollars for a tie. Socks. You just dress. All that— looking good. Then, you gonna take an overcoat and cover all that up. Why? You don't want to expose that, but if I dress up like that, I'm gonna throw my coat over my arm, I'm gonna show my jewelry. Show you what I got— That's how it is.

EW: Beautiful!

LB: Now, in the clubs of today, it's more of a style show because there's no way that I'm going to pay eight hundred dollars for a pair of shoes. No way. Only way I'd have a pair of shoes on my feet for eight hundred dollars is if a lady's husband dies and she gives them to me. [*laughter*]

Lionel Batiste passed away on July 8, 2012, in New Orleans. He had dedicated his life to the brass band/Social, Aid and Pleasure Club culture. His funeral garnered national media attention after the mortician agreed to display Batiste's body in a standing position for the visitation and viewing at his wake.

CALLING UP GLORY

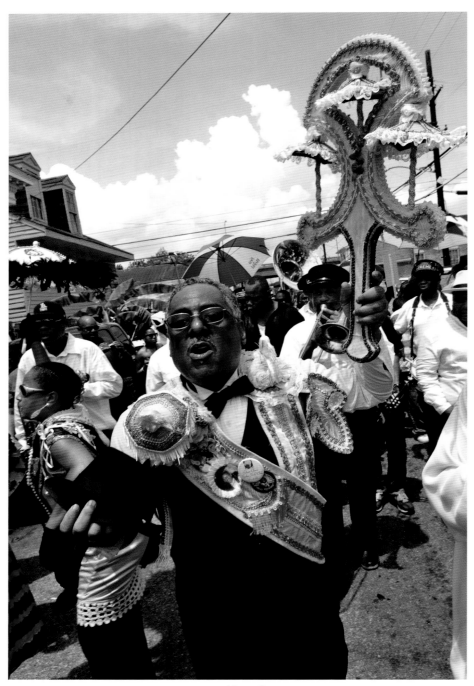

Gerald Emelle
August 13, 2011

You Can't Touch This . . .

KALAMU YA SALAAM

Some people study fish. Intently. At the microscopic level. They can tell you about feeding habits, mating habits, growth rates, swim speed. You name it. But those know-a-lot experts too often overlook what's troubling the waters. I believe if you really want to understand fish, you need to consider the source and quality of the water.

If possession is nine-tenths of the law, environment is a significant factor in social development and stability. So if cultural practices such as SAPCs (Social, Aid and Pleasure Clubs) and Second Lines are the fish, we should examine the nature of their water: Is it fresh, salt, or brackish? Is it polluted? What are the sources, and who controls the flow? Does it have major commercial use, or is it mainly recreational? And, of course, the ultimate question—especially for those of us who are waterborne: How you gon' be fish without water? That's a big-ass question.

Back in the 1980s, I sat on NEA (National Endowment for the Arts) literature and Jazz panels. Before participating at a decision-making level, I had no idea specifically how much tax money was pumped into cultural activities. I had never thought about where the SOBs (our sarcastic term for the funds-dominating trio of symphony, opera, and ballet associations) got their money. If those institutions had to make it mainly on ticket sales, drinks, and merchandise tables, they would all be extinct.

After closer inspection, I began to realize that the severely limited amount of money earmarked for cultural development was dominated by SOBs, who had no popular base. The argument was that the SOBs were absolutely essential to metropolitan areas and that it was our national duty to help ensure the availability of Bach, Verdi, and *The Nutcracker* in our major cities. Can you imagine Jazz, Mardi Gras Indians, and Social, Aid and Pleasure Clubs making a similar case for significant funding? Neither could the cultural czars who control the allocation of grants.

But there is an even worse twist of the knife when it comes to determining who even gets to get in the long line to request funding. Over and over, we heard the big-money mantra: in order to get serious funding, arts organizations needed administrative controls, boards, annual audits, in addition to competing in predetermined, mainstream categories.

Certainly, individual excellence might get recognized, but that is not where the bulk of cultural funding goes. The SOBs are hungry beasts, and the mainstream is not shy about keeping them fed and fat. In this context, where Black cultural formations have to fight for scraps, the fact that consistent Black cultural production even exists is close to miraculous.

Year after year, the Social, Aid and Pleasure Clubs present scintillating anniversary processions, all without any significant

monetary support from government or private philanthropy. (Although in the new millennium, Black cultural formations are receiving some funds, the funding equations are severely unequitable.) Do a cost/production comparison between the SOBs and our neighborhood organizations. Who is offering more bang for the buck? Indeed, in the Black community we produce big, culturally powerful "booms" even though we are working with nickel-and-dime mainstream support.

Moreover, audiences for the majors are small, whereas entire communities turn out to see and participate when Black groups come out. When one compares the percentage of a given community who actually witness an event, the audience for Black cultural formations easily outpaces the SOBs. But there is more. The now eleven-year-long destruction of the predominately Black public school system as it is replaced by a plethora of corporate-envisioned charter schools marks and masks the near complete destruction of a neighborhood support base for Black cultural production.

The neighborhood schools offered more than simple opportunities to pass on cultural skills to Black and minority youth; those neighborhood schools also offered employment opportunities for many of the major cultural movers and shakers. Often, that employment was in a noncultural sphere of activity, such as teacher assistants, sports coaches, even kitchen and janitorial work, but these tasks enabled cultural workers to financially support their private cultural production. That support network has been shredded.

And then there is the logistical hurdle that now exists as students are bussed miles away from where they live. After-school activities are no longer easy to coordinate, and often the students with the greatest needs or those who could better benefit from school programs are hampered in their participation by lack of transportation. They cannot afford to miss their bus.

These and other not-so-obvious factors are usually not noted when we analyze cultural production, but they are significant impediments and must be dealt with in order to continue to effectuate first-class cultural production on the Black-hand side. Obviously, the particulars of this analysis need further discussion, but there is one other not-so-obvious factor that must be appreciated if we are to understand Black cultural development in New Orleans.

Black cultural development was not simply a case of racial segregation. We were not doing the same thing as the main-

stream but just focused in our own racially defined communities. Black cultural production has its own standards as well as its own community. All of the expressions of Black cultural development that are considered significant within the Black community were alternatives to, rather than variations of, mainstream cultural activities and in a number of cases were actually oppositional to mainstream cultural activity. If one had to choose between catching Tootie Montana on Mardi Gras Day versus going on St. Charles Avenue to see the Rex parade, that really was no contest. Or like we used to say, Rex didn't sew his own suit, and old boy sure couldn't sing and dance like our big chief with his golden crown.

A contextual note. Black cultural organizations and formations had an oppositional core to them precisely because the social environment within which they were created had to, at minimum, include a level of militant self-defense against the Ku Klux Klan, police, and other political terrorism that continues to this day to bedevil the Black community. We were not simply combating mainstream apathy toward and ignorance of us. From day one, our culture had to fight the malevolence of the mainstream that actively exploited and oppressed us from slavery times to the present.

The overpriced materials we used for whatever was our cultural production were dearly purchased. Often our cultural activities were extralegal, if not outright deemed illegal by the mainstream. In case one thinks this an exaggeration, consider the current so-called noise abatement ordinances and the costly parade permits that shut down impromptu Second Lines and have even led to musicians being arrested and jailed for parading in the streets without costly city government permits and sanctions.

Without even having to say it directly in lyrics, every note of some Second Lines is a "fuck you" shouted to mainstream propriety, rules, and regulations. That is the secret sauce in Black cultural production: it may seem like we're doing it just for pleasure, but we're serious as a heart attack. Pleasure and heart attacks are clichéd ways to describe our cultural production, but there is a truth at the center of those oft-rendered words.

What would make a day laborer who earns less than $28,000 annually spend $7,848.56 to create a suit he is going to wear twice (Mardi Gras Day and St. Joseph's Night—or maybe three times if he chooses to come out on Super Sunday)? Is he stupid to spend that much money on shoes and feathers when he doesn't even own a car and is renting the house he lives in?

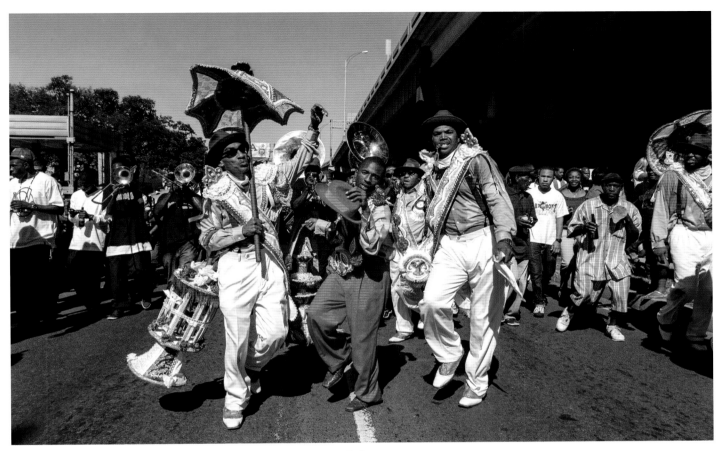

Sudan
October 2, 2011

The answer is both simple and serious: our culture is not just a representation of the artistic best of us; it is also a statement of our will and determination to artfully express our humanness. Regardless of what others think of us or try to do and not do to us, we will embrace and celebrate our own invaluable and essential human beauty and goodness. Our cultural existence is a positive statement, or, as community members exclaim when they give a big thumbs-up to a particular expression: "They was some pretty, yeah." To which the only sensible reply is a note of agreement with the community assessment: "Yeah, you right." You right, they was pretty, and you right, they was right to be pretty. In fact, it is essential that we produce our culture regardless of the cost, regardless of what others think, regardless of whether anybody else cares or witnesses.

Rain or shine, the imperative is to get out in the streets and do what we wanna. Our culture is a declaration of independence, of life, of humanity. An expression of our freedom to be we. Whoever we are, wherever we are, howsoever we choose to be "we." Yeah, we right!

The kings, the chieftains nobly sat: resplendently robed in colorful Kente, surrounded by an entourage of attendants and kin, attentive to every royal wish, desire, gesture, need. Supplicants respectfully bowed, casual conversations were suspended until well past regal earshot. They had a court of musicians with magnificent instruments: long, intricately carved drums; horns of various kinds, both natural and man-made; a choir of mellifluous vocalists. And, of course, agile and entrancing dancers. As is their birthright, these people of high birth sported metallic accoutrements fashioned from the finest of Ghanaian gold—lit-

erally, from the glitter dust on the cheeks of women, to nuggets the size of a baby's fist on the wrists of the wise ones.

They had arrived in a solemn procession carried in on palanquins, boat-like vessels shaped liked small canoes. The entire circumference of the massive stadium was rimmed by their majestic assemblages. I did not know the languages nor the specifics of these traditions, but even an untrained ear or an untutored eye could easily recognize that this was a presentation far beyond ordinary.

And then at the end, there was this joyous din originating from an impromptu, ragtag ensemble who were strutting like they were the highest of the high. Rather than drums, most of them had boxes and commercial containers now doubling as instruments to beat on. Sort of like a cross between an African cake-walk and a Ewe wobble working their thing while sporting their finest "rags"—literally, to use an Afro-American colloquialism, their "glad rags."

As I sat in the bleachers in some stadium in Cape Coast, Ghana, I immediately recognized myself, or, more precisely, recognized a component of my own cultural identity.

The way they danced and drummed, sang and shouted, bringing up the rear in an exuberant procession that proclaimed not their wealth but their vitality. This potpourri may have been impoverished materially, but it was spiritually and culturally expressive of an artistic, irrepressible, and hence, inspiring and invigorating lifestyle.

If you practice in the privacy of your bedroom but are restrained on the street as the parade passes by, you are not a second-liner. You may secretly love it and harbor a deep desire to be part of it, but you can't be what you don't do. Yes, some of us are observers rather than participants, and yes, there is an undeniable value in culturally relevant study and analysis, but the being and doing is the critical element—*the sine qua non.*

We can't all dance like Tee-Boy. Man, he could kick it up. He had been in St. Aug's Marching 100 band and had been trained to raise his legs high, his upper thigh parallel to the ground. One time he did a circular jig on one leg and then reversed his twirling—360 degrees clockwise and then a full circle back counterclockwise, all the time hopping to the beat of the music, his left leg steady-stayed high.

Or maybe we didn't have as much rump to bump as did Sister Vee, who could make her butt cheeks twine in time to the beat—right left, left right—enough to make a drummer throw

down his drumsticks. And she was on the usher board down to the church. But on this particular Sunday she was rocking a siren-red cotton dress and waving an oversized, rose-colored bandana, switching it like a metronome behind her pulsating behind. Oh, my Lord, what she want to do that for?

Seem like everybody out there had a little something, something they did to distinguish themselves. Even Old Broke Joe, who musta been ninety-some years old, leaned on his cane and did some kind of movements with his head like as if he was a super-hip pigeon or something; wasn't nothing else moving, just his head twirling atop his neck, in a herky-jerky, pecking motion, but on the beat. Right. On. The. Beat!

I started laughing, and this lady saw me looking on and said to her little girl, who look like she was maybe six years-old: "Go on, second-line." And you know that little girl dropped down in a quick squat, put her hands on her hips, jumped up, did some kind of hopscotch motion, crossing and uncrossing her legs, twirled, hippity-hopped for about half a minute, her two long braids with green-balled barrettes flying around her head, and then she leaned back, her lithe tan arms folded cross her chest, froze in that pose for five or six beats, and then, with her chin jutting out at a defiant angle, looked up sideways at her mama, not to ask for approval or praise, but as if she was some kind of goddamn exclamation mark when you the onliest one in the class what scored an A-100 on the final algebra exam. Got all them hard-ass equations right. Except this girl had just finished doing a nasty lil' juke-step like it wasn't nothing. If she could do math like she could dance, you could have been an astronaut and she would of guided your rocket ship to the moon and back.

Everywhere you looked, everybody was doing something with their body to let you know that they knew how to celebrate life and how to inspire any onlooker to want to celebrate too. Well, go head on with your bad self. Well. Well. There was no limit to the variations. No limit to the emotional joy their movements evoked in every onlooker. These revelers, your people, made you feel glad to be alive regardless of how well you were: physically, spiritually, intellectually, financially, or whatever. In each and every which way, they made you feel good.

The celebratory movements of your people made you thankful to be alive even if you couldn't expertly dance such-a-much like some of them seem to so effortlessly do. Didn't matter. Whatever you could do, if it was no more than admire, no more than smile, throw your hand up over your wide-open

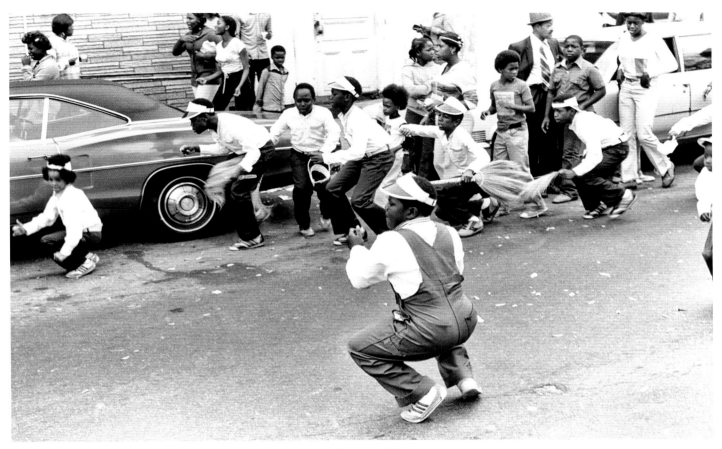

Tambourine and Fan
circa 1971

mouth, and shake your head in awesome wonder as you witnessed the vibrancy of this gathering of the saints—and that's who they were: saints. The holy ones. The elegant celebrants of sweet life.

This is the best of us. Yes, a handful of us are royalty, and some select few of us even have a healthy portion of gold. But whether prince or pauper, life is always about how you move through the world, dancing to whatever beats energize and motivate you. Regardless of how fast or how strong, how intelligent or how accomplished at this, that or the other, one way or another, we all could celebrate life. Whom-so-ever you were. How-so-ever you stepped. Our music. Our dance. On any given sun day, this was the best of us, of each of us individually, of all of us collectively. And you can't touch that!

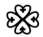

Ladies on the Move

KAREN CELESTAN

Give her of the fruit of her hands; and let her own works praise her in the gates.
—PROVERBS 31:31 (KJV)

Women have been at the vanguard of Social, Aid and Pleasure Clubs (SAPCs) since Africans first arrived on U.S. shores. They were more than "helpmeets" in the culture and not just confined to the stereotypical female roles of cooking, cleaning, minding the children, and loving their men. Lady SAPCers have always been the embodiment of African ritualized movement, color, and style.

Women in the SAPC community have endured denigration from male pastors standing in pulpits throughout New Orleans. Many in the religious sector regard second-lining as unholy and lascivious, and that only females of "low- and ill-repute" dance in the streets. However, such lambasting displays a lack of knowledge about the culture's cultural and historic value. It also speaks directly to the Church and its unspoken directive to control women and female children. It demonstrates a lack of understanding about ancient African movement and dance, and its role in African-American life that has existed for centuries.

Kim Vaz, in *The "Baby Dolls": Breaking the Race and Gender Barriers of the New Orleans Mardi Gras Tradition*, indicates that women who paraded did so to "reveal their sociopolitical struggles to realize their own passions, imaginations, historic understandings, and *joie de vivre*" (2013, 10). Vaz indicated that women

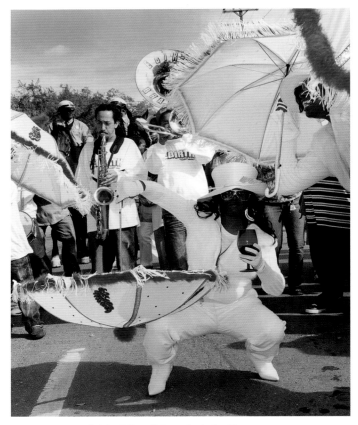

Original New Orleans Lady Buckjumpers
November 29, 2009

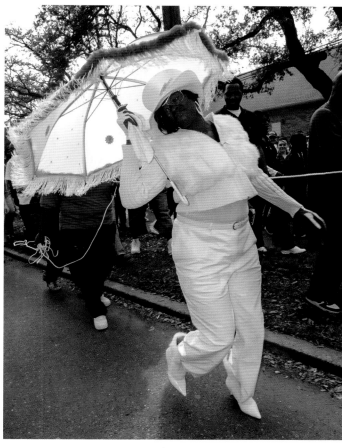

Linda Rainey

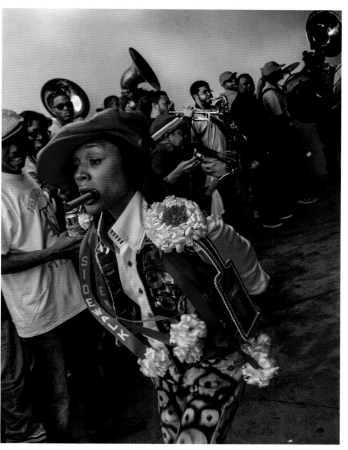

Shanta Selvent, Sidewalk Steppers
February 1, 2015

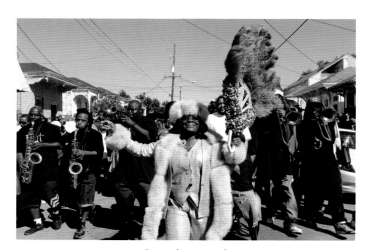

December 2, 2008

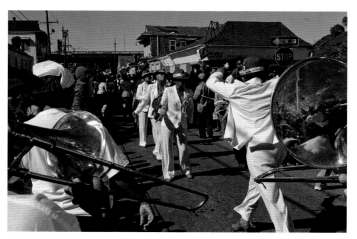

Lady Sudan
November 9, 2008

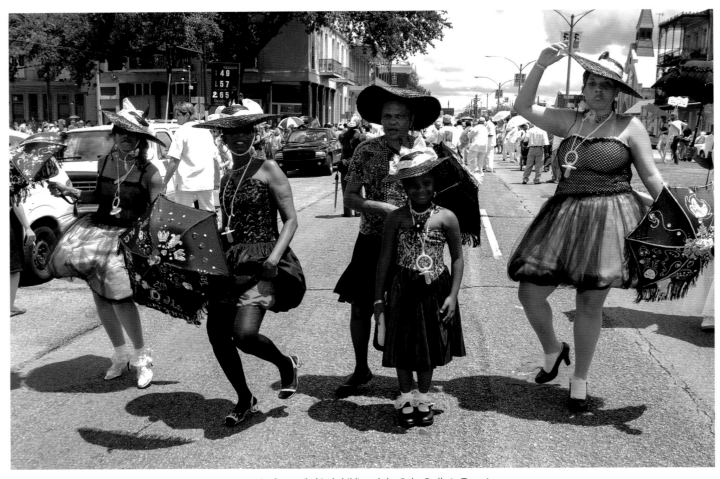

Lois Andrews *(behind child)* and the Baby Dolls in Tremé
August 6, 2006

in the culture would be "'walking raddy' (a kind of strut that would end with the steps needed to 'shake on down')" (2013, 14).

Dancing, with its attendant lively music, is a life force that is a parallel to fertility and vibrancy. It is a praise to God for life, thankfulness for living, and a homage to ancestors. Joy is a recognized part of the Bible and is mentioned 165 times in the King James Version. Spirit, in this context, is devotion and honoring God with *ibada* or *kuabudu,* Swahili for "worship."

The hallmarks and tenets of Christian life as dictated by religious leaders believe that a good, "virtuous" woman would not partake in such barroom behavior lest she "shame" her man and children. Further, dance in the African tradition by females tended to arouse men because of bouncing breasts and flailing limbs, so it was deemed taboo. This led to the belief that a Second Line was "no place for a decent woman." Of course, African-American women ignored such dictates in this and every other aspect of life, living in the thought that "just because you believe that about me doesn't make it so" (a quote often attributed to the late author Maya Angelou).

Women in the SAPC culture enjoy displaying their independence, freedom, creativity, and the complete *élan* of their African-American lives.

According to Vaz, the early incarnations of the "Baby Doll" culture in the 1930s and 1940s "actively participated in the entrepreneurial activity of sponsoring dances with live Jazz bands

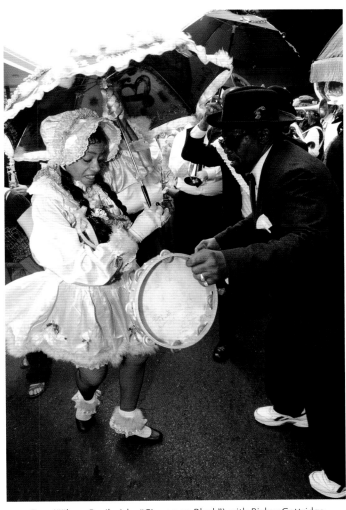

Resa Wilson-Bazile (aka "Cinnamon Black") with Rickey Gettridge
Baby Dolls parade
February 28, 2009

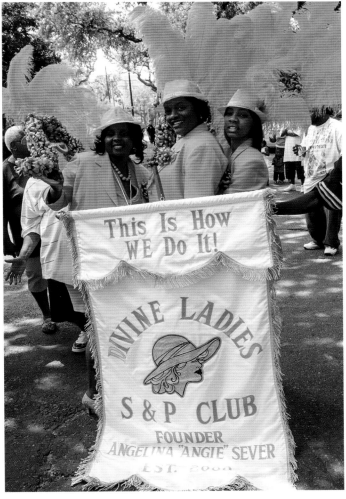

Divine Ladies
May 20, 2007

in which some women dressed in a variety of Baby Doll attire. . . .
They were simultaneously 'women who danced the jazz,'
'women of the jazz,' and jazz entrepreneurs" (2013, 22). This
tradition, in time, led to current female Social, Aid and Pleasure
Clubs and marching clubs.

Second Lines led by female SAPCs, in an ironic fashion,
follow the model of women's religious organizations or auxilia-
ries in the Black Baptist model—complete with "Sunday-best"
outfits and church-style banners proclaiming their mission and
founding year.

Female SAPCs served as a vehicle of empowerment and

sisterhood, especially for women who may have been excluded
from upper-middle-class social or collegiate service and social
organizations such as Black Greek sororities, Jack and Jill, or
the Links. Although Second Lines have been associated with
lower-class people, it is even more ironic that the Black Greek
sororities (associated with education and, therefore, a higher
class) and their tradition of ritualized "stepping" has a direct
connection to African dance movement that is at the center of
the Second Line.

These SAPCs are rooted in feminine strength and expres-
sion—both for individuals and as a group—distinct and apart

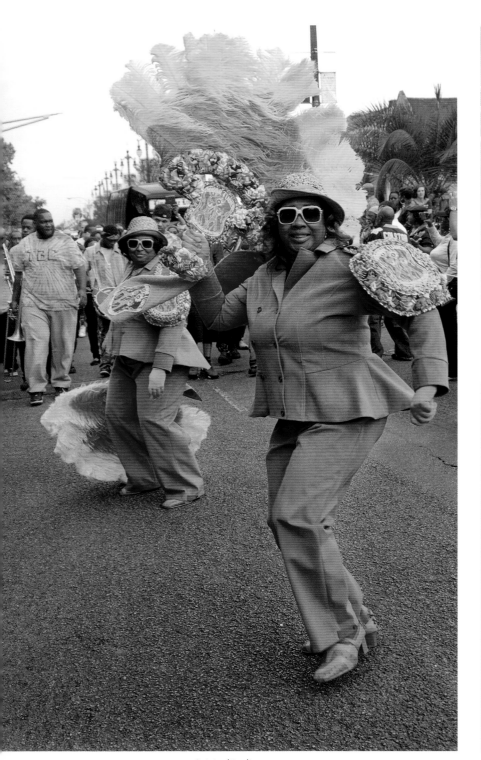

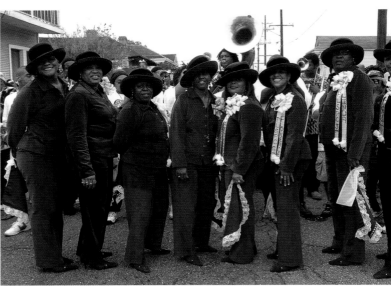

Popular Ladies
Left to right: Jill Small, Jackie Muse, Aquilla Journee, Cynthia Foots, unidentified, Flore
Franklin, Linda Ladmirault, Lynette Ladmirault
October 26, 2003

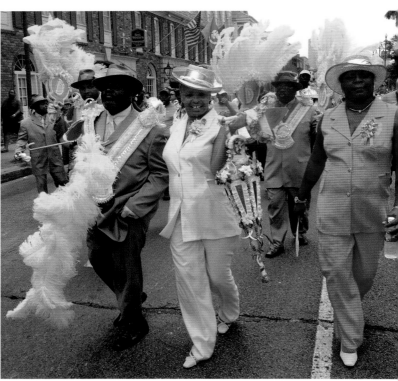

Original Ladies
October 27, 2013

Popular Ladies
August 8, 2004

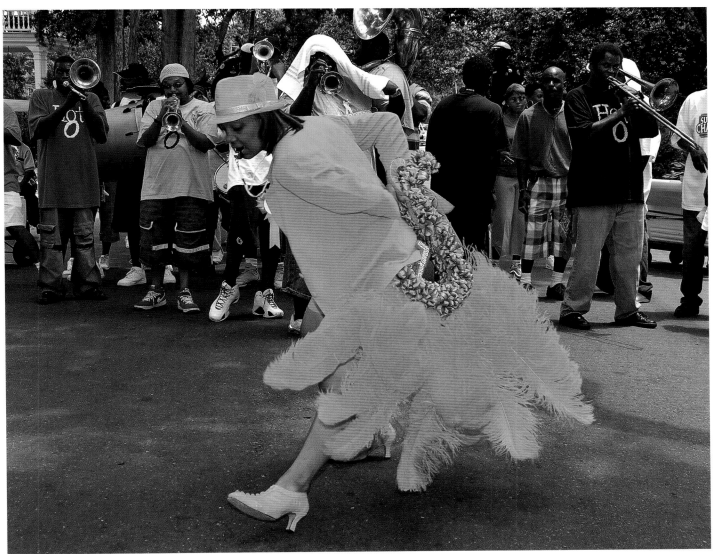

Iesha Palmer, Divine Ladies
May 20, 2007

from their male counterparts. The female clubs are proud of their position as the antithesis of Caucasian women and stand in the full being of their Africanness. Full lips, full hips—all-out African American in style, stature, and bearing.

REFERENCE

Vaz, Kim Marie. 2013. *The "Baby Dolls": Breaking the Race and Gender Barriers of the New Orleans Mardi Gras Tradition*. Baton Rouge: Louisiana State University Press.

Interview with Barbara Lacen Keller

Founder, Lady Money Wasters SAPC; member, Lady Jolly Bunch; former member,
Original New Orleans Lady Buckjumpers SAPC

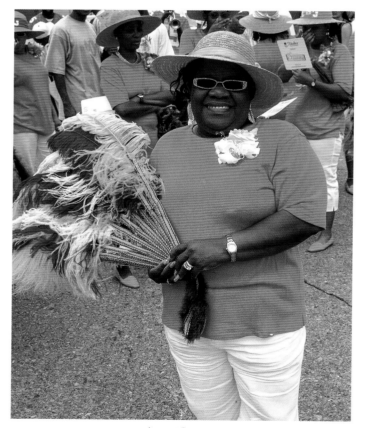

August 8, 2004

Valentine Pierce interviewed Barbara Lacen Keller on November 21, 2011.

Valentine Pierce: Which SAPC counts you as a member and for how long?

Barbara Lacen Keller: I have been a member of three SAPCs. I am a member of the Lady Jolly Bunch, one of the founders of the Lady Money Wasters, and I was a member of the original New Orleans Lady Buckjumpers.

VP: How long?

BLK: Lady Jolly Bunch, about ten years. The Lady Money Wasters, I was a member for about eight to ten years. And the Original New Orleans Lady Buckjumpers, I was a member for twenty years.

VP: Were you a member [of these clubs] at the same time?

BLK: No, I wasn't. The Jolly Bunch, the club is older than I was. At the time I was the youngest member in the club. I was in the club in the 1960s. The Lady Money Wasters, I was one of the founders and we organized that club in 1978, '79. Then the Buckjumpers was organized in 1984.

VP: What is distinctive about your SAPC?

BLK: Specifically the Lady Jolly Bunch was one of the clubs that was a spin-off from the men Jolly Bunch. It was a club that was created in downtown New Orleans around Gravier and

Perdido. At that time, it was not appropriate for women to be, as we called it, on the street. To parade on the street. Originally in SAPC when ladies participated, they participated riding on the back of cars. In big, pretty dresses. Beautiful, wonderful dresses. They were dressed very elaborate with nice long gloves. That was something very distinct with the Lady Jolly Bunch.

The Money Wasters, they were created [as] a spin-off from the men Money Wasters. One uniqueness of that was the Lady Money Wasters, that was a club that ladies participated and also what we did downtown. We brought horses to the parade. Some of us were on horseback, and some of us were on the ground. With the Original New Orleans Lady Buckjumpers I think it really changed the tone of women second-lining with the elaborate clothes that they wore — such as mink and just amazing things. I used to often say that we were our worst enemies because every year we did something we had to do better, and it brought such a taste to the street, and it became so elaborate that it took, for each one of the parades it took at least $2,500 or more. And also the uniqueness of the Original New Orleans Lady Buckjumpers, it was the only female Second Line club to parade consistently for twenty-seven years. They have paraded consistently twenty-seven years from the day they were organized until today. They are the only club that holds that title.

VP: You said the women rode on the back of vehicles all dressed up. What made them want to break out?

BLK: I think what happened and times began to change and women—because at one time you gotta understand the SAPC, at one time women were more of a support to the men. They were the leaders per se of the group. And certain things that they do they had to do behind men. What I mean, behind, I don't men parade behind the— I mean the men were at the forefront, and anything that you did you had to remember that you were a lady, and at one time they were more supportive of the men, assisting them. That went back as far as benevolent societies and churches or wherever where the women knew their role.

What happened is that when they allowed them to parade, they said you can, but you must ride. It wasn't appropriate for you to be on the street shaking your behind. What happened as time began to change and things changed.

Women became more liberated, and women said: "We want to take our rightful places, too. We want to dance. We wanna shake 'em down, too. We wanna roll." And there were some clubs that really— Like the Scene Boosters, they had a women's group called the Fun Lovers. I could be wrong, I stand to be corrected, but I think the Fun Lovers were the first, the Lady Fun Lovers were the first to really hit the street, what I mean, on the ground. See, a lot of times people get a misunderstanding or misinterpretation of Second Line as opposed to benevolence.

There was a women's group called the Lady Zulus. They were not affiliated with the Zulu SAPC. It was more like a benevolence. And they used to start up here, but they wasn't a Second Line club. All SAPC don't Second Line. People need to understand, and I say all the time, one of the reasons we have the problems we have is because people really do not appreciate the culture because they're not really knowledgeable about the culture. All SAPCs do not second- line. Over a period of time as time began to change, things began to change, women decided they wanted to take their rightful place, and they wanted to be on the ground. The men's club embraced them.

And another thing I need to say is the Lady Money Wasters, I have to check to make sure, but I think they were the first club to come under their own banner. What I mean is, they paraded by themselves. They didn't parade with the men Money Wasters. When they have their first parade they had their own banner. A lot of the women clubs would come under the banner of the men. Like the Lady Buckjumpers and men Buckjumpers, all them came together. So what happened as time passed, more women clubs organized, and they were basically bringing their own parade. When it first started, any women that paraded did it with a men's group. I think the Lady Money Wasters were the first, if I'm not mistaken.

VP: Is there any other history you would like to add, about the club?

BLK: No. Women, like I said, have played a very vital role in the culture. Be it from the benevolent society all the way to where it is now. And, it's no more than fair to say that some groups have never had women. Like, for instance, the Young Men Olympian's benevolent society. It is not a Social, Aid

and Pleasure Club. It is the oldest benevolent society, and it does not have women. And they have never had a women's group to come with them. They may invite candidates or something to participate in their parade, but they have never had women to parade with them. Also what they have done, they have allowed other groups to come with them like The Fearless Five, you know, different groups to come with them.

VP: What is the specific difference between an SAPC and a benevolent society?

BLK: The primary difference is that the benevolent society— As you know, the Second Line is different because benevolence started through the church, basically taking care of their own. With the benevolent society of the church, you would put so much into a fund and that would help in your burial or your sickness. The Young Olympians, they had the cemetery. The also had a plot, and when members died they had the choice to be buried over there. Social, Aid and Pleasure Clubs and Second Lines don't have that. Benevolence is basically taking care of their own. Most Social, Aid and Pleasure Clubs and the Second Line clubs as we know it is a self-sufficient culture. It raises its own money. After Katrina, they were able to get some funding where some clubs were able to get some assistance, but basically it's self-sufficient. It's a strong network where groups support each other. They have fund-raisers or whatever, and the other groups will support that.

VP: Why did you choose the clubs that you were in, or did they choose you?

BLK: The first club, the Jolly Bunch, was a tradition in our family. My mother, my aunts, and my cousins were members, and I joined to be like family. But the Lady Money Wasters, I was one of the founders and myself and Effie Andrews (she is no longer with us), Ann Mays, Lois Nelson Andrews—that's Trombone Shorty's mama and James Andrews' mama. We are the founders of the Lady Money Wasters because we wanted to have our own group. We started that. And the Buckjumpers, I chose to join the club because I was so impressed with them that I really wanted to be a part, but there was a process. You could be part, but there was a process where you had to apply. And you had to be interviewed. They had a rule, if one member said no, you couldn't get in. It was a process where you had to fill out an application, you had to apply, and you had to have an interview and if they accepted you.

VP: Is it still that way?

BLK: I think it is. Some things never change. I think it still is that way.

VP: Did you have any particular duties?

BLK: On the Lady Jolly Bunch I think I served as a secretary, and [with] the Lady Money Wasters I was business manager, and in the Buckjumpers I served as vice president, secretary, and public relations. With public relations I was able to create a lot of things, and I'm very appreciative that the members had a vision and wanted to do it. We started a back-to-school picnic, and we were the first of the clubs, the Second Line clubs, to do that. We gave school supplies. It was something that no club had done before. All in all, the things that we did, we did a lot of things that the benevolence would do. Just so much.

VP: What was the usual parade route?

BLK: Well, you know, at one time in the days of old there was no such thing as route. You parade from sunup to sundown. We parade uptown, downtown. Sunup to sundown. But after a period of time the city decided that it needed to be more structured, and if you wanted a permit, you had to have a route. Some clubs just had an uptown route; some clubs just had a downtown route. That's how it became this up- and downtown clubs. Everybody knows the Young Men Olympians, an uptown club. Everybody knows they always on this side of Canal Street. There are some clubs that start downtown and come uptown. Some clubs—not too many clubs—start uptown and go downtown. So, the route is basically dependent on the members of the group. They get together and they create the route, and the route is in the neighborhood where the club organized.

VP: What other accessories did you have to have for a parade?

BLK: Traditionally all you had to have for a parade is a streamer, a fan, and a band. That's all you needed. As time passed, it became more elaborate, and then it became very, very competitive. They were outdoing each other, and that's where the money came in, because the more they spend, the next club's going to spend more. So much so that, you know those championship belts that you see the wrestlers and the boxers have? There a belt like that and the clubs, the ladies don't do it, but the men do it. Like this club called the Revolution.

I participated with them one year, and they had this belt

in the club. The belt goes around the different clubs. Who's the baddest; who's the prettiest. There are some clubs that are very traditional and modest, but there are some that very nontraditional, elaborate.

VP: If you had to describe a Second Line or second-lining to someone outside New Orleans, what would you say?

BLK: A moving party. That's what it is. A Second Line parade is a party that moves, and every move it picks up people along the way 'cause at a party you eat, dance, and drink. And that's what you do at a Second Line. You eat, dance, and drink and moving. When I talk and give lectures, because I consider myself a keeper of the culture, I do say that. It's a moving party.

VP: You were the first person in your family to be a member.

BLK: My mother, my aunt, my cousins, traditionally. Not all of my cousins. My mother and three of her sisters. One of her sisters' daughter and me.

VP: When you were out second-lining, how did you feel?

BLK: It's a feeling that you can't describe it because what it does, it has such a strong network, it has such a strong bond, that a lot of people do not appreciate the culture because they are not knowledgeable of the culture. Second-lining is one of the most original cultures in the world, let alone in the city.

And what it does, what it does for me, it's a part of me. It gives me an opportunity to participate in helping to keep the culture that I truly appreciate. And feel like it's giving to my people, sharing the culture. I feel when I participated because there were others on the ground for a while, then after a while I changed and went back on the car, 'cause like I told you, most time we had to be on the car. But I was on the ground. I was dancing and whatever, but after a while I felt that I didn't want to do that anymore. I felt—and I'll never forget when I told them—I said I don't want to be on the ground anymore; I want to ride, and I remember one lady said, "Well, you know, if you get on the car you can't get off the car. Once you get on the car you gotta stay." And I said that's fine, 'cause you know what? I earned my place on the ground. I have no problem getting on the car, as long as I can participate. When I participated I felt that I was contributing to the culture and also giving myself back to my community. That's how I felt.

VP: Is there a particular song or type of music that makes you want to dance full out or go buck wild?

BLK: Yes. Yes. Yes. There's a song called, by Rebirth called— What's the name of that song, something about take the happiness out or something. I can't think of the name of it. When I hear that song, that song mesmerize[s] me. To the point where I can dance until I can't dance anymore. Then there is another song by Rebirth called "Who Dat Call the Police." And it's not that the song— It's the rhythm and rhyme; it's the movement; it's the flavor; it's the pull of it that just goes in me and moves me and makes me move and it just makes me feel good. [*laughs*] Yes. Yes. Yes.

VP: What is your favorite moment on parade day? Is it at the start, when you're coming out?

BLK: Part of the difference is the coming out. Is it a barroom or a hall or a house or whatever? You're coming out. You're nice. You're fresh and clean. Everybody's participating. The band starts up. People just cheering for you. That is the most inspiring moment. Looking at my people applauding. Make me know that my people have accepted us, accepted me, and they're saying to me, "Go 'head, baby. You look good. Come on." That is the most inspiring moment for me.

VP: Is there a particular parade year that stands out for you?

BLK: One year we celebrated our Second Line fifteenth- or twentieth-year anniversary. We were at Washington and Broad, and the band started and we just disappeared. We just fell out the parade and jumped in these limousines and we left. And the band kept the parade going. We went and we changed clothes, and we put on these beautiful royal-blue suits with royal-blue minks. It was beautiful. We got back in the limousines, and we met the parade coming up. I'm not gonna tell you some of the things that was said. We blew the people's minds.

Another time, a club, the Revolution, the guy, Wardell Lewis Sr., he is one of the most artistic designers and creators. This man created me a costume. You thought that I was in Endymion. That's how beautiful it was. Even now, and this was years ago, people tell me right now, that was the prettiest they'd ever seen in a Second Line. I want to be the very, very best for the culture of our people. Those were two of the finest moments ever, and I will always remember them.

VP: Are you aware that some people from outside the culture think that second-lining is a waste of time and money?

BLK: Yes, I do.

VP: How do you feel about that?

BLK: I feel sad for them because I think what they should do, again and I say it over and over. I think the reason why people do not have an appreciation for it [is] because they are not knowledgeable of it. They need to become knowledgeable. Luther Gray [leader of Bamboula 2000] and Carol Bebelle [director of Ashé Cultural Center] and all of them, for years I've been talking to them, and I've been talking to other people. It is very important. We need to create curriculum for our school system. The culture should be part of the curriculum. I think it would afford the opportunity of children [to] become more knowledgeable. Because what's happening, at one time we had a lot of children in the culture. It was customary. A lot of clubs had men positions, women positions, and children positions. And that's kind of obsolete.

I'm sixty-five. I really don't know what's going to happen. But what I think needs to happen is that if we create a curriculum and our kids could really be knowledgeable they would have a better appreciation and maybe they'd want to participate. Because of money, commercial and other selfish reasons, a lot of people think that the people who participate in Second Line are a certain class of people, which is further than the truth. Because people who participate in Second Lines and Social, Aid and Pleasure clubs are from all walks of life. Like myself. There are saved [religious] people, educated people, hardworking people, families. A lot of people really think—because at one time a lot of folks thought that they were—they used to define it as a backstreet culture.

And I need to be honest with you. Marc Morial, Mayor Marc Morial, he did more for the culture than any mayor I have ever known. Ray Nagin came, and he kept that drive going. And I'm glad, in spite of what they say about Mitch [Landrieu], Mitch is keeping it going. But Marc Morial really started to bring the culture to the forefront to get people to understand.

Because a lot of people, especially white folks, they make it to their convenience for them to benefit from the culture. You may not believe it, the sad thing is there are people, our people, African American people that really see that it's good. Bill Rouselle had a show, *Sunday Morning Journal,* I just start volunteering, and I would give a parade update. I would tell him what club it is, what's the name of the club, where the route is going to be, what time it starts, for two reasons: (1) for those who wanted to catch it; (2) for those who wanted to avoid it. Those people that think we have done nothing, they really need to open their minds and find out more about it.

Also, [I'm] founder of the New Orleans SAPC Task Force, and that task force was created because conditions at Jazz Fest were deplorable, and I had some concerns with that. I had some concerns with ways that I thought that the City of New Orleans was not treating the culture fairly when it came to routing and stuff of that nature.

There was some things, and I'm going to say it, after Katrina there were some things that I really felt, specifically Caucasians, had come in and thought that they had more input and more control, and I really felt that if we afforded them even the pleasure to participate in our culture. Some folks thought different than I did. You can't rewrite history. You can't go back and scratch that out and put that there. It is what it is. I am the founder.

Symbols and Accessories

KAREN CELESTAN

A host of Second Line participants and aficionados have looked at the accoutrements of SAPCers at parades, believing that the fans, baskets, cigars, flags, and sashes are merely part of the whole ritual of stylin' and profilin'. Many assume that these accessories reflect the tendency of Black folks to be colorful and sassy, to stand out in a crowd and strut like peacocks or peahens.

Every accessory has a purpose and a meaning. It isn't about "matching" or being "seen," although SAPCs are diligent about color-coordinating for their annual parade. This custom is rooted in African tribal rituals that are often displays of prosperity and wealth. Again, this unconscious/conscious memory has been carried down for generations, even though prevailing wisdom and dictates have been weighted heavily toward Black people's assimilation and integration into the body politic.

How does a SAPCer manage to get the bowler to pop atop his head in such a precise manner? How does the umbrella stand on its curved handle for the exact number of seconds necessary for a member of the Black Men of Labor to deliver his signature move to the delight of the assembly? How do female SAPCers stroll through the parade in furs and Sunday-best hats and keep their style intact?

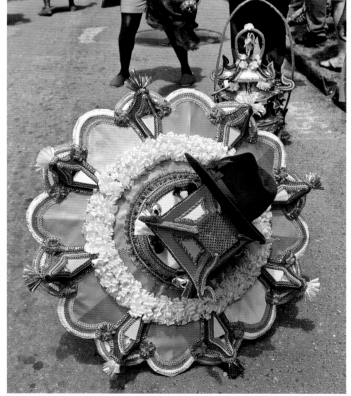

Second Line artistry
August 5, 2012

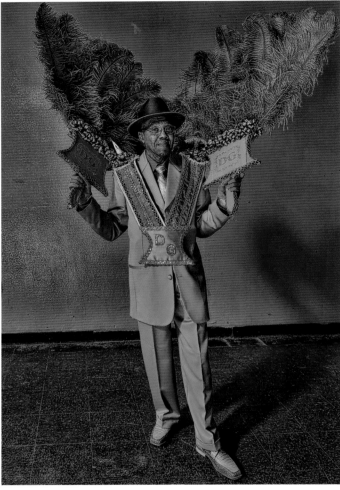

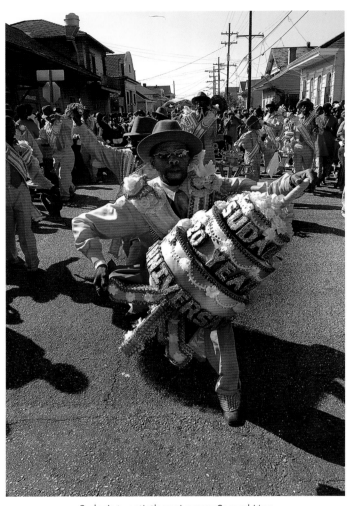

Richard Williams, Dumaine Street Gang
December 12, 2008

Sudan's twentieth-anniversary Second Line
September 9, 2003

The symbolism of a tribal-based movement that is a SAPC and its annual Second Line is rooted in total resistance to the European status quo that has defined America. SAPCers live and thrive in this fashion: We gather like we want, we dress like we want, we dance like we want, we parade where we want—period, *exclamation point.*

SAPC Accessories as Art, or Is It Vice Versa?

History and Overview from an Artist's Perspective

CHARLES E. SILER

Second-lining is a tradition associated with African cultural practices in this most African city in the United States. The persistence of this fascinating practice has drawn the attention of many who have studied and speculated on those who are drawn to this mobile art form.

The handkerchief-waving part of the dance, I discovered, was a link to the period of African-American enslavement and, in New Orleans, was tied to Congo Square. John Blassingame (*Black New Orleans, 1860–1880*) detailed a dance called the *carabine,* where the woman was twirled by her partner as she waved a handkerchief above her head. It is a fixture, along with the umbrella and decorated banners or flags, in today's Second Line.

The African processional tradition is lost on the continent somewhere in the mists of time. It begins with Olduvai Gorge as a starting point (the home of Lucy/Dinquinesh) on the continent now known as Africa and was spread to other parts of the world. The African processionals have been a part of ceremonial activities, celebratory and funereal. In the Western Hemisphere, wherever there are people of more recent African descent (since the advent of the Trans-Atlantic Slave Trade), a processional with a distinct West African flavor has existed. New Orleans, often called the Queen City of the Caribbean, has its own special characteristics, though it mirrors similar

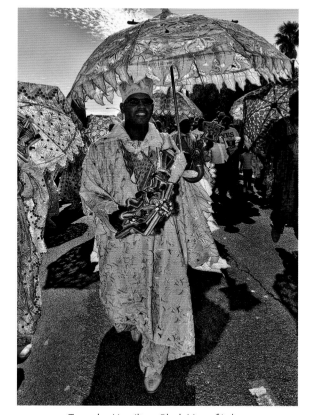

Townsley Hamilton, Black Men of Labor
October 25, 2008

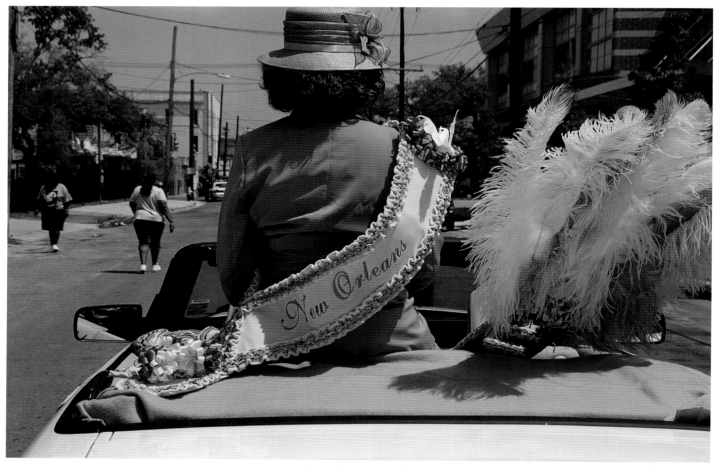

Bayou Steppers parade
April 6, 2008

practices on the South American continent and throughout the islands of the Caribbean where African people were deposited after Columbus's supposed "discovery" of a new land in his search for treasure and a route to the Indies.

There are iconic characteristics that define the African aspects of these cultural practices that serve as markers—the umbrellas, banners, flags, and beadwork styles that represent a continuation of practices that reflect particular regions of West Africa. Second Line practitioners travel along a path that leads them further into history for subject matter to be depicted in their suits. One has to understand the culture of New Orleans in order to fathom the impact of African Americans on a tradi-

tion-filled processional with its rhythms, colors, and dress style that came straight out of Africa and morphed into its present from the mid-nineteenth century.

My affinity with the Second Line traditions of Black New Orleans lies in the fact that I am an artist and attracted to its color and pageantry. The "well-making" that is necessary for creation to be deemed art is obvious in so many ways throughout the retentive African traditions that persist in the city. This is evident in the design of suits, umbrellas, flags, and banners, formal and informal outfits worn during the Second Line processionals. It is also evident in the creatively improvised dances and the music played by the bands and drummers. Improvisa-

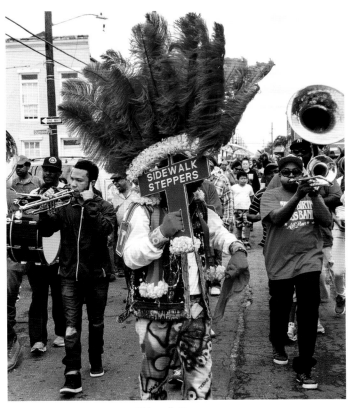

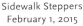
Sidewalk Steppers
February 1, 2015

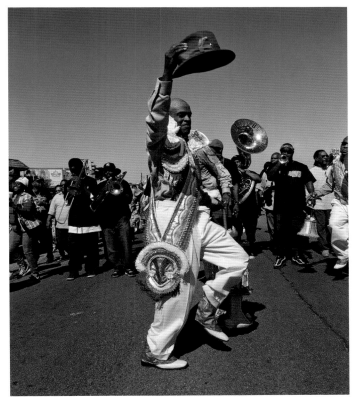
Family Ties
October 21, 2011

tion reigns, and it underscores that these are not newborn to this hemisphere but old, long-lasting features of the extirpated culture that fed the development of America.

Color has always been important in the African tradition. For example, the color yellow may represent, if pale, desolation, desert, jaundice, weakness, and illness. On the other hand, use of the color in its bold hues may represent vibrancy, and in its richest incarnation—gold—that signifies wealth. Vivid colors provide a considerable amount of information about the psychology of rebellion in the American African community. Red and black in certain African belief systems represent Shango, the warrior God.

African religions are still practiced in the region, and the use of color may represent or may have represented a particular religious following or even a singular *loa*. Rada and Petro voo-doo are two forms that are practiced through the Caribbean and parts of South America. Rada, the older form, was practiced before the infusion of Haitians following the revolution that freed the island nation from France. Wearing white is associated with Rada. Petro is younger and more closely associated with Haiti, and its color is red.

So, the colors could be a part of the unconscious memory that comes through cultural DNA and is enhanced by the dominant spirit of a people. Pastels, though considered soft, are in use throughout the African Diaspora *vividly*, with designs that incorporate beadwork, stones, sequins, and other decorative items. Further, color is used to illustrate unity. The organization and artistry that goes into the creation of the suits and outfits worn by the Social, Aid and Pleasure Clubs represent the survival of cultural continuations that have defied oppression.

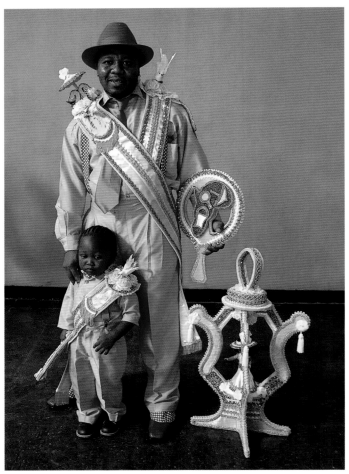

Sudan member and son
November 9, 2003

August 7, 2005

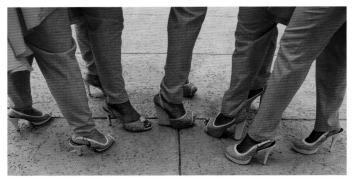

shoes, Original Ladies
October 27, 2013

Through the use of pure colors and their admixtures, people of African descent strive for recognition of their independence and, yes, for freedom from the travails of a system of enslavement and oppression that continues to exist more than a century beyond enslavement.

Rag pickers were once the purveyors of the fabrics and materials that went into the creation of early suits. The neighborhoods of American Africans were, because of cultural oppression, a thriving area with tailors, shoemakers, and dry good stores. I don't know who came up with the idea of everyone wearing a matching suit (and those "gators"), but back in the

day, it served the community because the cash stayed close to the neighborhood.

Competition leads to outrageous creativity, and I suspect that the need to be, as the Mardi Gras Indians would say, "the prettiest" had a lot to do with the development of styles and use of color. Colors became important because of the way hues remain in the memory. The grace of the naïve that goes into the creation of work by folk artists guarantees that the outcome will be daring and that it will represent the prevalent feeling of a particular moment in time. It is the visual interpretation of the music that is called Jazz, blues, or rhythm and blues be-

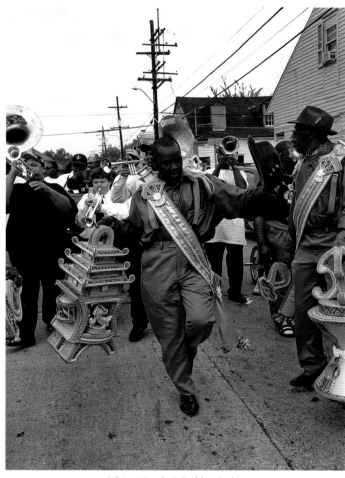

Adrian "Teedie" Gaddis, Sudan
November 11, 2007

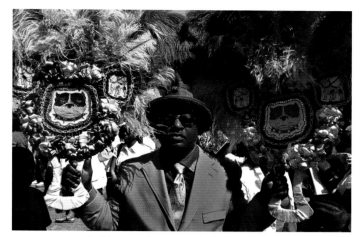

Bulldog motif, Distinguished Gentlemen
September 27, 2008

cause it embodies the spirit of improvisation that is representative of the African cultural heritage.

This is artistic expression and the ability to craft. The umbrella, sashes, flags, and patches are not haphazardly thrown together in a childlike frenzy but are well-planned, carefully designed, and constructed for maximum effect. This is when the artists move beyond the naïve.

When you view a marching club as it moves, the mass of color that is the organization itself represents the spirit of that group in motion. Thirty, fifty, or more people dressed in fuchsia are guaranteed to make you stop and look twice when a march-

ing club is *en passant*. And then there are those handmade alligator shoes. . . .

The modern Second Line showcases the colors of spirit as it relates to the persistence of ancient African religious practices in the Crescent City and throughout the Diaspora.

Each Second Line has a life of its own and a distinct personality. Artists document what is going on around them. Art, according to one of my teachers, sculptor Frank Hayden, is "the well-making of *whatever* you're creating." To that end, I have seen something new every time I've gone to a Second Line.

The art of capturing the essence of a Second Line requires a sensitivity to all of its elements, beginning with the humans who create and wear the suits, and the movement—the dance—that underscores the brilliant coloration and "flash" that comes from the sequins, beads, marabou, bows, toile, and its decorative aspects.

There is also, within this artistry, the ability to express familiarity with the environment and use it as an expression of love. This is what it feels like to grow up in an environment rich in synesthesia, in which the interaction of all the arts is a continuous and effervescent part of life.

Second Line organizations have a stamp that is indelibly New Orleans. Most of the members are working individuals whose incomes range from low to middle class. The suits and outfits worn by members of the Social, Aid and Pleasure Clubs

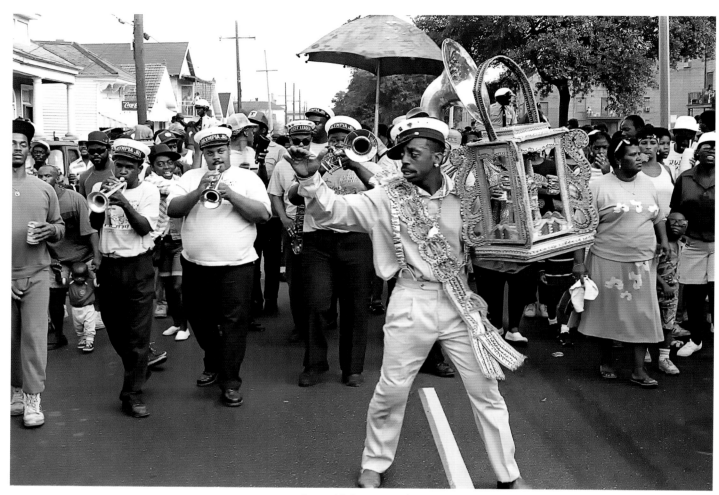

Bernard Robertson, Sudan
July 18, 2008

are tailor-made and display a kaleidoscopic array of color. I was amazed when I discovered that a pair of "gators" (alligator-skin shoes) could cost upward of five hundred dollars and the shoes were hand-made to order—custom fit and hand-dyed.

One can question the why and how, but the end result is part of planned beauty, and the entire organization—flags, umbrellas, banners, outfits, and shoes—is a singular work of art. It is the body corporate that is the art.

The Second Line is an expression of joy and liberation, a freedom dance, an expression of the real soul of a city. It has cousins who can be found wherever African people are represented in the Western Hemisphere. New Orleans, however, represents a unique incarnation that has worldwide influence on the music via its contributions to dance and America's classical music form—Jazz. The spirit of the Second Line, which drives the organizations from their gathering places in an annual presentation, is one that embodies rhythm, color, textures, and movement—all aspects important to art.

Interview with Fred Johnson

Founding member, Black Men of Labor

Valentine Pierce interviewed Fred Johnson on March 6, 2012.

Valentine Pierce: Do you have a Second Line name?

Fred Johnson: Fred. Some people call me Fred. Some people call me Molos, which is my daddy's nickname and my brothers' nicknames. We all are Molos. Two other brothers. Molos. Lenny Molos, Willie Molos, Fred Molos. I have nephews, and they call them Molos.

VP: How long with the Black Men of Labor?

FJ: BMOL, since we started. The inception. This 2012 parade will be eighteen years that we've been parading on the street. Benny Jones, Gregg Stafford, and I started it as a result of burying Danny Barker. Danny Barker passed, and Danny had single-handedly created the Fairview Baptist Church Brass Band—Reverend Darby, 'cross from the St. Bernard Project. He created that band because he thought that through attrition the bands would die. So, he went to the musicians and said, "Look, we need to start teaching the young people the music."

A lot of musicians were not in favor of that because they thought the young guys would take their gigs. So he started the Fairview Baptist Church Brass Band—Leroy Jones, Shannon Powell, Michael White. I mean just a whole group of guys. That band ended up spinning into a bunch of other bands, the Dirty Dozen, so forth, so on. When Danny passed—and he had become very disenchanted with the brass band process, especially with when it got to funerals—he told his wife that he don't want to be buried with a brass band. So, when he passed, everybody was intimidated to say something to her about it because Danny himself had already told Miss Lu he didn't want to have a brass band funeral. They call her Lu for short; her name was Louise. Her music name was Blue Lu Barker.

So anyway, I think I must've got there about an hour after it happened, and Gregg Stafford was sitting on the bumper of a car in the street. I said, "How we doing?" He said, "Bruh, we got a problem because Mr. Barker done already said he didn't want a brass band funeral." Nobody was gonna broach Miss Lu. So about two hours pass, and the press start calling from all over the world because they knew that he was a famous musician and because the funerals that New Orleans has is like nowhere else other than one of the African countries or in one of the islands. By that time, the press start calling and she said, "Okay. Fine. Let's meet tomorrow and discuss this." So we got to her house. Packed the house, and Gregg, who came [became a musician] under Danny Barker, said, "Well, Miss Lu, I'll make certain the musicians come in black and white because the musicians had

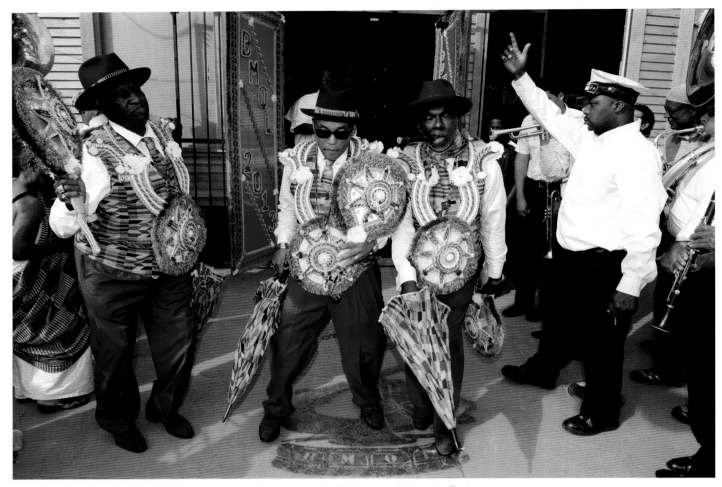

Benny Jones, Fred Johnson, and Gregg Stafford
Co-founders, Black Men of Labor
October 20, 2013

gotten to a point where they would come dressed any kind of way. They were just completely out of uniform.

Gregg was on the right side of the room. I was on the left side of the room. I said, "Well, Miss Lu, I'll make sure we have a group of men dressed in funeral clothes, suit and ties, to marshal the funeral." So she said, "Okay, let's do this." So the funeral came up out of the church over there on—behind the St. Bernard Project, Paris Avenue. There's a Catholic church right there [St. Raymond Catholic Church]. Procession came out that church. It went up Paris Avenue to St. Bernard. Then they pick the whole funeral up. Drove

it to St. Bernard and Claiborne, and they put it back on the ground. The procession proceeded to go up Claiborne to St. Louis Cemetery at St. Louis and Claiborne.

VP: Who picked it up?

FJ: Limousine service, the bus—just picked all the people up. The casket was already in a limousine. It just took the band, all the people who were dirging. Just put everybody in the bus and drove to St. Bernard and Claiborne and put them back on the ground. And then they proceeded up Claiborne. It was for me, one of the most powerful musical experiences surrounding a funeral that I had ever witnessed. They guys

just did a remarkable job for him, know what I mean? So we coming out of the cemetery and the guys said, "Wow! This is powerful; we need to do this again." And I said, "Yeah, but not with a body." So one thing led to another, and we went to, I think, the Tremé Music Hall. We went in the Sixth Ward to the Tremé Music Hall, start having some drinks, and the guys start to talking: "We need to do this. We need to do this. That's the kind of music." And I said, "Let's figure [it] out."

VP: You got the musicians to play the traditional brass band.

FJ: Yeah. Oh, yeah. They couldn't play nothing else for Danny Barker. So, and a lot of people were hungry for it, and when it hit the street like that, guys were like, "Wow! This is what we've been missing." They start asking me because I had a history of coming out—the Bucket Men with Jerome Smith and Rudy Lombard, we had hired all the bands back then. Had about five divisions, and it was very brass band traditional.

So the guys start to say, "Well, Fred, what you think?" I said, "Let's sit down some Monday and have some red beans and rice and kick it around." We met, and I said, "I think the most important thing is to keep the music on the street. Not so much the clothes but the music." So we started with a little group we put together called the Black Men of Labor, and the reason we named it the Black Men of Labor was because all of us were Black men, and we thought that on the whole, Black men got a bad tip about they don't want to do this. They don't want to be responsible. They don't wanna take care their families. They wanna be drug dealers, so forth. No. Not all of us. And there are those of us who take care of everything we need to do, and we still love and appreciate and respect our culture.

So we took that, and the other reason we did the Black Men of Labor, we mimic it behind the longshoremen's parade, Labor Day Parade. They didn't have a brass band, but they had a Labor Day Parade, which was a show of force in the early 1900s of these men who labored, and they would walk from one place to another—hundreds of them. So, I said, "Well, let's take the Labor Day Parade and put a brass band and then we'll do something that everybody's afraid to do or won't do: We'll get some African attire because most of the culture in New Orleans come out of West Africa. Let's

get some African attire, some African fabric, and create something and put it in a parade."

So I was in New York, Rudy Lombard and I was talking, "Say man, go in that store over there. They got some Africans over there, they give you all the fabric you need." So I went in there and struck up a conversation. Guy was able to help me put some stuff together. I brought it back. The guys here liked it. We put the parade on the street eighteen years ago. So every year after that we've continued to fine-tune that process.

About the fifth year we had a celebration at the House of Blues, and we brought in all the musicians that we could think of and gave them an award to say thank you for keeping this music alive and on the street. Shortly after that we said, "What else that we could do?" We then ventured out and created a children's brass band, same way Danny did. We said we didn't need to reinvent the wheel. Just add another spoke. So we brought the children's brass band into the fold.

Sunpie Barnes, who's a local musician, he's in the group, so every Saturday he works with these kids. So our main thrust has been about trying to keep a certain degree of the tradition from evaporating. We not gon' keep it in its totality, but we certainly can hold onto some semblance of it, and that's why the band is in black and white. And we did it a lil' different. We added the African fabric. So we have an African fabric shirt, European pants. Shoes might be made in Spain. Hat made in Chicago.

Melvin Reed puts together all of the fans and streamers, and prior to Tootie Montana dying he would make the grand marshal and the captain's fans and now Melvin make 'em all. Melvin and I have been friends for the last forty-plus years. When I was masking Indian, he was instrumental in helping me put my suits on the street and make sure I had a quality product. So him and I have been around this culture—either Mardi Gras Indians or Second Line in one form or the other doing that, you know. And that's what it's been about.

VP: I was going to ask what was distinctive—

FJ: That's our niche. We have a twofold niche. One is we gon' have African garb on, and two, the band is going to be [wearing] black and white with traditional brass band music. Not knocking anybody else. When you hear this band, you gon'

know it's a brass band. Not a school band. It ain't playing R&B. It's not trying to play Michael Jackson. It's playing traditional New Orleans music. A lot of other groups do a lot of other things. That's their choice. Our choice is to stay to the traditional brass band music.

VP: Yeah. And with the younger ones, they are always evolving and testing their roots and stuff anyway.

FJ: Right.

VP: Aside from African print, you have specific colors.

FJ: Uhm, uhm. All the colors in the rainbow work for us.

VP: I have the history already because you told me that. You all chose to create this group for Danny Barker's funeral.

FJ: Spin-off from Danny Barker's funeral.

VP: Do you have any particular duties?

FJ: Me?

VP: Yes.

FJ: Whatever needs to be done. I was one of the founders. Benny Jones. Gregg Stafford. Gregg is a well-renowned musician. Benny's a well-renowned musician. And, like I said, I had been in the culture a long time, so they trust and respect my skill and my ability. So, the three of us sit down and hammered it out, and then we opened it up to the rest of the guys who wanted to come in.

VP: How many people are in your organization?

FJ: At any given time, you can anywhere from twenty-five to forty-five. Depends on how the economy is going and how the guys are feeling.

VP: What's the age range?

FJ: They can start at twenty and go up to seventy, it just depends.

VP: What's your usual parade route, basically?

FJ: Downtown. We stay below Canal Street, leave Sweet Lorraine's. Go up Rampart to Donna's. Turn at Rampart by Louis Armstrong Park. Come back down to Barracks by Little People's. Make a right at that corner. I think that's Marais and Barracks. Make a right on that street. Go to Esplanade. Esplanade to Robertson. Up Robertson to Candlelight [Lounge]. Pass Candlelight, go to Basin. Make a right on Basin to Claiborne. Claiborne down to St. Bernard. Left on St. Bernard. St. Bernard to Claiborne. Make a left on Claiborne, down Claiborne to A. P. Tureaud. A. P. Tureaud to Miro. Make a right on Miro. Stop by the bar on the corner of Miro and St. Bernard. Go up Miro to Tonti. Make a left

and back up Galvez. There's a stop right there on Galvez and St. Bernard at a member's house. Then we make a right on St. Bernard. Up St. Bernard back to Claiborne. St. Bernard to St. Claude. Left on St. Claude. St. Claude to Touro, 'cause Sweet Lorraine's is on St. Claude between Touro and Pauger. Back to Sweet Lorraine's.

VP: Are there any particular accessories you have to have for a parade? I know you mentioned the fans. Everybody seems to have those.

FJ: You have streamers because it shows that you're in a parade. Different ranks have different streamers. You have a fan 'cause the fan goes with the dance style and it should keep you cool. Some people have baskets. We have fans and umbrellas. The umbrella is to keep the sun off you. And the fan is to keep you cool. And you sashay with that and you do a certain dance. You do a certain choreography with the group based on the umbrella. Put 'em down, pick 'em up. Skip around.

VP: So y'all choreograph beforehand?

FJ: Well, sometimes if we got a lot of new members, yeah, sometimes we go back and say, let's have practice. Like the Mardi Gras Indians have a practice every Sunday before Mardi Gras. So sometimes we'll have one or two practices where we get in a big room, put some music on, and they line up by partners. So you know who your partner is, and when the grand marshal calls pick up, you pick 'em up. When he call, put 'em down, you put 'em down. He call crisscross, so you know when you get in the street you just don't want to just look good, you want to have some coordination among your group.

They know what they doing and that also, when that group is moving like that, that stops people from getting in the middle of it. Some folks use rope to keep people out. We just say if you keep moving, then people are not going to get in the way of a moving object. You not gon' stand in front of a moving car. So if you see people moving and they got some energy moving, why would you get in the middle of that when you see all the people that's moving is in uniform? They all look alike. So if you stand in the middle of it, you the odd person out. So you know, "What the hell am I doing in the middle of this division?"

VP: How would you describe a Second Line or second-lining to

someone who is not from New Orleans, who doesn't know what it means?

FJ: It's a group of people. It's a band. The Second Line, the division. You have the band. You have the division. Then the people who follow the division is the Second Line. That's the Second Line. Actually, it's a group of people who's following the division.

VP: Who's following the main line?

FJ: Right.

VP: But it's more than just dancing, right? A lot of people think second-lining is just a form of dancing.

FJ: It's having a good time. The other thing it is, Black people has used Second Line as a form of expression, as a form of relief. Some people have money. They go sit on the sofa and get people to talk to them about what their problems are. We have a way of having therapy in dance. Sometimes we have therapy by sitting in the kitchen with a cup of coffee. So different people do different things when it comes to therapy.

VP: Are you the first person in your family to be a member?

FJ: No. My uncle, Roy, my dad's brother, paraded in the 1960s with a group called the Sixth Ward Diamonds. There was a bar on the corner of Villere and Basin. The name of it was Holly's. That's the first time I saw—was very close up—to witness a band and a division and how these men did this. So I always remembered that, so no, I wasn't the first, my uncle was.

VP: How do you feel when you are out there on the route?

FJ: At the end of it I feel fulfilled because I made a commitment to do something and I did it. It's like doing something in your community. You commit to doing it, you do it.

VP: Is there a type of song or music that makes you dance full-out or go buck wild?

FJ: I think there is a type of music that will make me dance stronger, not buck wild. At fifty-eight years old, I ain't got no reason to be buck wild. I better be buck smart.

VP: I know some elders who use [the term] buck wild.

FJ: They using it. They ain't doing it. The better the music is, the more energizing the music is, the more the music will move you. The less it's played, it's a turn-off.

VP: What is your favorite moment on parade day?

FJ: At the end. Because we've completed what we set out to do.

VP: Do you feel energized or tired?

FJ: Energized.

VP: Is there a particular parade year that stands out for you?

FJ: Not really. I think that I approach each one of them the same way in terms of fulfilling my commitment to get it started and get it over with so that history can write it. As long as we can put on the street what we set out to put on the street and not let anything else dictate to go in any other direction.

VP: How do feel about the fact that some people outside our culture think that second-lining is a waste of time and money?

FJ: Don't faze me. That's their loss.

VP: What do you think is the biggest misconception about Social, Aid and Pleasure Clubs and second-lining?

FJ: That everybody is a drug dealer, everybody is doing something illegal, and that's not the case.

VP: Is there anything you want to add that I didn't cover?

FJ: Other than the fact that at this point in my life, I don't know— There's nothing else that I know that would replace what I'm doing, and if I had to leave and come back, I would do the same thing, and if I woke up tomorrow and was independently wealthy, I would just do it more better.

I would bring in groups from the various countries, from the islands, and put 'em in there and show the world that we understand the origin of what this come from, that we just not doing it, we doing it because it came here on the slave ship and we were able to sustain it and maintain, and now we want to show the continuity and connection of it without having to kiss anybody ass or beg anybody for money to do it.

WE ARE THE SECOND LINE

New Orleans Negritude and the Second Line

Stankness, Stupidity, and Doofus Overload in the Streets of the Big Easy

JAMES B. BORDERS IV

NON. New Orleans Negritude. That's shorthand for our local Black cultural patrimony. It manifests as the funk in our step, the Jazz in our speech, the gumbo in our veins, the daiquiris on our breath, the euphoria beaming out of our eyes, the *tout ensemble* of "the way we be in the place we at." *Négritude à la Nouvelle-Orléans.* It permeates every corner of the city, but there's no better place to experience its full panoply, its multisensory richness (good, bad, and ugly) than at a Second Line. We are at our best—and sometimes our worst—on these occasions.

First, though, a note on the proper pronunciation of the acronym NON. You have options. Our culture is postmodernist, after all. NON. You can say it like all French-speaking people when they mean "no." You can also sound out each letter and say "en oh en." With a slight Creole accent that becomes an elided version of "ain't no in."

If you want to go the hip-hop route, however, you can pronounce it more like "no in" or, more subtly, "know-in'," depending on the company you keep or your attitude about the particular aspect of the culture you are referencing. "*Non, absolument.*" Or "No to the In (or end), my friend." Or "That's Know-in', bruh (**G**, **OG**, dawg, dude, man, blood, Black, bleak, falley, podna, child, baby, bae, boo, lil mama, lil daddy), Know-in'. Ya heard me?"

Unless you are among the very, very hip—the sly hip—the

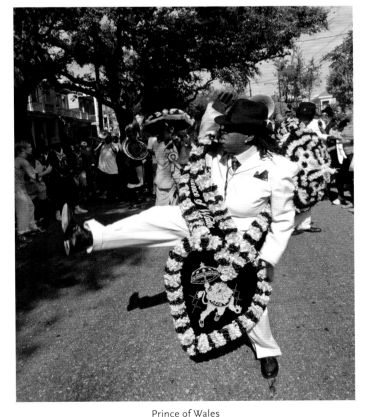

Prince of Wales
October 9, 2011

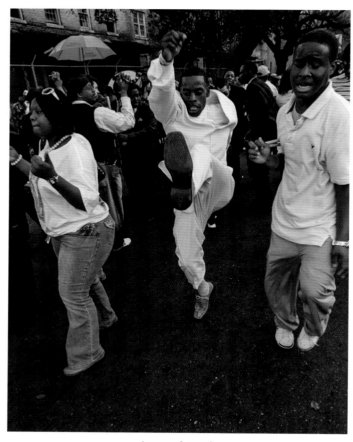

January 6, 2006

second-liners are: *ambianceurs*. And the ambiance they create has all the essential qualities that comprise New Orleans Negritude—intoxicating joviality, unpretentiousness, clannishness, tribalness, and, paradoxically, the privileging of public celebrations over private ones.

Interestingly, the Congolese *ambianceurs* seem far more sybaritic than their New Orleans counterparts—and a lot less epicurean, even though both cohorts are drawn predominately from working-class and underclass segments of society. The Congolese (in both countries, Congo-Brazzaville and Congo-Kinshasa) dress up in fine threads on the weekends. And that's almost the whole point. They have competitions to decide who is wearing the best outfit, who is most creatively stylish, who is most authentically Euro-fashionable, head to toe, accessories included. The more expensive the outfit, the better. The more luxurious the get-up, the more it invokes a state of peace, they say.

And who can blame them? With all the brutality and barbarity Congolese people have endured at the hands of Europeans and each other, who can blame them for fantasizing about living lives of peace and prosperity? For making exquisite, unsullied fetishes of themselves and being the change, if only on Sunday, they want to see in the world? Who would dare fault them for that?

In New Orleans Second Line culture, however, transcendence is achieved by celebrating and being merry despite the way you may be dressed, not because of it. SAPC members also like to get dressed in expensive, colorful garb that costs far more than they can afford or should afford. But that doesn't stop them from dancing and cavorting until they are dripping in sweat and reeking of alcohol and tobacco and whatnot. When our splendid outfits are no longer pristine and unsullied, it's a sign that we have achieved our goal. When we have wasted our money in the pursuit of pleasure, we have done our duty. Nothing can stop us from having a grand, good time. Nothing. Not clothes or weather or the police. When we party, we party hearty.

What else would you expect from people who, like our Congo cousins, have been on such intimate terms with tragedy? Not just periodic storms and plagues, but persistent oppression and soul-killing socioeconomic constraints. Who would begrudge us a few hours of release, relief, and suspension of the otherwise unrelenting pressure of being downtrodden in a place that used to be the biggest slave market in the country? Who

term NON will be completely unfamiliar to you, even if you're immersed in Second Line culture. And that's okay, too. Some modes of self-reflection and analysis are less necessary than others. "A tiger doesn't proclaim its tigerness. It pounces," Wole Soyinka wrote in 1960, when the African independence movement was on the verge of massive triumph. That, too, is *NON, absolument.*

THE GOOD

Our contemporary Congolese brethren have coined a term that also is an apt description of the organizations, people, and sensibilities propelling Second Line culture. *Ambianceurs,* they call them—atmosphere setters, scene creators. That's what our Social, Aid and Pleasure Clubs (SAPCs) are; that's what all the

would begrudge you a few hours a week, a Sunday afternoon, to get some stuff off your chest? Certainly not me.

The year I was born, Satchmo was the Zulu King. My mother, seven months pregnant with me, her first child, went out to catch the parade. She waited for the Zulus at the corner of Rampart and Thalia Streets. Thalia Street, of course, is named for the Muse of Comedy.

My earnest young mother, a college librarian at the time, waited hours on that corner for the Zulu parade to pass. She wanted to see Louis Armstrong in the flesh. She wanted to report the sighting to my father. He was a trumpet player, a former GI, working on his bachelor's degree in musical performance at Bethune-Cookman College in Florida. Unfortunately, he couldn't take off from his studies that year to come to Mardi Gras in New Orleans. Even though he much preferred Miles to Armstrong, he would not have passed up any opportunity to see Satchmo, even vicariously.

And so my mother waited patiently—as much for my father as for herself. Since she was seven months pregnant, she couldn't walk very far or very fast anyway. So she stayed put. Back then, Zulu's route was known only on the grapevine, and the grapevine had made it known that the parade would definitely roll down Rampart past all the streets named in honor of the mythological Greek Muses.

So she stayed put even when others lining the street began dispersing. Finally, an older gentleman approached her. "Are you waiting for the Zulus?" he asked. "Yes," she replied. "Well, they're not gonna come. One of the floats broke down. Armstrong got tired of waiting for it to get fixed. He said he was going back to his hotel to get some sleep since he has a gig to play later tonight."

Disappointed, my mother returned to her parents' home. She never did see Louis Armstrong. And she never made much of an effort ever again to see the Zulu parade. I mention that story as a possible explanation for why I never had any innate desire to be in or to run after parades and Second Lines. It was crushed in the womb, I suppose. I have never had any interest in joining Carnival krewes or SAPCs either—not that any of them would have me—though I deeply appreciate what they do and what it contributes to our culture. But growing up in the 1950s and 1960s, it was marches and demonstrations for such issues as civil rights, Black power, and African liberation

that captivated my attention. Second Lines seemed pointless, senseless, jive, retarded even.

As a younger teen, I greatly preferred to spend my Sunday afternoons shooting hoops or playing razzle-dazzle, our peculiar Crescent City version of touch football in which players can throw unlimited numbers of forward passes until they either score or get stopped. Though parades were good for girl-watching if you weren't mesmerized by the music and movement, it was public dances at the International Longshoremen Association (ILA) Hall that were best for meeting members of the opposite sex. Those dances gave guys like me the chance to slow drag occasionally with unfamiliar pretty young things (if I didn't come with a date), to hold them in my arms, to gradually press them as close as possible and attempt to become better acquainted, you might say—something that could never happen at a Second Line. And when the Royal Dukes of Rhythm were headlining those Saturday night ILA gigs, they played lots of popular New Orleans R&B, always closing out the night with that great blues grinder "Driving Wheel" followed by the "Second Line," which allowed our posse to buck-jump down the stairs, out the door, and into the thick night air with hope of being able to slip into some barroom later for a nightcap without being carded. Why bother with a ratty parade the next day? The music wouldn't be nearly as popping as the Royal Dukes.

My feelings wouldn't change until the late 1970s. That's when the Dirty Dozen Brass Band revolutionized New Orleans brass band music and brought hot-paced heavy-duty funk to the streets. In late 1977, Ernest "Dutch" Morial was elected the first African-American mayor of New Orleans. Black people in the city started standing taller and straighter. Around the same time, the Dirty Dozen began playing Monday nights at a hole-in-the-wall joint called the Glass House on South Saratoga. It was located near the Magnolia Housing Projects and the fabled intersection of Washington Avenue and LaSalle Street, just down the block from the Dew Drop Inn, the legendary American music club. The Glass House was so tiny and decrepit people routinely spilled out into the street outside the club to listen to the music. The sound was infectious, however, and you couldn't help but move your body to the beat whether you were inside the shack or out. Some nights, being in that crowd was magical, otherworldly. It seemed everyone would lock on to the same groove but keep doing their own thing. People would start

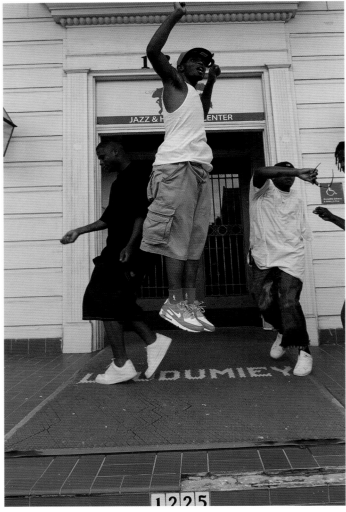

September 6, 2009

rhythms compelled were hot, second-lining and buck-jumping improvisation, as opposed to the coolness of the Popeye and New Orleans swing-out. The Popeye was a short-lived dance fad everywhere in the country except New Orleans, where it reigned for years. Nevertheless, it and swing-out—which is a cross between a hand-holding cha-cha-cha and Chicago-style stepping—like traditional brass band music, had been on the wane since James Brown dropped "Papa's Got a Brand New Bag" in 1965 and the boogaloo exploded a year later.

Boogaloo, like the Second Line, encouraged terpsichorean individuality and creativity. But the bigger point to be emphasized here is that when Dutch Morial was elected mayor and the Dirty Dozen started hyping up the crowds outside the Glass House and, increasingly, at Sunday Second Lines, at that point in the late 1970s, the new New Orleans was born and New Orleans Negritude (our beloved NON) was reinvigorated. It was pure, unadulterated stankness, one hundred years in the making. And the Second Lines found a way to embody that new spirit. There was good reason to dance in the streets again. It was a glorious moment. The question was: could it last? The short answer is . . . NON.

THE BAD

At one point in the nineteenth century, when Europeans were still obsessed with cataloguing and categorizing everything in the world, some anthropologists formalized the observation that all the peoples in the world could be slotted into three groups according to the texture of their hair, and they coined terms to describe these characteristics: ulotrichous (nappy/wooly), cymotrichous (wavy/curly), and lissotrichous (straight). Lots of Black folk are hyperconscious of these physiological typologies, though not the scientific terminology, and assign all kinds of bogus values to them—i.e., good hair, bad hair, which are also supposed to be subtle keys to whether the people themselves are good or bad. It's total B.S., but some fools apparently subscribe to it.

What I do consider useful, however, is attempting to understand the psychological essence of people. For me also, there are only three kinds of people: rulers, rebels, and retainers. Most of us, of course, are not rulers and have no overwhelming need to constantly dominate others. Some of us are rebels, though, and

gravitating toward each other and tightening the dance space. There would be no room to **pop a gator** (these were pre-worm days). And so, out of the blue, some sweat-drenched manchild would start jumping straight up and down like a Masai warrior.

And it would spread, becoming manic almost. And there was no telling where this energy might lead, what spirits it might invoke, what consciousness it might raise. At which point the band would stop playing, catch their breath, and let the crowd chill out a bit.

The steps these Dirty Dozen bop-inflected, funk-drenched

refuse to accept being bossed or dictated to on any level. But the vast majority of us are retainers. We crave someone to lead us, someone to work for, someone to follow, someone to tell us what to do and when, to make the big decisions about our welfare, to take much of the worry out of our lives.

In a very practical sense, slaves are the ultimate retainers. And because New Orleans was such a large slave market for so many years, one would presume that the overarching characteristic of its people of color would be their docility, their obsequiousness, their retainer-tude. After all, so many Black folk continued to occupy menial positions in the workforce long after Jubilee. It should not be surprising, then, that by the middle of the twentieth century, in some circles (mine included), New Orleans had acquired a reputation as the Handkerchief-Head Capital of America.

There were many factors that led to this sorry state of affairs, including a sustained pacification campaign that lasted from the dismantling of Reconstruction in the late 1870s to the end of Jim Crow in the 1960s. The effects of that Negro Pacification Program could be seen in Louis Armstrong's grinnin' and skinnin' performance style and his many imitators throughout the city in various walks of life. These individuals and their behavior were/are flat-out embarrassing to anyone committed to racial uplift.

But this wasn't always the case. Throughout the eighteenth century, New Orleans was notorious for its "rowdy rebel niggers," to borrow Brenda Marie Osbey's term. Enslaved folk were always running away, defying the legal establishment, raiding plantations, setting up their own encampments, killing their enslavers when forced to. And free Black folk were frequently allies in this cause, though some earned their freedom by betraying their brethren.

One morning when I was pondering what had become of us from 1877 to 1977 and from 1977 to today, I came across a couple of passages on delanceyplace.com taken from Ian Buruma's book *Inventing Japan, 1853–1964* that shed light on our situation. When the U.S. Navy showed up in one of Japan's harbors in 1853, it made the Japanese realize "how far behind the world their technology had fallen—they had nothing but swords to counter the cannons and guns of the Americans. The Japanese acquiesced to a treaty with the Americans, but the outrage and humiliation resulting from this treaty led to 15 years of civil war, brutal murder and assassinations within Japan." During

these times, "mobs gathered in the large cities . . . visiting shrines, dancing half-naked in the streets, having sex in public, and raiding wealthy houses, while shouting in a state of quasi-religious ecstasy: 'It's okay, it's okay, anything we do is okay.'"

It's okay, it's okay. Anything we do is okay. It's an attitude that seems to have infected nearly a whole generation of young Black people in New Orleans. It's an attitude that contributes to our being a perennial winner/contender for Murder Capital of America. It's like the whole world has told these youngsters, has told us that we are not only a defeated people, we are also a despised one. Why wouldn't the outrage and humiliation of coming to terms with those realizations lead to violence and destructiveness? And whom to inflict it on most readily if not those in closest proximity?

It's no secret: in this world, power is acquired and maintained primarily by military force. Political power can be illusory. If you have no military, you have no real, sustainable power. If you are powerless, you suffer. The only way to escape suffering is to die, get high, or suck up to the powerful—to hope to be their faithful retainer. And if your suffering (or your selling out) doesn't kill you, it will likely drive you crazy. So if you're powerless and crazy, you're liable to do anything. By that line of reasoning, anything we do is okay.

That is the kind of defeatism permeating much of our society these days. So it should be no surprise that it pops up occasionally at Second Lines and other public gatherings. Maybe the wonder is that more people aren't showing up loaded on all kinds of drugs, dressed like sluts and nuts, acting like they have completely lost their minds—dancing funny, singing wrong, and even trying to settle beefs with gunplay in the crowds. It's part of the human comedy, sure. But it's also nihilistic and way stupid (which I mean in the conventional, verbally abusive connotation, not the cool, hip "stoopid" usage).

In the May 7, 1881, edition of the *New Orleans Louisianian*, an editorial commented on the frequency of parades by the city's Black benevolent societies, the precursors of today's SAPCs. Their overall comportment and organization also were praised, and the paper observed that "in this direction, at least, the colored people are silently but effectually building up a reputation which will go far to refute many of the slanderous reports relative to their imbecility." I wonder what the paper would say about Second Lines today?

As I read more of Buruma's *Inventing Japan,* I came across something else that really resonated. "Overconfidence, fanaticism, a shrill sense of inferiority, and a sometimes obsessive preoccupation with national status—these have all played their parts in the history of modern Japan," he notes in the book's prologue. "But one quality has stood out to make Japan better than any other place: the grace to make the best of defeat."

Substitute "racial status" for "national status" and "Black New Orleans" for "Japan," and you have an apt summary of our situation in the Big Easy.

The grace to make the best of defeat. That phrase also sums up what Second Lines represent to our psyches and souls: We are poor, ignorant, diseased. And yet we party. Excessively. We are, it seems, working very hard to make the best of our defeat as gracefully as we can. So the next time some perfectly sober, perfectly rational individual asks almost rhetorically, "How in the hell can a bunch of broke-assed New Orleans muhfukkas afford to waste so much money on a parade/party/ball/funeral like this?" you will have an answer.

THE UGLY, THE VERY UGLY

Looking at film and photos of Second Lines in the 1970s and 1980s, it seems we were more attractive then, more ulotrichous and proud of it. Go to a parade today and our psychological weakness is on full display—droves of Black women and girls in weaves and wigs that are supposed to render their manes attractive because they are straight or wavy. Forget the crazy colors and dye jobs for a second and focus solely on the textures. Anything but nappy is preferred. And so we display our sickness outwardly, openly. It's an ugly scene, very ugly.

Second Lines didn't start or cause the current craze for weaves, extensions, and wigs; they just reflect the tastes of the people, the community. For decades, the fashion sense of the SAPCs has been rooted in the Superfly aesthetic. The aspirations are to appear "sharp" and "clean."

Unfortunately, that aesthetic lost its hold on the young when the gangsta/prisoner look evolved in the late 1980s among the hip-hop generation. Now the goal is to look "hard," "real," and "strapped" (possibly armed and dangerous). Natty dreads were also part of the look. By that time, perhaps, the young had recognized that Black politics alone would not end poverty and dysfunction in our community, our realm; that crooks and shysters come in all colors and both sexes; that without an army of our own we would be merely prisoners in someone else's empire; and that the best we could do in the absence of waging straight-up war would be to become rowdy, rebellious, and uncooperative with the ruling regime—which promptly got perverted into self-destructive, internecine beefs. Those who didn't want to go gangsta opted to bow their heads and cover their natural glories, to try to fit in, perhaps, and find a place as cymotrichous and lissotrichous brunette, blonde, or orange-haired retainers.

Our problems and oppression aren't simply in our heads or on our heads, however. There are economic and material dimensions as well. The ramifications, like everything else in the world, can be both tragic and comic at the same time.

For instance, it seems there have always been one or two homely white folks each year who stumble onto New Orleans Negritude and become captivated by it. Maybe they have problems fitting into their own cultures, their own worlds. They become regulars at the Second Lines. Many come in with a Columbus Complex—they think they have discovered some colorful, quasi-primitive cultural practices that the whole world needs to know about. They make it their mission to do so.

Some find ways to profit from our cultural patrimony as filmmakers, photographers, anthropologists, musicologists, sociologists, producers of various sorts, directors, curators, journalists, lecturers, artist managers, etc. Some make a love connection and enter into interracial relationships as a result of hanging out at the parades. Others keep their distance romantically but develop "friendships" with people in the Second Line community. Whatever the case, their presence at the Second Lines and the neighborhood barrooms along the routes has changed something in the culture, for better and for worse.

The outsiders, who are generally white but can be yellow, brown, and Black as well, come in three basic flavors: fawners from abroad, hicks from the heartland of America, and slicksters from the coasts. The slicksters, being what they are, sometimes appear to be fawners or naifs, but that's just cover for whatever angle they are working to penetrate the inner workings of the culture. Some take up residence in the city after they witness a Second Line, backstreet Mardi Gras, or Jazz Fest. And, of course, there are native, homegrown varieties of these outsiders as well.

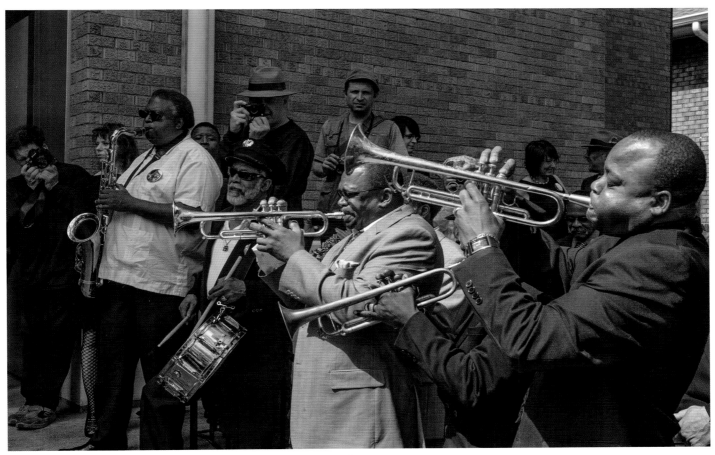

March 12, 2011

What gives them away, what marks them as outsiders, usually is their inability to dance in the New Orleans tradition, even those who think they have mastered the steps and the attitude of locals. And when the weekly Second Lines first started being overrun by tourists, college students/teachers, and other outsiders in the early 1980s, it turned off a lot of the neighborhood folk.

"White folks fuck up the flow, man. It's some disgusting." That was one of the common sentiments muttered in the crowd. Over time, however, accommodations were made. The doofus outsiders learned to form a third line and to give berth to the insiders. And the insiders learned to be more accepting of the guests. "Get in where you fit in," they began to say aloud to no one in particular, casting knowing glances and slightly sardonic smiles among each other, gesturing to bystanders to jump in the mix and do their thing. That, too, is quintessential NON—generous and supportive.

But since the devil can always find work, as the saying goes, it didn't take long for some native celebrants to find a useful role for the outsiders, especially those who showed up faithfully week after week at the Second Lines: "Buy me a drink, a pack of cigarettes, a sandwich, a plate of food. Let me hold $10, $20." They became—and remain—marks for petty hustlers, alcoholics, dope fiends. The tacit bargain is that the beggar will provide friendship and protection to the outsider in exchange for a small monetary favor. It's understandable. It's what tourism produces in poor countries around the globe. It's a mini-industry for segments of the underclass—hustling tourists. It's a ve-

nial undertaking in the grand scheme of economic activity, but it's also ugly, very ugly and inexorably soul-crushing on both sides of the exchange.

THE HOPEFUL, THE REALLY HOPEFUL

What would all the great rowdy rebel heroes of New Orleans—Samba Bambara, San Malo, Charles Deslondes, Andre Cailloux and the Louisiana Native Guard, Robert Charles, Ernest Wright, Oretha Castle, Dutch Morial, Dorothy Mae Taylor, and the many unknown others—think about the current state of affairs of New Orleans Negritude and Second Line culture? I suspect they would be both encouraged and discouraged. We have come a long way since the first shipment of enslaved Africans arrived in the city in 1719, but we are still much too poor, too ignorant, and too diseased to be comfortable with our lot.

The global Black Freedom Struggle has now embarked on its final phase—economic justice and equity. If history is any guide, this fight will consume our energies for most of the twenty-first century. Remember, it took almost the whole twentieth century to win national liberation in Africa and the Caribbean (and first-class citizenship in the United States). And it took nearly the whole nineteenth century to abolish legalized slavery around the globe. Those were herculean tasks, but we accomplished them. So no matter how dim our prospects look today, we will prevail eventually if we remain diligent. We *will*

reach a point when Black people are no longer disproportionately poor, ignorant, and unhealthy. Ya heard me?

New Orleans, tiny as it is, also may play a significant role in this large, messy fight for economic justice and equity. We have oil, natural gas, seafood, shipping, tourism, and a burgeoning biomedical industry. And Black folk need to fight for our fair share in all of these sectors. But culture—Black culture, NON—is the city's competitive advantage, and we need to seize control of it. The greater likelihood is that New Orleans's primary function over the next century and beyond will be to remain a party capital, a respite from the woes and worries of life, a glimpse of the joy that will be permanently inscribed when Black folk, when all folk, are finally free, self-supporting, and prosperous citizens of the world.

Until then, as a global icon of cultural celebrations, we New Orleanians owe it to the rest of the world, I suppose, to continue singing, blowing, beating, eating, and dancing our way to freedom and full equality.

But maybe our rowdy rebel spirit can emerge once again and, like the Native Guard of Civil War days, lead the assault on injustice and win the victory on the battlefront as well as in the boardrooms and out in the street. And maybe through our steadfast refusal to fall for the same old okey-doke, we can become supreme *ambianceurs* and set the scene for real and lasting global peace. That, too, would be totally NON, totally. *Absolument.*

Cradle of the Community

KAREN CELESTAN

I n New 'Awlins (that's how the locals pronounce it), there is an undeniable sense of belonging within some of the city's oldest neighborhoods. The tradition of the Second Line is part of a kinship, a familiarity that comforts and defines a person throughout his or her life.

It is that same ritual and belonging that has kept Second Lines rolling through the streets of New Orleans since the late 1800s. If your father and mother, auntie and uncle, **nanan** and **parrain** all did the Second Line and **buckjumped**, then chances are, you will too.

No one teaches anyone how to Second Line. It's a movement of ancient wisdom steeped in revelry, joy, heartbreak, release, tradition, and display.

In the African-American community, there is another rite of passage that is as unavoidable as it is comforting—being nicknamed. Some folks manage to avoid it, others are crowned with a quick, easy label that may or may not be flattering, but will stay with them for life. In some cases, the person's given name is forgotten, remembered when they die. In 1994, the local daily, the *Times-Picayune,* acknowledged this tradition and changed its obituary policy to begin including nicknames of the deceased.

You can live from cradle to maturity with a nickname that defined you as a member of a society that accepts you just as you

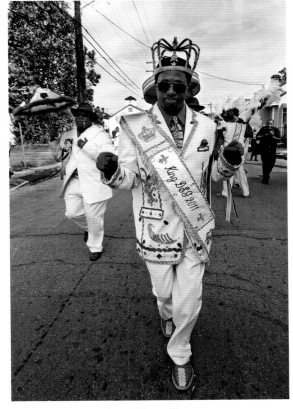

James Henry, King,
Dumaine Street Gang December 4, 2011

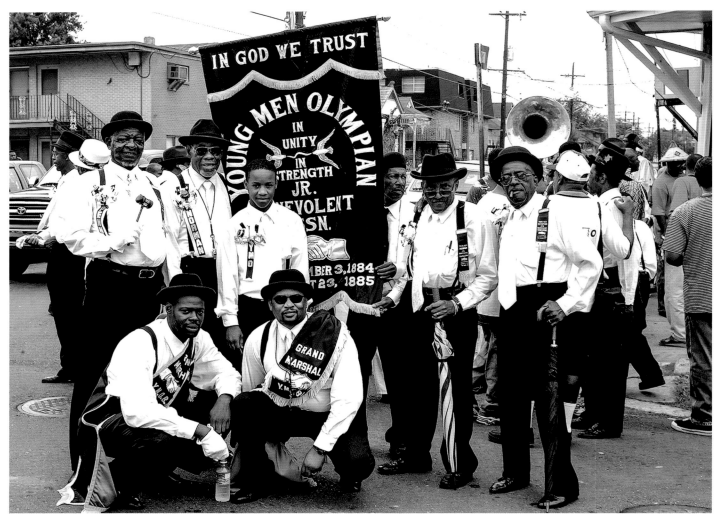

Norman Dixon Sr. *(back row, second from left)* with some members of Young Men Olympian, a division of the oldest SAPC in New Orleans: *(standing left to right)* Raymond Joseph, Dixon, Charlie Brown, unidentified, Leon Anderson, Alfred "Bucket" Carter; *(front)* Garrard Williams, Joseph Spots
September 8, 2002

are. You could grow up in the Seventh or Ninth Ward, graduate from high school at McDonogh 35 or St. Augustine or St. Mary's, earn your degree at Xavier or Dillard or Harvard or Spelman—but if you become "Frog" at an early age, it's "Frog" you will stay.

"Oh, yeah, that's my pardna 'Greedy Man' runnin' for that robe, man. I'ma go handle up on that Satiddy for 'im!" ("Yes, that's my old neighborhood friend 'Greedy Man' running for judge. I'm going to vote for him in Saturday's election!").

Erica Dudley started out at age seven with the Sudan SAPC

and exuded complete confidence as she glided and dipped down Tremé streets in her finery. Gregg Stafford swings on the trumpet throughout New Orleans and the world with his traditional Jazz group, the Jazz Hounds. He also is a longtime member of one of the oldest traditional brass bands, the Olympian, and cofounder of one of the most respected Social, Aid and Pleasure Clubs in New Orleans, the Black Men of Labor. Squirk's Second Line exuberance is frozen in time as he shares the complete freedom of a Sunday afternoon surrounded by friends and

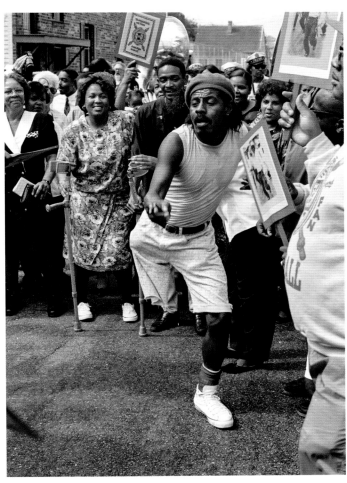

Wayne hands off his crutches to immerse himself in the Second Line spirit.
1994

served as their event guru. For nearly thirty years, he saw to it that the clubs had parade permits and police escorts, and he also helped decide where the parade stops would take place. He made sure that the rivalries between clubs did not dissolve into violence. For most of his life, he was a member of the Young Men Olympian Jr. Benevolent Association, a club so large and diverse that it spawned five divisions—the Original Four, Young Men Olympian, Distinguished Gentlemen, the Furious Five, and Nine Times.

Dixon even talked like a Second Line. With rapid-fire, colorful language, picturesque imagery, and an exciting demeanor, he could give you a quick history of each club. He also enjoyed talking about individual club members who demonstrated the true Second Line spirit.

In a 1999 interview with Karen Celestan to list and outline the scope of the city's clubs for the New Orleans Jazz & Heritage Festival's program guide, Dixon gave an example of the dynamics between two female SAPCs. (Individuals' names are fictitious.)

"Yeah, yeah, yeah, you know how Chantell and the Popular Ladies rolled out with their red suits, **cut to the bone**, hats **cocked ace-deuce**? Had the whole town hollerin' about how good they looked, about how nobody would be able to top that stuff? What was that? In '97 or somethin' like that? I think that's when it was. Well, last month the whole club was over at Kemp's Lounge sittin' at a table getting their plan together for March, and Ba-Ba and her girls from Buckjumpers roll through after their parade. Honey! They fall into the club with their white-on-white-in-white suits, fans, the whole nine!" Norman jumps up from his chair, throws his arms up, and cackles at the memory.

"Now, they had finished their route and everything, but those women still looked like two sticks of dynamite and a match! You hear what I'm sayin' to you?! So, Ba-Ba strutted over and twirled all the way around right in front of Hermine and them. Ba-Ba said, 'So, how you like me now?' I thought there might be a little **humbug** or somethin', and I was ready, but no, Hermine smiled just as good, raised her glass to those girls, and said, 'Ya'll go 'head on. Ya'll lookin' some fine.' Man! I thought I was gonna fall out! But you know what? Hermine was right.

neighbors with the liveliest music on the planet; he also shares a lifetime of participation in innumerable Second Lines from a wondrous and spiritual perspective. Wingie (Franklin Davis) has one arm, but what appears to be a handicap does not get in the way of whatever he wants to do: playing basketball or baseball, sewing beads and sequins on an elaborate sash or fan, or serving as grand marshal of a Second Line parade for the Bucket Men SAPC.

Norman Dixon Sr. was probably one of the most respected persons involved in Second Line life: he helped the clubs organize their parades and got out the word about the parade route. He was in contact with nearly every SAPC in New Orleans and

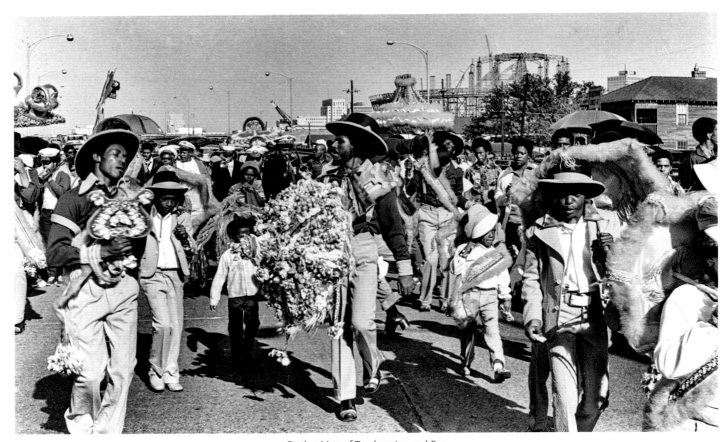

Bucket Men of Tambourine and Fan
(Note the Superdome under construction at top right.)
circa 1972

There wasn't nothin' she could say, them Buckjumpers had their outfits laid. She had to give 'em their praise. But I know one thing, Hermine been in this too long, her and those Ladies were gonna roll come spring, and I know it! I couldn't wait until March just to see how bad they were gonna fall out and present with their outfits. A little competition is good, you know, keeps everybody on top of their game. This ain't no joke."

Social, Aid and Pleasure Clubs pride themselves on a certain level of organization and attention to detail. Managing an SAPC and hitting the streets each year with a distinctive themed and color-schemed parade requires devoted members and a strong desire by the club to "come correct." Planning meetings and a

dedicated revenue stream through membership dues are the support system.

There is a traditional hierarchy of officers, by-laws, and regulations for the club—some rules are documented, and some are unspoken. Everyone has a purpose, including getting the parade permit from City Hall, working with the clothing/shoe vendor, seamstress, or tailor who will provide the outfits, booking the brass band, and determining the route and rest stops along the way. SAPCers have to design and create their parade accessories, either making them by hand or hiring local artisans to do the work if they don't have time. Members have a budget or account that must be paid by a certain date to cover the necessary expenses. Some clubs host public fund-raisers such as crawfish boils or fish dinners to defray costs and lessen the

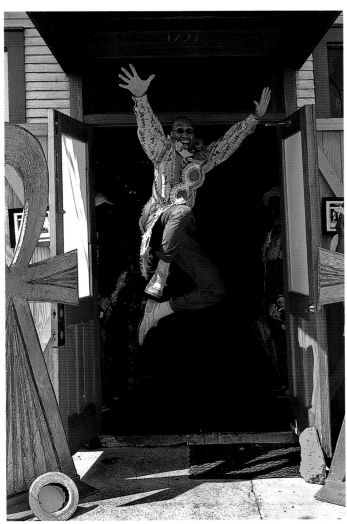

Willie Johnson, Black Men of Labor
Sweet Lorraine's
September 5, 2004

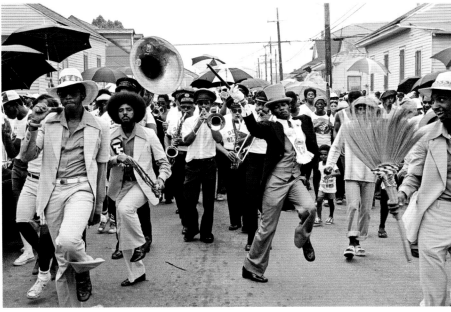

Franklin "Wingie" Davis *(center)*, Bucket Men
1975

out-of-pocket expense for members. The communal effort that surrounds SAPCs and their activities is a source of pride and fosters a sense of "oneness" and belonging. This communitas is what creates the strong vibrancy that draws people from in town and out of town. The spirit emanates from the club members and touches all who enter into the orbit of a Second Line.

Oliver "Squirk" Hunter says that when a Second Line rolls through a neighborhood or area, "people done left pots on the stove in the kitchen. Whatever is going on in life at that time, that's behind us. Sometimes, we don't know where it's [parade] going, 99 percent of the time, we don't know . . . but when we come back, whatever's in the house, that's what we dealt with. We deal with the situations life brought us through and (when) we come back from the parade, no matter what it was, we deal with life."

Noted second-liners such as Hunter, Terrylyn Dorsey, or Darryl "Dancing Man" Young are self-creators on the parade route. They don't rehearse moves but are following the music and the spirit. Most dedicated second-liners respond to nearly any instrument on a 2/4 beat. Whether it's the bass drum, clarinet, trumpet, trombone, or snare drum, their feet begin tapping a polyrhythm in the flow—an ancestral heartbeat. Second-liners are not deterred by age, disabilities, broken pavement, rain, police, or the occasional fight that breaks out. Once they are in a groove, the music and the dance propel them.

Interview with Norman Dixon Jr.

President, Young Men Olympian Jr. Benevolent Association

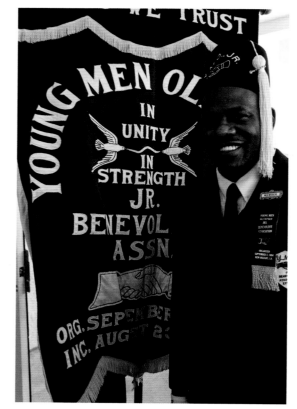

Norman Dixon Jr., Young Men Olympian
October 7, 2011

Valentine Pierce interviewed Norman Dixon on February 15, 2012.

Dixon has been involved with the Olympian for his entire life. He wants everyone to know that he belongs to a benevolent association. The Olympian is the oldest recognized organization of its kind in the United States, dating back to 1884.

"I have been around since 1974. My dad was a member, and I joined when I was seven . . . I am forty years old right now," Dixon said.

Dixon's father, Norman Sr., was a respected, long-standing member of the Olympian. Dixon Sr. was instrumental in bringing the culture to a worldwide audience through his association with the New Orleans Jazz & Heritage Festival. Both father and son organized the Social, Aid and Pleasure Club parades that wove their way—with full finery and brass band accompaniment—through the festival site every spring.

"We had a senior [division], and the junior was the second part of it. You stayed a junior until you [turned] thirty-seven. [That age] marked when you would go to the senior part of the group. Those who became thirty-five and over didn't want to be known as the older members of the group, so everybody started staying [in] the junior part," he said. "I just know that in the bylaws it said at thirty-five a member would go from being a Young Men Olympian Junior to a Young Men Olympian Senior."

Dixon Jr. is only the sixth president in the association's 132-year history.

"I keep trying to get out, but they say it is until I die. Every president before me has died in office. I always try to tell them to get somebody in, but they seem to want me here. We have an election every year. I've been in since two years before the hurricane [Katrina]."

Dixon wants everyone to know the full scope of the Olympian and the group's dedicated history.

"[We] actually started out for musicians. Of course, as Black Americans, we couldn't obtain death policies, so we would put together [money] and bury our own, take care of our own. So a group of musicians came together— Anytime a musician died, or a member of a musician's family [died], they would put together and have a parade going to the cemetery after the church service," he said. "They enjoyed it so much they decided to do it more than just when somebody died. They decided not [to] just raise money when somebody died; it would be a year-round affair. And raising money to bury somebody was throughout the year now instead of a one-time thing when somebody died."

Dixon said the parade was held once a year—the fourth Sunday in September.

"That's been going on since the existence of this organization. We only missed two times, and both times was because of hurricanes [Betsy and Katrina]. The big one [Katrina] came in August [2005], and we all were displaced."

He said the association "just grew. We still have musicians in the organization. We have five musicians. We have five [Mardi Gras] Indian chiefs. We always said if we couldn't second-line one day, one more day, the benevolent part would still be here. We own two tombs around the corner on Washington and Loyola, and one is on Washington and Liberty. Any member who dies and wants to go in there, that's a part of what we do. Our motto is we take care of the sick and bury the dead. That's our work. Our sick members, we visit them in the hospital. We take care of them. We take care of the family. Everybody who dies, we give them a band, a Jazz funeral. We take an oath, we have to do that."

Dixon and his father were noted throughout New Orleans for their bond, a close relationship that stood as a standard for family.

"I chose it [association membership]. I'm in it. I always say I have to see somebody who had a closer relationship with their father. I love my dad. We did everything. He was Young Men Olympian, I'm Young Men Olympian. He was a Mason, I am a Mason. But he never asked me or made it seem like this was something I had to do. I asked him to do this," he said. "He never told me who to associate with or what to do. He put me in a situation, hanging with him I can see things. I always saw that as my biggest example. You can either go this way or you can go that way. [Norman Sr. would say,] 'It's on you, but I'm here for you either way you go. No pressure.'"

The family tradition continues with Norman Jr.'s son—Norman III. Norman Jr. laughs as he describes his approach to keeping the family tradition alive.

"I put him in [Norman III]. Actually, he's the youngest person to ever get in. I dragged him in at six months. Then the next year I said no kid can get in unless he was two. He's twelve [now], and he's been in since he was six months old. Then we have another brother out there, he got in when he was one."

Norman Jr. is proud of his service as president of the Olympian.

"[I] govern, oversee the running of the organization. We have twenty-two positions. The first Sunday in September, all seats are declared vacant, and every seat is up for election. The second Sunday we go to church. All officers get sworn in, then we have our anniversary parade on the fourth Sunday. It's two hours long. [On the] third Sunday everybody can come in and make sure they are all squared up. All dues are paid. All fines are paid."

The Olympian is separated into five distinct divisions: the Untouchables, Furious Five, the New Look, the Big Steppers, and the First Division.

"That's the five groups that's within the body. The body is always there," he said.

The First Division is the oldest group, founded around 1971 (forty-six years ago), the Furious Five is twenty-six years old (founded in 1986), the Untouchables was started about fifteen years ago, and the two most recent divisions are the New Look and the Big Steppers at four and three years old, respectively.

Dixon describes the set-up for the association's major fall parade and says that his job on that day is to keep track of the body as a whole.

"The September parade, the big parade, every group has their own color and the body [the organization] is [in] black and white. How you dress it up is on you," he said. "I parade

with the group called the Untouchables. If some reason I didn't want to parade with the Untouchables and I wanted to go to the body as a member, I can do that. If any member wanted to become a member of the Untouchables, they gotta come and ask me because I'm the president of the Untouchables. We have 152 members."

Dixon says it would be hard for such a large group to be in one band, so that division is split in half.

"On parade day, we put those who want to be with the organizational band, which is the body, can go with them. If you want to go with the other group, you can."

Dixon believes that the Second Line is the quintessential experience of being in New Orleans.

"It's [some]thing that brings blood to the heart. The heartbeat of this city is music. Our way of expressing is connected to that heart, and the heart is the musicians. That's what New Orleans is. The music and the culture of the music is different. Second Line is just another big vein. You come and you get the Jazz music. Now you get the dance that's with it," he said. "People ask me how you second-line. There's no special way. It's not a dance where you get a line dance where you doing the same thing no matter how the music changes. You feel the beat, and however your body brings you, that's the way you go."

Dixon said when he was a kid, he always asked his father to teach him how to dance in the Second Line fashion.

"He said, 'I can't teach you how to dance. I can't feel the beat the same way you do. The beat might bring me left, and when you hear that same beat, it's gon' bring you right. I can't teach you. I can't hear the music the way you hear it.'"

Dixon says people often ask him to show them how to second-line, and he is direct in his response.

"I tell them, 'I can show you how I dance or what you do to the beat, but how you react to it, how you hear it— If I look at a good dancer and you look at a good dancer, you're going see the dancer that's your style of dancing. Every group's style is different. Whatever style you like, that's the best dancer. That's just like when you wear your clothes. You ain't gonna ever tell me that you dress better than me when I go and pick out the clothes that I have on. That's my style. Dancing is the same way."

Dixon revels in being out on the streets of the city on parade day.

"I feel great because I have that pride of being a part of something that's keeping a tradition going. That's important.

I've been doing this so long—about thirty-eight years. I'm real excited when I'm out on the route because I know I'm a part of a tradition, not only to New Orleans culture, but any culture."

"[But] without a doubt, [my favorite moment is] when we first come out, each group. We are blessed enough to have a building. We have six different doors, and we have six different groups. Every group comes out of a door of their own from the front to the back. Just to hear each group come out— We're the fifth group to come out. To hear the crowd roar when the other four groups ahead of me come out, then to actually pop out and see all the people around, is probably my favorite moment of the parade."

Dixon says the association celebrates every ten years, but the most memorable was the group's one-hundred-year anniversary.

"My dad was here. My brother was still parading. The whole family. I had nephews and cousins that paraded with me. I remember that year being one of the best because the whole family was out there to celebrate. Of course, every year we reach a milestone, it's important—128 years. That's exciting."

The easygoing, jovial man frowns when a question is posed about the belief by those out of the culture that parades are a waste of money for participants who have limited resources.

"I think the people who have those thoughts, in town or out of town, are ignorant of the culture. They haven't taken the time to understand it, study it—its history. [There's] a new museum over by City Park that just opened. A member called me. He said after he took five steps in there, the first thing he saw was the Young Men Olympian, 1958, doing a funeral of one of its members. I think it's just a matter of just being ignorant of a culture that exists.

The biggest misconception, I think, is the money that's spent. People think it's a lot of money and that it's a waste of time, a waste of money. It's not a waste of money to people who . . . are getting enjoyment out of it. Somebody might spend five thousand dollars on a cruise, it's [still] five thousand dollars. So, if I want to spend five thousand dollars to parade, which I don't, to get the same enjoyment or more, I spend it. The misconception is to think people are wasting their time or wasting any money on something they love, and it's not fair."

Norman sets up a comparison between him and his brother and their spending habits.

"My brother will go and buy a seventy-dollar pair of jeans.

I'm gon' buy a pair of jeans for $19.99," he laughs. [That's] because I don't get enjoyment out of that, but he does. I don't look down on him because he work[s] for his money, he spend it how he wanna. That's the same thing, I think, that people waste their money on second-lining and parading when they could be doing something else with it."

Norman says that the Olympians' parade route is in uptown New Orleans, a tradition that he has known his whole life. He has many childhood memories of his father and his life as an Olympian:

"When I was a little boy, when I first came [into the organization], they used to parade right around the corner, it's strange, on Jackson at the funeral home. I came out, when I first started in '74, me and my brother laugh because that was the first place I ever seen a dead body. My daddy told us, 'I going upstairs to meeting, I'm gonna pay the dues and y'all are gonna sit right here,' he said. So, this particular Sunday, he wanted to just run up and pay his dues and said, 'You guys don't move.' We were running around. [My brother] was chasing me, I was chasing him, and I ran into this room. He wasn't far behind and we froze. It was a body. We turned around and got the heck out of there. We ran back and never told him a word. We sat down. We were quiet. It was like ten, fifteen minutes [and] we didn't say anything. We couldn't believe it. A dead body."

Norman said he was privileged to see the Olympian's history as it was made:

"Usually, we would go straight upstairs. I'm glad he [his father] did that because even today I can tell, as a young man, how things should be ran, how they were running, and how things have changed. I can give that history. I might not have the age, but I have the experience, as they say. I can recall one of the things my dad always said about me is I was one to observe, even as young child."

The Dixon family always had a strong presence in the organization.

"I had an uncle who actually introduced my dad to second-lining. He died many years ago. He was a downtown hanger so he actually belonged to a group called the Jolly Bunch. And my daddy, by him hanging uptown, he belonged to the Young Men Olympian," Norman said. "You see it more now, but at one time, the Young Men Olympian was the only group that would have people from uptown and downtown. You would join the Social and Pleasure [Club] by the people you hung out in your neighborhood with, so the Social and Pleasure [Club] was in your block. That's what you would join because that's where your friends would be. We were the only people who come from all over the city."

The Olympian has a distinctive style of dress when the organization has its annual parade:

"Every division has to wear black and white. All six. On parade day, they [dress] in any black and white they want to, without all the other fancy stuff that they have to do in other groups," Norman said. "The organization wants to make sure that it is about the organization. If you are a member, you should be able to come out that day whether you can afford the other outfits or not. That has nothing to do with what the body represents."

Norman remembers one of the Olympians' largest parades, which took place in 2011:

"The police who do the details for our Second Line said they estimated five hundred thousand people at the parade. [One cop] said he had never witnessed this, even during Mardi Gras. You know the landscape of New Orleans? From one sidewalk of Claiborne, over the neutral ground, as we call it, to the other sidewalk. They had to stop traffic both ways."

The group's legacy continues into present-day practices and relationships.

"Still now, people want to always call us and say, 'Can your group come and do a funeral for us?' Everybody wants to be part of the group that goes outside of the Social and Pleasure [Club]. We got a sick committee. We pick ten people. You get sick, those ten people plus other members come and see you in the hospital. We gonna come there, we gonna read the Bible, and we gonna sit with you. We are going to leave there, and we're gonna go to your wife and your kids and find out if they need anything," Norman said. "And the community knows. We got community uptown, downtown, Ninth Ward. We got the Double Nine. The Perfect Gentlemen. The Furious Five."

· · · · · · · · · · · · · · · · · · · ·

Stylin' and Profilin'

KAREN CELESTAN

SAPC culture-bearers become de facto representatives of the neighborhood and the club that holds their membership. It is rare to see longtime SAPCers who aren't dressed well. Even in casual settings when they are running errands or headed to "make groceries," their jeans will be starched with a razor crease, shirts crisp and bright like a cottony cloud, hair on men and women will have fresh scissor-cuts with precision hairlines and photo-ready coifs. It is a matter of pride in self that is a part of life in Social, Aid and Pleasure Clubs.

This same "self" will not have a lick of insecurity about being overtaken by the music when the brass band hits those first notes and they step out of the house or the club's den to the roar of the crowd on the street. SAPC members do not rehearse moves, but let the music and the vibe stir an internal creativity that is derived from childhood—years of dancing to R&B on the stereo and second-lining in innumerable street parades.

Critics outside of the culture have questioned why most SAPCs meet in bars or clubs and whether or not, in those environments, the tradition is a true tribute to beloved ancestors, especially if children or elders are part of the organization. SAPC members navigate that issue by offering respect through club rules and regulations that follow Black societal mores.

New Orleans neighborhoods have a plethora of bars—

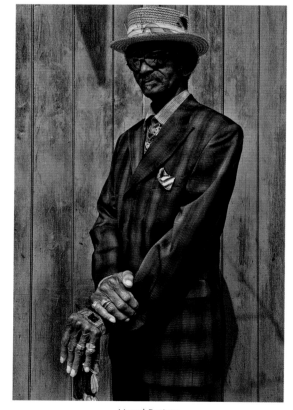

Lionel Batiste
August 15, 2008

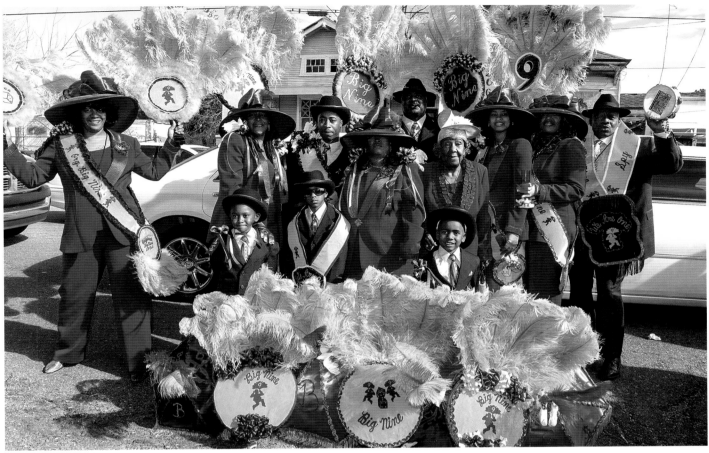

Family portrait (four generations)
Big Nine
December 24, 2007

"watering holes" that cater to area citizens. Every other corner might have a lounge, sports bar, or private club (an absolute must to watch Saints football games after church on Sundays!) that caters to working people looking for an evening cocktail or beer to wind down. During Jim Crow, these were the only places that Black people could enjoy social functions and avoid harassment from law enforcement.

A number of SAPCs—particularly the Olympian, Black Men of Labor, Sudan, and the Money Wasters (the latter involving both male and female members)—begin their parade day with a prayer circle. Most club participants are dedicated church members who believe in honoring God.

An unspoken tradition for some in the New Orleans African-American community is to spend Sunday morning in church praising the Lord, Sunday afternoon with family, and Sunday evening with a cocktail at a neighborhood lounge to bolster their spirit for whatever might have to be faced in the coming workweek. This religious-social custom is in line with a belief that it is not a sin to be in both worlds, but a life that recognizes that a "good person" can straddle the line between the sacred and the secular. The Black Men of Labor pray as a collective at the start and the end of their parade to thank God for safety, blessing their membership, and in gratitude to the ancestors.

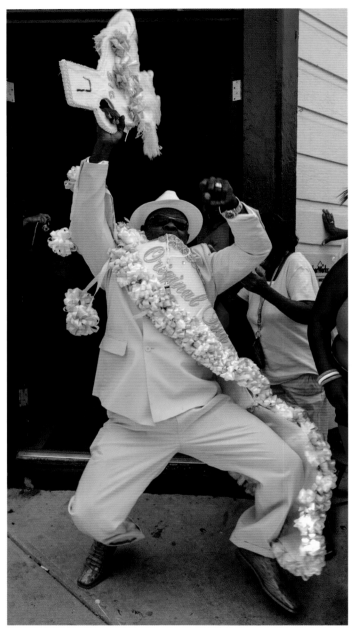

Original Big Nine
May 11, 2008

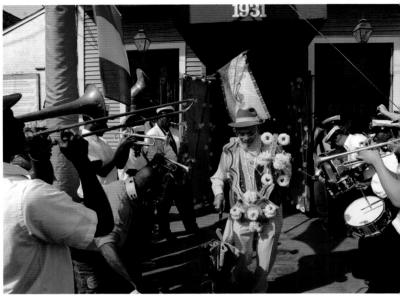

Edwin Harrison, Black Men of Labor
October 17, 2015

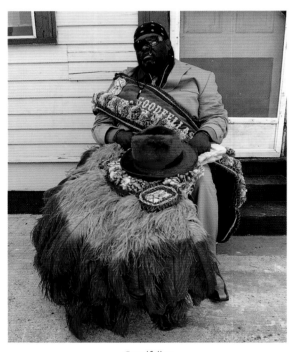

Goodfellas
September 27, 2008

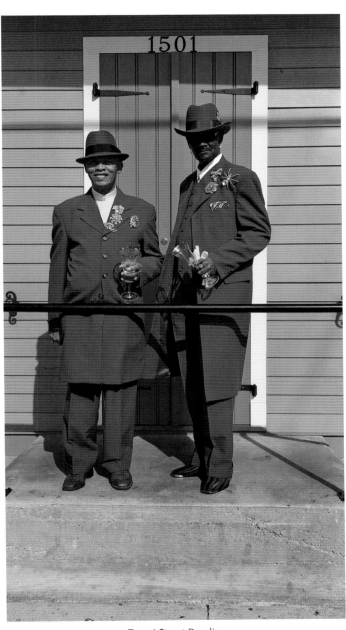

Tremé Street Dandies
Joseph Washington (*left*) and Wayne Wheeler (*right*)
December 4, 2011

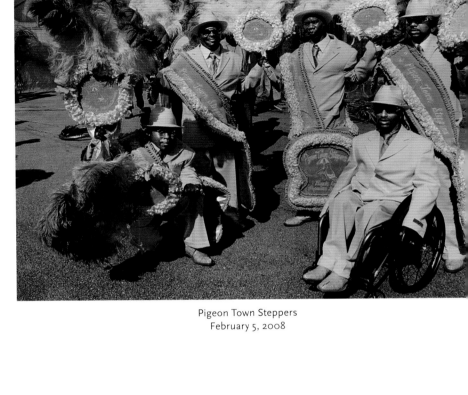

Pigeon Town Steppers
February 5, 2008

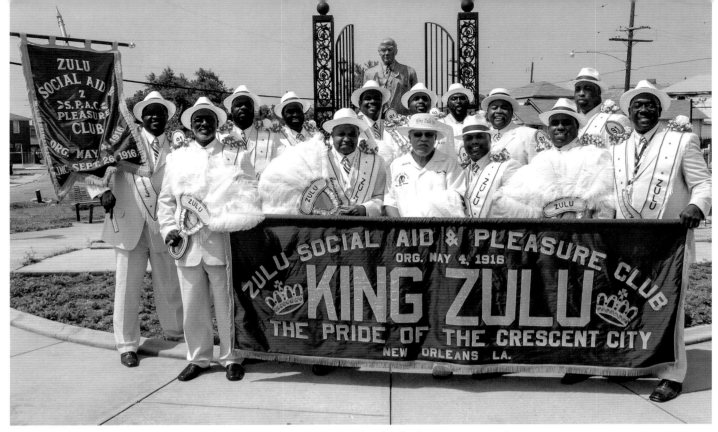

Zulu SAPCers pose near statue of Civil Rights lawyer A. P. Tureaud
Back row (*left to right*): Eric Davis, Anthony Jackson, Steve Luke, Charles Hamilton, Brian Sims, Travis Taylor, Andrew "Pete" Sanchez. *Front row* (*left to right*):
Wilbert Thomas, Randy Moore, Jay Banks, Delone Perkins, Louis Cushenberry, Isaac "Ike" Wheeler, Ashley Jenkins
May 20, 2007

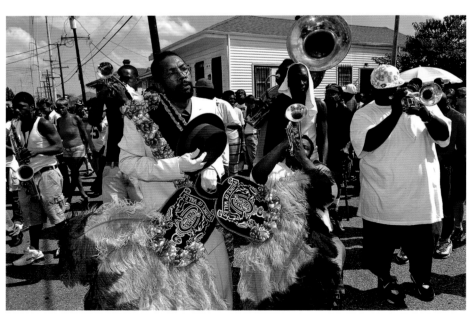

Noland Stansberry, Prince of Wales
October 14, 2007

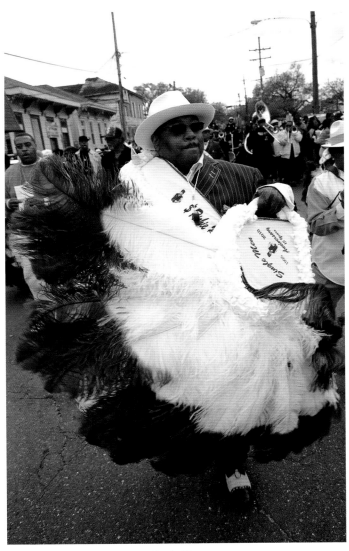

Single Men
March 21, 2010

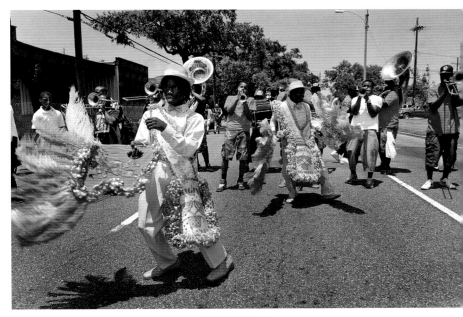

Original Big Seven
May 13, 2012

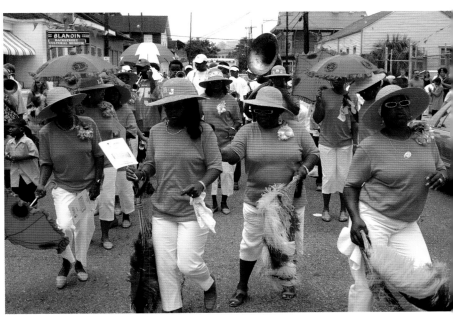

Lady Buckjumpers
August 2, 2002

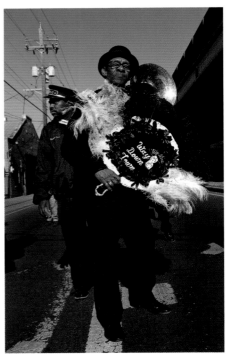

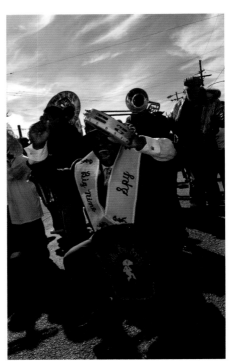

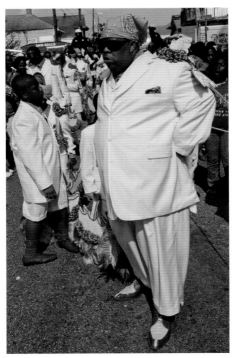

Oswald "Bo Monkey" Jones, Big Nine
November 24, 2012

Rickey Gettridge, Big Nine
December 24, 2007

Cedric Mason, Distinguished Gentlemen
September 28, 2008

Each SAPC has a distinct style and formation, created according to the mission and direction of its founding members. Some make changes after reviewing other clubs and their practices over time. Some might restrict the number of members who hit the street for their annual parade, and others might have a come-one, come-all policy for anyone able to pay club dues. One SAPC will require that every parading member create their own accessories, and another might permit subcontracting the work after approving the club design for that season.

Some SAPCs restrict membership to family members or particular affiliations, such as attending the same school or being born and/or living in the same neighborhood. Membership is by invitation only in a majority of clubs. A number of SAPCs are service-oriented—adopting a local school that will be maintained with scheduled cleanups or painting, hosting holiday food distribution for poor families, subsidizing school uniforms for disadvantaged children, or distributing school supplies each year in August before school starts.

A number of male-only SAPCs are dedicated to mentoring at-risk or fatherless young men. Club members might invite such youngsters to attend church services (taking them to buy a suit so that they can be "presentable," even teaching them how to properly navigate knotting a tie) or to participate in selected club events to learn the nuances of organization, punctuality, and accountability. Young males are given "man-training" about handling finances, proper and respectful treatment of young ladies, how to carry themselves in the world to avoid violence, encouragement to complete their education, and preparation for leading their households and families. Often, these are purely charitable acts by club members, and in many cases, the young men grow to admire their "social uncles" and ask to be admitted into the SAPC.

The same is true for female-only and female-auxiliary SAPCs. Many "lady" clubs guide young women through specific life rituals with training that may be missing in their home environments. Female SAPCers have taught girls about taking

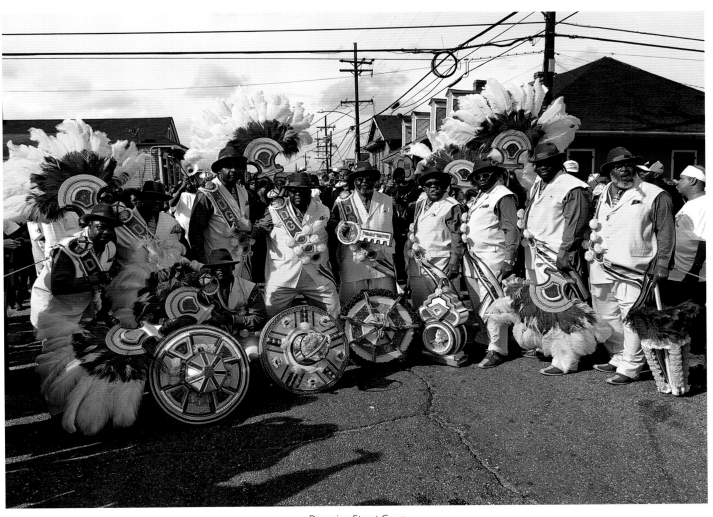

Dumaine Street Gang
Left to right: Robert "Moonie" Jarvis, James "Kelley" Terry, Byron "B" Hogan, Nathaniel "Fat" Jackson, Lawrence "Chocolate" Gains, Cornell Glasper, Rene Reynolds, Benny Ranson, William Jones. *Front:* William Todd Batiste
December 4, 2011

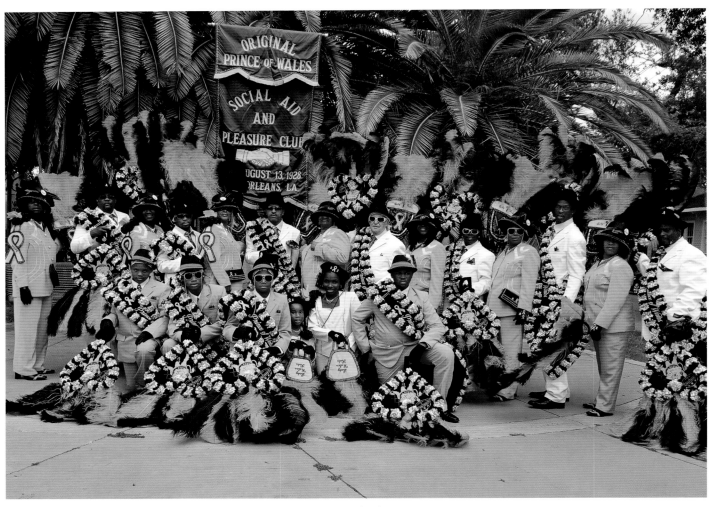

Prince of Wales

Back row (left to right): Janice Riley, Stan Taylor, Terina "Trina" Norbert, Keith Gardner, Phyllis Davis, Alvin "Quiet" Epps, Betty Coleman, Joe Stern, Adrian Pogue, Desiree "Rae" Jones, Elinore Wright, Paul "Stumbling Man" Landry, Donna Pierre, Bruce Goodrich. *Front row (left to right):* James Andrews, Nick Melancon, Henry Melancon, Amiria Smith, Shakina Crawford, Chris Rankin.

October 9, 2011

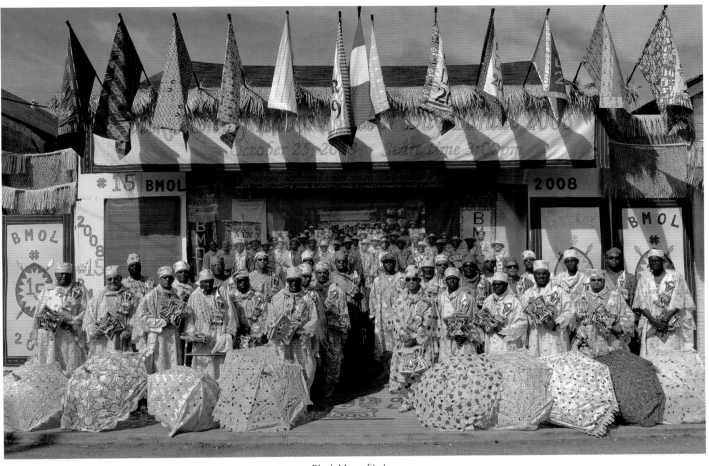

Black Men of Labor

Left to right: Roy "Sundown" Johnson, Bobby "Boozer" Sardie, Wilbert Thomas, Todd Higgins, Barry Taylor, Nathan "Raddy" Thomas, Alvin Jackson, Deshawn Burks, Willie "Molo" Johnson, Gregg Stafford, Townsley Hamilton, Tyrone Calvin, Ulyss "Rudy" Pichon, Edwin "Eddie" Lombard, Gralen Banks, Fred "Molo" Johnson, Malcolm "Wild Man" Williams, Sean Edgerson, Joseph "Lil" Robinson Jr., Paul "Dusty" Honore Jr., Harold Wilson, Arthur Williams, Ralph Walker, Mike Hughes, Bobby Parker, Glenn "Molo" Johnson Sr., Kenneth Rivere, Bruce "Sunpie" Barnes, Abdoulaye Diwa

October 25, 2008

care of their bodies and age-appropriate birth control, how to command respect as a young woman in society, and appropriate dress for a variety of environments. They also offer educational and career guidance, instruction on managing a budget, and introduction to other ritualized social options, such as debutante balls and cotillions. These relationships—for both young men and young women—are lifelong and the bonds are sometimes stronger than that of their biological families.

SPECIAL FEATURES

· ·

Interview with Lois Andrews

Member, Money Wasters SAPC and The Baby Dolls Social and Pleasure Club

Eric Waters interviewed Lois Andrews on October 30, 2013.

Eric Waters: How long have you been second-lining?

Lois Andrews: I guess I've been second-lining since I was four.

EW: Okay, I won't tell your age, but how long has that been?

LA: Sixty-one years.

EW: Sixty-one years! So how has that experience been?

LA: It's been lovely—

EW: And you are also a part of what Second Line group?

LA: The Money Wasters. I'm a Baby Doll main gang, and me and my children are about to start another group.

EW: When will that hit the streets?

LA: Well, we're working on it—

EW: Now, give me a little historical background on the Baby Dolls.

LA: Well, what I know about the Baby Dolls was that it was a lot of women who wanted to do something on Mardi Gras because of the men, they was doing their thing, and the women wanted to do their thing, so they got dressed and put on stockings, put money on their stockings and go out as a baby doll, which was really started in Storyville. Once the Blacks started the Baby Dolls club around Storyville, which was the Golddiggers, and the white Baby Dolls uptown started that too.

EW: And the Baby Dolls dress up like baby dolls? And they not only come out on Mardi Gras, they come out as a Second Line?

LA: They come out for everything now. Everything—

EW: Right . . . Now the Second Line, you come from a very historic family? Give me some background.

LA: I come from the Hughes family, the Nelson family and the Lasties.

EW: The Lasties? So you're— You and Herlin Riley are relatives?

LA: Yeah, that's my cousin.

EW: Okay, great. Trombone . . . Troy, James, and Twelve, they're your sons.

LA: I have a daughter named Tameka and a daughter named Deja.

EW: And their grandfather was a— Give me a little historical background on that—

LA: Well, Jesse made the song in—

EW: Jesse. Jesse Hill.

LA: Yes, that was my father, and we lived a life, not like the children of today. We live[d] a life like children of backstreet. Jesse and my mom would travel. We wasn't allowed to play outside, we had a backyard, it was nice.

EW: Nice— It was special.

LA: Yes, our playmates were Dr. Daddy-O, Ernie K-Doe, Brenda, Shelley Polk, they used to come over to our house, and they would play with us.

EW: So you were raised in Pontchartrain Park, and now you live in Tremé?

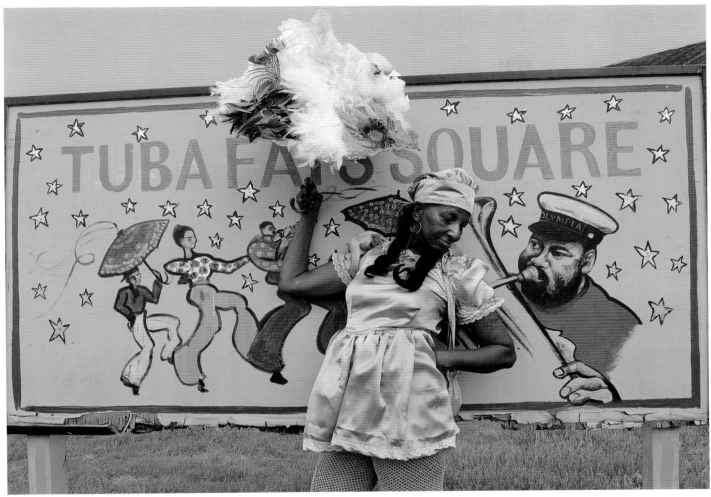

Lois Andrews
August 13, 2011

LA: No, I don't live in Tremé. I live four blocks from the lake— I used to live on St. Charles.

EW: Is that right? Yes, indeed.

LA: I was a Garden District person.

EW: Just tell people for purposes of historical relevance, Blacks were not allowed to live on St. Charles.

LA: Blacks weren't allowed to live up there at all, that was strictly for white people.

EW: Right.

LA: But I guess after Katrina, things changed, and my son bought a condominium with all white people, so I didn't live on a side street of St. Charles, I lived on St. Charles.

EW: So your whole family has been part of the Second Line, part of their existence, right?

LA: My whole family has been a part of music, Jazz.

EW: Your son is very prominent in the Second Line tradition. James— You name them.

LA: James, Buster, Troy, and Darnell.

EW: May I ask you about Darnell?

LA: Sure, we can talk a little bit about it.

EW: You know I shot that photo of you dancing on the coffin, and a lot of people have a lot of different views about that. You tell me why.

LA: Well, why I got on top of the coffin, Eric, it was because they

was [honoring him], and my son [talked about a] Second Line, but this particular day, Buster said, "What's wrong?" And I'm like, "Nothing ain't wrong." If I don't dance, then they gonna know something is wrong because all of them know I like to dance. The Second Line is my life. And when I said that, everybody stopped. And I said, "Well, why are you doing that?"

EW: So that was Buster?

LA: Yeah, that was Buster. Buster was the one that made me get up there.

EW: Yeah, sorry for your loss.

LA: Thank you. I think about it every now and then.

EW: Did you feel a sense of release when you got up there and started dancing on his coffin?

LA: Yeah, I did, I did. The reason why I felt that way was that he was letting me know not to worry.

EW: You know, when I saw you getting on top of that coffin, I lifted my camera, and I didn't know what to expect; it was just one of those moments for me. It was very, very moving.

LA: Well, you know how I look at it, like this, I was the head [of the household] bringing him in, and he was going out, that's how I look at it.

EW: Now, what is the significance of the Second Line in your life? What purpose does it serve?

LA: It's a family gathering, and it's to have fun and enjoy yourself. If you was like me, sixty-one years old, and you get out and you parade, you don't have to worry about no sickness. I don't take medicine, I don't take none of that.

EW: The New Orleans Second Line, do you have a sense that there's freedom—?

LA: Yeah, you're free! You're free to dance!

EW: Yeah, that's what I thought, but when I see it, I see people doing things in a manner that releases all the tensions and problems they may have.

LA: Yeah, it's a release, to release problems, but when it's over, those problems come back. When you think about the fun that you had for that day, it'll be all right.

EW: James and Troy Andrews have been playing in Second Lines all their lives. I have a picture of Troy when he was six,[1] so they've been an important part of musical traditions in New Orleans. Tell me something about that, too, James and Troy's involvement in the Second Line tradition.

LA: Well, when James was young, he was playing in school band, so I had to [go ahead and] give him one, too [an in-

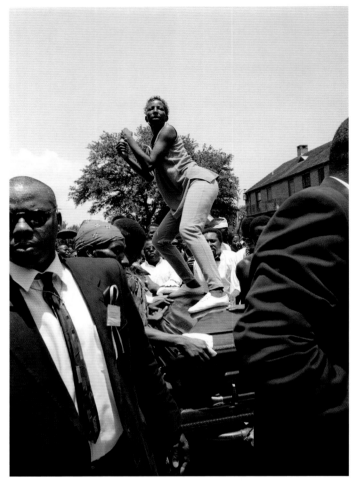

Andrews alleviates some of her grief by dancing atop the coffin of her son, Darnell (known as "D-Boy"), as it is carried through their neighborhood. April 26, 2006

strument]. He said, "See, I want to start my own band." I said, "James, how you go[ing] to start your own band?" He said, "I'm going to get all my brothers," so what happened was Darnell— [*pauses*]

Buster always did play music at my momma's house under the sink in the projects, the pots would be all bent up, we knew he was gonna be a drummer. But James wanted to play the trumpet, so we went and bought him a trumpet. He formed a band called the All-Stars; once he formed that band, I became pregnant with Troy. Now that's a story by itself! So, we didn't force them to play music, they told us what they wanted to do, so me and his daddy, we went along

with whatever they told us, wherever they went we had to go, because we had to drive them. So we've made sure that they stayed out of trouble. And we told him, "Look, you could go anywhere you want to go but not the quarters [French Quarter]. So what James would do, he would tell the band that they were going to rehearse at Armstrong Park, so when he called us to come get him, he would sneak off to the quarters and come back to the park.

So when I was pregnant with Troy, every time James would have practice in our house, I couldn't be in the house, I would go into pre-labor, I think that's what the doctor said, and it would be the worst thing. The last time I went to the doctor, he asked me what was going on in my house, and I told him every time my son would start the band up, I would go into like a labor thing. So he said, "Well, when they get ready to rehearse, you go outside." So when they would rehearse, I would go to the lake until I thought it was over. Back then, there wasn't no cell phones or none of that, so when I got home they would be finished. I went into labor early with Troy, and when I had Troy, I had him at Hotel Dieu, and me and my husband paid a pretty penny for that. And after I had Troy, they wasn't equipped to handle babies that come early.

EW: Premature.

LA: He was just like two weeks early, and they took him to the hospital on Napoleon, and they was equipped, and the doctors told me all that they was going to do and all that, when they get there. I didn't know where Troy was for about a week. During the time when the [space] shuttle blowed up, I didn't know where he was, but my neighbor used to go see him because I couldn't go; I was still in the hospital because my pressure was too high. I had to have a C-section because the cord wrapped around Troy's neck, and that happened New Year's Eve with all the noise and the bands. I guess he was ready to come then, but he wasn't born on New Year's, he was born on the second. So my aunt was going up to see about Troy, and she had them in a bed and all that, and when she come back, she'd tell me how he was and stuff like that, and she'd say what the nurse said. They said he was the crying-est baby they ever had, [and] I said, "Well, why is he crying, is something wrong with him?" The nurse said as long as they put the radio by his head, he all right, but when they moved it,

he would cry. So we know that Troy was a musician in the womb.

EW: That's a beautiful story.

LA: Yeah.

EW: Tell me the story of a club being named after him.

LA: Oh, the Trombone Shorty club. All right, that came about was [*garbled*] and all of them was young, real young, so I was like, all right, Twelve, that's the daddy, what I'll do, I was with the Jazz band, and I want Troy, and I'm gonna take and name the club after Troy, so I didn't put it in James' name, I named it after Troy. And we had a drink called Trombone Shorty. Well, the Trombone Shorty consisted of alcohol, but when he would get out of school, he would come to the bar and ask for a Trombone Shorty. The waitress would put grenadine, Hawaiian Punch, and a little 7-Up, and let him think that was the Trombone Shorty. You know I used to take him in the barroom?

EW: Well, everybody does that in New Orleans. Yeah, taking kids in the barroom, yeah.

LA: Now, this child, the first time he played, he would be on the floor in the shop wanting to know how to play that tune. And Tuba Fats would be showing him how to play that, and he did a little of the tune trying to show them how to play. And Buster walked over to a set of drums, and I used to have to sit down and hold him on my lap to play the drums.

EW: And now how many instruments does he play?

LA: Play them all. Play every day. Played the tuba last night, and it's been ten years since they've been together. You know he went to jail for doing what he liked? They put them in jail in the French Quarters.

EW: How old was he then?

LA: I think he was about ten. Ten years old and he went to jail. For playing music in front of Brennan's hotel— Brennan's restaurant.

EW: That just shows the ignorance of this city.

LA: The city, yeah. Sylvester got that paper, yeah. They put in the paper that little bitty boy with the big horn going to jail. [*laughter*] But the city know it paid off. And you know, Eric, I really think that children need the drums, and now the younguns go out there in the Quarters to play music, they not forcing nobody to put nothing in their box. I think the city should appreciate that because they not trying to hurt nobody. They not trying to rob nobody,

they just showing you what they could do. If you want to put your money in there, you're welcome, but if you don't, it's still fine. They not grabbing you and make it you put your money in there, yeah, well now you know it's a thing where they don't want them to play in Jackson Square, they don't want them on Canal Street, they don't want them here, they don't want them there, well, where do you want them, in jail?

EW: That's probably where.

LA: I know. If you go in Armstrong Park and face the Cathedral, you can see the windows with they used to watch the slaves dance in Congo Square. But then you come back and you want them to show you what they do where you can find the limit on that, I don't think that's right.

EW: I agree. You mentioned Tuba Fats.

LA: Yeah.

EW: He was an iconic figure in the Second Line culture, wasn't he? Yeah, he was a good guy.

LA: Oh, yeah. Tuba was the man! He taught a lot of them. Danny taught a lot of them. Danny Barker.

EW: Yeah, with the Fairview Baptist Church Band. Yeah, a lot of guys came out of that. A lot of what you would call our seminal musicians—

LA: Yeah, Mr. Danny used to come by my house every day, and he'd come heavy with horns. One for him and one for Troy. I'd say, "Hey, Mr. Danny where you and Troy going?" He'd say, "We going play music," but they all was playing around the neighborhood. Mr. Danny with the straw hat and a big cigar in his mouth. And my brother Fritz, he died, he used to tell Troy to call me a boss, and right now, when I be talking to him, he'd say, "Yeah, that's right, you're the boss." Yeah, you know, he'd parade too.

EW: Yeah, I know. And you also can dance up high.

LA: Everybody see me on Darnell's coffin, so they wanted me to do it on [they] coffin. But you know what? Everybody can't dance on top.

EW: Oh, I know.

LA: Not when they moving.

EW: It was for Darnell. They was moving, and they were carrying it to the street and you were dancing.

LA: The coffin is slippery on top. There's a certain way you have to stand up there. And why I do it, I don't know.

EW: You know why you do it. You been doing it because you love it.

LA: I love it, Eric.

EW: It's a passion for you.

LA: I was born in the Sixth Ward. I was raised in the house with music. My uncle, my uncle Papoose, name Walter Nelson, was Fats Domino's guitar player, he died at the hotel in New York. And my other uncle, LaLa, named Warren Nelson, he made "You Put the Hurt on Me," and my grandfather, he played with Papa Celestin, Louis Armstrong, Alfred Hicks, Louis Belson, that was it, a lot of music.

EW: So James, Buster, and Troy come from a musical lineage, yeah.

LA: Yeah.

EW: That's fantastic. You know, I gotta commend you. Your son, he's just regular people. Whenever I see Troy, he comes up and he talks to me. I saw him in Atlanta, he's always the same. He's a fine young man, a fine young man. And James, he's a regular dude.

LA: James is a comedian.

EW: He's regular people.

LA: You know what he tells me now? Ain't no future in that life. [*laughter*] He's doing all right. My oldest daughter she drives a school bus. She doesn't want nothing to do with playing no music, but my baby girl, she's at (Ellis) Marsalis' school right now, she's taking piano.

EW: Do you have any musical talent?

LA: No, I just like to dance.

EW: Well, you gave birth to kids with musical talent.

LA: My mama had twelve children. And out of the whole twelve, all of the no-talent fell on me.

EW: Why was your husband called Twelve?

LA: Because he liked to play dice. And he always shot the dice, and he always came up with twelve.

EW: James is called Twelve also.

LA: James is called Little Twelve.

EW: Is there any more that you want to add to this interview?

LA: Ain't nothing more that I could think of, Eric. If you ask me, I'll tell you.

EW: I'm trying to think— I been photographing you for years, and it's just an honor and a pleasure to be able to talk with you. The Baby Dolls is a special thing to me, as a photogra-

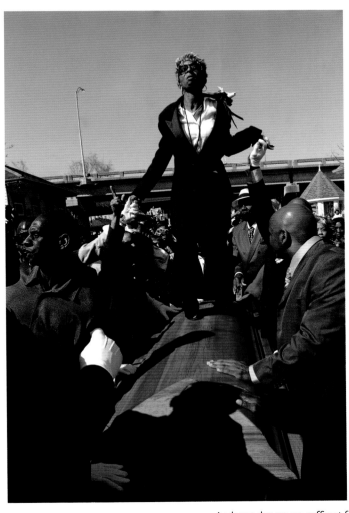
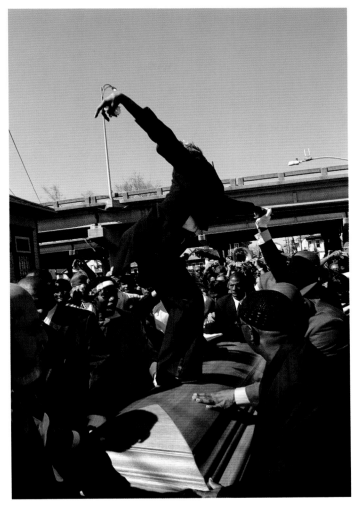

Andrews dances on coffin at funeral of her brother, Fritz Nelson.
February 6, 2008

pher I can only shoot what's there. But they got to respect the people that's important, I've always tried to do that. Anything I have—

LA: You always give it to me, yeah.

EW: Going back to your grandfather, uncles, has anyone talked to you about them? I don't know if it's ever been done before—

LA: No, nobody's ever done that on us— I done read stories that their people have wrote about my family and others, but what we read is not true. Half of the stuff you read is not true. Instead of coming and ask, they write [garbled].

EW: Well, if you decide to allow me to do it, I'd be happy, I'd be honored.

LA: You've been trying to get me for a long— but, feel me, I'm always on some issue.

EW: That's a good thing. You got to keep moving, you know what the alternative is if you stop moving?

LA: If I stop moving, I'll be with a walking cane. That's why I got to second-line.

EW: There you go, there you go, there you go! What's the next Second Line coming up? You know, Sylvester's is Friday.

LA: All Saints [Day]. I'm in that.

EW: I'll be there.

LA: All right, all right. We bury everything down here, dog, cat, bird—

EW: [*laughing*] What do you think about (the) Second Line being appropriated by white people? You know, everybody's second-lining now.

LA: I don't have a problem with white people second-lining, but I do have a problem with them trying to take the culture away. I think, you know, you want to second-line, come on and join one of our clubs. Don't take and form your own club to take that away from us. Y'all got Rex, you know, all them parade clubs; we ain't got nothing but Second Line. That's all. You want to come, you're welcome. But don't try to take our culture.

EW: Another example of—

LA: Yeah. They be out there selling Pradas, they sell beer, but the city humbug with the Blacks about selling beer, but not the whites, and I think that's wrong.

EW: Yeah, it's another standard. It's all a part of the racism that exists in America.

LA: Ain't nowhere in the world besides Zulu, no Black parades on Mardi Gras. So if we say we gonna go parade in front of Rex, we Dorothy Taylor.[2]

EW: But we have our Sundays.

LA: Yep, but we have our Sundays, and they have their Sundays, too. They gotta go in front of Tipitina's, they white.

EW: Lois, thanks again.

LA: You're welcome.

EW: Appreciate your time. Thanks for taking time out of your busy schedule.

LA: Yeah, it's busy, Eric.

EW: I feel honored, I really do.

NOTES

1. For a photo of Troy Andrews at age six, see chapter 8, "Inheriting the Line."

2. Dorothy Mae Taylor, an African American who was president of the New Orleans City Council, battled old-line, wealthy Carnival organizations such as Rex, Comus, Proteus, Momus, and other exclusive "blue-blood" clubs in 1992 to integrate their memberships. Taylor authored and pushed an anti-discrimination city ordinance that passed after a bitter public hearing banning discrimination in Mardi Gras krewes due to their use of city funds and services to host annual Carnival parades. Comus and Momus never again held a public parade.

Oliver "Squirk" Hunter

I always look at Second Line [as] a spirit thing to me. . . . I look at a guy blowing an instrument coming from [his] inside to my inside. So when you blow, it come from your inside out, it go to my inside. It's a spirit thing for me.

—OLIVER "SQUIRK" HUNTER

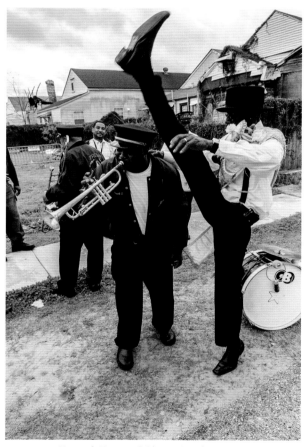

Kenneth Terry and Oliver "Squirk" Hunter
February 22, 2012

I say, [in a Second Line] do what your spirit tell you to do. It's endurance, it's self-creativity. It's part of our life. This is my strength, it feeds my spirit, and I'm proud to be part of that . . . this is God-given. I love that every Sunday, you can get out of your bed and get on a Second Line.
—OLIVER "SQUIRK" HUNTER

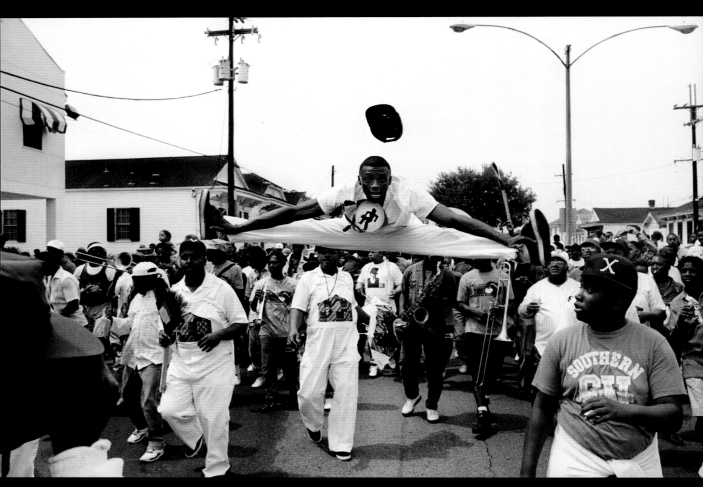

Super Sunday 1993

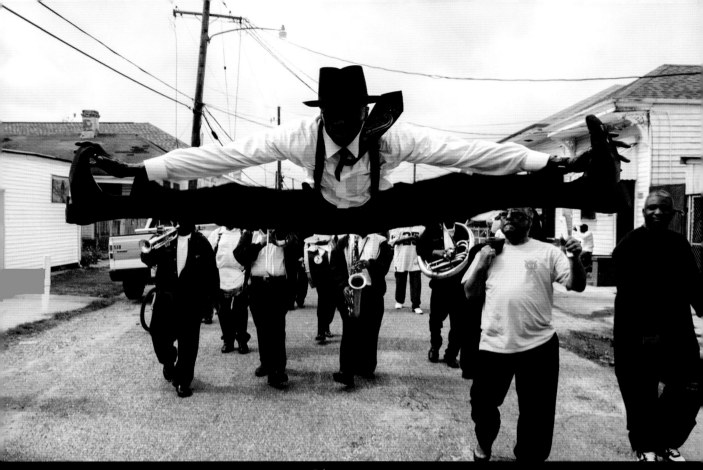

February 22, 2012

The acrobatics of "Squirk," whose gravity-defying, hat-flying feats amaze even regular parade-goers, displays the jubilation of second-liners at the height of a parade.

ESSENTIAL RHYTHMS

A Musician's Life in the Second Line

MICHAEL G. WHITE

For a young musician, being in Doc Paulin's band was like going to school. It was a unique way of gaining authentic, hands-on experience that could only happen in New Orleans. Where else could you be a Jazz musician for years and never play a solo? Every song was done in the New Orleans ensemble improvisation style: with three-part trumpet melodies or lead lines; trombones that played sliding tailgate and punctuating rhythmic figures; saxophones that played rhythmic riffs; and with the drums and tuba expounding on their characteristic driving syncopated pulses. The clarinet was free to soar above the ensemble: filling in empty spaces, playing high-note harmony to the melody, or dancing and weaving in response to the trumpets' lead.

To survive in Doc Paulin's band was almost like being in the military. You had to be disciplined and tough. You were thrown into a situation in which you had to learn how to listen, improvise, and contribute by following the basic role of your instrument. You had to develop a strong body and lips to endure the long, hot, sometimes grueling six-hour-plus Social Club parades. Doc was very proud and adamant about not only the look and punctuality of his band but also its sound and repertoire. He made sure that each musician "held up his end," or they wouldn't be hired again. It was the start of a very different kind of education, unlike any that I received in formal school-

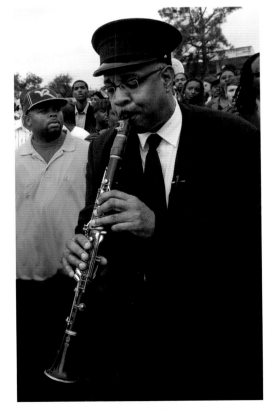

Dr. Michael White
January 6, 2007

ing; one that would teach me about the meaning of community, heritage, tradition, Black history, values, spirituality, identity, and life.

My first job was on a hot Sunday in May 1975. After driving over the Mississippi River in Doc's beat-up old station wagon, the band was standing in front of Macedonia Baptist Church in Marrero, Louisiana, with church members in line in front of and behind us. Then a few trumpet notes came from behind me, followed by a drum roll to begin the music and the church's anniversary parade. "But wait a minute. What song are we about to do? What key is it in? What do I play?" Too late. A thunderous "BOOM, BOOM, BOOM" from the bass drum introduced the hymn, "Lord, Lord, Lord, You Sure Been Good to Me." From the first notes, the music was an exciting mix of melody, improvisation, and driving rhythm that made the church members strut ever so gracefully along to the music. I remember just trying to place a few good screaming high notes in empty spaces. After an hour and a half of parading around the neighborhood and my skating through up-tempo hymns, the parade ended. We went back to New Orleans, and Doc quietly slipped everyone a folded hand of cash. I went home feeling a sense of accomplishment for having played a professional music job in spite of not really knowing what I was doing.

There was no way of knowing then what would be the significance of that Sunday-afternoon church parade in 1975. I had embarked on a path that would forever direct my life toward a long and rewarding career in Jazz. It was the start of an informal apprenticeship in traditional Jazz that had been standard for New Orleans musicians since the earliest days.

I talked to older players and listened to the only brass band record that I had, the Young Tuxedo's *Jazz Begins,* to hear how clarinetist John Casimir was able to cut through the louder brass and drums. These methods, along with getting a more open mouthpiece and stiffer reeds, solved the volume problem, and I soon secured my place as a key member of the Doc Paulin Brass Band. Over the next several years, I played dozens and dozens of "to do's" (jobs—mostly parades and funerals) with Doc's band—over 160 in all. We performed all over New Orleans and in surrounding areas like Metairie, Marrero, Gretna, and Kenner. We also had work in small rural areas—Westwego, Waggaman, Hahnville, and Independence, Louisiana. Doc's group—like other brass bands had done throughout most of

the twentieth century—featured a repertoire of songs commonly played in traditional Jazz: marches ("Panama"); hymns ("Bye and Bye," "Lord, Lord, Lord," "Just a Closer Walk with Thee," "As I Walk through the Streets of the City," "Just a Little While to Stay Here," "Down by the Riverside," and "When the Saints Go Marching In"); blues songs ("St. Louis Blues," "Whoopin' Blues," and "Joe Avery's Second Line"); and Jazz standards and old pop songs ("Tulane Swing," "Margie," "Bourbon Street Parade," "Paul Barbarin's Second Line," "Baby Face," "Let Me Call You Sweetheart," "Down by the Zoo," and "Bye Bye Blackbird").

All of the songs were played in a characteristic swinging medium up-tempo—perfect for the characteristic leisurely New Orleans Second Line dancing. The only change in tempo came during the early part of Jazz funerals, when hymns like "What a Friend We Have in Jesus," "Just a Closer Walk with Thee," and "Old Rugged Cross" were played in a slow dirge tempo. Unless one was part of that culture, it is hard to understand the power and impact that the original traditional Jazz style still had in Black New Orleans during the mid-1970s. Many, especially outside of New Orleans, erroneously viewed traditional Jazz as irrelevant "old people's music," "primitive and archaic Jazz," "white music," or music played by Black people "tomming" to satisfy stereotyped white perceptions, but the great majority of Doc Paulin's work was in Black community parades, funerals, and other events. Far removed from the atmosphere of nightclubs, tourism, and the French Quarter, the brass bands remained largely Black music played by and for Black people. Among the many ironies surrounding these decades-old traditions is the fact that these processions were the most widely attended and socially relevant traditional Jazz events in the world. In both uptown and downtown African-American New Orleans neighborhoods, the authentic traditional Jazz style was accepted and danced to by countless thousands of all ages and levels, from the oldest of the old to the hippest of the hip to the youngest of the young. Many times I've seen babies too young to walk wiggle in tempo in their mothers' arms.

Doc's reputation for having uniform band appearance, charging lower prices, being punctual, and providing good Jazz that remained strong from start to finish assured that his band was among the most visible and popular groups hired by community organizations for events. We regularly played for nearly every Black Social, Aid and Pleasure Club, benevolent or-

Terrell "Burger" Batiste
July 18, 2011

appearance, dancing, humor, speech, laughter, mannerisms, experiences, hopes, joy, and sorrow—all converted into hot, expressive, rhythmic Jazz, accompanied by the loose, creative second-lining of Social Club members and the hundreds of anonymous people who followed alongside.

Although the Social Club parade season ran from late August into June, there were occasional community parades year-round. A club's annual parade was usually held on a Sunday, beginning in the late morning or early afternoon, and lasted about six hours. Uptown club parades started either at the intersection of Jackson Avenue and Simon Bolivar Avenue or a little farther uptown at Washington Avenue and Lasalle Street. Downtown parades often left from Claiborne and St. Bernard Avenues or from the Tremé section.

Black Social Club parades didn't have floats, masks, throws, cars, high school bands, or the largely passive onlookers associated with Mardi Gras parades. The first thing you saw in the parade was men in street clothes carrying the club's banner, the American flag, and the Louisiana state flag. Then came the main body of the parade: divisions of club members walking or dancing in front of and behind one or more brass bands. Large parades could have many divisions and up to five bands. Club members wore elaborate, boldly colored outfits with matching hats and shoes, and they often carried decorated ornaments like umbrellas, handkerchiefs, fans, and baskets. The brass bands wore black pants and white shirts and black ties with white band caps, though some groups were starting to use T-shirts with the band's name or logo by the 1970s.

From the first beat of the bass drum, dozens of people would begin to appear from everywhere and follow the parade in the streets and along sidewalks, dancing and cheering the whole time. As the crowd grew larger and the music and dancing increased in intensity, the entire scene was converted into a kind of spiritual dimension in which there was total freedom, a uniting of souls, and a constant reinterpretation of earthly reality. It was impossible to see more than a fraction of the endless variations of the West African–derived Second Line dance that was going around. Individual and collective movements were as common and fleeting as the constant ripples of waves in the ocean.

Among the sea of gyrating bodies that surrounded the band and club, there were dancers everywhere: on top of cars, belly down in the street, on porches, swinging from telephone poles,

ganization, and fraternal group parade, including the Elks, Eastern Stars, Odd Fellows, Young and True Friends, Young Men Olympian, Prince of Wales, Zulu Club, Money Wasters, Scene Boosters, Lady Zulus, Jolly Bunch, and Sixth Ward Steppers.

The Social, Aid and Pleasure Club parades that Doc's band played were the most exciting and revealing work that we did. It was there that I was first exposed to the purpose and meaning of Jazz, as well as to its unique social significance in New Orleans. The parades were the ultimate expression of living community folk culture and a model of democratic culture. As they passed through neighborhoods and different sections of town, you could see and feel that the exciting brass band music was an expression of the lives and spirit of the people—their

on the rails of bridges, on rooftops, and some on the backs of others. They jumped, twisted, shook wildly—as individuals or as impromptu couples or groups—constantly forming and reforming. Some dancers would get "possessed by the spirit" and move their bodies in ways that seemed supernatural. At slow periods and stops along the parade route, club members and second-liners sometimes formed small circle dances. The entire scene seemed like a contemporary, mobile version of the famous nineteenth-century Congo Square dances. Many viewed the Social Club parades as a unique "New Orleans thing," but I learned later that several West African nations maintain centuries-old traditions of similar massive social processions—complete with bands (though the music and instrumentation are very different), umbrellas, handkerchiefs, boldly colored outfits, and second-lining crowds of followers.

The music and dance not only inspired each other, but at times they seemed to switch roles. Often, I remember when song titles, structure, and keys became almost insignificant, as the dancers seemed to take control of the sound and spirit of the band. It was mystifying to see a magical transformation in which notes seemed to leap from my instrument and take gyrating human form. I would feel dancers key in and have their movements draw exciting new sounds and phrases from my instrument that came *through* me but not *from* me. There was a feeling in those Social Club parades that everyone was free and equal to be open and express themselves with acceptance without the normal societal limitations and judgments. Common social dividers disappeared as young and old, middle-class and poor, dark- and light-skinned, educated and illiterate, physically handicapped, well-dressed and ragged, mentally challenged, flamboyantly gay, beautiful and unattractive—all seemed to rise to a level of royalty and nobility. Over the years, I developed a number of friendships with club members, other musicians, and second-liners who followed Doc's band or liked my clarinet sound in particular. There was a sense that we were all family, uniquely bonded by our special spiritual music and ancestral tradition.

When swept up in the magic spell of Social Club parades, things like ninety-plus degrees of humid heat, blisters, feet burning through the soles of your shoes, soaking-wet clothes, sore lips, bloody clarinet reeds, and hours of walking and hard blowing seemed minor—until later that evening. The parades made stops at houses, bars, or housing project apartments

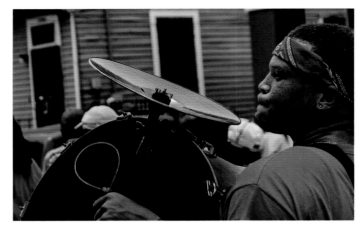

New Division Brass Band
May 25, 2014

where club and band members were given refreshments and got a few minutes of rest. The climactic end of the parades (a stop at a designated location and final rousing song) sometimes occurred miles from the starting point, on the other side of town. Band and club members usually had rides back to their cars. Dozens of second-liners—now without hot music and thus out of the trance—were disgruntled that they had to walk all the way back the same distance that they had just *danced*.

The die had been cast for new groups to form and mimic the popular trend-setting Olympia Brass Band, or to consider the concept of changing or shaping a brass band to fit their own needs, desires, musical tastes, and abilities. The Majestic Brass Band, a nonunion group consisting of several ex-Paulin members and other younger players, became popular on the streets and began to play contemporary pop songs like the 1970s Loggins & Messina hit "Your Mama Don't Dance and Your Daddy Don't Rock and Roll" with rhythm and blues–style horn riffs and solos. The first radically innovative new group, young trumpeter Leroy Jones's Hurricane Brass Band—formed in 1974 from the first generation of Danny Barker's youth group, the Fairview Brass Band—began appearing in Social Club parades more frequently. They wore T-shirts and blue jeans, no hats. Jones's band developed a repertoire of songs that featured unified swing-style horn-section riffs playing under his blaring bebop-style trumpet lead and solos, which seemed to herald the dawn of a new era. The Hurricane offered its original version of

traditional standards but also expanded the repertoire to include current soul radio hits such as "K-Jee" (originated by the 1970s Detroit-based R&B jam band New Birth, which evolved out of the instrumental band The Nite-Liters).

Olympia Brass Band tuba player Anthony "Tuba Fats" Lacen developed another very influential change. Sometimes when Doc's band came to a rest stop, the groups ahead of us would already be there getting refreshments. Lacen and his tuba were too large to fit comfortably into the chaos of the crowded small bars and homes. Staying outside with the riled-up second-liners, he began to play a two-bar solo tuba riff over and over, to which the crowd played percussion and danced. Other musicians eventually joined in, and the hip, modern-sounding riff became the basis for several new songs. Lacen had already been modifying the tuba style from a two-beat approach to a smoother four-beat rhythm. He told me once that he was trying to sound like a string bass for when the Olympia band played concerts and small band jobs. And so, Lacen was a pioneer of the new style, which brought the tuba to a more prominent role as a lead and solo instrument. His innovative tuba style is the original model for the driving lead bass sound commonly heard in dozens of contemporary brass bands.

In 1977, we started to hear talk on the street of a new group called the Dirty Dozen Brass Band, which was causing quite a stir by wearing street clothes and playing a completely new style unlike any other. Eventually, I encountered them at a club parade. Their sound was tight and organized. Their tempos were very fast. Their songs and style were a mixture of older and original songs that blended modern Jazz, rhythm and blues, brass bands, Mardi Gras Indian chants, and school marching band influences. At first, they received mixed reviews in the community. Some found the Dirty Dozen's pace too fast for second-line dancing, but the Dozen captured the voice and spirit of a younger generation in a way that none of the conventional brass bands could have. Many traditional bands had settled into a static repertoire of limited songs that were played the same way time after time. The Dirty Dozen was fresh, hot, young, and exciting. The group's obvious rebellion against and extension of tradition expressed the sentiments of a post–Civil Rights Era generation challenging established values and seeking change. This was the evolution of the brass band: an update of tradition with a contemporary sound and attitude.

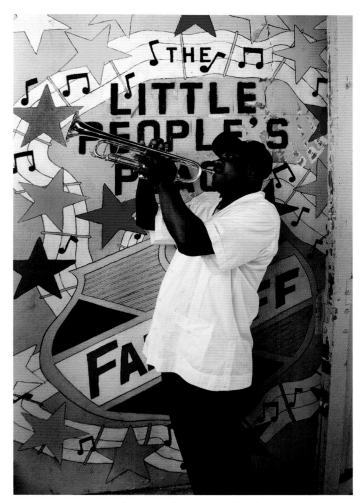

Kenneth Terry at the Little People's Place
November 1, 2013

Many credit Danny Barker for spearheading the explosion of new brass bands that took place during the 1980s and led to today's active scene. In 1970, Barker's noble attempts to keep the Jazz tradition alive and to help young kids learn about their heritage resulted in his forming the Fairview Baptist Church Christian Brass Band. The first generation of the band consisted of teenagers, like Leroy Jones, Gregg Stafford, and Lucien Barbarin, who all became important players on the New Orleans scene. Jones formed the Hurricane Brass Band, some of whose members went on to form the Dirty Dozen in 1977. The Dozen was a major influence on the Rebirth Brass Band, founded in

the early 1980s. Those two groups shaped the modern brass band sound and inspired the formation and style of dozens of contemporary brass bands today.

In 1979, after four years of playing almost exclusively in Black community Social Club parades, church processions, and Jazz funerals, I left Doc Paulin's band and joined the musicians' union. I was immersed in another "school" for several years through an association of older musicians who were born between the late 1890s and 1910. These second-generation musicians shared a wealth of experiences learned among their contemporaries such as Louis Armstrong, Sidney Be-chet, George Lewis, and many others. The very fulfilling and rewarding life in Jazz that I have had for over forty years has continued to teach and challenge me. It has forced me to keep growing and made me more appreciative each day of the blessings and gifts that God has bestowed on me. I was fortunate to experience Jazz in its natural environment, among people who not only understood the music and lived the music but also *were* the music. These were my people, and I feel the responsibility of keeping this incredible Jazz tradition alive, teaching it to younger generations and sharing it with the world.

· · · · · · · · · · · · · · · · · · ·

Rollin' and Strollin'

KAREN CELESTAN

It just makes no sense at all that the New Orleanians who create the culture that attracts tourists
from around the world are, for the most part, "struggling people."
—CAROL BEBELLE, executive director, Ashé Cultural Center, New Orleans

This conscious/unconscious feeling and joy is rooted in devotion. The pull of the Second Line is so strong that people participate without a thought about weather, buildings, cars, street signs, or any external obstacle. And the camaraderie is so deep that second-liners live it in full-throttled glory.

"[Second Line] is one big family. One big family. One big nation, one spirit," said Oliver "Squirk" Hunter. "And look, when you get in that spirit, you gonna know, I tell ya!"

Granted, some folks have shape-shifted the joyfulness by imbibing alcoholic beverages and other substances at Second Lines. Also, there has been the occasional violent incident, but that is an anomaly, given the number of parades that take place each season. Most Second Lines are peaceful events with the vibe of a huge barbecue or a birthday party, all tangled up in an organized mishmash of music, dancing, and celebration.

Second Lines have helped wounded people find healing and rejuvenation through engaging in collective release in post-Katrina New Orleans. The energy and emotion exuded was cathartic in a number of ways. It allowed Black citizens to laugh, cry, reconnect with friends and neighbors and old neighborhoods, hear the music that informed their lives, and go forward with renewed vigor and purpose.

An unfortunate by-product of any pure venture is its eventual dilution or cultural appropriation. The Second Line has be-

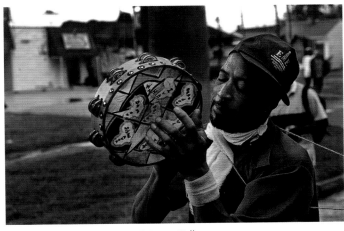

Brinson Colbert
November 1, 2004

come a moneymaking vehicle for the City of New Orleans and a host of vendors.

Brass band musicians have been afforded the ability to make more money due to the plethora of parades held all over the city, particularly in the French Quarter. Conventions and businesses from near and far often host parades to celebrate the opening or closing of an event. New Orleans has grown into a destination city, especially for weddings, and people come

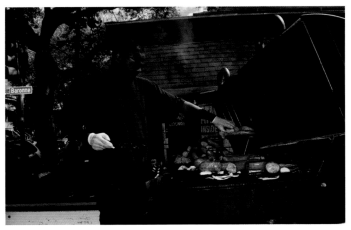

March 12, 2011

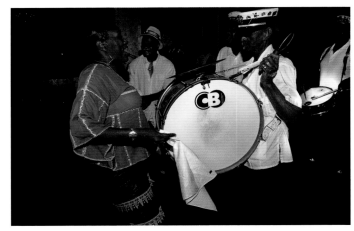

Ausettua Amor Amenkum and Lionel Batiste
August 9, 2008

from all over to re-create what they have been told or have seen on television. Most travel agents, convention bureaus, hotel concierges, event coordinators, and public relations firms hired to market the city are staffed with people who don't know the full history of Second Lines and, either consciously or subconsciously, tend to minimize the culture's African-American face to their clients. A sanitized version of the Second Line appears in marketing material disseminated by city and state officials.

A notable example of sterilization that may or may not have been by design is a highly stylized national television commercial for Wild Turkey bourbon that aired in early 2017. Hot 8 Brass Band members are dressed in black suits and meshed into a dark canvas that gives only fleeting shots of instruments as the music plays. The thirty-second commercial closes with the ad's director and star, Matthew McConaughey, tinkling out a number on the piano. The band's social media tag does appear for about three seconds as the commercial closes.

This success can be a sword of Damocles for brass bands. The aggregate can make more money and expand their brand, but have to maintain their neighborhood repertoire and swagger to bring the funk for SAPC and memorial parades. One band, Rebirth, has been able to navigate that delicate balance by being in demand during the Second Line season and maintaining their regular Tuesday-night gig at the uptown Maple Leaf Bar, where their audience is comprised of young, white, upper-class college

students attending nearby Loyola and Tulane Universities.

According to the *Times-Picayune* article "Selling the Second-Line," by Chelsea Brastead (September 11, 2016): "Of the businesses and conventioneers that have hosted their own second-lines, there are few local names. Instead, the applications are from Home Depot, IBM, Jason's Deli, the American Bar Association, the National Association of Mortgage Field Services, Southwest Airlines, Planet Fitness, Bridgestone, Nike, the New Jersey State Bar Association, the International Convention of Exhibit and Fine Art Transporters, John Deere and music artists Nick Jonas and Jidenna, who hosted second-lines for music videos. There was even a second-line for Sonic Drive-In, which paraded for the unveiling of its Saints-themed Who Dat Burger."

Brastead's article went on to note: "Between the summers of 2014 and 2016, there were 2,482 second-line applications submitted to the city. That's three times more applications for second-lines than there were days. Only 5.7 percent of those applications were 'for the traditional New Orleans social aid and pleasure clubs or memorial second-lines.'"

New Orleans' city administration benefits from this heightened out-of-town interest in Second Line culture, especially through the cost of permits that are required in order to parade on city streets and the police escorts needed to close roads and provide security. Brastead reported that "each parade permit application filed by an individual, such as those for a wedding or birthday party, requires a $50.25 fee paid to the city" and that

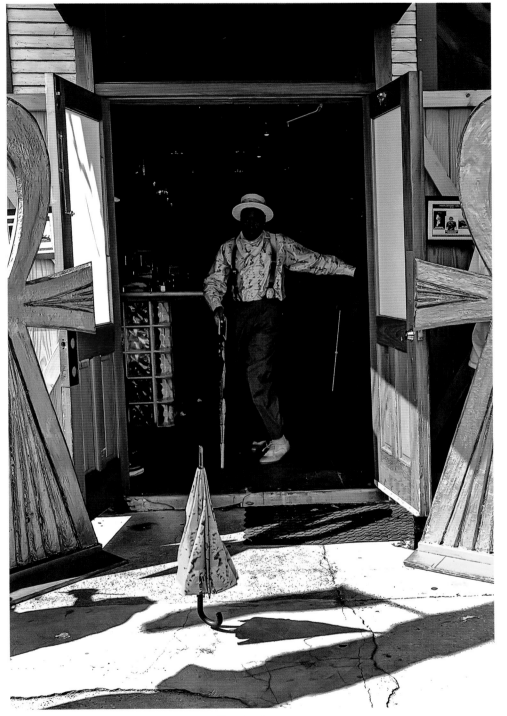

Throwing Down
Nathan "Raddy" Thomas, Black Men of Labor
September 5, 2004

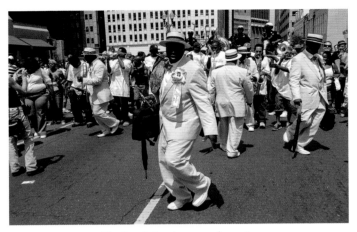

The Revolution in seersucker suits
March 31, 2008

"for a business, the application costs $200.25. Police escorts, which are required, start at $384.98."

A calculation of the baseline fees of $585.23 per business for two thousand parades over two years adds up to approximately $1,170,460 going into city coffers.

Due to all of the monetizing and appropriation by entities outside of the culture, there remains a fundamental lack of understanding about the etiquette that surrounds a Second Line. Some SAPC members hired to "perform" at city events have shared stories of being verbally and physically accosted by naïve, drunken conventioneers wanting to dance with them or touch their hair. It should be noted that SAPC members and their parade, even in a pay-to-play setting, are on par with the bride and groom at a wedding—you're free to enjoy yourself, even pushing an envelope or two, but you are never to upstage the couple or disrupt their special day. And so it is with an SAPC parade—if you don't know, just observe and then behave in accordance with others in the scheme of the event.

It's important to understand that you are in a public/sacred space and can't jump up on the altar and gyrate in the middle of a service. There's a difference between getting the proverbial Holy Ghost and behaving like you are high at a rock rave—it is wise to remember your home training. The Second Line is not about you or your desire to be seen as cool or "down" with Black people. Pay attention to the assembly's vibe and flow. Don't jump the rope line designed to maintain the order and safety of the SAPC and the brass band. Pay attention to the arena that you're in—musicians in full parade mode might swing an instrument to hit a particular note, and a strike to the forehead by the slide of a trombone, the bell of a tuba, or a drumstick could result in a trip to the emergency room. Spatial awareness can help you get into the rhythm of a parade (the "sweet spot" that touches your spirit) and avoid injuring a fellow second-liner. Give latitude and space to more experienced second-liners and don't feel compelled to challenge them (you will be made to understand why, quickly!).

Honor the ritual, respect the culture-bearers, and avoid any notion of trying to overtake the moment. Just be . . .

Interview with Wanda Rouzan

Educator, singer, actress, dancer, grand marshal (retired)

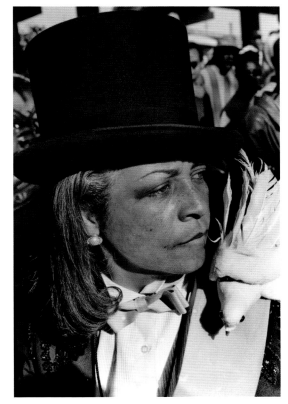

Wanda Rouzan, grand marshal, at
Danny Barker's funeral, 1994

Karen Celestan interviewed Wanda Rouzan on September 18, 2013.

Wanda Rouzan: There are only three women, and I'm not sure what your focus is going to be, but let me preface it, there were only three women to my recollection that I would see second-lining, grand-marshaling, leading the Second Line. And one, of course, was Ellyna Tatum—

Karen Celestan: Yes, I remember her.

WR: Who I considered to be *the* female grand marshal, because I didn't know about this "tradition" per se because it was mostly male. But when I started going to Second Lines, I started seeing another little woman, she would be dressed up in a tutu, red and black, with a little derby on her head, playing the flute. And the third woman, I don't know her name, but if anybody was shooting Second Lines back in the day, the 1970s and early 1980s, these three women—well, Ellyna would have passed by then—but before that, and the other woman was Felicia. Either Felicia Jones, but she's Benny's [Jones'] kinfolk, I want to say she's Benny's sister because I have asked him about this woman. And I would always see her dancing, and you know the little guy that sometimes leads the Tremé who went even before Uncle Lionel passed, and he used to lead the Second Line band that

was at Harrah's, that's a kinfolk to that bunch. And I think that might have been Felicia's brother. That's the names that come to mind, women—

KC: I remember Miss Ellyna, I don't recall those other two, but Eric might have photos, but I'll double-check with him, but he wanted to focus on you because I think he has more of you—

WR: Sure, sure, because those were the days when I was new to it and just loved it and with a passion for it.

KC: Well, let's talk about tradition, and I'm going to reference a situation that you and I had years ago, it might have been one of the Humphrey brothers' funerals, I can't recall, but people, we were all just into it, and I inadvertently got ahead of you. And I remember you did— You just, this little thing you did, you had a fan and you kind of—

WR: —And I moved you out of the way!

KC: —And kind of hit me on my shoulder, as if to say, "Girl! What are you doing?!"

WR: That's right. [*laughter*]

KC: So talk a little bit about that. And I wasn't offended, I was like, "Oh, oh, what am I doing? And I realized—

WR: [*laughing*] You know, when I think about it, and I don't always think about it, but, for me it was like . . . I was a young girl at Xavier Prep High School and I became a majorette, it was my passion. I loved dance, and people think sing, sing, sing, but I always loved to be a dancer. I was the lead, the head majorette. That head majorette led the majorettes *and* the band with the bandleader. You were always in front, nobody got in front of you because you were the lead and you directed it and that was your job.

KC: Yes, yes.

WR: And that is the same parallel that I make to [being] grand marshal and that is the rule of thumb—that the grand marshal leads the first line, and those people that come behind are the Second Line. Hence the name Second Line, and they follow the band, so as a result, when people jump in front of the grand marshal to lead, because they want to be in it, too. You know, in New Orleans, we don't just observe, we have to be in it! And we understand that, it's the culture.

KC: And we forget! We get caught up. We forget.

WR: And not only do we forget, we don't know.

KC: That's true.

WR: That's because we're involved and loving every minute of it,

and so when somebody comes, it's a gentle nudge. A gentle tap.

KC: Yes, that's what it was. [*laughter*]

WR: Then it gets less than gentle when there's a paparazzi feel about it. When there's "I want to be in the picture," "I want to be in the mix," and "I want to be it!" So, it gets to a point where it's not like that for me, it's not about me "being it," it's about being that respectful leader. And so, for example, a funeral, just to give you an example, Johnny Adams' funeral was a little chaotic because first of all, he wasn't a trad [traditional Jazz] cat, and so they hired a Second Line band to do the funeral, and it's a difference. Because if it's a trad cat, then it's part of the tradition of the Second Line.

KC: Like Michael White.

WR: Like Danny Barker, like Blue Lu Barker, like Teddy Riley, like Ervin Charles Jr., that's just throwing out some of the names.

KC: Doc Paulin.

WR: The ones who I've led. So, everyone just comes out! Because that's the tradition. John Brunious, you know. So when it's not a traditional person, like a Johnny Adams or an Ernie K-Doe or— And those are people whom I have grand marshaled as well, it was a different kind of grand marshaling completely, but we can talk about that later. But it was like, James Andrews was there and leading the brass band. He was so aggravated with the whole paparazzi thing, and I had never seen anything like it before. They were obnoxious, out of control with the pictures coming out of Rhodes on Washington Avenue to get those pictures. You couldn't even move hardly. I had to pat him and say, "You have to calm down and let me do my job." Because cussing them and swearing at them—

KC: But it was a funeral.

WR: So I politely moved in front.

KC: That's why I didn't stay.

WR: So you knew.

KC: You get that feel that it's not going to be, you just get a feeling.

WR: And that's what it was. Ultimately, once I was able to calm him down and move in front and do what I do, it was graciously using that umbrella not over my head to block the sun, but moving it to move them out of the way. So, to nudge you and to move you and to lead is what that job

is and to take that individual home in an elegant and respectful way with the dirge in front until we cut that person loose. And once we cut him loose, and I'm a real stickler for that process happening, because it's too often that the youngsters jump the process, and they want to jump before the person or the body has been cut loose. Now if you have ashes or something, that's different because it's more of a tribute rather than an actual funeral.

KC: So tell me what that feels like for you, you've been leading for all of your life, in a sense. So tell me what that feeling is like when you've got a good Second Line and the band is rolling and the people are doing it in the way that they're supposed to be doing it, what does that feel like for *you*?

WR: It just puts a smile on my face even though it may be a sad time and I don't look like I'm happy. The ultimate feeling is "rejoice" because I know I have stepped. Because you hear people say, "Aw, girl, go 'head and step!" And for me, stepping, for that person, strutting for that person, doing my number for that person, is a tribute. And it's from the head to the toe. That's the only way I can describe it to you.

Even when I'm putting that sash on and when I'm putting that hat on, and when I'm laying out my regalia, as I call it—my sash, my whistle. And if I'm missing any part of that, something is missing. So, before I go, it's almost like I have a checklist, I have all the things that I need. So it's very special, the feeling, sometimes it just sends chills. When you have the music, and I mean, when you have a *huge* band— See, when you really have the Second Line and you have such a huge conglomeration of musicians, from all cultures, from Europe, because when the Europeans, when they know there's a *real* Second Line, for some[one] who's passed, they come out, they want to get it as much as the guys who are in it because they want to be a part of it. So when the band is huge and the crowd is huge, like in Ellyna or Danny's funeral, or even David Lastie, those were some of the largest funerals that I've ever second-lined, traditional, that I've ever grand-marshaled. Now, other ones were more like a parade and that had a different feel when you had three or four bands, and the floozies, and it got to be, well—what? [*laughter*] It got be more of a parade. So it is what it is.

KC: So you've done more funerals than you've done Social, Aid and Pleasure Clubs.

WR: Correct. I have rarely done Social, Aid and Pleasure Clubs.

But I have been invited to "walk" with them, especially the Black Men of Labor. I've done quite a bit with them, more than any of the other ones.

KC: When you're in the midst of it, how— Do you ever get the feeling that it's not quite right? And what do you do?

WR: Yeah, you get that feeling that it's not right, so when it's not right, I politely creep myself through the band, park myself in them for a minute, take a breath and get back out.

KC: Okay, okay.

WR: Because sometimes it takes that to back up when you know that there are four or five other people who are going to be insistent on being in your face and in your space. Or you might feel a little uncomfortable with the crowd and their behavior, and I politely, as a woman, know where my refuge is—it's in the middle. So I might politely move myself in the middle of the band. If the band separates too far, too, sometimes that will happen, you're looking and you'll find that the crowd has come in so much that you're here [*gesturing*], the crowd is here [*gesturing*], the band is there, and you just politely do what you do. But you have to be cognizant of everything around you, and so that's what I do. I just politely know how to space myself.

KC: Do you think that we, as New Orleanians, respect the band more than anything? Is that part of it, too?

WR: I think so, personally. Just the music and we want to be in it, that we want to be in the band. And so, even if we don't have an instrument, all right, that's sort of what I feel. And I think if could teach the youngsters to dress accordingly, appropriately. I had that same conversation yesterday doing a wedding. The wedding is going to require three bands and maybe two brass bands, it's going to be a big ceremony. And so, as a result, I had to make it clear, I use these people, these are my brass bands because I know that they're going to follow protocol, they're going to follow tradition, they're going to have a special presence about them that for me is a requirement, and I don't have to worry that that is not going to happen. It's always going to happen with certain brass bands.

KC: You know, I'm not going to ask you to name them, because—

WR: No. No. But for example, we just had a mini–Second Line for the reopening of Saint Katharine Drexel Prep on Magazine [Street].

KC: Yes, yes. So glad y'all did that.

WR: It's still going to be a fight because there's a mortgage to be paid ultimately, and you know, we, the alumni, quote, purchased the property and reopened the school as Saint Katharine Drexel, but you've got a huge mortgage that the alumni have as part of that. We're still funding, so that's a challenge. But anyway, it was considered a *procession* rather than a *Second Line* because they didn't want it rowdy. But it had *all* the passion of a Second Line because it was burying Xavier Prep—

KC: The old.

WR: And re-opening Saint Katharine Drexel Prep. So we had some combination of the Kinfolk Brass Band, who are one of the bands that I particularly like, along with Algiers, Treme, and Pinstripe, and so those are *my* cats. And we walked just about four blocks around the perimeter of the back of the school, came out to Magazine Street, and then walked in, a little program and ceremony at the steps, and then a ribbon-cutting and then to Second Line, and let those girls pass through, the band and the crowd into those front doors. It felt like—

KC: So you were blessing the school, blessing the doors and—

WR: And cutting the old loose and bringing the new in! That, to me— And nowhere else does anybody do this.

KC: No, no. Absolutely, it's the most African-centric ritual.

WR: That's correct! And when you look at that or you look at some ceremonies happen down in Haiti or South America, then you see some of that too, because that's where we came through. So you see the dance, you see the floor dancing, you see the umbrellas, and you even see the elevation of the deceased in a ritualistic way, in an almost "hip-hip-hooray," and I had never seen that done until James Black's funeral. That— My mouth opened up on that one!

KC: What happened? I wasn't there,

WR: They took him out of the hearse, put the casket in front of his door, and they did a "hip-hip-hooray." Three times, elevated that casket in front of James' door on, um, the street right before Armstrong Park that runs parallel to Governor Nicholls. That was a first, so there always seems to have been firsts, one particular funeral, and again, it's funerals, it's not social, even though a lot of times, they're represented.

KC: It's totally relevant.

WR: Okay, and Teddy Riley's funeral was so amazing because it was dark, and it was— It almost felt like, if you're a Christian, the day that Christ died because that was the darkness that was hovering as we came out of church. And we had to go a little ways before we cut him loose. And I tell you, the skies opened up when we cut Teddy loose. And that, to me, was another kind of spiritual parallel. And we were able, in just enough time, to get to our cars after he got cut loose.

KC: Wow. I'm going to have ask some elders about that, what the belief is, does that mean the spirit didn't want to leave or something. There's something to that.

WR: I don't know, it was quite amazing to me.

KC: I'm going to ask the elders, they would know or be able to tell me what that means just that old, If the sun is shining and it's raining, that's the devil—

WR: Beating his wife, yeah.

KC: I'm going to find out, I'm going to ask. That's too bad, I'm sorry to hear that because you never want to get soaked.

WR: No, but you do, and it's just part of whatever it's going to be. One time, I basically— I keep my core people around with water, room temperature to keep hydrated because— Now it's very hard for me to do it, I'm almost practically retired because of the physical constraints, and I have back issues. So, for example, when Wardell [Quezergue] passed, they didn't advertise a Second Line, and you find that more and more because they don't want everybody in the world coming who doesn't even know the deceased.

KC: People just there to see—

WR: They just want the people who knew him and are inside the church. Oftentimes, you can't contain that because word gets out, and in Wardell's case, I wasn't even dressed out. I didn't dress out because I was having back issues and traditionally, the family— I don't just go to funerals.

KC: You need to be asked.

WR: [*hushed tone*] You need to be asked or someone invites you, either the leader of the band as part of the family activity will ask, or the family will ask. And so, I wasn't dressed out, but when they came out of the church, the band is looking at me because there's no leader. Now, I'm in black, okay, and I'm with them, and not to throw anything on the young girl, Joe Jones' daughter.

KC: Oh, yeah, Jennifer.

WR: Jennifer, because she just needs to learn the tradition a little more.

KC: You're not the first person to say that.

WR: She needs to be taught. I think this was a relative of hers in some way, so she was just bouncing about, flitting and half-tapping and doing what she does, in spectacle. And the fellas are saying [to me], "Girl, come on! Take us down!" So, what did I do? But Germaine, Germaine Bazzle, got in front and led the band for a few blocks or so because they are accustomed—

KC: To somebody leading them in the proper way.

WR: [slaps the table in agreement] That's right! And that's what they wanted, as an example. I just had to step in for a few blocks, and I was still teaching at the time and I had left school to come and do the funeral, so I wasn't trying to be all visible. I didn't do it incorrectly, I signed out, but I wasn't trying to be all in the newspaper, okay? It was really wonderful because I had been close to this man since I was a young girl. He was one of the first people, Wardell was one of the first people in my musical life, in my musical journey that held my hand and my father allowed us to work with and record because *he* said it was okay. Wardell. He knew me from a little girl, performing.

KC: That's just amazing. What was the first Second Line that you served as grand marshal?

WR: Ellyna Tatum. Ellyna's was the first.

KC: So she passed the torch on to you?

WR: To me. And she specifically picked me, because at that time she was the grand marshal—

KC: I heard that! I think that Eric had told me. I heard that.

WR: She might have been the grand marshal for the [basketball team, New Orleans] Jazz. Ellyna was all over, everywhere.

KC: Yes, that's what I remember.

WR: It's funny, she was a hairdresser, just like—

KC: Mahalia Jackson.

WR: And all of them out of the city. She did this, she loved dancing and singing in the street. And she would do the French Market in the French Quarter so much. And she didn't necessarily wear traditional clothes, Ellyna loved to wear shorts and high heels, and she had her some outfits, baby! And so, she used to come to the club every Sunday when we played at Storyville with David Lastie and a Taste of New Orleans, and we had that locked down for a long time. What was wonderful about that place was that families could come, you could eat, you could spend the afternoon, kids could

go walking and enjoy the Quarter and families . . . parents could dance and enjoy themselves and feel comfortable and safe. Well, anyhow, Ellyna would come and she'd sit in with the band—

KC: Could she sing?

WR: She danced and she'd sing. She only had certain songs she sang, but she'd sing and she'd dance to get the crowd going. She knew that I loved to dance, that was my thing, and then for a while, we found out, she was off the scene with Lou Gehrig's disease. And so she came, and we would check up on her to see how she was feeling. And she came one Sunday and she sat, and I went and sat with her for awhile; she was having a good day. And she said, "Well, you know I'm not going to live very much longer," and she said, "I would *really* like for you to lead my funeral." I said, "Ellyna, I don't know anything about [that], not really, I've just been a bystander." She said, "I want you to do it, and there will be someone there with you who has done it before."

KC: What year was that?

WR: 1980, '88— Let's see, David was '87, he was the second one, had to be around '86, maybe a year or six months after David, 'cause David's was a shock, but I said David's because he was the leader of the band, and he was from the Lastie family down in the Ninth Ward, who was Jessie Hill's nephew and Herlin Riley's uncle and the Lastie Brothers, that whole clan.

So, I told her, yes, ultimately, and she passed me a glove of hers, and her daughter came here [to Wanda's home], she brought me her picture, she came to visit me, an autographed, signed picture of her in her grand marshal outfit, and when I got the call she had passed, then I went and got my tuxedo suit and started putting the ornaments on it. And went and got my umbrella decorated, made a sash, and started moving forward with it. When I got there, and I had been to enough that I knew the stepping of it, and when I got there, ooh, lo and behold, but who was next to me but Morris Jeff, Senior, and you know, he did that as well. Morris Jeff was a grand marshal, and there was another elderly man, I don't know his name, but the two of them said, "Just walk with us and do what we do." And so, that's my first one. And so, I had two great people on both sides of me, and the second one was David Lastie. David dropped dead, surprisingly, and so his funeral was from a spiritual church

right back here on Elysian Fields. And that was another experience, I had never really experienced that whole spiritual church thing before—

KC: It's not Pentecostal, it's something altogether different, and they have those icons—

WR: Aw, baby! [*laughter*] And so, we took David on home and that was a very painful— Ellyna's wasn't painful, in a sense—

KC: Because you knew it was coming.

WR: And she said, "What I have is killing me, and there's nothing to do about it, there's no cure." With David, it was a sudden, drop dead, so that was so hard.

KC: So how do you deal with that? If it's someone that you're close to and you're asked to be the grand marshal, how do you process, how do you deal with that?

WR: You cry a lot. The reverence. But the people lift you up, because they know, that's family to you. The pain—

KC: So it's okay to cry.

WR: It's okay to cry, and in that—

KC: And serving in that capacity.

WR: And ultimately, to even sing, because I remember that grand marshal coming down Elysian Fields because the church is right there, so we went that way, going to right here, right there. So I could sing, that was a way of letting it out, a lot of the old spirituals instead of walking, I would sing as I walked. So, that was a way for me, but that was a very painful walk. And my cousin, Oscar Rouzan, he was

an elderly man, so it wasn't the same kind of pain, it was family, but it was painful, so some of those, you just express the sorrow in different ways and you put it into the dance.

KC: Yes, yes. Do you miss it?

WR: Um, yeah, I do, but guess what? I just came back from Brazil—

KC: Ohh, everybody tells me about Brazil, never been.

WR: Oh, baby! This is our fourth trip over, the first concert— Well, this year, I decided to bring my sash and my umbrella and my gloves and my whistle and I was going to give them a little bit of the tradition. Well, honey, when I— I did it as part of my stage performance. We did it in [Iba Puera] Park, the first concert, which is a free concert for the people sponsored by the Bourbon Street Club, where we played the other concerts.

KC: Yeah, Blodie told me about that.

WR: Yes, and baby, you could see people as far as the eye could see. Like being at the Acura Stage at Jazz Fest. Like that. Or at the French Quarter Fest at that river where you could see— Girl, those people went crazy. And I stood up there and put that sash on and those gloves and my umbrella and my whistle, and we did "Bourbon Street Parade." And we did the "Tremé" song and "Blow the Whistle," and the only thing I didn't do was "A Closer Walk," that I've done quite a lot before, but I did "Wonderful World" instead, so that's that, I don't care where we go in the world, when we do THAT music, it's received everywhere!

· · · · · · · · · · · · · · · · · · · ·

Flying High

Function and Form in New Orleans Second Line Dancing

RACHEL CARRICO AND ESAILAMA ARTRY-DIOUF

Music and dance are the lifeblood of many communities around the world. This is especially true for New Orleans. Music and dance, inseparable from each other, permeate the ways in which many New Orleanians walk, talk, connect with life, and memorialize those who have made their transition from the physical to the spiritual world. For New Orleans, this marriage between music, dance, and life dates back more than three hundred years to when the first enslaved and free people of African descent arrived in New Orleans.

Although people of African descent came to New Orleans from different parts of West and Central Africa, and later from Haiti and Cuba, many of their music and dance forms were strikingly similar. As in Africa and the Diaspora, early eighteenth-century dances in Congo Square and throughout the city served many functions, such as celebrating rites of passage (births, weddings, comings of age, or funerals), passing time while working, and accompanying certain religious or spiritual gatherings. Elements in the dances practiced by enslaved and free people in New Orleans included the use of call-and-response, when one person or group initiates a phrase (music, song, or dance) and another person or group responds with the same or a different phrase; polyrhythm, the simultaneous sounding of two or more independent rhythms or the simultaneous, but contrasting, movement of body parts within

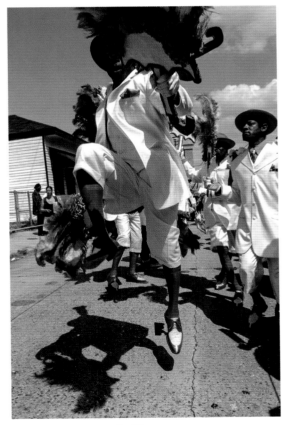

Buckjumpers
September 29, 2008

the same rhythm; and improvisation, spontaneously creating movement or musical phrases within the basic beat or pattern.[1]

Most of the musical and dance forms observed in eighteenth-century Congo Square continue to permeate the very fabric of people's lives in New Orleans. Like those living in Trinidad and Tobago, Brazil, Haiti, and practically all of the African continent, dance for New Orleanians not only presents a form of entertainment and leisure but also serves as a canvas on which to paint identities and as a conduit through which to transmit, preserve, and transform cultural heritage. The blending of African, European, and Native American styles and techniques of both music and dance has led to the evolution of new styles that have become indigenous to New Orleans; some of these styles have become a signature of the expressive culture of the United States. Cultural expressions performed at Congo Square and on the streets of New Orleans gradually developed into Mardi Gras Indian traditions, New Orleans Jazz and rhythm and blues, and the Second Line.

Jazz historians and other documentarians of the Second Line tradition have long acknowledged the importance of dance within the Second Line parade. In his 1960 autobiography, legendary musician Sidney Bechet lauded the movements of the grand marshal, the high-stepping leader of each funeral or Second Line procession in the late nineteenth and early- to mid-twentieth centuries. "It's what you want from a parade," he said. "You want to *see* it as well as hear it. And all those fancy steps he'd have—oh, that was really something!—ways he'd have of turning around himself. People, they got a whole lot of pleasure out of just watching him, hearing the music and seeing him strut and other members of the [Social, Aid and Pleasure] club coming behind him, strutting and marching."[2]

More recently, clarinetist and Jazz historian Michael White described Second Line dancing in terms of a "trance" induced by the music, which propels second-liners to dance "on top of cars, swinging from lamp posts, on the roofs of two- or three-story buildings, riding in tempo on the backs of others, or gliding belly down in the street, all while keeping perfect time and pace with the procession."[3] Whereas these writers were concerned with Second Line dancing as a response to brass band music, some dance historians have documented second-lining as a sophisticated dance form with specific attributes. One of the earliest written descriptions of Second Line dancing was published in a 1959 article in *Dance Magazine* entitled "New Orleans' Marching Bands: A Choreographer's Delight." The author, Roland Wingfield, is described in the article's short biography as a "young dancer-choreographer" in New York City, specializing in Afro-American themes, who was "associated with Katherine Dunham and her school for several years."[4] In the article, he narrates an experience in New Orleans on Labor Day weekend in 1958, in which he unexpectedly encountered a "marching band" (he does not say "brass band") while driving toward "back o' town." He quickly parked his car and hurried back to the scene. As the parade turned onto North Claiborne Avenue, he found himself "no longer walking, but strutting and suddenly dancing." He describes the dancing he saw—and probably imitated—as such: "The dancers moved with pelvis thrown forward, the upper body slightly tilted back, loose and responding freely to the rhythm, legs slightly apart and propelling a shuffling step with a subtle bounce."[5]

What Wingfield described in 1959 is an apt description of second-lining footwork as it is practiced today, for although Second Line dancing is constantly changing, the basic form has remained fairly consistent. Dance scholar Jacqui Malone emphasizes the improvisational nature of second-lining when writing about it nearly forty years after Wingfield: "Although different generations incorporate the social dances of their era, there is a characteristic style that is unique to Black New Orleanians. The most important thing, however, is to move to the rhythm of the music."[6] Due to the improvisational nature of second-lining, its foundational tenets persist even while dancers constantly innovate the form to make it their own.[7]

SECOND-LINING AS CHOREOGRAPHED IMPROVISATION

Second-lining is a choreographed improvisation. In other words, some of the dancing is choreographed, or consciously organized to happen in a particular way, and much of it is improvised, or invented in the moment. Dance anthropologist Yvonne Daniel uses the term "choreographed improvisation" to describe tendencies that she has observed across a large category of African Diaspora ritual dance. She likens the exchange between dancer and dancer, and between dancers and musicians, to a Jazz ensemble, in which the musicians play within

a specific musical organization and elaborate upon that organization when creating new material on the spot, either during a solo or as a collective. Similarly, dancers conform to identifiable patterns of movement that fit within the vocabulary of the dance form, but equally important are their elaborations upon and abstractions of that vocabulary. The combination of these two movement tendencies, choreographed and improvised, is what enables dancers to access extraordinary, even spiritual, experiences, both in sacred and secular settings.[8]

In second-lining, footwork is organized by two principles: the dancers keep traveling forward, and their footwork steps match, respond to, and complement Second Line rhythms. Within that basic, choreographed framework, individual expression is prized. Dancers are expected to manipulate, riff on, and create variations of basic footwork. Even the notion of "basic footwork" varies from dancer to dancer, depending on age, neighborhood, gender, number of years spent second-lining, other dance experience, and dozens of other factors. Basic footwork can take the form of a grounded, lilting, side-to-side step-touch, much like what Wingfield described in 1959. In recent decades, second-liners also began to display a more elevated, scissor-like, heel-to-toe step.

Dancers at any Second Line today can be seen improvising within their basic footwork. Some examples include spinning on one leg, dragging one toe behind, crisscrossing the feet, jumping back on the heels, dropping down to a squat, or jumping several feet in the air. And just like the dancers described by Michael White, second-liners can still be seen hopping atop cars and buildings, swinging from lampposts and utility poles, riding on each other's backs, and rolling on the ground. Dancers are constantly inventing new variations of existing themes. When they improvise, dancers are careful to do so within the vocabulary of second-lining's form: traveling forward and staying on the beat. These two elements of second-lining's choreography remain constant, and individual improvisations flourish inside of this basic framework.

At the collective level, the parade's choreography can be described as a multiplied and amplified version of the individual dancer, as the entire crowd travels forward in time to the same beat. The band organizes the crowd to move in relation to the music, unified by the underlying, consistent beat, and dancers organize themselves to orbit around the band(s).[9] De-

pending on a second-liner's intention—to dance or not, a little or a lot—he or she might decide to dance in different locations at different times. The serious dancers—"the real knockers," as they're sometimes called—usually parade on the sidewalk, located on the right side of the procession. Dancing on the sidewalk is often called "side-lining," and when the energy of the Second Line reaches its peak, the band locks in with the dancers, and all are moving together, not in unison but unified. The most stunning embodiment of this energetic zenith can be witnessed on the sidewalk, where some of the most dedicated dancers execute intricate, athletic, quickly moving footwork in close proximity to each other—and they never step on each other's toes![10] Even though the sidewalks are usually cracked and dramatically uneven, even though dancers must navigate physical obstacles such as fire hydrants and porch railings, even though dancers remain tightly packed near each other and must keep moving forward, and even though no two people are executing the exact same steps, the side-liners manage to dance inches from each other without stepping on each other. They come dangerously close, finding spaces in between each other's feet and around the shoulders, stepping in a space that was occupied by another person's foot just a millisecond before, crawling under each other's legs, dropping and spinning in front of a forward-moving dancer, swinging a leg over the head of a dancer on his knees—but they move sensitively and smoothly, rarely disrupting another dancer's footwork.

Some dancers prefer to position themselves behind the band, especially if they like to feel the vibrations of the bass drum pounding through their bodies. Others station themselves directly to the side of the band, where they can hear the music more forcefully, but they risk getting hit in the head by the slide of a trombone, and they must constantly wrestle with the rope carriers for space, especially when negotiating narrow streets lined with parked cars. Many (but certainly not all) second-liners also belong to Social, Aid and Pleasure Clubs (SAPCs) and will take a turn dancing inside the ropes, or mainlining, during one Sunday each season. When they are outside the ropes, second-lining, they give energetic sustenance to the parading club by dancing alongside them, shouting encouragements or challenges to club members whose dance performance feeds the band and in turn, the entire crowd.

Those paraders who are not especially interested in danc-

ing might walk far in front or behind the crowd, where there is more space to push a stroller and it is quiet enough to have a conversation. People with bicycles might lag far behind, maneuver through the neutral ground (the wide, grassy median in the middle of wide boulevards), or force cars to meander around them in the lanes of oncoming traffic. Vendors pulling coolers often congregate several rows behind the band, chanting, "Cold beer!" and other announcements in time with each song's rhythm. This is also the spot where people in wheelchairs routinely place themselves, since they can remain in the middle of street, where the pavement is relatively even and flat, and still hear the band. Photographers hired by the SAPC and family members carrying smartphones walk inside the ropes to catch up-close shots, but semiprofessional, hobbyist, and academic documentarians—the third line—orbit around the perimeter, trying not to disrupt the action.[11]

When the procession pauses, small circles of dancers form. Either stationed behind the band or peripherally in a parking lot or driveway, second-liners widen into a ring and encourage/challenge one or two dancers in the center by clapping, shouting, or even by playing cowbells and tambourines. This is often the domain in which children's footwork skills are honed, as they step into the center of the temporary circle and perform their best moves to the supportive yet demanding comments of onlookers, who are often family members and friends of the family.

Once the procession starts traveling again, the circle dissolves back into the procession, and the collective of many mini-collectives moves forward once more, all dancers orbiting around the band and moving in close proximity to one another. Even though each person is dancing his or her own combination of specific and unique movements, the beat coheres the crowd, so that it is possible to stand on a porch, overpass, or other elevated structure and see thousands of heads bobbing up and down together, not in perfect unison, but overwhelmingly unified. The effect is breathtaking, like the rippling of a vast ocean wave. The processional column, or line, constantly overflows its boundaries, spilling out into parking lots, onto roofs, and into surrounding streets; but these peripheral dancers are always moving in relation to the first line and the second-liners closest to it in the middle of the street.

The forward-moving procession periodically pauses during preplanned stops at bars, houses, or other establishments along the route, when the musicians lay down their instruments and the crowd disperses to cover streets and sidewalks for several city blocks. But once the tuba strikes up again, the SAPC members come out the door pumping feathered fans overhead, the ropes are unfurled, and the collective column of individuals resumes its forward motion. Dancers find their chosen spot in the procession, and many dance fervently, sharing energy, dance steps, and rhythms with other dancers and with the musicians. The horizontal connections formed between people on the street support a vertical connection to a spiritual realm above.

SPIRIT OF THE DANCE

Like music, dance also transcends material and geographical borders. It involves rhythm yet isn't dictated by time. Second Line dancing doesn't require any special clothing, but clothing adds to the personality of the dancer and the story of the dance. In second-lining, the spirit of the music interlocks with the spirit of the dancer. Beyond verbal dialogue, music, dance, and dancer enter a dialogic and dialectic conversation that alters the dancer's entire being and existence in the world, exposing him or her to a kaleidoscope of colors, shapes, textures, smells, tastes, sounds, and understandings. Wellington Ratcliff Jr., better known as "Skelly," expresses his most joyous second-lining moments as out-of-body experiences in which his spirit lifts high above the crowd:

> I tell people, I could be out in a crowd of 1,500 people, but I don't see them people. All I hear and see is that band, and that's where I want to be: behind that band listening feeling that beat. . . . When I'm in the music, . . . it's like that experience, some people say, "I had an out-of-body experience." My body could be right here but my spirit— You know what I'm saying? I'm flying above the whole Second Line. That's my spirit right there. . . . People like, "Skelly, man, boy, he be cutting up!" And that's not just to be for show. That's how I be feeling. When I'm feeling the music, you're going to see me dance.[12]

Skelly's out-of-body experience would be significant for anyone, but he is a paralyzed man bound to a wheelchair, and his

second-lining allows him to transcend the limitations of his physical body. Skelly's elevated spirit, "flying above the whole Second Line," contrasts sharply with his physical body, contained by the limited mobility of his chair. However, the fact that Skelly cannot walk does not relegate him to a status as a second-rate dancer. On the contrary, he is widely recognized among second-liners as a legend. Inspired by the music, the Second Line dancer exists in a world of being and becoming, floating between an individual identity and the identity of the immediate surrounding group, neighborhood, and/or SAPC. The dancer's body, therefore, is the site through which representation and experience are generated. The "spirit of the music and the dance" is the "it" that no one can seem to describe, yet second-liners feel and acknowledge when they reflect on second-lining's healing, out-of-body, spiritual dimensions.

The spirit of the music and the dance is the "vital force" that keeps bodies in the procession of the Second Line, creating choreographies that go beyond basic patterns of kicks, jumps, and turns into ways of comprehending how human beings enact and encode culture, identity, and power. In these liminal moments between the parade's beginning and end, between one note and the next, and between physical and spiritual worlds, the dancer is fortified by the music, and the spirit of the Second Line persists. Second-lining reminds us that we are free people with feeling who can love, mourn, weep, rejoice, and keep it movin'.

NOTES

1. Scholars have helped in coining and understanding these aesthetic elements in African Diaspora dance cultures. Many of these authors have contributed theoretical grounds as both practitioners and scholars that have added new dimensions to the understanding of African music and dance as lived art. See Germaine Acogny, *Danse Africaine* (Dakar: Novelle Ed. Africaines, 1980); Yvonne Daniel, *Dancing Wisdom: Embodied Knowledge in Haitian Vodou, Cuban Yoruba, and Bahian Candomblé* (Urbana: University of Illinois Press, 2005); Katherine Dunham, *Dances of Haiti* (Los Angeles: Center for Afro-American Studies, UCLA, 1983); Brenda Dixon Gottschild, *Digging the Africanist Presence in American Performance: Dance and Other Contexts* (Westport, CT: Greenwood, 1996); Peggy Harper, "Dance in a Changing Society," *African Arts* 1, no. 1 (1967): 10–13, 76–77, 79–80; Melville Herskovits, *The Myth of the Negro Past* (Boston: Beacon, 1941); Pearl Primus, "Africa," *Dance Magazine* 33 (March 1958): 43–49, 90; Fodéba Keïta, "African Dance and the Stage," *World Theatre* 7, no. 3 (1958): 164–78; Robert Farris Thompson, "An Aesthetic of the Cool: West African Dance," *African Forum* 2, no. 2 (1966): 85–102; and Kariamu Welsh Asante, "Commonalities in African Dance: An Aesthetic Foundation," in *African Culture: The Rhythms of Unity*, ed. Molefi Kete Asante and Kariamu Welsh Asante, 71–82 (Westport, CT: Greenwood, 1985).

2. Sidney Bechet, *Treat It Gentle* (London: Twayne and Cassel, 1960), 64–65.

3. Michael White, "The New Orleans Brass Band: A Cultural Tradition," in *The Triumph of the Soul: Cultural and Psychological Aspects of African American Music,* ed. Ferdinand Jones and Arthur C. Jones (Westport, CT: Praeger, 2001), 82.

4. Roland Wingfield, "New Orleans Marching Bands: A Choreographer's Delight," *Dance Magazine* (January 1959): 34. Katherine Dunham (1909–2006) was a legendary dancer and choreographer who pioneered dance anthropology with her studies of African Diaspora dance in Haiti, Trinidad, and Jamaica. The school that is referred to in Wingfield's biography was a place to train dancers in Dunham's highly influential system of dance pedagogy, the Dunham Technique, which combined Caribbean dances, traditional ballet, African rituals, and African American rhythms.

5. Ibid.

6. Jacqui Malone, *Steppin' on the Blues: The Visible Rhythms of African American Dance* (Urbana: University of Illinois Press, 1996), 183.

7. Other writers have also contributed evocative descriptions of Second Line dancing, and thoughts on the significant role of dance within the broader Second Line tradition. See especially the writings of Kalamu ya Salaam, including "Second Line: Cutting the Body Loose," *Wavelengths* 21 (1982): 26–30. Jean and Marshall Stearns included a brief mention of second-lining in their early survey of African American social dance: *Jazz Dance: The Story of American Vernacular Dance* (1968; New York: Schirmer, 1979). More recently, Margaret Olsen writes that Second Line dancing dramatizes the tradition's prioritization of the communal over the individual (Olsen, "The Gift of the New Orleans Second Line," in *Neoliberalism & Global Theatres: Performance Permutations,* ed. Lara D. Nielsen and Patricia Ybarra, 176–88 [New York: Palgrave Macmillan, 2012]). Richard Brent Turner views Second Line dancing as the expression of African diasporic cultural memory (Turner, *Jazz Religion, the Second Line, and Black New Orleans* [Bloomington: Indiana University Press, 2009]). Kim Marie Vaz writes about Second Line dancing in the context of women's role in Jazz dance history in New Orleans in *The "Baby Dolls": Breaking the Race and Gender Barriers of the New Orleans Mardi Gras Tradition* (Baton Rouge: Louisiana State University Press, 2013).

8. Daniel, *Dancing Wisdom,* 53, 62–63.

9. Ethnomusicologist Matt Sakakeeny describes the brass band at a Second Line as a "perpetual motion machine" that literally moves the entire parade and organizes the crowd's movement with sound. He discusses the decisions that every second-liner must make when deciding where to place oneself in the forward-moving collective, which orbits around the band, and more specifically around the tuba (Sakakeeny, *Roll with It: Brass Bands in the Streets of New Orleans* (Durham, NC: Duke University Press, 2013), xi–xii, 16.

10. Daniel makes this same observation when watching ritual dancers in

Haiti and Cuba: "Everyone inside was dancing and performing the identifying *oricha* gestures together, sensitively, above the changing but repetitive foot patterns. [In Cuba, j]ust like in Haiti, despite the densely crowded space, no one stepped on anyone's toes!" (*Dancing Wisdom,* 20–21).

11. Sakakeeny discusses his decisions about where to place himself as an academic studying the Second Line (*Roll with It,* 16). Anthropologist Helen Regis discusses the "third line" of ethnographers, musicologists, and photographers that occasionally block the dancers ("Blackness and Politics of Memory in the New Orleans Second Line," *American Ethnologist,* 28, no. 4 [2001]: 777).

12. Wellington Ratcliff, interview by Rachel Carrico and Daniella Santoro, March 26, 2014, New Orleans.

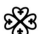

SPECIAL FEATURE

.

Dance and Movement

KAREN CELESTAN

Individual and group movements at Second Lines are spontaneous expression fired by African tribal dances and rituals. From on-beat head-butting to the Duck Walk, every step, leg-lift, and twirl can be found in Bambara, Kongo, Mandinga, and Wolof tribal moves that date back to antiquity. Social, Aid and Pleasure Clubs take ancient motions and mix in some jook-joint swing and 1970s-era nightclub funk with a touch of hip-hop swagger.

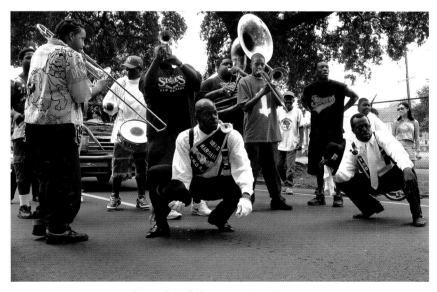

The Duck Walk, by Young Men Olympian
Crouched in front: Ivan Lastie, Walter Ramsey. *Band, 1st row (left to right):*
Ersel Bogan *(trombone)*, Sammy Williams *(trumpet)*, Troy Andrews *(trombone)*
September 8, 2002

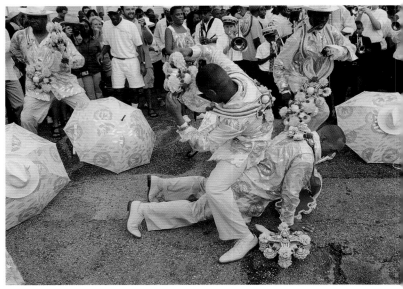

September 6, 2009

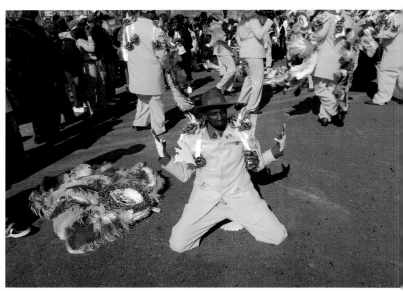

Black Men of Labor members doing the Alligator
October 25, 2008

Gerald Platenburg, Nine Times
December 12, 2006

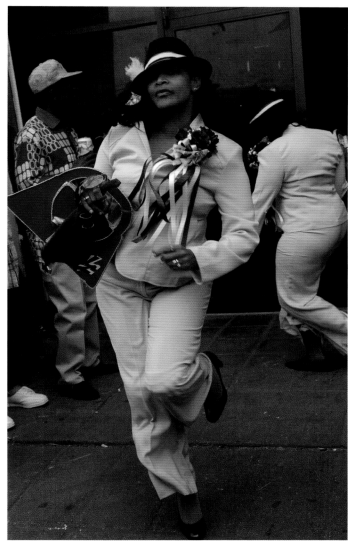

Versatile Ladies
November 11, 2007

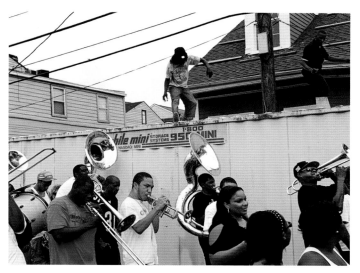

July 18, 2012

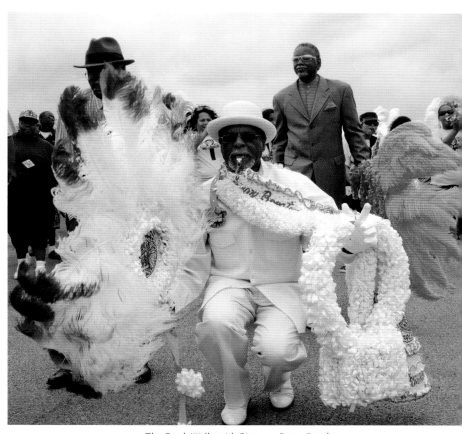

The Duck Walk, with Pinettes Brass Band
Philip Clay, Scene Boosters
May 2, 2008

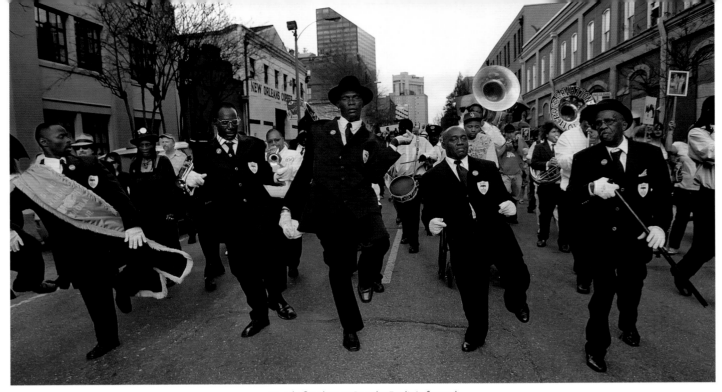

Parade first line at Snooks Eaglin's funeral
Left to right: Jerome "DJ Jubilee" Temple, Shedick Davis, James "Yam" Harris, Harold "Shorty" Brown, Alfred "Bucket" Carter
February 27, 2009

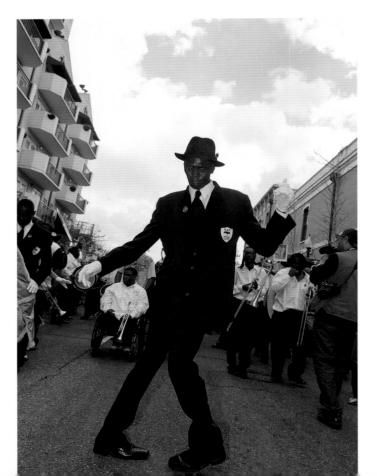

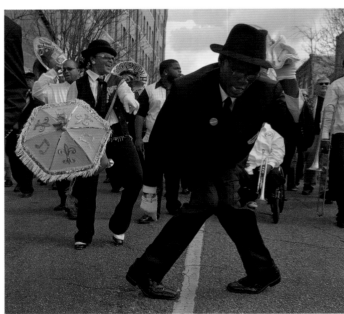

James "Yam" Harris

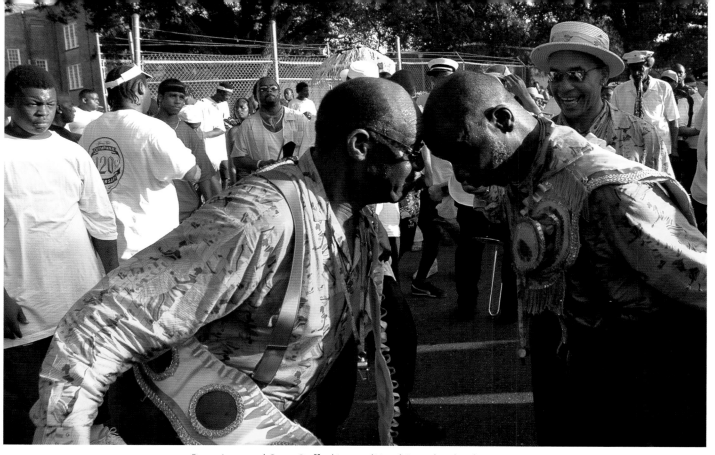

Benny Jones and Gregg Stafford in a traditional Congolese head greeting
Black Men of Labor
September 5, 2004

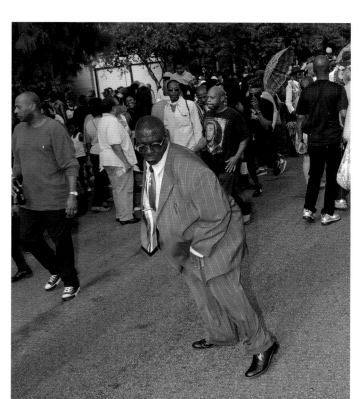

Albert "Frog" Jackson
October 20, 2013

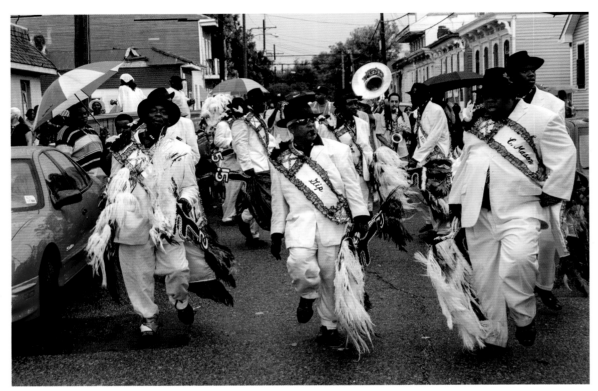

Drill Team Style
Furious Five
September 24, 2006

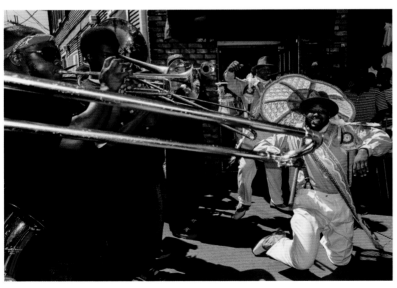

Family Ties
October 2, 2011

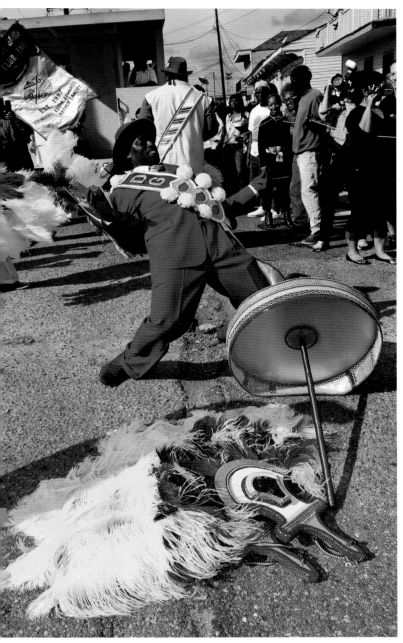

Lean Back
Dumaine Street Gang
December 4, 2011

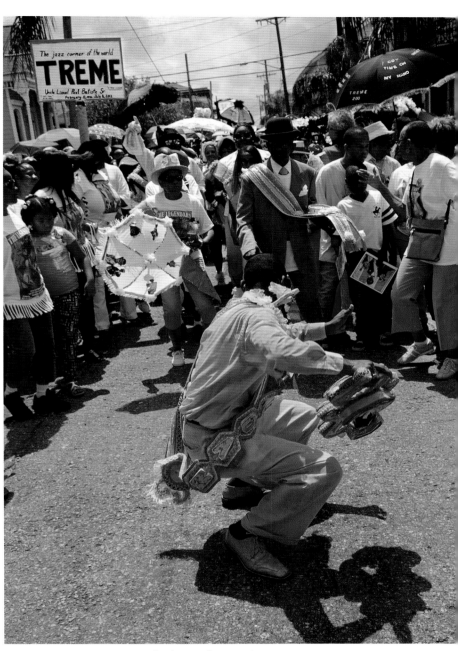

Markeith Tero (*foreground*), Norman Batiste
July 23, 2012

· ·

Keeping the Beat

KAREN CELESTAN

There could not be a Second Line without a brass band and drums. Bass and snare drums are the truth—rhythmic placeholders for the Second Line pulse. The drum serves as the call to order for Social, Aid and Pleasure Clubs. It is the replication of feet striking the earth in tribal gatherings in Africa and, later, in assemblies for the enslaved in Congo Square.

Musicians are the strength of a Second Line—tireless artists who breathe life into the parade and create the impetus for memorable movement through the streets of New Orleans.

People of African descent tend to gravitate to public displays and dedicated "sharing" of talents and gifts. There is comfort and solace in numbers that is a holdover from slavery, Code Noir, and Jim Crow eras that tended to use police forces and the often-attendant brutality to control the movement and assembly of Black people.

Social, Aid and Pleasure Club events could have been restrictive and exclusionary in line with white, blue-blood social organizations that position themselves by class to maintain power and superiority over the masses. However, in the African tradition, SAPC practices are *ku kugawa* or *kw-a watu,* Swahili that means efforts are to be displayed, distributed, and shared by all. Christopher Small has observed that African-American music is that of "the common tongue that is made for *use,* with little pretension to Art and its high social status." There is a communal

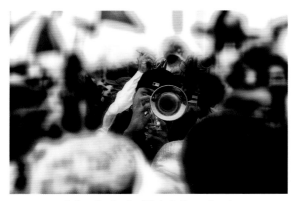

Julian Gosin, Soul Rebels Brass Band
January 6, 2007

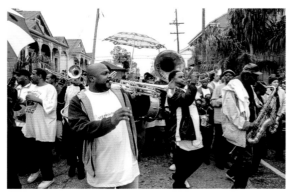

New Birth Brass Band
November 13, 2005

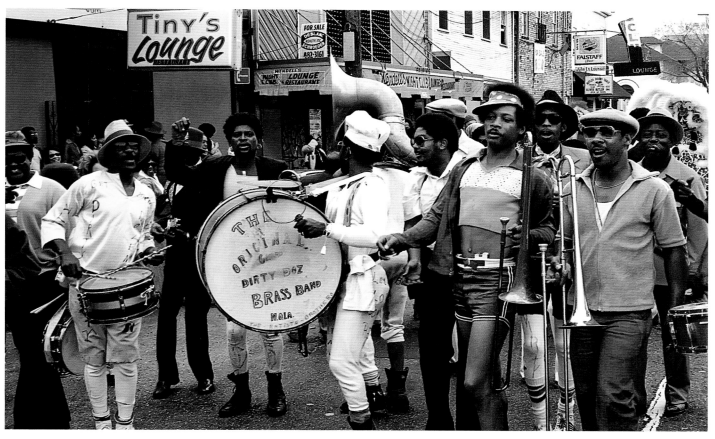

Original Dirty Dozen Brass Band
circa 1970

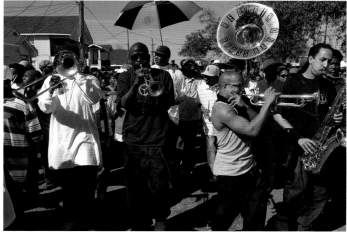

Rebirth Brass Band
February 25, 2007

approach that embraces "both feeding on it and feeding back to it," according to Small (1987, 20).

African Americans in New Orleans, particularly in their social organizations and gatherings, redefine their past and present struggles in a distinctive and outward way. The specter of Congo Square and its activities continues in a dedicated "breath of life" that will not and cannot be restricted. But SAPC parades are different every season, and though clubs may have a predetermined style and approach, each annual gathering reflects the moment. Second Line music may be pulled from a canon of about fifteen numbers, but bands remain open to trading off and creating on-the-spot notes and riffs. This becomes a fresh call-and-response on the part of the SAPC members, whose movements take on the tone and tenor of the music as it is delivered. It is, as Christopher Small notes, "a ceaseless and

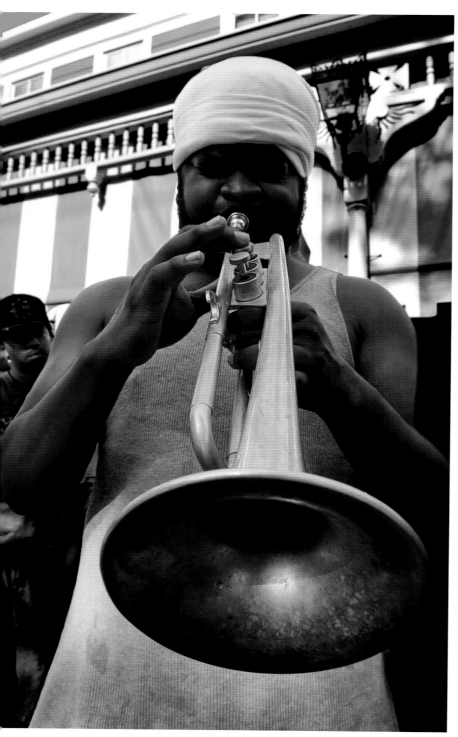

Chris Cotton, Stooges Brass Band
October 9, 2011

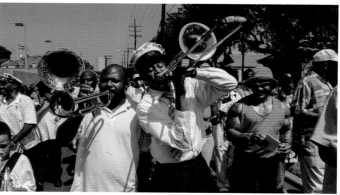

Kenneth Terry *(left)* and Glen David Andrews *(right)*
September 26, 2004

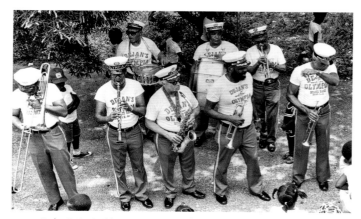

Duke Dejan's Olympia Brass Band with Duke Dejan *(center)* and
Milton Batiste *(center right, on trumpet)*
circa 1970

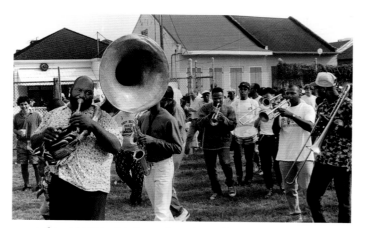

Left to right: Tuba Fats Lacen, Leroy Jones, Benny Jones *(on drum)*,
Kenneth Terry *(on trumpet)*
circa 1980

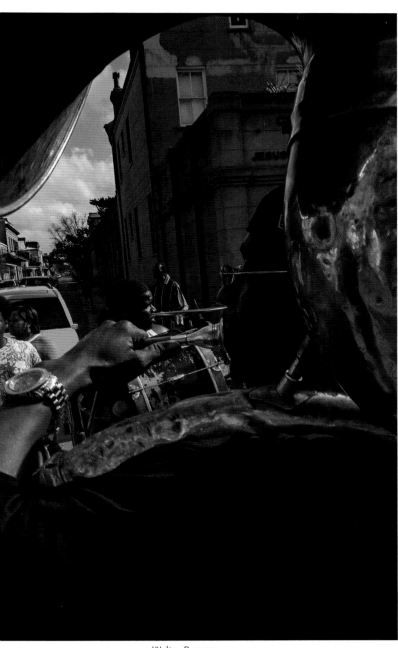

Walter Ramsey
February 5, 2008

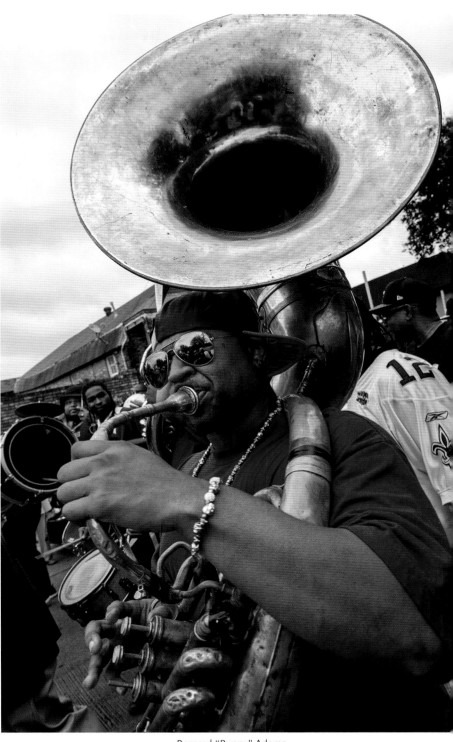

Bernard "Bunny" Adams
Hot 8 Brass Band
December 27, 2015

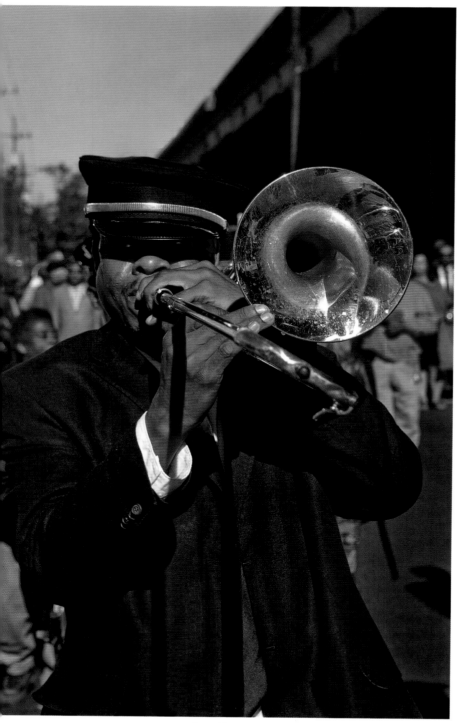

Corey Henry
November 24, 2012

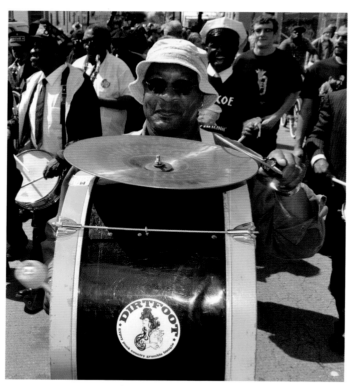

Anthony Bennett on bass drum
March 12, 2011

spontaneous activity of countless human beings, all of them living within, responding to and trying to make sense of, certain social, political and economic situations" (Small 1987, 23).

According to Freddi Evans in *Congo Square,* displaced Africans in New Orleans used instruments that were "visual representations of African cultural practices" (Evans 2011, 42).

> The principal instrument among them was the drum, which musicians used to summon others. . . . The drum also fused the music of each circle—laying the foundational beat, calling and answering, sending signals and cues, alerting other musicians and dancers to changes and breaks in the music, and responding to the constantly shifting improvisations of other participants.
>
> The larger of these [drums] carried deep pitches, and their long, intense beats provided the underlying pulse for the other instruments. The smaller drums carried higher pitches and provided quicker, syncopated, and more intense beats. (Evans 2011, 63)

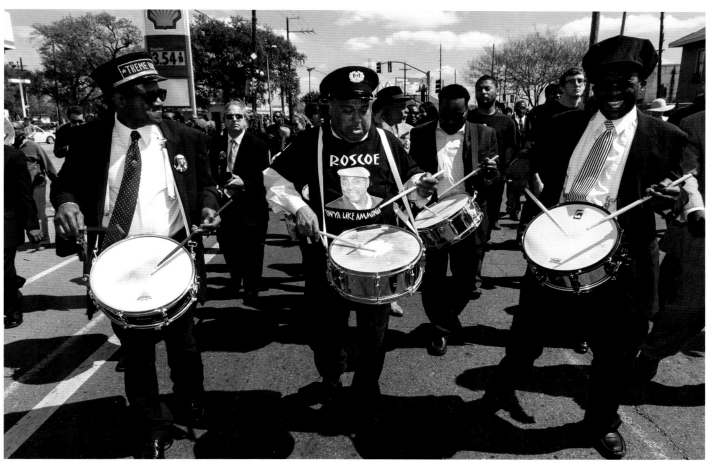

On drums: Benny Jones, Shannon Powell, Kerron "Kerry" Brown, and Herlin Riley
March 12, 2011

The drum and drummers serve as a spiritual anchor for Second Lines and Second Line dancing. It is the drum beat that signals the start of nearly every Second Line. For example, two smacks of a bass drum signal to the assembled that a deceased person has been funeralized and the final journey is to begin. All other associated musical instruments—including feet-striking and hand claps—are critical to any Second Line, but the drum serves as the bottom, the weight, and point of reference for all African-American dance movement.

REFERENCES

Evans, Freddi Williams. 2011. *Congo Square: African Roots in New Orleans.* Lafayette: University of Louisiana at Lafayette Press.

Small, Christopher. 1987. *Music of the Common Tongue: Survival and Celebration in African American Music.* Hanover, NH: University Press of New England.

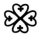

Interview with Gregory "Blodie" Davis

Trumpeter, Dirty Dozen Brass Band

Karen Celestan interviewed Gregory Davis on August 3, 2016.

Karen Celestan: So, you were in the Dirty Dozen at an early age, right?

Gregory Davis: Well, early for me. I was like twenty-one, twenty-two, something like that when we got the Dirty Dozen started. When we started having those rehearsals, I was a student at Loyola [University]. Well, my first brass band experience was with Leroy Jones' Hurricane Brass Band; then he disbanded that and started playing on Bourbon Street and doing other stuff. And we started up another effort call the Tornado Brass Band, gigging here and there or whatever. But as my interests grew in music— Like I said, I was a student at Loyola and some of the other guys were studying with Kidd Jordan out at SUNO [Southern University at New Orleans], our musical interest was piqued. We were actually rehearsing, just learning a whole bunch of music, not necessarily New Orleans traditional music or New Orleans traditional brass band music. We were looking to learn some music, but as it turned out, at that time, this was in the 1970s, there were not any gigs because disco was king.

KC: Right.

GD: So the only gigs that would come along with any regularity were those things associated with brass bands like, you know, funerals and parties and picnics, stuff where they wanted some music but couldn't hook up the stereo and all the electronics to make it happen. So they just hire a brass band.

KC: Right.

GD: That's where we sort of figured out where we're gonna get gigs. Might as well learn some of this New Orleans traditional music just to let people know who want to hire a brass band, hey, here's a brass band. Because the older brass bands, they weren't really actually doing functions.

KC: Right. And then, you all were young. You were teenagers.

GD: We were young and stupid. [*laughter*]

KC: But you—

GD: We were looking for a gig.

KC: Right. Didn't you come out of that Fairview, Danny Barker's time?

GD: No. I was aware of them. When that was going on, I was playing in R&B and funk bands that were happening around town. But I knew, well, I had met Leroy at St. Aug. [St. Augustine High School], and he had a brass band thing. St. Aug., the marching band, had to perform at something and then Hamp [Edwin Hampton], the band director, wanted a smaller unit to play something for whoever we were performing for, and he asked Leroy to put something together. Because by then Leroy had a reputation for having the brass band thing happening, and he and I were good friends, so he

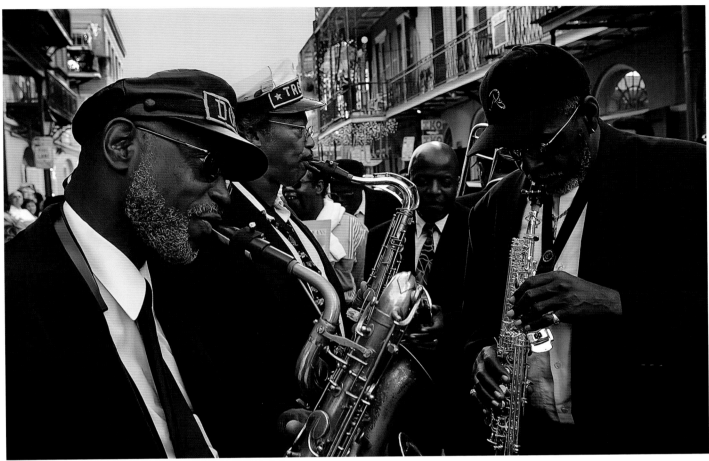

Left to right: Roger Lewis, Elliot "Stacman" Allier, Gregory Davis, and Rasheed Akbar
at Tuba Fats's funeral in the French Quarter
January 18, 2004

asked me to come play with them. And that was the beginning for me and then from the small school unit that Hamp wanted to put together, Leroy started asking me to come play with his brass band.

KC: Okay.

GD: So that was my introduction into the brass band world. And he had an interest of sorts in doing what I was doing with the R&B and funk bands. He kind of sort of wanted to get involved in that where I was looking to play more. I was learning all this music at Loyola, and I wasn't having a chance to really play it. Then I saw that practicing with the guys that I was working with in the brass band world, that they were willing to rehearse more than just "Skin Tight"

[Ohio Players] and "Jungle Boogie" [Kool & the Gang] and stuff like that, so that got some of us started. When Leroy's band broke up, we started another, tried another, and that didn't work out, so we just started rehearsing, and that became the Dirty Dozen.

KC: Okay, okay. I got it now. But, can you recall your early Second Line days? I mean, you all played functions, but when did you start playing for Second Line parades involved with the Social, Aid and Pleasure Clubs?

GD: Well, the first few gigs that I can remember were playing for some of the uptown clubs, like the Money Wasters and Young Olympians, stuff like that. Some of those clubs uptown, and I kind of remember the Bayou Classic was just

starting to happen. And it might have been the Money Wasters. They wanted a band to come with them into Tulane [stadium]. They wanted to second-line into the Southern/Grambling game and all that stuff. And so those parades, you know, those Social and Pleasure Club parades typically start at—back then they did—would start like, oh, late September, October, November, you know. When it would start to cool off a bit. That was when I started to become involved with that world—which was exciting to me. It was quite exciting to see all these Black folks come together to have their own parade. Of course, I was aware of, you know, Zulu and what that was and all that, especially being at St. Aug. We marched in Rex and now Zulu, so I was aware of that dynamic.

KC: Right.

GD: But when I started to play in the brass band that was the time of year when brass bands were in demand. The Second Line parade season when the weather would cool off in the fall, leading to the Thanksgiving holiday and the Bayou Classic and all that kind of stuff. So that's when I started to kind of get involved in that and realized that although it was an opportunity to play, to play more than I would play in an R&B band or a blues band, you know, those are real tough, tough, tough gigs. Exciting to be in that atmosphere, to be performing and watching the dancers. It was happening in live time.

KC: Right.

GD: It's not like you put on a record, dance to Marvin Gaye or whatever. We were playing music, and they were dancing to it live. That was an amazing sight to see. For me, for us, the Dirty Dozen, we went from that to clubs and onstage and all that kind of stuff.

KC: So it's almost like you went from functions to Second Lines to becoming a known band that played concerts.

GD: Oh yeah, that played concerts, and it was like we took the Second Line off the street and put it onstage, put it in the club. And then, in many ways, I guess, you know, captured that parade feeling atmosphere indoors. You know, we put it indoors where before the parade was outside. The parade marched and went here and there. Once we were able to make it happen at the Glass House and a couple other places, that was it. And that in turn sort of enhanced

whatever reputation we had when we would go out into the streets to do a parade. There were people that had come to the club, the Glass House, dance all night Monday. We would just be there 'til the wee hours of the morning. Then we would maybe get a parade the next week or whatever. Those people would show up.

KC: Got it. Got it. Got it. So I assume this also means that you all learned to develop a club repertoire and a Second Line repertoire.

GD: Oh, we— Definitely. We mixed and messed. What happened for us, the first time we played the Glass House we had done a Sunday Second Line parade that ended at the Glass House.

KC: Oh. [laughter] What year was that?

GD: That had to be around '77, '78, something like that. And so, along parade routes you know some of those clubs had their favorite watering holes, so you get to barroom and they have to go Second Line in when all the club drinks. Of course, when they ready to start up again, you gotta Second Line them out and continue the parade. We got to the Glass House and the end of the parade. We brought 'em in, and they kind of stayed. That ended the parade.

KC: Uh, hmm.

GD: Then they asked us to stay around, play a few more numbers, and it ended up being probably about another two hours. But in that stretch of time, they sold every single thing that they had. On a Sunday. The parade probably ended like around six o'clock or something like that.

KC: When you say they sold everything they had, you mean all their liquor?

GD: All the liquor that they had. [laughter] All the liquor, all the Cokes, all the beer, everything they had, they sold. This was at the Glass House. So, tradition also was that they would meet on Monday. The club, whatever club had hired us for that day. They would meet on the Monday after the Second Line and get together for red beans and rice or whatever. And they'd asked us to come back that following Monday. Parade was that Sunday, then the next night, Monday, want us to come back and play some more, and that began our Monday night at the Glass House.

KC: Yeah.

GD: And, of course, that Monday night word got out that we

were gonna be there. We performed, and they sold damn near everything they had that Monday night.

KC: So you were very profitable for the Glass House.

GD: So they said, "Y'all come back the next Monday." That started a regular happening for us every Monday night. And before that, we had tried the club in the Seventh Ward called Darryl's over on St. Anthony's [Street]. And Darryl's was a Thursday night, but the thing that really developed us was the Monday nights at Glass House, which again started from that parade atmosphere sort of thing. We were able to take it in, and those club members—not just that club, but the different clubs—they would just show up. People would just start showing up on Monday just to dance to what we were playing, and we realized we had an opportunity then to rehearse, experiment with some music. Put it in practice. You can rehearse all you want, but if you don't perform it live before an audience, you don't know what you have. And so we knew Monday night was gonna be our laboratory night. We were gonna experiment with as much stuff as we could because we were rehearsing four or five nights a week, and we got to put it into practice on Monday nights.

KC: That makes sense. So do you have a recollection of which Second Lines you may have played for once you all established? You said you played with Young Olympians, Money Wasters—

GD: Yeah. Young Olympians, Money Wasters.

KC: You ever played for Sudan?

GD: All of 'em. Sudan was down this way.

KC: Downtown. Uptown, downtown. You were downtown for Sudan.

GD: Yeah, but the uptown parades were more consistent. They were happening more consistently than the ones downtown at that time.

KC: Okay. Meaning like a schedule?

GD: Yeah. We knew that the folks uptown were accustomed to, had gotten accustomed to having parades. There weren't any bands really around to play those parades. There was maybe Dejean's Olympia Brass Band and Majestic— There were only one or two bands that were around to perform those Second Lines. Then these young guys, us, being the Dirty Dozen, were willing to play these parades, and once

that word got around some other clubs— Every year there would be one more, one or two more clubs would come back into existence because they knew there was a band willing to do a little five-, six-mile parade, eight miles, whatever it was. Parade typically last about four hours.

KC: Right.

GD: The young musicians that were willing to go out there and do it. It actually got to the point, some of the clubs would come back so fast, they would have parades on the same day, we started hiring extra musicians to make up a second Dirty Dozen.

KC: Wow.

GD: But that didn't work because they didn't play the same music that the core unit played. But eventually the parades downtown in the Sixth Ward and Seventh Ward began to develop, and that just added to the workload that existed. We could play what we knew. When the Second Line season parade came in we knew we were going to do eight to ten parades between September and some point in November. Which then added— They started asking us to come play their parties, backyard barbecues, mixers. Then funerals and that led to us, like I said, disco was really king and we would get hired to play on the breaks from the DJs. Didn't have digital music so a lot of times when the DJ took a break, a lot of times the music would stop. So some of those organizations started hiring us to play on the breaks for the DJ. Then after a few weeks or whatever, some cases it turned out we were hired to play the party, and they hired the DJ to play the break. Which was good for us. [*laughter*]

KC: Yeah, yeah, yeah. Consistency, you know. But how did you and Roger [Lewis] and all of them have the stamina because you're talking about— You're walking, but you're also blowing for four hours, and it may not have been cool outside.

GD: It was not cool. It was— Now that I am fifty-nine, I can see the value in doing it in my youth. Because I certainly, I am totally opposed to doing them now. [*laughter*] A parade for me now is two to four blocks. That's long enough. [*laughter*] Back then, the parades would last three and four hours. You get some clubs that would wanna go from eleven o'clock to six o'clock or something like that.

KC: Whooo.

GD: And back then the adventure of taking on the job and

completing it was the challenge. And of course, you know, you had your pride. Some other bands probably sprung up by then to take the work that we couldn't physically do. So you just found the strength, the energy to do it because you wanted to make it happen. At that time early on, I was in college, a student at Loyola, and I soon found out if I played a parade on a Saturday or Sunday, my lips would be so swollen on Monday I couldn't play the stuff that I was required to play in school in symphonic band or the Jazz band.

KC: Oh, goodness.

GD: After you— Like any other muscle, if you use it a lot, if you overuse it, it tends to swell.

KC: Right, right.

GD: You just have to wait 'til the swelling goes down. Usually it would be by Wednesday.

KC: Oooo.

GD: That I could start getting back to what I was supposed to be doing in school.

KC: Oh, my God! But you were getting paid, though, that's what you were thinking. [*laughter*]

GD: I was getting paid. Which became an issue in that even back then, folks had an opinion of what they thought a musician's worth was, and now we were at a point where we were popular, and for the most part, we were the only game in town, so if you wanted the Dirty Dozen to play, you had to pay the price. When we first started doing those parades, like those clubs were accustomed to paying six hundred dollars. It was not uncommon to get a band to play a four-hour parade for fifty or sixty dollars per person, something like that. Once we realize we had a little something going, this was like in the mid-1970s, by the time the '80s rolled around, I had them up to, we were getting more than $2,000 to do a parade—$1,600, $2,000, which was still not enough, now that I look back at it. But the thing that sort of kept the prices, for most bands, we were getting what we thought we were worth. But by then, we were getting a whole lot of convention work. I didn't care if I never did another parade. [*laughter*] We did conventions for about fifty minutes, and you make two to three times what you get trying to do a parade. So we just eventually faded from the street.

KC: But you all had been out on the street since then, maybe like French Quarter–type parades.

GD: Yeah, but even the last parade, per se, that we did, they asked us to come out and play the— What's the precursor to Mardi Gras?

KC: French Quarter Festival?

GD: No, no, no. The parade they usually do before Mardi Gras. And it's still kind of cold.

KC: Oh, the Krewe du Vieux.

GD: Yeah, so about four or five years ago they asked us, "Hey, for old times' sake, won't y'all come out and do the—" so the guys wanted to do it, and I'd started playing with the band again regular so I had to go out there and do that, but whew!—that was the about the last one I did.

[*laughter*]

GD: Now I'm saying that, but Roger, Roger Lewis, he's seventy-five. He's the oldest guy in the band. He will go and play those parades when we come off the road.

KC: I've seen him.

GD: He's playing with all those bands all the time.

KC: All the time. I can recall him the last Black Men of Labor parade he was out there. I remember vaguely you telling me how old he was, and I'm like, okay, all right.

GD: Yes. He's out there. And quite frankly I believe that because he's that busy, that active all the time, that really keeps him going.

KC: He's never really lost that touch because he does it consistently.

GD: He does it all the time. Wednesday night he's playing at Snug Harbor. Everyone's at Snug Harbor with Delfeayo [Marsalis]. I work a series Friday and Saturday with a brass band at Harrah's. If he's available Friday and Saturday, he's over there doing that. He's very active.

KC: Well, let me ask you about specific songs because I know you know the era of disco/R&B/funk when musicians started inserting like Levert's "Casanova," and from our era, "Skin Tight," Ohio Players' "Skin Tight." But you all would mesh that with traditional pieces like "I'll Fly Away" and "Didn't He Ramble" and all of that, so could you tell me just a little bit about that. How did you all mesh those two worlds?

GD: Well, the mixing of the music for the Dirty Dozen was actually mixed in so-called modern Jazz and some R&B with New Orleans traditional music.

KC: Okay.

GD: For us it was the mixing of like Duke Ellington's "Caravan" with "Bourbon Street Parade" or "Caravan" with "Second Line." From time to time, we might've— First so-called pop tune that we added to the repertoire was Michael Jackson's "Shake Your Body Down to the Ground." That was a big hit. At some point that was a national, international hit. We started playing around with that more so because it had some horn parts in it. Quincy Jones arrangements and all that stuff. And so we adapted some of that to what we would like, and it worked. The first so-called Jazz, modern Jazz song that we played on the street was "Night Train."

KC: James Brown's "Night Train"?

GD: No. Well, James Brown's "Night Train" was a take-off of the original. Well, anyway, we had been rehearsing that song, "Night Train," and we were gonna do St. Joseph's Day parade or something like that when the Indians come out. We were going to start back on the bayou and our habit, Dirty Dozen habit, was to play a song just to warm up. And we started warming up on like "Night Train," and people gathered around because they weren't used to hearing a brass band play nothing but "When the Saints Go Marching In" and "Bourbon Street Parade" and the regular fare. But we started playing "Night Train," and people gathered around, and they liked it. Then we tried a tune that we had rehearsed called "Bongo Beep" that was a Charlie Parker tune. And that had that Latin rumba kind of feel to it. People gathered 'round, they just danced and danced while we were just warming up and along that particular parade route we probably ended up playing that song about eight to ten times because people just kept asking for it over and over and over again. Typically, when you doing a parade, you're trying to stretch it out. You're not repeating the songs.

KC: Right.

GD: People, sometimes they'd ask if you have certain songs. Anyway, we played "Bongo Beep," and they got into that, and I think that was the first indication to us that what we were rehearsing and playing was okay for the public. They wanted to hear so-called new stuff. From that moment on, I think that really encouraged us to continue learning the so-called new stuff. New to brass bands. Not new to the public, but it was stuff that hadn't existed before. Duke Ellington, Charlie Parker, Coltrane. We started adding stuff

like some James Brown, some Stevie Wonder, some Marvin Gaye. Anybody wanted to rehearse and experiment with something, we'd bring it to rehearsals. Back then we also had a lot to do with our youth, so we would rehearse in the evenings, starting at six or seven o'clock and go to one or two o'clock in the mornings. And still had to go to work or school the next day.

KC: Yes, Lord.

GD: That's what we would say, "Yes, Lord."

KC: Yeah, but when you're young, you could do it. You might suffer a little bit, but you could make it.

GD: Yeah. I just finished a trip this weekend. It was one, two, three . . . four gigs over five days, and I got here on Sunday. My flight got in about five thirty, six o'clock, something like that. I had time enough—I had not practiced all day, and I try to make sure I practice every day 'cause if I miss a day it was like I miss a week. But I had enough energy to come in, get something to eat, and I might've practiced about forty minutes. I laid down. I still, I don't sleep all the way through. Last night, I'm sure I slept at least three hours then sat up a while and went back to sleep. But a two-week trip now almost seems like six weeks. [*laughter*] Can't wait 'til it's over.

KC: Yeah. Let me ask you some more music stuff. So the "Night Train" I'm familiar with, not being a musician, is James Brown's "Night Train." *Ba-ba-ba, ba-ba-ba, bomp, bomp, bomp.*

GD: Yeah. That's a take-off of the Jazz "Night Train." Just added the James Brown funk to it.

KC: Okay. So what James Brown did was take the Jazz "Night Train" and made it a funk song.

GD: Right. Yep. He added that James Brown funk to it, and it became like an opening number for his show.

KC: Right.

GD: He allowed his band to play some stuff because most of 'em were pretty good players and to give them an opportunity to play something other than just playing James Brown background stuff. He would let them play a song or two, and "Night Train" was one of those songs. But then he eventually came to sing, put some vocal leads with it or whatever.

KC: Right. 'Cause they were legitimate musicians Maceo Parker, Bootsy (Collins), and all of them.

GD: Yeah. They could play. They, just so happened they earned their living, earned more money playing R&B and funk.

Which, for the most part, is still the way it is today. Pop musicians tend to earn more.

KC: Right. Do you remember the songs that got crowds, Second Lines going more than others?

GD: I do. There was one, it became known as Tuba Fats but it was really a take-off, [*sings a sample riff*] One of New Orleans Second Line kind of tunes but Tuba Fats— So he had started a bass line riff to a song, had a call-and-response to it. "Hey Pockey Way." And so he had a way that he started that song, and some of us developed like an intro to it, and the crowd would always look for that particular song. And the Olympia Brass Band had done an arrangement of "Mardi Gras New Orleans." [*sings a sample riff*] They had some pretty good success with that. So that was two of the so-called nontraditional Second Line songs that the crowd recognized and always wanted to hear. But then we developed a couple of songs. One of 'em was called "My Feet Can't Fail Me Now."

KC: Yes. Yes.

GD: That became like, for a while, the anthem until, I think Leroy came out with "Do Whatcha Wanna." And that was used in a movie, and that sort of became the thing. But when we first did "My Feet Can't Fail Me Now," some of the college bands would play it, and that was really just a simple dance riff that we added Charlie Parker stuff to, which set it apart and made the guys, the other musicians want to learn that.

KC: So "Feet Can't Fail Me Now," is that a Dirty Dozen original?

GD: Yes, that's a Dirty Dozen original. And another one was called "Blackbird Special." A lot of the so-called jam bands, funk bands, Galactic, they play a lot of Dirty Dozen—even Trombone Shorty—they play a lot of Dirty Dozen and/or Dirty Dozen–influenced music, which is good 'cause we get a lil' check every now and then. [*laughter*]

KC: Nothing wrong with that.

GD: Those songs became the standard fare for New Orleans brass bands. And then that because we were starting to add other stuff, other genres of music, that sort of gave other bands license or permission to start doing like the "Casanova" and some of the others, I hear—

KC: "Ate Up the Apple Tree."

GD: "Sweet dreams are made of—"

KC: Yeah, "Sweet Dreams," the Eurythmics song.

GD: Annie Lennox, whatever. What a lot of 'em have missed is that the root of it all is the New Orleans traditional beat. The New Orleans traditional music, the fundamentals of New Orleans traditional music is the foundation of what allowed us to— We figured out the harmonies and the rhythms. We took time to try to figure that out to see what would fit with the different harmonies and rhythms, how to alter them and augment them and all that kind of — We wouldn't play a James Brown tune just to play it like James Brown played it. We wanted to try and make it fit within the foundations of, fundamentals of New Orleans traditional music because that in itself has a real meaning. It really means something. More so to other musicians around the world than it does to some people that live here. They take it for granted.

KC: Right.

GD: I've really, really noticed it when we played the *Late Show* [*with David Letterman*] couple of times. Paul Schaffer had the band, and every time we would come on, they would wanna play some New Orleans traditional, "Royal Garden" or some New Orleans traditional stuff. They would have all the notes and such but just would not have the rhythm. The drummer wasn't right. The bass wasn't right.

KC: It was dry.

GD: It was a very, very dry, dry martini.

KC: It was dry like they're playing note for note, but there's no feeling.

GD: No grease. No fatback.

KC: That's what it is, no fatback.

GD: You can't fix your greens without putting fatback or ham hocks. [*laughter*]

KC: So, one more question. "Paul Barbarin's Second Line" and "Second Line," what's the difference?

GD: Well, "Paul Barbarin's Second Line" was more—more in the style of a traditional march [*sings a sample riff*], but it had a Second Line beat to it. "Second Line" is street, you know, gut bucket [*sings a sample riff*]. It would be almost like if you listen to the two kinds of R&B that were out at the same time, what was happening with the, you know, that Wilson Pickett kind of—

KC: Juke joint.

GD: Juke joint. That kind of stuff versus Motown stuff. Now

the Motown stuff probably became more famous. And it was good. It was great and all that, but it was not raw. Wilson Pickett, Otis Redding—

KC: Yes.

GD: That kind. I'm a fan of both, but there's a difference between the two. So the "Paul Barbarin's Second Line" was more of a high-society structured kind of song, almost a march kind of thing. But "Second Line," what people tend to call "Second Line," is actually "Joe Avery's Second Line." It's really based off the blues changes. If you played it like we do, a version of "Blue Monk," you could actually play "Second Line" at a slow tempo, but it's based off 1-4-5 blues changes, and there's a difference in the feel, the basic feel of both songs.

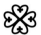

THE ETERNAL FLAME

Inheriting the Line

KAREN CELESTAN

S ocial, Aid and Pleasure Clubs and Second Line traditions are neighborhood and family affairs. Children are eager to be a part of clubs and annual parades, and parents will agree to their participation if their academic grades and household responsibilities are in order. A lot of New Orleans children engage in Second Lines in the same manner as they join local sports teams—it is a dedicated movement in their lives, as necessary as lacing up their "tennis" (New Orleans parlance for sneakers) and playing baseball, basketball, football, or running track. Often, their coaches are officers in SAPCs, and kids will "play Second Line" along with other childhood games.

Young people participate in SAPC service events and are dedicated to preparing their parade attire and accessories. Their energy and vibe are infectious, and children often put a contemporary spin on Second Line dancing. They are fierce and fearless actors on the Second Line stage.

Alvin Jackson of Black Men of Labor is adamant about passing along the tenets of the culture to younger members who are coached and mentored:

"We don't want anyone to embarrass the culture or us. The culture's first. We're second. We look for someone with the proper frame of reference in terms of who he might be. Not that he necessarily know all that we know but has an open mind and [is] willing to listen to the elders because we need to pass it on

Chris Rankin, Prince of Wales
October 14, 2007

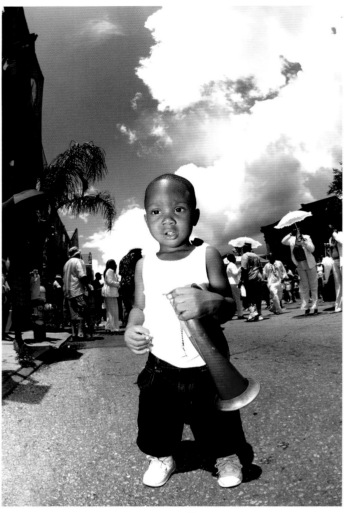

Hassan Goffner
August 6, 2006

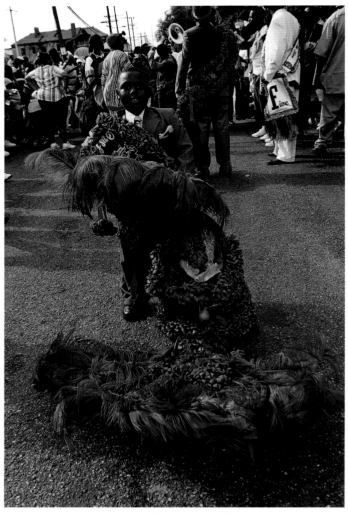

Young Men Olympian, junior division
September 24, 2006

to them, and when they reach our age, the ripe old sixty-plus, they need to pass it on to continue the process. The perpetuation of the culture is critically important. If we lose that and fail to pass it on to the younger generation, we're killing ourselves. We'll have Hollywood and Disney World right here [in New Orleans]."

Young men in the SAPC community are trained in the culture, and it is a foundation so strong that the mere mention of Bucket Men or Tambourine and Fan to a man brings forth a smile, a hand slap that morphs into a shoulder bump of masculine love, and a sharing of memories steeped in fun and innocence.

Oliver "Squirk" Hunter said: "Coming up as kids, we had Second Line practice on Robertson and Claiborne streets—this place called The Building. We was just excited. Excited to be part of something, you know? Second Line was a big thing like the Super Bowl. It was a movement. It was so big in my life."

Kids learn a Second Line cadence, how to sidestep, "Duck-Walk," and "Alligator." SAPC adults share insight on parade endurance and pacing as a form of self-control and exercise. They

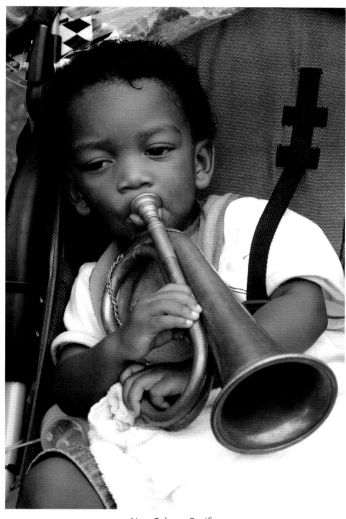

New Orleans Pacifier
Que'Dyn Growe
September 24, 2006

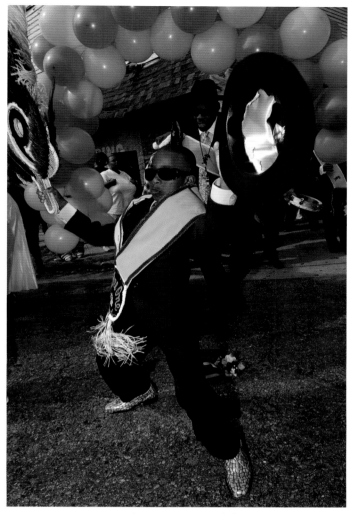

Noah Stewart, Big Nine kids
December 24, 2007

are taught the timing of a parade, spacing, and how a group should move within the confines of a parade. If two brass bands are hired, the club is divided into two sections, each one block apart. Youngsters learn various parade cadences and formations, such as single-file or two-by-two, and how to parade with and without a rope line to separate the club from second-liners.

The spiritual component of membership in an SAPC is emphasized—an individual contributing his or her gifts to the whole is often attributed to Aristotle or Rousseau, but it is an African philosophy rooted in the ancient Bantu notion of self-assurance or Ubuntu (pronounced *un-boon-too*) in which the group supersedes the individual. According to Stephen Lundin's online blog, in Ubuntu "there exists a common bond between us all and it is through this bond, through our interaction with our fellow human beings, that we discover our own human qualities."

Children are taught to share at an early age. However, an extra layer of humanity is instilled in SAPC youngsters—compassion, generosity, warmth, and affirmation. Archbishop Desmond Tutu, the Nobel laureate from South Africa, describes

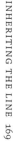

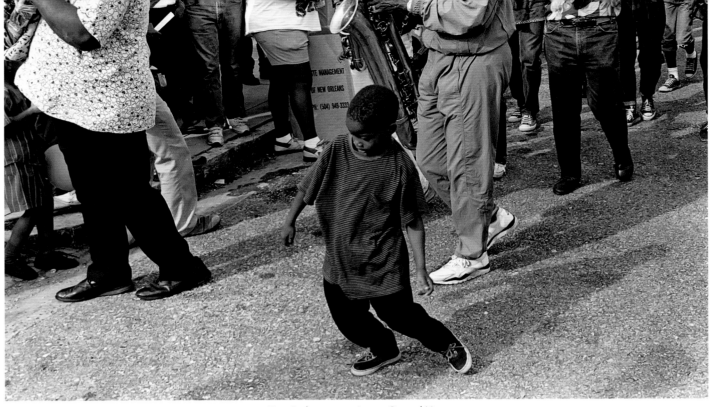

Troy Andrews, age six, at a Second Line
1992

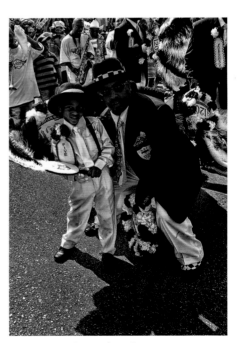

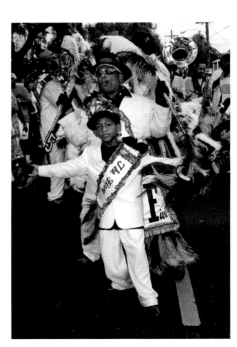

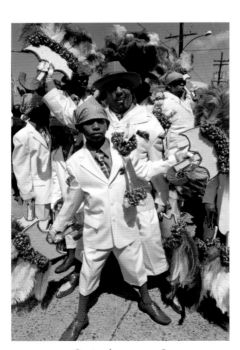

September 26, 2004

September 24, 2006
Waldorf "Gip" Gipson III and son Waldorf IV,
Five Gentlemen

September 29, 2008

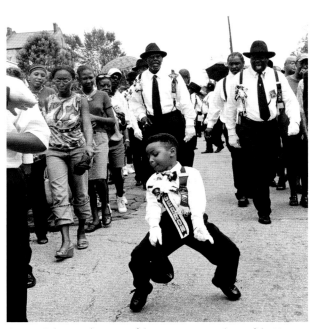

Reginald Blouin (*center*), Money Wasters
November 3, 2002

Gerron Coleman, then one of the youngest members of the Young
Men Olympian Benevolent Association, takes the lead and kicks
off dancing to the delight of adult members at their annual parade.
Children's participation turns Second Lines into a big family affair.
May 18, 2005

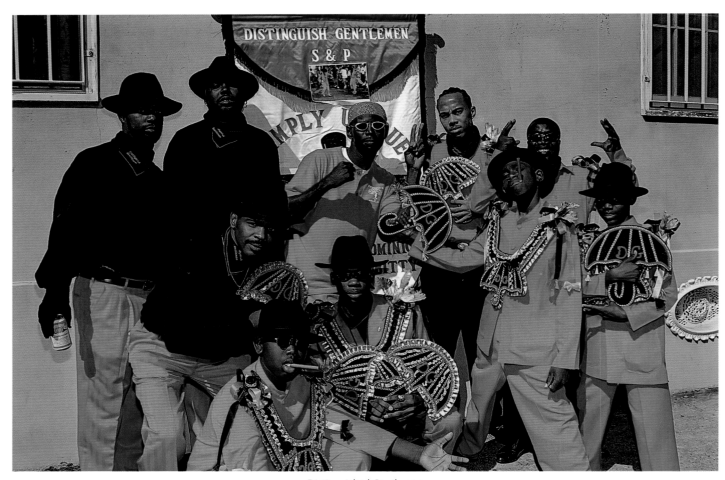

Distinguished Gentlemen
Back row (left to right): Carl Dyson, Les Dominick, Philip Dominick, Deshoun Augustine, Johnny Shields (*leaning forward in black shirt*), Jerome Brown, Markeith Tero, Alfred Alexander (*front with hand outstretched*), Philip Dominick, Jr.
July 18, 2008

Ubuntu as "the essence of being human. It speaks of the fact that my humanity is caught up and is inextricably bound up in yours. I am human because I belong. . . . [This] gives people resilience, enabling them to survive and emerge still human despite all efforts to dehumanize them."

REFERENCE

Lundin, Stephen. 2017. *Ubuntu.* Blog: *Motivation, Inspiration and Life.*

Interview with Eric "Tweet" Dudley and Erica Dudley

Member, Sudan Social and Pleasure Club, and daughter, Erica

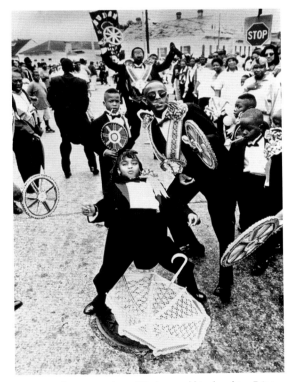

Eric Dudley, a member of Sudan, and his daughter Erica show off their prowess with second-line dancing. The movements are not sexual, but based upon motions passed down from African tribal traditions.
circa 1990

Karen Celestan and Eric Waters interviewed Eric Dudley and Erica Dudley at their home on July 28, 2012.

Erica Dudley: My name is Erica Dudley, and I'm twenty-eight years old.

Eric Dudley: Eric Dudley. I'm fifty-three years old, also known as "Tweet."

Karen Celestan: All right, we're going to be talking about Second Lines and your life in the Social, Aid and Pleasure Clubs. So, we have to start with Tweet first. So tell me how you got involved with Social, Aid and Pleasure Clubs.

Eric D: Well, uh, you know, I'm part of Sudan, and in 1983 that's when it was established. And I was with the different people who wanted me to join the club like that; at the time, I didn't really get involved in it right away because I wasn't really into it, and then I kept hearing about Sudan and their Second Line, and I just went there one Sunday and seen everything, and I was amazed—the umbrellas, the fans, the masks—and then when I seen it was all the brothers, we all come up together, and once I seen that, it was on from there. My daughter was small at the time and second-lining started with me and my daughter, but it goes back for generations.

My name is Eric Dudley, I have an uncle named Henry

Dudley, he was the grand marshal for the Olympia Brass Band. Way back when I was a kid, he was traveling around the world. On Sundays, he would come to the house, dressed up, and put those old albums on. I used to go play football and then after awhile I was just sitting there one time listening to the music and they would come knock on [the door on] a Sunday to play go football, but at the time, I told them they can't get me out of the house because I was into that old-school music. Take me to barrooms, take me to the Second Lines when I was small, so it was in the family. Matter of fact, everybody calls him Uncle Lionel, but he was really kin to me. I mean, first cousins, and everything like that. So, it goes back, awhile back, so second-lining is in my generation, it's in my family. My mama took me and I liked it, and I took my daughter— It's the culture of New Orleans.

Eric Waters: So what was so attractive about Sudan, let's go back, why Sudan? Why not Young Men Olympian, why not Black Men of Labor?

Eric D: Well, at that time, it wasn't Black Men of Labor, it wasn't uh—

Eric W: Young Men Olympian.

Eric D: They was uptown.

Eric W: Right.

Eric D: You know, we was downtown.

Eric W: Gotcha, it was all about location.

Eric D: Yeah, location. And when I seen what they make, you know, the umbrellas, the fans, the clothes, the shoes, you know, it was beautiful. And once you see them dance, then everybody want to know, I don't know if they know how they got the name Sudan. But if you look on the map of Africa, there's a small, tiny island called Sudan, and it's one of the best dancing tribes in Africa. So that's how we come to get the name Sudan. And when you go see a Second Line, that's one thing you're going to see is decorations and they're going to dance.

Eric W: And there's another family member who's involved in Sudan, right?

Eric D: Yes, my sister, Toes. Her name is Bernadine LeBoeuf; she's been sewing for like fifty years. When I was in the club with Sudan, we already had a lady, Ms. Amy, she would do all the sewing, but then after a while we always in the club like that, we always want to be ahead with the sewing to get your clothes made. The next thing, you know, Thomas with Sudan, like an older man who would do the alterations for the police department, he would do the alterations. I think that's how Thomas got to know my people. Toes is the best, and Sudan love her. She really don't have the machine to do all the pants and stuff, but the last thing I heard is that we were trying to buy her a machine so she could do it all.

KC: Take me back to the very first Second Line with Sudan, what did that feel like for you?

Eric D: Oh, it was beautiful because right now, we used to come out of the building at St. Bernard and St. Claude. It was a building we had there, it's no longer there. That was the building where we used to go and work on our decorations and all the stuff like that, that was our clubhouse. It was a house where we had meetings. You know, now, we have meetings at various bars and stuff like that, but when I was in the club, we had a clubhouse at St. Claude, St. Bernard, that's where we would keep all our stuff at, that's where we'd have our meetings, we used to make our stuff and left it there, that's where we came out at. So, if you go back into the '80s and the '90s, if you have any of those pictures, you're gonna see us coming out at St. Bernard.

KC: How old were you when you first came out?

Eric D: Um, let me see, I think I was about twenty-eight years old, something like that. Twenty-eight. I haven't paraded in a couple of years—

KC: Describe the feeling you feel when you're in the middle of the Second Line, let's say you all have gone a little ways, the music is going, and the people have gotten around you, and the Second Line is really rolling. Describe how you feel, you, yourself when that's happening.

Eric D: Oh, it's really great because it ain't nothing like good music. When you have that good music, it's like feet first, you don't even know they're your feet, but the music, you gonna jump to that music like you've been knowing it all your life. So, once they have the good music out there, then you see the club members, they jamming, everybody having a good time, the band is playing good music, and you know you're having a good Second Line when you have the side line jumping with you, yeah, you really have a good Second Line. So that's the beauty of good music. When you on the streets of New Orleans, and you've been to a real Second

Line, now it's good to go and see people, you know, to see it, but when you participate in it, ooh, it's a whole 'nother level.

KC: What do you say to people who look at the culture who say that's a waste of money, you put on the suit and the shoes and go out there and Second Line and basically, sometimes they might be ruined. What do you say to people who don't understand and say you should save your money, doing something like that?

Eric D: I mean, that's our culture. I mean, like you say, that's your money, you can spend your money the way you want to spend it, you know, and then let you see. Over the years, Sudan, a couple of years when we paraded, I mean, you see us on the ground, they see us coming out with all those nice clothes on, but you'd never think that when you see us on ground, scuffing our shoes up and our clothes, but this is a tradition in the Second Line, and it's something we don't really care about.

I mean, that's what we pay our money for, to go out there and have a good time. When you scuff your shoes up, I mean, it's on the individual, some tear their clothes up, they on the ground, that's the culture. I mean, when you go to see the Sudan, you gonna see us on the ground, on our knees. [Somebody might say,] "Why you on your knees ruining y'all clothes?" That's just how we second-line, that's how they do it, it's a tradition. I mean, it's different, maybe uptown might not do it, but downtown, that's just our culture. That's just how it go. Scuff up your shoes, you know, throw the basket up in the air, throw your hat in the air, I mean, it's the culture of the Sudan.

KC: You get caught up in the moment.

Eric D: Yep, caught up in the moment.

KC: Well, let me ask Erica. Go back to your earliest days, how old were you? Do you remember being a part of Sudan as a young Social, Aid and Pleasure Club member?

Erica: I think I was probably about eight in the youth division, and the first time I came out, I had on a green dress. I think the colors were green and beige, and they put me on the car. "Oh, you're so cute! We want you to see you ride on the car. We want you to wave." I waved and rode for one block, but when I heard that music playing, I called my mama because my mama wanted me walk on the side, and my daddy was getting ready to come out and second-line, so I told my mama, "I don't want to ride on this car." The music sounded good, I hopped off that car and got down. That was my first time. And I loved it. Then after, I really got into it and I wound up going by my daddy every time.

KC: So, how did you feel that day, and how have you felt since then out there when you're dancing, and music is going and the sun's shining? How do you feel? What does it feel like to you?

Erica: It's a beautiful feeling. And when you're out there and you have all of the attention around you. People are like, "Look at that little girl! She looks like she's five." And I'm thinking, "No." And I'm listening to the people say, "Oh, she's so cute!" It's just a good feeling. It's fun. And especially having my daddy there too, I felt, and if I think about it, if I had been by myself would I have had so much fun, but because my daddy was out there with me I was more (subdued) doing it. He was good with me, and I had my mama there also.

KC: Do you think the culture is going to survive with your generation? Because your daddy and his friends, they're getting a little older, and when your generation comes along, do you think your generation is going to keep it going?

Erica: Um, I don't know. I don't see it. I don't know, my generation is too focused on other things. But I'll be keeping it because it's the culture, like my dad said. I hope they keep it around.

KC: Can both of you talk about, without going into anything that people in the general public should know, about the organization. How do you go about picking out your clothes? What's going to be your accessories? How do you go about that every year? Can you talk about that and how that goes?

Eric D: Well, Ferdy and them and Bernard, they be over the kids. But, your colors, we go to meeting and whatever color comes to your mind, you know, present it to the club and if they like that color—it could be a burgundy, it could be a red, orange, or whatever color comes to your mind, you represent it to the club, you might have a piece of material that you show them. Everyone might have a color, might have a piece of material, show it to them, everybody look and see what color it is and then we vote on it. "What color do we want to be, everybody?"— It's always not one decision, it's a club decision, see what I'm saying, so everybody votes, "Yeah, we like that color, we'll go with that color."

The hat. The hats will always match the shoes, and then once you get your color, and what you want to come out in, everything else is basically all right. Once you figure the decorations for that color and everything like that, then you have to order your hats, say like a couple of members will go to the stores, Godchaux's, shop around, see a shoe, bring them to the club. We always bringing something to represent—"See, this is the shoe I picked out, this is the shoe you picked out"—and we might look at them and say, "We don't like none of them, go back to the drawing board." Come back and represent some more shoes, and we'll say, "That look good, that's all right" or "We don't like that, so how does this look?" "Okay, that look pretty good." So, we're gonna stick with this shoe here or maybe not, so we gotta go out and shop around to represent, it's a certain shoe you're looking for, but first you gotta get that color. Shop around, bring some more shoes, [everyone says,] "That's the shoe," and we vote on the shoe.

KC: Go back and forth.

Eric D: Yeah, back and forth.

KC: So when do you start on that, like the year before? You know the Second Line is that the same time every year and you need to decide, when do you start on the next year, when you finish the Second Line that year?

Eric D: Yeah, once you finish the parade in November. We're always the second Sunday in November. After November, come the new year, January, we might have a board meeting, the president and all them will have a little meeting. Early January, have a little meeting, then in middle of January, they call a club meeting to start getting ready, getting together early. You have to get ready early because you have to pick out clothes, the decorations that we gonna come up with— That's another thing we go back to, whatever come up in your mind what decorations you can go out and represent your club that we can make—fans, basket, umbrellas, whatever—represent it to the club, they look at it, they like it, the preparation and by going to go get the stuff and we got to start early.

January, we might have our first meeting, February, trying to get the colors, then once you get the colors, then March come in, you already have your colors, then you get the decorations, then April, once you have everything, you start ordering stuff, every time you have a meeting, you have to put money on the books for your dues. And you can't go out and buy a pair of shoes without putting some kind of down payment on it. So, people come to me, and everybody put one hundred dollars on the books, because that's money to go get whatever you gonna go get—your shoes, the decorations, hats. So, the Sudan always start early.

Eric W: Are there dues beyond what's needed for the clothes?

Eric D: No, no. Are you saying it's expensive?

KC: When you pay your dues, is it just for your clothes and decorations or is it used to cover other things?

Eric D: Your dues, I mean, once you pay your dues, it's for everything. Once we—and that's another thing I'm leaving out—once we have our first meeting, and we see, maybe twenty [people] might show up, starting out but eventually, things be going on and people's finances aren't right, they're going to start dropping out and stuff like that. Let's say we start out with twenty, and when we see it might be twenty, it might be five hundred dollars a man, and when I say five hundred dollars a man, that means your whole decorations for Sudan, your shoes, your hat, your fan, your umbrella, everything. Then, that's five [hundred] when you're counting twenty people. Now when they start falling out, well, you know that gots to go up. It might be with ten, so that might be eight hundred dollars a man, you see what I'm saying, you got to go up now to keep Sudan going. The more you have in Sudan, the cheaper it is. And always going to be doing it every year, I don't think— I don't even spend a thousand dollars. Sometimes it might be fifteen hundred, they don't even be two Gs [two thousand dollars], but you look good!

KC: Oh, yeah, that's the truth.

Eric D: I think they're about one of the cheapest clubs I know you can parade with and look good. And nobody can make that decoration, we make our own decorations.

Eric W: A lot of the dues also cover the fees for the—

Eric D: Oh, yeah, now, the dues that you're paying, that's just for your clothes. The dues you pay, that's for your clothes, decorations, but also you have to pay for— That's why they give dances, raffles, you know, because you gotta pay for fans, you gotta have your permit, you gotta have your bar, so once

we pay fifteen hundred dollars a man, you know, that fifteen hundred included everything. Then we give dances and your tickets, all that money you're making from the bar that go toward paying for the band, paying for the permit and stuff like that.

KC: So, Erica, when you all are no longer kids, is there a women's version of it, are you, at this point in the women's division?

Erica: No, I'm not in it anymore.

KC: Oh, you're not?

Erica: I'm not in it anymore because after a certain age, Dad, what is it, sixteen?

Eric D: Yeah.

KC: There's only a kids' and a men's division?

Eric D: Yeah. In Sudan, you can parade as a kid, but they don't have— Just like this year, I heard they supposed to have five divisions this year because that's other groups that want to parade with them on that day.

KC: Okay.

Eric D: So, it is Sudan parade that day, but they have other clubs that want to parade with them. But with the women, once you get a certain age, she's out of it, they don't have no ladies' club, don't have a Lady Sudan. Now, they have a ladies' club, I don't know, whatever it is, they ain't with Sudan, but they come out with Sudan. They have their own meetings, Sudan don't have nothing to with they meetings, however it is you want to run it, that's on y'all. If y'all want to parade with us, y'all gotta raise your money, do what you have to do.

KC: [*to Erica*] Well, how do you feel about that? I assume that you miss it, huh?

Erica: [*nodding*]: Uh, huh, I do want to second-line again, but I just don't know.

Eric W: I've seen her at two Second Lines over the years, one was with your friend at Dinerral Shavers' funeral Second Line uptown, and I think I've seen you at another Second Line.

Erica: Yeah, I do want to come out again, but I just don't know. It's just a lot of different Second Line clubs, and there's been so many changes over the years, and it's kind of expensive. I don't know, but I do want to do it again.

KC: Have you ever thought about forming your own club? [*laughing*] You don't think you could do it?

Erica: I think I could do it, but this time, it would be with adults.

KC: But you've got the history, you know, and the experience. Could there be a Lady Sudan, if your daughter started it?

Eric D: It's possible, but it's like family, you know? Um, I think the only way they could probably have a Lady Sudan and really call it family, like the men in it, it would have to be their wives. It would have to be our wives with close contact, like my wife— All our wives would have to be involved in that, that way it still would be a family. Once you bring outsiders in, things change. So, with Sudan, they welcome anybody, they open to anybody, but when you say you want to parade with Sudan, we have rules and regulations. If you can't go by their rules and regulations, you can't parade with Sudan.

Eric W: I think you remember, I shot a photo of you and your dad at the anniversary of Sudan. How old were you then?

Erica: That was by the funeral home?

Eric W: Right.

Erica: Um, I know I was in junior high, I was like, twelve or thirteen. I do remember that because I was in class and I had a Black History test, I was at Behrman Junior High and this man was in love with the Seventh Ward culture, and he would have us, like every week, go to different places and take pictures, the Circle Food Store, the hot sausage place that was on Saint Bernard, we would go to different places. And I was fine with it because I was born and raised [in the Seventh Ward], and everybody was like, ["I can't do it,"], "Oh, I stay uptown," "I stay across the river," and I was like, "Okay, I can do that!" So, he had pictures all around the wall and the bottom of the room, and it was newspaper articles. So he would tell us, "Walk around and pick your favorite article, and I want y'all to write a paragraph." I used to always go to his class and not walk around until he said that, so I'm walking around, and here's me and my daddy with a newspaper article and picture of me going across the porch with the cigar in my mouth. So I said, "Wait a minute, Mr. Henry, that's ME!" And he said, "That's you right there?" And I said, "Yes, I dance with the Sudan Social and Pleasure Club." He said, "Wait a minute, that's you?" Aw, he thought I was a movie star. Everybody wanted to write that article. [*laughter*]

Eric D: I remember that.

Erica: You remember that?

Eric D: That picture you took of us when she was small with the

dress, I made a move and she made a move, something was going on in school, and y'all was second-lining.

Erica: Yeah, yeah.

Eric D: Remember when Jerry called? My little nephew called, "Man, we was in class with the Second Line history and they got you in the book!" You know, I had that picture but lost it in the storm.

Eric W: I'll get you another one. Who is the originator, the founder of Sudan?

Eric D: Uh, wait, I'd have to say it was? A. D. Berry, Teedie, Ben Fowler, and Bernard, Kenneth Dice, uh, Squirky Man—

KC: What's Bernard's last name?

Eric D: Robertson. Squirky. Oliver—

KC: Y'all grew up together, so what school did you go to?

Eric D: We all went to Rivers Frederick Junior High School, remember Jackie? All of us went to Rivers Frederick, Kevin Beaman, John Dobard— And they [stayed] **front o' town**, on the other side of Claiborne and Toledano, and then you had to cross over Claiborne. I stayed two blocks from Frederick. Marcus Quinn, Barnell Quinn, Leo Young, all of us went to Frederick. Frederick Junior High School was like a college, we had leather jackets in the '70s. We won football, basketball, baseball, track, discus throw. Oh, yeah. As a matter of fact, I was one of the first Hunters [Hunter's Field team], Terry Hunter—

Eric W: You played on the football team?

Eric D: I played football, I was light like this here [*pointing to himself*], but I played cornerback. I was one of the first when the Hunter first came out in the '70s. I was one of the first Hunters.

Eric W: I wanted to ask if he was one of the Bucket Men? [*laughter*]

Eric W: Well, you know, I was a basketball coach.

Eric D: You know, me and Chickie go way, way back.

Eric W: Yeah.

Eric D: He had a lot to do with NORD [New Orleans Recreation Department]— Getting back to—

KC: He was with Tambourine and Fan.

Eric D: I was with—me, Terrie Green and John Dobard, Teedie— no, Teedie was behind us. Teedie was way behind us.

Eric W: Did you ever parade with the Bucket Men?

Eric D: Uh, yeah.

Eric W: You did? You were a little bitty boy.

Eric D: Yeah, my cousin Wayne, Wayne Kendrick, all was on the team together. We was the first Hunters. I liked to always try out for Saint Roch. Saint Roch was lily white. A white park. It was hard to get on. Then, the Hunters came along. And I used to stay right there on Touro where I used to go straight up Derbigny Street to the cut. I stayed right around the corner from the Hunter's Field. I was born and raised—

The Point of It All

KAREN CELESTAN

A sense of belonging, being, place, and self is a major force in maintaining a healthy human psyche. The dynamic of knowing who you are and where your heritage originated has become a cottage industry through various DNA search/research companies.

African Americans are now familiar with a range of African tribes and tribal affiliations in their backgrounds. A number of Black people are taking great pains to pass along limited information to their children and grandchildren since so much data and memory had been erased and systematically omitted from mainstream historical records. An award-winning introduction to such eradication was showcased in the landmark 1977 television series *Roots,* based upon the book of the same title by Alex Haley. One of the most memorable and searing scenes was the public lashing of young Kunta Kinte (portrayed by Levar Burton), hung by his wrists and beaten senseless by a white overseer until he uttered his new slave name, Toby.

It is more crucial that information provided by several respected scholars documents the rich history that had been previously denied so many Black people in America. For example, according to Gwendolyn Midlo Hall in *Africans in Colonial Louisiana,* traders under French rule brought people from the following tribes to be placed on slave blocks in New Orleans:

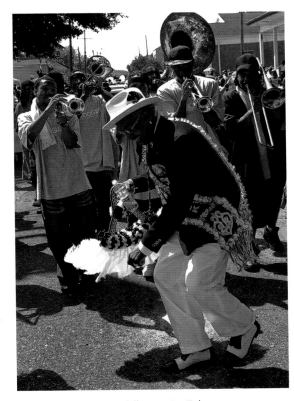

Wardell Lewis Sr., Zulu
September 26, 2004

- Bambara
- Mandinga (also known as Mandinka)
- Wolof
- Fulbe
- Nard
- Mina
- Fin
- Yoruba (Nago)
- Chamba
- Adó
- Kongo Angola

- Caraba
- Ibo
- Moko

A number of others were brought to America from Sierra Leone (the Kissy), the Windward Coast (the Canga), the Gold Coast, and Mozambique (Hall 1992, 293).

At least two-thirds of these tribes were taken from the Senegambia region and others from the Bight of Benin. People from the Kongo tribe were the largest single African group in New Orleans. Traders under Spanish rule added people from the following tribes to slave numbers in Louisiana:

It should be noted that the enslaved in America, particularly in New Orleans and the surrounding area, may have appeared to be "broken," but they held onto a semblance of spirit-strength to survive the harshest of physical treatment and psychological damage placed upon Black human beings in the United States. A view of the horrors visited upon Black free people and slaves was documented in the 1853 memoir, *12 Years a Slave* by Solomon Northup, later illuminated by an Academy Award–winning film starring Lupita Nyong'o and Chiwetel Ejiofor, directed by Steve McQueen; and *Django Unchained*, an

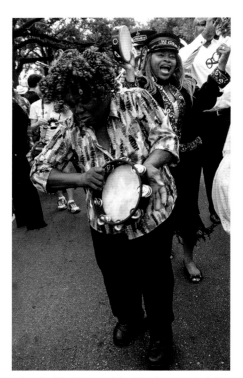

Rosalie Washington (aka "Tambourine Lady")
August 2, 2014

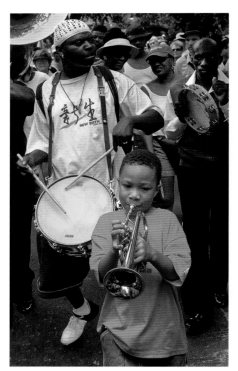

Glenn Hall III (on trumpet)
May 25, 1986

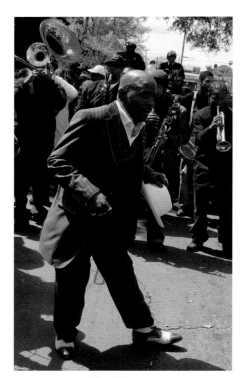

Therol Thomas
March 21, 2010

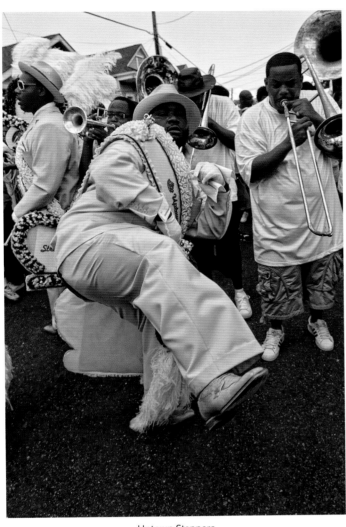

Uptown Steppers
June 6, 2011

Leo "Slick Leo" Coakley, Sudan
September 9, 2003

award-winning film starring Jamie Foxx, Kerry Washington, and Samuel L. Jackson, directed by Quentin Tarantino.

According to Hall, "Colonial Louisiana left behind a heritage and tradition of official corruption, defiance of authority by the poor of all races, and violence, as well as a brutal, racist tradition that was viewed by its ruling groups as the only means of containing its competent, well-organized, self-confident, and defiant Afro-Creole population. But it also left behind a tradition of racial openness that could never be entirely repressed" (Hall 1992, xv).

But in line with that internal strength, African Americans continued to "make a way out of no way." According to John Hope Franklin in his outstanding work *From Slavery to Freedom: A History of Negro Americans:* "In New Orleans, where in 1845 Norbert Rillieux had invented the vacuum pan for evaporating syrup in the manufacture of sugar, there were teachers, jewelers, architects, and lithographers in 1860. Almost every community had its free Negro carpenters, barbers, cabinetmakers, and brick-masons; many had shopkeepers, salesmen, and clerks, even where it was in violation of the law" (1980, 164).

Franklin also noted: "The affluence of a large number of free Negroes in New Orleans is well known. They owned more than $15 million worth of property in 1860. Small wonder that in the preceding year, the *Daily Picayune* was moved to describe them as 'a sober, industrious, and moral class, far advanced in education and civilization.' . . . Thomy Lafon, the tycoon of New Orleans, was worth $500,000 at his death" (1980, 166).

It is with history in mind that this collective has defined the culture in *Freedom's Dance.* Creating an etymology for and overview of the Second Line by people of African descent honors the ancestors and gives renewed pride to SAPC culture-bearers. African Americans are constantly evolving, responding to the ever-changing tides of political and social mores fueled by race and class that impact their daily lives. The drumbeat of their strength and survival cannot be denied.

Africans and Afro-Creoles have expressed their spirit-freedom through music and dance—the prime connection to a centuries-old break from their Motherland. It is this modicum of joy that has been passed down from the eighteenth century and appears on the streets of New Orleans nearly every Sunday (including the revered holidays of Easter, Mother's Day, and Father's Day) for ten months. The psychic release normally viewed in Black church worship throughout America takes on a more public form through the traditions of the Social, Aid and Pleasure Clubs in New Orleans.

REFERENCES

Franklin, John Hope. 1980. *From Slavery to Freedom: A History of Negro Americans.* 5th ed. New York: Knopf.

Hall, Gwendolyn Midlo. 1992. *Africans in Colonial Louisiana: The Development of Afro-Creole Culture in the Eighteenth Century.* Baton Rouge: Louisiana State University Press.

Interview with Markeith Tero

Vice president, Distinguished Gentlemen SAPC; member, Revolution SAPC

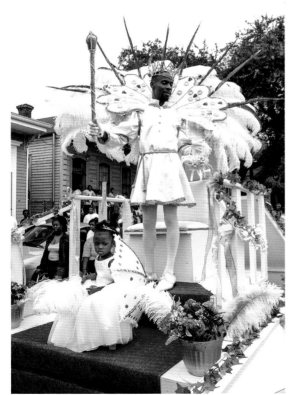

Markeith Tero, king of Popular Ladies parade
October 26, 2003

Eric Waters interviewed Markeith Tero on October 13, 2013.

Eric Waters: Give me some background on your involvement in New Orleans culture, particularly the Second Line culture.

Markeith Tero: Well, way back in 1989 I was involved with Tambourine and Fan with Jerome Smith, Ike Bennett, Tee Gulley. My mother and father and them, they were always involved with Tambourine and Fan, so Jerome Smith grabbed me and taught me how to second-line, taught me how to sew—

EW: How old were you?

MT: I was about ten years old, I'm thirty-five now, so I've been around for a long time in the Indian culture and the Second Line culture, and I have a love and a passion for it.

EW: Were you old enough to ever have paraded with the Bucket Men?

MT: No. I was always in the stroller while my dad was the one second-lining with the Bucket Men. I came up under the youth Bucket Men. They always paraded on Super Sunday.

EW: Exactly. Eric, my son, paraded [with them]. How many Second Line groups have you belonged to?

MT: Well, I belong to this Distinguished Gentlemen Social, Aid and Pleasure Club, I always served as a member and went from member to the businessman and to the vice president.

I rank in team with the Revolution Social, Aid and Pleasure Club in 2011, that's about it. That's the Second Line organizations that I'm involved in.

EW: You are very involved in the culture in itself, so even if you're not in or participating with one of the clubs, you're part of the Second Line.

MT: That's right.

EW: What's your feeling about the culture of the Second Line? I mean, you've been involved since you were ten years old. You've been involved, but what's your personal feeling? So what are you feeling about the importance of the culture called the Second Line?

MT: Well, now the way the culture is now as compared to back then, it's all about fashion, it's all about—

EW: Let's go back to how you saw it back then, and then we'll go into how you see it now.

MT: Back then, it was more of, uh, a rejoicing, like a release of a spirit that was in you. When you went to church and there was a song or a hymn that came on, you would feel the spirit to where, can't nobody control that spirit, but you control that spirit. It's the same way with Second Line, once you hear that music, you hear that bass drum and that tuba playing, you get into the spirit where your feet just can't fail you. [*laughing*]

EW: I hear you.

MT: And now, it's to where who have on the best suit, who spent the most money on shoes, whose decorations look the best, to where back then, it was wearing shirt, pants and suspenders, handkerchief and a band, umbrella and a basket, where now where it's two fans, a big ole streamer, big baskets, and stuff like that—

EW: What's the significance of the dove?

MT: The dove symbolizes, it will always symbolize members that went on, who have passed away, and you always keep that dove on your shoulder over your heart to symbolize the members before you that have gone.

EW: The basket.

MT: The basket? Sometimes you will see a basket that has doves or they would have the lady dressed up in her dress with the baby doll, but now, there's all types of stuff. You might see the Sudan Social, Aid and Pleasure Club, they may have the Ferris wheel, they may have the horse and carriage with

a [respected] member inside of it, they keep the tradition, they keep it to where how they started—

EW: Like Bernard, he had the picture of his son in the fan, his son had just died—

MT: Yeah, they all pay homage to a family member or someone in the club that's special—

EW: Talk about the fans versus the handkerchiefs.

MT: The fan is where, if you don't see the fan, you see the handkerchief, when the sweat come down you always have the fan, you have the towels to catch the sweat. [*laughing*]

EW: [*laughing*] I hear you. I photographed you one time when you were king, and what parade was that?

MT: That was the Revolution Social, Aid and Pleasure Club, no, that probably was the Popular Ladies Social and Pleasure Club back then. My first year as being king, and that was in, I want to say—

EW: Before Katrina.

MT: I want to say it was '02 or something like that—

EW: Now, since we are talking about you being king, when you first started second-lining, I remember back in the da— thirty-five years, photography, photographing it, uh, I don't remember kings and queens.

MT: No, that is something they started back then to— If a person was always supporting the club, sometimes they'd ride as an honorary member to where now they had started— to where you support them and they pay homage to you to where you either ride on the car or you ride on a buggy as a king or you ride to be their grand marshal.

EW: They have floats now; they didn't used to have floats.

MT: Those came about— It's kind of like the twist to the Carnival clubs to where the kings— Now they have the big collars, the crowns, they have the king's outfits, they have the dukes and the maids riding in the parade to where everybody can't ride on the car so they got the floats now— You have a king looking like Rex.

EW: Tell me the importance of the grand marshal in the Second Line.

MT: The grand marshal kind of, I have to go back to pictures where— Arthur Batiste, Lionel Batiste to where the grand marshal— That was the man that everybody wanted to see, just like when somebody would pass they would do the dirge. Some people just don't know how to do the dirge.

EW: Explain the dirge.

MT: The dirge is to where you hear the bass drum is knocked two times before the casket rolls out of the church, the procession starts rolling, the tuba starts playing, the trombone, they all start playing, the people walk slowly. The grand marshal holds his hat in one hand and holds the streamer in the other hand to where he's leading out the procession of the person in the casket.

EW: And he's leading the dirge, and objects that he's holding—

MT: He's holding the hat in one hand, is holding the streamer, he's rocking from side to side.

EW: And that's called the dirge. And the dirge is immobile.

MT: Exactly.

EW: That's one thing I had not heard.

MT: He'll either hold the hat in his hand or put the hat over his head when they're walking out in procession.

EW: Right. What is that called [when] they rub their heads together?

MT: I don't know.

EW: That happens in the Black Men of Labor parade. Benny Jones and the guys, I don't know, I thought you may have— Okay, now, let's fast-forward to what's happening now with the clubs, you don't think that people have the same emotional feel in the Second Line?

MT: It's just about spending more money, and my feeling about that is it doesn't matter what you have on when you're out there and you're second-lining because you've got a six-thousand-dollar pair of shoes or a five-thousand-dollar suit, it's not about that.

EW: But what about people on the side? The name of the book is going to be *Freedom's Dance*, The Second Line in New Orleans is going to be the secondary title, but— What I've experienced in shooting Second Lines over these many years is that sense of feeling, it's like a release, and people feel motivated to act out that freedom when they second-line. I mean I've seen guys hop, crawl, they don't say anything, I've seen them—

MT: There was a funeral, I can't think of what year it was, but it was one of the Dollioles at St. Augustine Church, and I tell you, when that band strikes up, the pallbearers and the family members jumped on top of the hearse, on top of Rhodes' hearse, and they danced, they dented limousines to

the point that they didn't want the members second-lining, that's just how bad it got.

EW: That's over the top. But I was just thinking about how the second-liners, not particularly the guys who dress up in the Social, Aid and Pleasure Club, but the side-liners—

MT: On top of Circle Food Store, on top of the building, on top of the [street]light, on top of cars, to the point that people would literally be outside bodyguarding to make sure that people wouldn't be on top of their cars. It's like that spirit, once that spirit hits you—

EW: That's what I'm saying, in terms of freedom, the freedom release.

MT: Yeah, it's like a lot of stuff might've happened over the weekend, and you go to the Second Line and the Hot 8 brass band is playing, the Rebirth, TBC, the Tremé Brass Band, they play your number-one numbers that you want to hear, and that spirit just hits you, and you just can't control it to where I'm gonna jump on top of this car, don't care whose car is or how much they paid, it's just that spirit and you can't control it. You're into a totally different world.

EW: Out of sight. Well, one picture that I've taken where one guy had climbed up on the crate. It was at Howard Avenue, at that exit off of 610, they were building around there, and the Second Line was coming up toward—

MT: Going toward uptown?

EW: I think it's Julia, Julia Street— Well, anyway it was a crane— and it was the weekend and they weren't working, so and this guy climbed up on the crane and was all over the crane and he was second-lining. [*laughing*] And I've also seen the guy who was second-lining, and he stood on his head, he's not walking, he's second-lining, never seen that—

MT: Dancing. It's all type of stuff they do. They haven't seen [the] guy who parades with Nine Times, he would literally stop, stand on his head and just move his feet, twist around.

EW: Uh, Gerald [Platenburg].

MT: Yeah.

EW: Gerald is one of the best out there.

MT: He— I can't do that. [*laughing*] I can't do that.

EW: Yeah. Tell me about your friend that you're real close to.

MT: Emmanuel [Hingle].

EW: Y'all were close, not just in terms of Second Line culture—

MT: Well, we were close as far as, I had a strong bond with

him, we started [masking] Indians together, we started second-lining together, we just— Everything I did, he was always there. And since— When he passed in 1999, that was one of the hardest years of my life besides Hurricane Katrina. I lost— There were always three of us, they used to call us three peas in a pod, when you see one, you'd see the other two. One died in 19— [pauses]. It's hard for me to talk about this, he died in a forklift accident, he was going to mask, his first year he was going to mask as Wild Man, he didn't make it through that year.

Then, within that following year, July 11, I remember it like it was yesterday, the times when the Eighth Ward and the Seventh Ward had some kind of conflict going on. We went to a pool party because one of the guys who was in our Second Line club invited us, some kind of way they had the girls there in the bathing suits— He [Emmanuel] was a player, he loved the girls, he had left and I thought it was strange because he was going with this one girl at the time. I went to looking for him, went all outside, didn't see him, came back, and I could hear this lady say, "Cut the music down, someone's in the pool." I'm coming through the crowd, not knowing. Somebody says, "Does anyone know CPR?" And as I was getting through the crowd, I saw the red shirt. I said, "I know CPR," but when I found out it was him, I just broke, I was in a state of shock. Nothing I could do. I was in a state of shock. Eric, right now when I tell you, it's hard for me to second-line because that was my partner. It's hard for me to mask because that was my Spy Boy, I was his Flag Boy— It was hard then. Now me and "Man" was two years apart, I was his front man because I couldn't make it to church and I couldn't stand for him, but some kind of way they wound up with my name as a relative. So I was like dad, brother, friend rolled into one.

EW: So you were two years older?

MT: Yes, and it has been hard to stick with it, bruh, how can you go on in life without him being there, and I'm like, he's there, you just can't see him, he's there in my heart.

EW: Right.

MT: So, that year, I just didn't— I could mask no more, I couldn't second-line because he wasn't there. To this day— even when my daughter was born—

EW: Thank you for sharing that, man. I know it was difficult, but I remember you talking about him because you and I go back a ways.

MT: [laughing] Way back. All the business I have, we have a picture when I went to this Christmas party, and it was like a baller's club, we was all dressed up and it was before Katrina. Only pictures I have, and it finally got to the point I grabbed them, put them in a shoebox, and buried them in my grandmother's yard because it was pictures of Man. And it was like a week after the funeral, it was in my mailbox, no name, nothing on it, it was just pictures of the funeral. It was like a Band-Aid on this wound. and it just opened it back up. And it took me a while, I used always come to the house and look at the pictures. I came out on St. Bernard Avenue, my grandmother stayed right there on Marais, so before I would come out to get Tootie [Big Chief Montana], I would always turn down St. Bernard, make that right on Marais Street, all that has changed.

EW: Yeah. Anything else you wanted to say?

MT: No, I just hope that they keep the tradition alive because that's one part of New Orleans you can't take away. Like with Katrina, on Sundays I was going to church out there in Houston, but after church, there was no Second Line. [laughter] There was no Second Line! It took me a while to kind of like, settle, to get comfortable because I missed home. It wasn't home. I was determined to come back home. I couldn't stay in Houston, that—

EW: I'm trying to get back myself. The Second Line for me is every Sunday, every single Sunday there was a Second Line.

MT: And now, it's now where they have Second Lines on Saturday, it don't feel the same because I understand that they don't have enough Sundays. And I don't see why they don't have enough Sundays, I guess it's just the city.

EW: Well, they really have enough Sundays, there are so many Second Line groups. The Black Men of Labor had to get special dispensation to change their date.

MT: I was to die somewhere else, you'd have to bring my body back. This is the only place that they are going to have a Jazz funeral.

EW: Right.

MT: The only place where you're going to hear a tambourine, and this is where they're going to bury you at.

EW: So you see the culture continuing? I know I see a lot of guys

bringing their children out to be able to see the Second Line, and they dress them and everything.

MT: They do, but my thing is you just can't have your kids dressed up to participate without knowing the background and the history of why we do what we do. They need to know the history, they don't need to know, "Oh, it's Sunday, come March 19, I put on these clothes and I'm going to second-line." If someone was to stop you and say, "Well, why do you second-line?," they would know. And I think that should be a part of New Orleans history in schools. A lot of people with the Indians, they don't know their history, they just know they wear feathers, they are beautiful, that's all, but that's not taught.

EW: Well, hopefully this book will be inspiration to have people pay more attention to the culture. A lot of people have documented it, they've studied it, but [it] really hasn't received the notice. Because if you look at New Orleans celebrations in this city, white folks, Black folks, everybody has a Second Line. I'm just afraid, maybe I shouldn't say this on tape, but I'm afraid of assimilation and the Second Line being co-opted. But I don't see that happening right now, but what needs to be changed, is that everybody in New Orleans, no matter what ethnic group they're in or from, they have Second Lines.

MT: The Mardi Gras Indians that used to participate used to have their "a taste of New Orleans" at these weddings.

EW: But what the rest of the country needs to understand is why these cultures are so important to us is the background. It's something that needs to be understood, first of all, and that's why I wanted you to talk about the emotion in terms of Second Line, how you felt back then, and I know you're still out there.

MT: Yeah, I'm going to go to my grave dancing. [*laughing*] Everybody says that I'm going to go to my grave dancing. I used to always tell my mama, before I got married, I said, "When they bring me out the church, don't put me up in the carriage, don't put me in the hearse." [She said,] "What do you want me to do?" "Put me on a float because I might decide to get up and start dancing."

GLORY FULFILLED

Cutting the Body Loose

KAREN CELESTAN

The African-American community continues its participation in ancestor worship and holds on to the belief, passed from generation to generation, that death is a reward from earthly bondage. And in New Orleans, the passing of a beloved friend or relative receives a level of pageantry that is equal to the life lived and status in the community.

It is expected that the "dearly departed" receive a "proper send-off"—African- or Caribbean-based rituals, dirges after a church service. A window of sadness to acknowledge passage into the spirit realm. Then, the body is "cut loose"—the assembled release the hearse, and limousines with family members travel in private to the grave site, to "take 'em home."

A funeral parade combines the fervor of a Black church service, a house party that spills out into the street, and the "letting go" once a beloved family member has been placed into the crypt.

And the celebration begins, a joyous wail from a trumpet, a blast from a tuba, and the drums—oh, the drums! The call of Mother Africa. Bodies dip and flail, handkerchiefs are twirled, and with eyes closed, hearts and minds are given over to the rhythm, as the Second Line commemorates another soul joining the ranks of ancestors.

Oliver "Squirk" Hunter second-lined after his mother's funeral. He said that it was a difficult thing to do—willing his

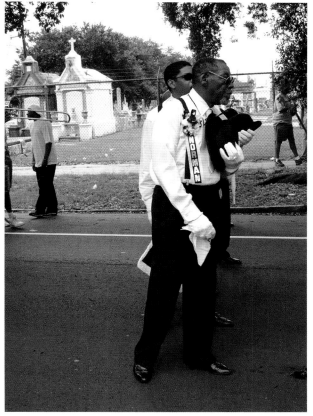

Norman Dixon Sr.

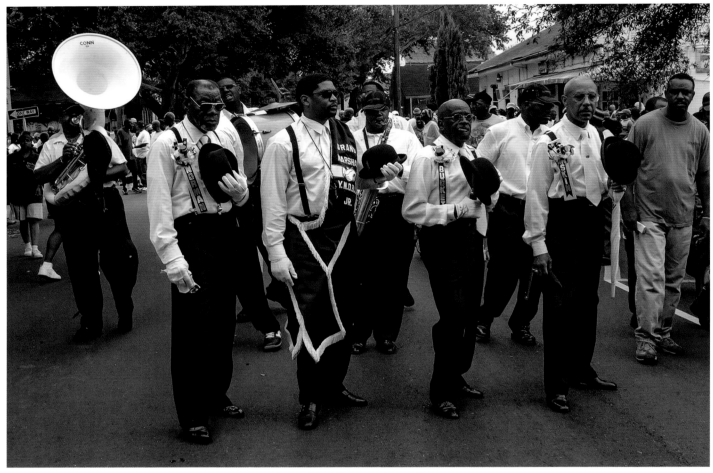

Young Men Olympian, funeral dirge
July 23, 2002

body into free movement normally associated with joy—but he said he *had* to do it.

"I was thirteen years old and was doing what was supposed to be done. This is what we do. This [is] our spirit, our culture, so I did it for my own mother. If you [are] a part of that community and it's somebody I know, I just go on and do it. It takes me in different directions, takes on a different spirit, but the more you put in, the more you get."

Alvin Jackson, of Black Men of Labor, talks about the funeral dirge in specific terms: "The dirge came out of the Civil War, and it was a way that Europeans recognized and honored their deceased with a funeral service. Our ancestors in the nineteenth century recognized and appreciated how solemn it was,

adopted that, and incorporated it with an ancient ritual from West Africa, Senegambia, which was a slow procession."

Jackson said that those movements, actually military drill-like movements, came out of the war between French and Prussian soldiers: "And we continue that today, that carriage and the horse— It was the culture back then which utilized carriages and horses. Coaches. And thanks to Charbonnet [Funeral Home] we are able relive that [ritual]."

He shares that the dirge is a dedicated part of the Black Men of Labor's annual parade: "We perform the funeral dirge for our fallen members on Robertson [Street] between Esplanade and Dumaine, stop by the Candlelight [Lounge] and old Joe's Cozy Corner or the Tremé Music Hall, places which are

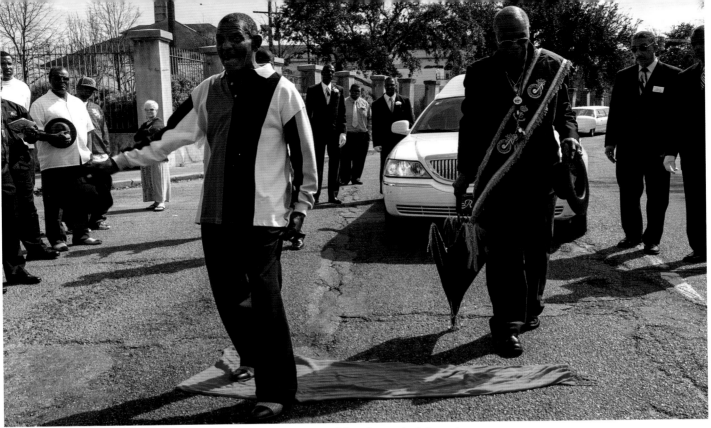

Sylvester Francis (*left*) at his mother's funeral
February 12, 2008

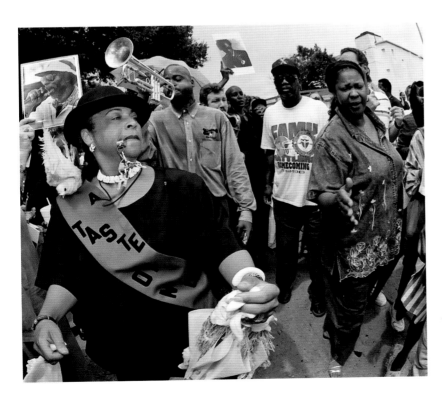

Wanda Rouzan, grand marshal at Second Line following R&B
singer Johnny Adams's funeral, with James Andrews
on trumpet and singer Juanita Brooks (*far right*)
September 1998

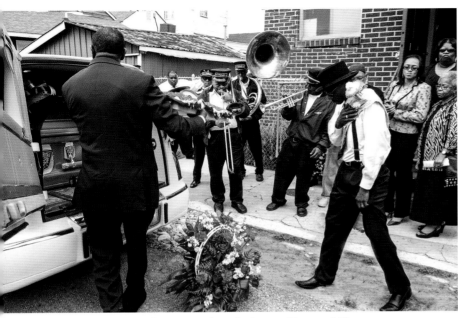

Oliver "Squirk" Hunter salutes the late Joe "Bummer" Allen.
February 22, 2012

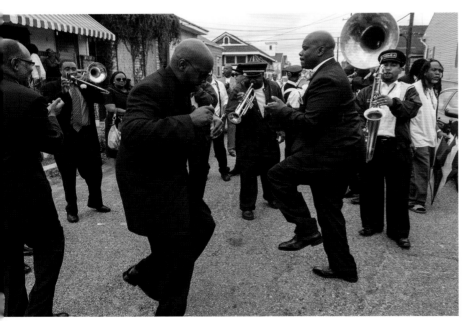

Joe Allen Jr. (*right*) second-lines in honor of his late father.
February 22, 2012

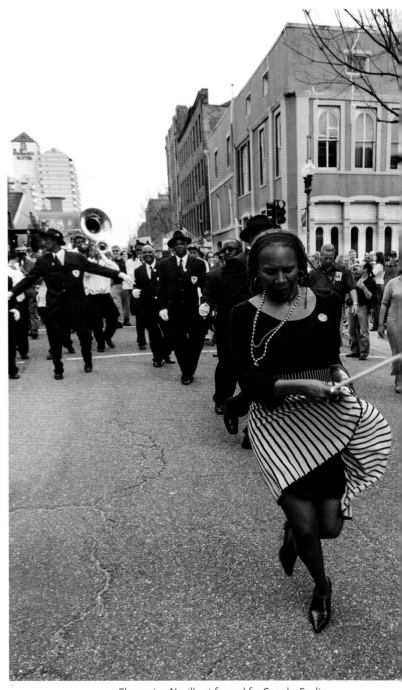

Charmaine Neville at funeral for Snooks Eaglin
February 27, 2009

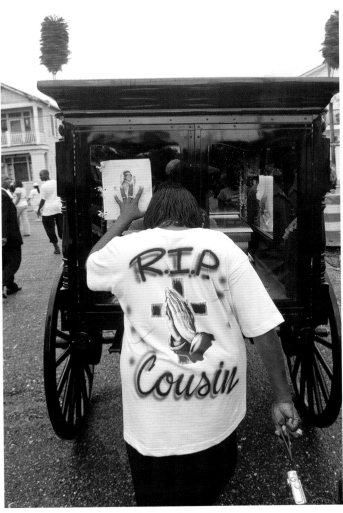

August 16, 2008

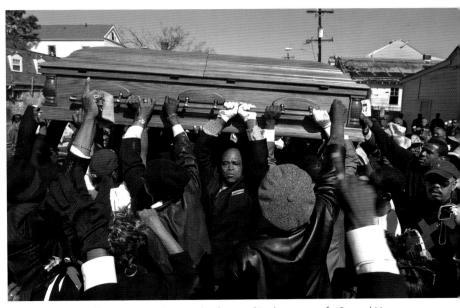

Coffin raising in tribute to the deceased in the course of a Second Line.
This is a Caribbean tradition that has been incorporated into
modern Second Line customs in New Orleans.
February 2, 2008

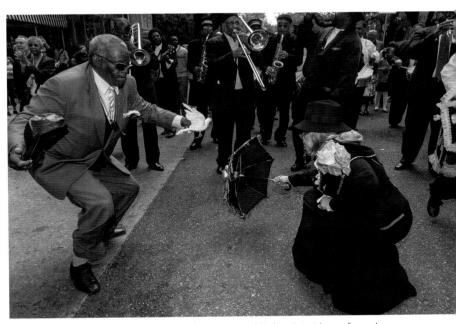

Grand Marshal Wanda Rouzan and Rickey Gettridge at funeral
for Bernard "Bunchy" Johnson
March 27, 2010

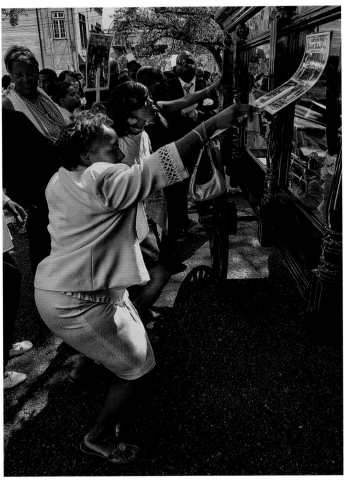

September 27, 2008

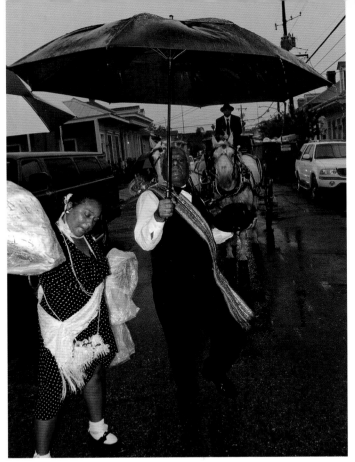

Jennifer Jones and Gerald Emelle, Kenneth Terry (*below*)
at Porgy Jones's funeral
August 30, 2014

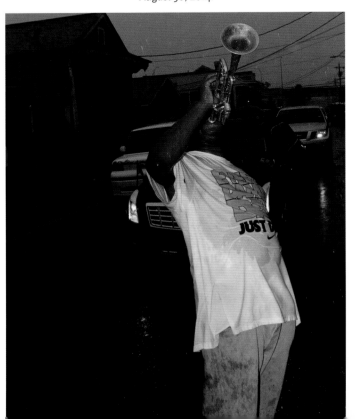

no longer there. That dirge coming up Robertson Street, we'll always perform and perfect because it speaks volumes to our fallen heroes. It's important that we do that and perpetuate that memory."

"God controls all the paths. Rain ain't never stop a Jazz funeral. We loved it when it rain," Oliver "Squirk" Hunter said. "Take all that away for a moment, that [sad] hour or whatever it is, [the] music takes that away. Lift that spirit. Lift that soul."

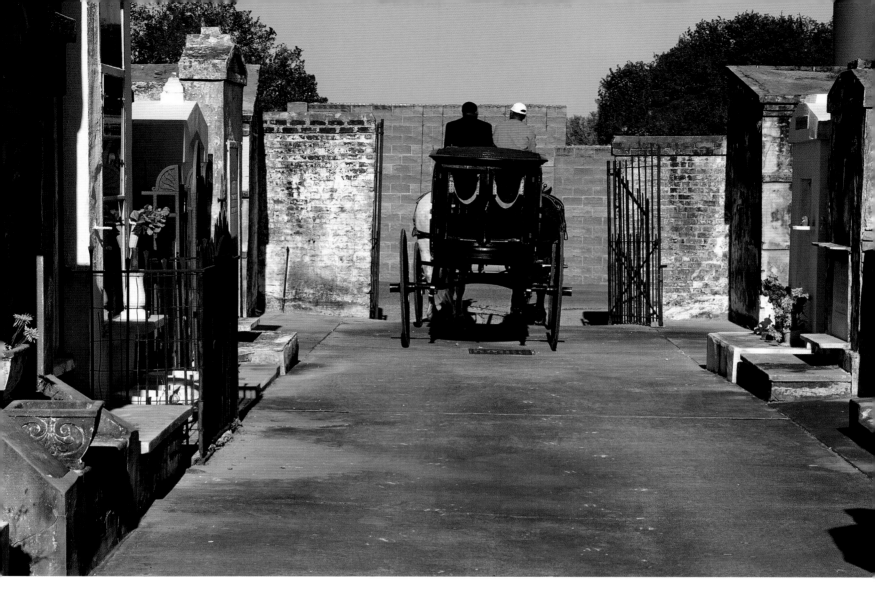

IN MEMORIAM

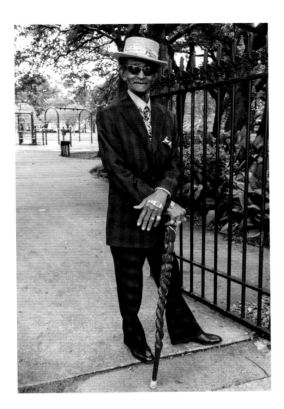

LIONEL "UNCA LIONEL" BATISTE SR.
(1931–2012)

Musician, singer, tailor, and cultural raconteur, Batiste was a bass drummer, vocalist, and grand marshal of the Tremé Brass Band for more than twenty years. He was one of sixteen children born to a blacksmith, and he began his music career at age eight playing the bass drum with the 6th Ward Band, playing for the Square Deal Social, Aid and Pleasure Club. He was the first African-American king of the Krewe du Vieux, a satirical parade group. Batiste had a long career as a tailor, which was evident in his distinctive sartorial style, featuring a gold watch spread across the knuckles of his left hand. He dedicated his life to the brass band/Social, Aid and Pleasure Club culture. Batiste passed away at age eighty-one in New Orleans on July 8, 2012.

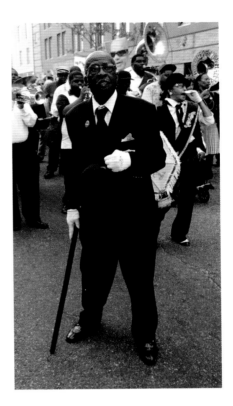

ALFRED "BUCKET" CARTER
(1934–2015)

Faithful member of the Young Men Olympian Jr. Benevolent Association for more than seventy years, Carter was a retired laborer, working for K&B (Katz & Besthoff) Warehouse for fifty-plus years. He passed away at age eighty in New Orleans on March 9, 2015.

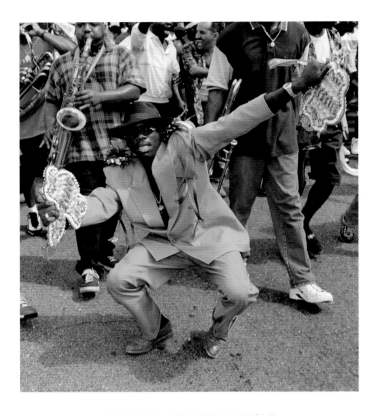

NORMAN DIXON SR.
(1935–2003)

Social, Aid and Pleasure Club coordinator and Mardi Gras Indian consultant for the New Orleans Jazz & Heritage Festival for more than twenty years, Dixon was a founding member of the revered Young Men Olympian Jr. Benevolent Association. He participated in more than five hundred Second Lines and brought the true, powerful movement of the Second Line culture to Jazz Fest and, in turn, to the world. Dixon passed away at age sixty-eight in New Orleans on May 30, 2003.

EMANUEL ROYNELL HINGLE
(1980–1999)

An active member of the SAPC culture and youngest Mardi Gras Indian chief, Hingle led the Trouble Nation tribe until his untimely death in a pool accident on July 11, 1999, at age nineteen.

ANTOINETTE DORSEY KADOR
(1943–2009)

Kador, also known as Ms. Antoinette or Nettie, was devoted to the Baby Dolls Social and Pleasure Club. She was instrumental in reviving the dormant tradition of the group parading on Mardi Gras morning and gave a home to the club at the Mother-In-Law Lounge on Claiborne Avenue in Tremé that she opened in 1994 with her husband, Ernie K-Doe. Kador was a welder's helper on offshore oil rigs, paving the way for other women in that male-dominated field. She was also a respected seamstress and a flamboyant cultural supporter. Kador rode out Hurricane Katrina in her apartment above the lounge and, armed with a shotgun, kept looters at bay for a week. She passed away at age sixty-six on Mardi Gras morning, February 24, 2009, in New Orleans.

ERNEST KADOR JR.
(1936–2001)

Kador, known by his stage name—Ernie K-Doe—was a New Orleans cultural icon noted for his public performances and gift for exaggeration. The novelty song "Mother-in-Law" (written and arranged by Allen Toussaint) was a hit in 1961 due to K-Doe's strong lead vocal. His time as leader of the Blue Diamonds group in the early 1950s led to memorable songs such as "Honey Baby," "Do Baby Do," and "Hello, My Lover." He was a regular on New Orleans' club scene, performing at the Sho-bar and Dew Drop Inn. He revived his career in the early 1990s and opened the Mother-In-Law Lounge in Tremé with wife Antoinette. The lounge, housed in a prominent location on Claiborne Avenue, was a regular and welcoming stop for parading Mardi Gras Indians, the Baby Dolls, and a number of Social, Aid and Pleasure Clubs. Kador passed away at age sixty-five in New Orleans on July 5, 2001.

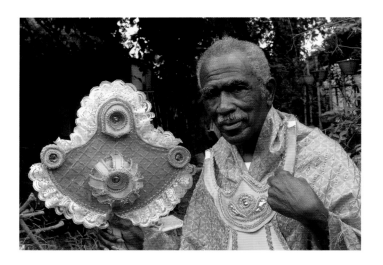

ALLISON "TOOTIE" MONTANA
(1923–2005)

ANTHONY "TUBA FATS" LACEN
(1951–2004)

Lacen was a beloved tuba player and a founding member of the Dirty Dozen Brass Band. He was invited to join the Fairview Baptist Church Band in the 1960s and was tutored by Jazz band leader and banjoist Danny Barker. Lacen was trained in traditional Jazz, but he put a contemporary twist on standards with his tuba. He performed with the Paulin, Olympia, Tuxedo, Gibson, and Onward brass bands, and played in innumerable Second Lines. Lacen's affable personality and tuba mastery led to a career with Sweet Emma Barrett, Kid Thomas, and the Preservation Hall Band. He was so prolific that he formed his own band, Tuba Fats & the Chosen Few. Lacen passed away at age fifty-three in New Orleans on January 13, 2004.

Montana was known throughout New Orleans as the "Chief of Chiefs" of Mardi Gras Indians. A second-generation Mardi Gras Indian and chief of the Yellow Pocahontas tribe, Montana would stun the public early every Mardi Gras morning for fifty-two years with a "new suit." He would sew every single bead and feather with painstaking, spirit-led dedication for eleven straight months, creating vivid and distinctive suits in which to "mask Indian" and parade. A master lathe worker by trade, Montana earned the respect of the entire African-American community and was revered as a wise elder in both the Mardi Gras Indian and Social, Aid and Pleasure Club cultures. He suffered a fatal heart attack on June 27, 2005, while speaking at a New Orleans City Council meeting to protest police harassment of Mardi Gras Indians on their sacred anniversary, St. Joseph's Night. Big Chief Montana was eighty-two.

DEDICATED MEMBERS OF THE SECOND LINE CULTURE

Rest in Peace with God and the Ancestors

Placide Adams
Eldridge Andrews
James Bollock
Leroy "Boogie" Breaux
Robert "Bob" Clark Sr.
Alphonse Cotton
Sandra "Big Sam" Davis
James "Phat Nasty" Durant
Thaddeus Ford Sr.
Nowell "Pa-Pa" Glass
Glenn Patrick Hall Sr.
Travis "Trumpet Black" Hill
Joseph "Smokey" Johnson
Raymond Joseph
Dorn "Pappy" Kemp
George Mattio Jr.
Ezall "Money" Quinn Jr.
Dinerral Shavers
Edgar Smith
David "Chubby" Stevens
Johnnie "Kool" Stevenson
Ellyna Tatum
Charles Taylor
Willie "Pa-Pa" Williams

Ashe, Ashe, Ashe-O

APPENDIX

Parades of the Social, Aid and Pleasure Clubs in New Orleans

AUGUST
Valley of Silent Men/First
 Parade of the Season

SEPTEMBER
Young Men Olympian
Good Fellas

OCTOBER
Family Ties
Prince of Wales
Black Men of Labor
Men of Class
Original Four
Women of Class

NOVEMBER
We Are One
Sudan
Nine Times and 9SL
Men & Lady Buckjumpers

DECEMBER
Dumaine Street Gang
Westbank Steppers
New Generation
Big Nine
Men and Lady Rollers

JANUARY
Perfect Gentlemen
Lady Jetsetters
Undefeated Divas
Ladies & Men of Unity

FEBRUARY
Tremé Sidewalk Steppers
CTC Steppers

MARCH
VIP Ladies and Kids
Keep N It Real
Single Men
Revolution

APRIL
New Orleans Bayou Steppers
Single Ladies
Pigeon Town Steppers
Old & Nu Style Fellas

MAY
Original Big Seven
Divine Ladies
Zulu
Money Wasters

JUNE
Perfect Gentlemen
Uptown Swingers

GLOSSARY

African Diaspora—communities of African descent throughout the world that have been created or have grown as a result of the historic movement, both voluntary and involuntary, of people from Africa to areas around the world that dates back to antiquity, but primarily refers to the slave trade in the eighteenth and nineteenth centuries (see **Trans-Atlantic Slave Trade**).

back o' town—(often pronounced "backatown") refers to the Faubourg Tremé, located at the extreme edge of the French Quarter.

banquette—the old type of granite-curbed sidewalks found in the French Quarter and other nearby neighborhoods.

buckjump—a derivative of the nineteenth-century dance known as the "buck and wing"; co-opted to mean engaging in Second Line dancing that includes jerks, leaps, and fast, intricate footwork.

cocked ace-deuce—a slang term usually referring to a hat, its brim pointed to the side and lowered just below the hairline, worn with swagger and confidence.

Creole—African Americans who generally have African, French, Spanish, and Native American heritage; Creoles distinguished themselves as being a mix of Black and Caucasian and created a separate class, especially those who were "free people of color."

cut to the bone—slang, refers to being extremely well-dressed from head to toe; a derivative of "being sharp."

cut loose—refers to the point in a Jazz funeral procession when the dirge ends and the hearse turns from the parade to transport the body and bereaved to the gravesite.

flambeaux—plural of *flambeau,* or flaming torch made of several thick wicks dipped in wax and lit; a Mardi Gras tradition dating to the mid-1800s, when slaves were conscripted to light the path for Carnival parades. The men would twirl the torches and dance (often enduring serious burns from the dripping hot wax) to entertain mostly white parade-watchers for coin tips that were always thrown to the ground. This practice has endured, although it is severely reduced due to the danger of open flames near Mardi Gras crowds and Black people's rejection of its racist implications.

front o' town—the streets and neighborhoods closest to the Mississippi River (French Quarter), known as the Vieux Carre; this area starts at the river and stretches back to Rampart Street.

G, OG—slang for gangster (gangsta), original gangster; often used in reference to a man who is cool or can handle any situation with calm efficiency; original refers to an older man with the aforementioned style. A woman can be gangster, depending on the circumstance.

humbug—an argument or disagreement, fight; nonsense.

Mardi Gras Indians—people of African descent who create elaborate and colorful "suits" derived from a melding of African, Caribbean, and Native American cultures. In the United States, "Indians" are found only in New Orleans, where they are grouped into tribes and appear in ceremonial parades on Mardi

Gras Day (also known as Carnival Day), Super Sunday, and St. Joseph's Night.

maroons—runaway slaves who left plantations in the 1800s to hide in swamps and bayous to avoid detection by police or overseers.

nanan/parrain—Creole terms for godmother (nanan) and for godfather (parrain).

pop a gator—a move associated with dancing or "doing the Alligator," slang referring to the moment when the dancer drops down to the floor to do the move or dance.

Trans-Atlantic Slave Trade—the largest involuntary deportation in human history of African people, mostly in the eighteenth century. Approximately 10–12 million Africans were captured, torn from their homes and families, deported to the American continent (South and North America), and sold as slaves. The journey across the Atlantic, known as the Middle Passage, was noted for its brutality, with slaves packed tightly below deck in hot, oxygen-deprived spaces, chained together by the ankles with ropes around their necks. Between 15 and 25 percent of African slaves died aboard these ships, their bodies fed to sharks. This trade was a major determining factor in the eighteenth-century world economy. Africans fueled a U.S. economy that was bolstered by slave auctions and the attendant high productivity in the cotton and sugar industries from free slave labor. United States banks also profited from investments in slaves and plantations.

CONTRIBUTORS

JAMES B. BORDERS IV is the author of *Marking Time, Making Place: An Essential Chronology of Blacks in New Orleans since 1718* (2015). Borders also has been a full-time consultant since 2001, specializing in organizational development and capacity building for small and emerging cultural and social-service non-profit corporations. He has previously served as executive director of the Louisiana Division of the Arts, managing director of the National Black Arts Festival, managing director of Junebug Productions (an outgrowth of the legendary Free Southern Theater), founding editor of the *New Orleans Tribune,* editor of the *Black Collegian Magazine,* coordinator of major events at the University of Rhode Island, and cofounder of Rites & Reason Theatre at Brown University. He can be reached at www.jbborders4.com.

RACHEL CARRICO is a scholar, practitioner, teacher, and lover of dance. Her research on Second Line dancing, which has been published in *TBS: The Black Scholar* and *TDR: The Drama Review,* has earned her numerous fellowships, grants, and awards. Carrico has taught dance and theater to young artists from New York City to Southern California and many places in between. In New Orleans, she cofounded Goat in the Road Productions, with whom she has directed two international artist residencies and launched Play/Write, a youth playwriting festival, in New Orleans schools. She parades annually with the Ice Divas Social and Pleasure Club.

ESAILAMA ARTRY-DIOUF is the founding director of Bisemi Inc., which supports African-derived cultural artists rooted in and making positive impacts within underserved communities. Artry-Diouf has worked for more than twenty years as a dancer, scholar, arts administrator, and cultural worker on a national and international basis.

FREDDI WILLIAMS EVANS is an independent scholar, arts education consultant, and author of *Congo Square: African Roots in New Orleans,* the first comprehensive study of that historic landmark. *Congo Square* received the 2012 Louisiana Humanities Book of the Year Award. Her research and advocacy influenced a New Orleans City Council ordinance in 2011 that designated Congo Square as a landmark and assigned its official name. Evans cochairs the New Orleans Committee to Erect Historic Markers for the Transatlantic Slave Trade to Louisiana and Domestic Slave Trade to New Orleans; initiated the New Orleans Teaching Artist Institute; initiated and co-curated an exhibition on Congo Square at the 2012 New Orleans Jazz and Heritage Festival; and coauthored text for the historic marker at Congo Square. She is the award-winning author of historically based books for children: *Hush Harbor: Praying in Secret; The Battle of New Orleans: The Drummer's Story;* and *A Bus of Our Own.* Evans received the Community Arts Award from the Arts Council of New Orleans in 2011.

JOYCE MARIE JACKSON is the director of the African and African American Studies program and an associate professor in the Department of Geography and Anthropology at Louisiana State University, Baton Rouge. She has directed the LSU in Sénégambia Academic Program Abroad, bringing students to Senegal, The Gambia, and Ghana. She is developing an academic Study Abroad ethnographic field school in Jacmel, Haiti.

Her key interests center on African-American music and culture, and she has conducted extensive ethnographic research on

Gospel music. Jackson has been instrumental in the production of several documentary recordings and authored several interpretive liner note booklets published by Smithsonian Folkways Recordings, Capitol Records, Inc., and the Louisiana Folklife Recording Series.

Jackson's other research is based on performance-centered studies of rituals in Africa and the African Diaspora, including the Ndupp healing ceremonies in Senegal, West Africa, and the Baptist Easter Rock traditions in northern Louisiana. She produced a documentary, *Easter Rock*. She has examined the sacred rushing tradition in the Bahamas and Carnival traditions in Trinidad and Haiti to coincide with her research on the New Orleans Mardi Gras Indians.

Jackson has been the recipient of awards, grants, and fellowships, including the Rockefeller Foundation Fellowship, the National Academy of Recording Arts and Sciences grant (agency responsible for the Grammy Awards), the National Endowment for the Arts Fellowship in Arts Administration, and the Foreign Language and Area Studies Fellowship to study Bambara (a West African language).

ZADA JOHNSON is an associate professor and academic program facilitator in the Carruthers Center for Inner City Studies at Northeastern Illinois University in Chicago. Johnson teaches courses in anthropology, African-American studies, and inner-city studies education. Her research includes African-American performance traditions, popular culture, and ritual performance in the African Diaspora. During her doctoral research, Johnson lived in New Orleans investigating the relationship between the city's African-American parading traditions and the rebuilding of African-American communities after the devastation of Hurricane Katrina. Her dissertation—"Walking the Post-Disaster City: Race, Space, and the Politics of Tradition in the African-American Parading Practices of Post-Katrina New Orleans"—examined the traditions of Social, Aid and Pleasure Clubs, Mardi Gras Indians, Bone Gang maskers, and Baby Dolls. Johnson researched Afro-Cuban ritual performance in Cuba and Miami. Johnson's publications include articles in the *Journal of Southern Religion* and the *New*

Encyclopedia of Southern Culture. She designed the Mardi Gras Indian K-12 educator resources for the Tulane University website Music Rising at Tulane.

VALENTINE PIERCE is a New Orleans poet, writer, graphic designer, visual artist, and actor. Pierce's debut book, *Geometry of the Heart,* was published in 2007. A resident writer at A Studio in the Woods in 2006, she has displayed her artwork at Tulane's Carroll Gallery and performed in several productions at Ashé Community Art Center. Pierce has won two awards from the American Academy of Community Theatres.

KALAMU YA SALAAM is a New Orleans writer, filmmaker, and educator. He is a senior staff member of Students at the Center, a writing program in the New Orleans public school system. Inspired by the poetry of Langston Hughes and the Civil Rights Movement in New Orleans, he became interested in writing and organizing for social change. Kalamu is the moderator of *neo-griot,* an information blog for Black writers and supporters of Black literature worldwide. Salaam can be reached at: kalamu@mac.com.

CHARLES E. "CHUCK" SILER is an artist who studied with Jean Paul Hubbard, Frank Hayden, and Harold Cureau. A native of Baton Rouge, Siler served in the U.S. Army as a correspondent during his tour of duty in Vietnam. He returned to Southern University to serve as sports information director and assistant public contacts director. Siler produced cartoons and illustrations for a number of publications, including a black-and-white sketch used in *Billboard* magazine's "Michael Jackson" special edition (1984). Siler created the popular "Music at the Mint" (U.S. Mint, New Orleans) series that featured Jazz, blues, and R&B artists and a host of other entertainers. He has produced programs in conjunction with the National Park Service and the Old State Capitol Museum. In 1985, Siler was named division information representative and program coordinator for the Division of Black Culture for Louisiana's Department of Culture, Recreation and Tourism. He was instrumental in the development of many of the state's African-American

museums and cultural centers. His art has appeared in galleries, museums, and private collections throughout the United States.

MICHAEL G. WHITE is a professor of Spanish and African-American music at Xavier University in New Orleans. A respected clarinetist on the Jazz scene who performs, writes, and lectures on Jazz, he is an acknowledged expert in the field of traditional New Orleans Jazz. White tours worldwide with his own Original Liberty Jazz Band and other groups at major concert halls (such as Carnegie Hall and Lincoln Center) and festivals, and he has appeared in many documentaries and films. White has received numerous awards and recognition for his work, including the title of Chevalier of Arts and Letters from the French government in 1987 and a National Heritage Fellowship Award from the National Endowment for the Arts in 2008. He received the 2013 Humanist of the Year Award from the Louisiana Endowment for the Humanities. White holds the Keller Endowed Chair in the Humanities at Xavier University.

ABOUT THE AUTHORS

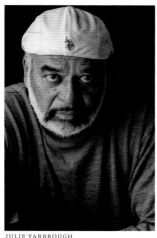

JULIE YARBROUGH

ERIC WATERS has been a professional photographer for more than forty years. He studied under the tutelage of the late Marion Porter, a respected African-American photographer and owner of Porter's Photo News in New Orleans. Waters' relationship with Porter helped him to see the world around him in a new way and built the foundation for Waters' future in photography. Waters decided early in his career that New Orleans street culture had significant historical value and was worthy of documentation. He is a highly regarded event and wedding photographer but is known best for capturing the vibrant and energetic scenes of the New Orleans Second Line and Mardi Gras Indians. He is one of few photographers with an insider's view of what makes this culture come alive.

Hahnemühle USA selected Waters' thematic work on clarinets and Mardi Gras Indians to showcase a new line of archival paper at the 2009 Imaging Expo in New York because of his technical proficiency, richness of color, and the beauty of his subjects. Waters' iconic *Squirky Man* photo (1992) appeared as part of the opening photomontage with the theme song for the HBO series *Treme* (season 1, 2010).

He was the lead photographer for projects such as *Ties That Bind,* an exhibition and catalogue sponsored by the Casey Foundation; *Great Day in New Orleans,* a group photo from 1998 capturing nearly three hundred African-American artists of all genres; and the New Orleans Jazz and Heritage Foundation Archives. Waters' photography has graced CD covers for numerous New Orleans Jazz artists, including Bob French, Victor Goines, Juanita Brooks, and Smokey Johnson. His work has appeared in local and national magazines, newspapers, brochures, and show bills.

In 1985, he founded EbonImages, a nonprofit organization, to catalogue and exhibit the collection of Marion Porter. The organization is dedicated to documenting African-American culture in New Orleans, especially Jazz musicians, Black Mardi Gras Indians, Social, Aid and Pleasure Clubs, Second Line parades, Jazz funerals, and other social events.

In 2005, Waters lost his home and the majority of his life's work to Hurricane Katrina, but that has not deterred him or his desire to continue the documentation of the culture. Semi-based in Atlanta, Georgia, Waters travels often to continue documenting his love of New Orleans culture.

His work has been exhibited in the African-American Museum (Philadelphia), New Orleans Museum of Art, Georgia Gallery (Atlanta), Stella Jones Gallery (New Orleans), the New Orleans Jazz & Heritage Festival, and The Essence Music Festival.

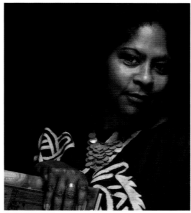

GUS BENNETT

KAREN CELESTAN is the executive writer/editor in University Advancement and an adjunct professor in English at Texas Southern University in Houston, Texas. She was senior program manager for the Music Rising at Tulane program in the New Orleans Center for the Gulf South at Tulane University and was an adjunct instructor in English at Southern University at New Orleans. She is a regular interviewer at the Allison Miner Music Heritage Stage at the New Orleans Jazz & Heritage Festival, holding live conversations with such artists as Cassandra Wil-

son, Rance Allen, Joe Sample, Germaine Bazzle, Henry Gray, James Johnson, Me'Shell Ndegeocello, Jon Batiste, and Pura Fé.

She is a member of the National Association of Black Journalists (NABJ), the Association of Writers and Writing Programs (AWP), and the National Council of Teachers of English (NCTE).

Celestan is the coauthor of *unfinished blues: Memories of a New Orleans Music Man* with Harold Battiste Jr. (2010). The Black Caucus of the American Library Association, Inc. (BCALA) presented the 2011 Outstanding Contribution to Publishing Citation to *unfinished blues* for excellence in scholarship.

Her short story "Higher Ground" about the aftermath of Katrina was selected as a winner of *Carve* magazine's 2013 Esoteric Award for the "Natural Disaster" special issue. Her creative work has appeared in several literary magazines and poetry collections.

She was community relations and policy manager in government affairs at Tulane University; senior director of university communications for Dillard University; publications and media coordinator for Festival Productions, Inc. of New Orleans (which produces the New Orleans Jazz & Heritage Festival [Jazz Fest] and produced The Essence Music Festival); and a copy editor for the *New Orleans Times-Picayune, Louisiana Weekly,* and the *NABJ Journal* (National Association of Black Journalists). She was a longtime host of *Writers' Forum,* a literary talk show on WBRH-FM (New Orleans). A former journalist, her work has appeared in a number of publications, including the *Times-Picayune, Gambit Newsweekly, Louisiana Weekly,* and the *Niagara (Falls, NY) Gazette.*

INDEX